D0077232

Exploring Visual Culture

Exploring Visual Culture

Definitions, Concepts, Contexts

Edited by Matthew Rampley

Edinburgh University Press

© in this edition Edinburgh University Press, 2005
© in the individual contributions is retained by the authors

Transferred to Digital Print 2009

Edinburgh University Press Ltd
22 George Square, Edinburgh

Reprinted 2007

Typeset in 11.5/13.5 Perpetua
by Servis Filmsetting Ltd, Manchester, and
Printed and bound in Great Britain by
CPI Antony Rowe, Chippenham and Eastbourne

A CIP record for this book is available from the British Library

ISBN 0 7486 1845 7 (paperback)

Contents

Acknowledgements

There are many people whose role in the development of this book needs to be acknowledged. These include: Amy de la Haye, Corinne Day, Susan Babchick, Richard Braine, Nick Knight, Jake Harvey, Glen Onwin, Donald Urquhart and Sutherland Hussey Architects, Martin Elliott, Janet Morton, Karin Muhlert, Helga Reay-Young, Alison Britton, Takashi Murakami, Paul Rennie and Nicholas Zurbrugg. Thanks are also due to the Research Board of Edinburgh College of Art for supporting this project.

It is also important to thank the various visitors to Edinburgh College of Art whose indirect contributions to this book, through debate and discussion, should be mentioned. They include: Judy Attfield, Rosemary Betterton, Norman Bryson, David Michael Clark, James Elkins, Michael Ann Holly, Hubert Locher, Angela McRobbie, Keith Moxey, Maria Orišková, Donald Preziosi, Charlotte Schoell-Glass and Peter York.

Lastly, thanks are due to Sarah Edwards of Edinburgh University Press, whose unstinting patience and support have helped make this book possible.

List of Figures

Contributors

Fiona Anderson is Senior Curator of Dress and Textiles at the National Museums of Scotland. Her research has focused on men's fashion. Recently published work includes 'Museums as Fashion Media' in Stella Bruzzi and Pamela Church Gibson, eds, *Fashion Cultures: Theories, Explorations and Analysis* (Routledge, 2000), 'Fashioning the Gentleman: A Study of Henry Poole and Co. Savile Row Tailors 1861–1900' and 'Spinning the Ephemeral with the Sublime: Modernity and Landscape in Men's Fashion Textiles 1860–1900,' both in *Fashion Theory*.

Glyn Davis is a lecturer in screen theory and history at Edinburgh College of Art. The co-editor (with Kay Dickinson) of *Teen TV* (BFI, 2004), his research focuses on representations of gender and sexuality in television and film. Recent work includes articles on 'Youth and Teen Television' in the *BFI Television Handbook 2005*, 'Dirk Bogarde and International Queer Stardom,' in R. Griffiths, ed., *Queer Cinema in Europe* (Intellect, 2005) and 'Stephen Fry and Oscar's Queer Heritage' in Griffiths, ed., *British Queer Cinema* (Routledge, 2005).

Juliette MacDonald lectures in design and craft at Edinburgh College of Art. Her research interests focus on the relation between craft and cultural and national identities. Her PhD was on cultural identity in the work of the architectural glass artist Douglas Strachan. She has published articles in *Journal of Design History*, the *Journal of the British Society of Master Glasspainters*, and is currently undertaking research into craft and consumer ritual.

Neil Mulholland is a lecturer in contemporary art and visual culture at Edinburgh College of Art. His research is currently centred on global contemporary art, criticism and visual culture. He is a regular critic for *Frieze*, *Flash Art*, *Texte zur Kunst*, *Untitled* and *Flux*. Recent work includes: *The Cultural Devolution: British Art in the Late 20th Century* (Ashgate, 2003); *Err . . . Shrigley* (Channel 4, 2003). He also curated *Leaving Glasvegas* at the Prague Biennale (2003).

Ruth Pelzer is a lecturer in art and visual culture at Edinburgh College of Art. As a practising artist her research focuses on reproductive technologies, especially printmaking, and the interface between theories of reproduction and print-making practice. She has exhibited her work in exhibitions and galleries in Germany, South Africa, Portugal and Scotland.

Matthew Rampley is director of the Graduate Research School, Edinburgh College of Art. His research has focused on aesthetic theory, and the philosophy and historiography of art. He has published widely in journals such as *Art History*, *Res*, *Kritische Berichte*, *Art Bulletin* and *Word and Image*. Books include: *Nietzsche, Aesthetics and Modernity* (Cambridge University Press, 2000) and *In Remembrance of Things Past: On Aby Warburg and Walter Benjamin* (Harrassowitz, 2000).

Richard Williams is a lecturer in art history at the University of Edinburgh. He has published widely on late modern art and urban culture. Publications include: *The Anxious City* (Routledge, 2004) and *After Modern Sculpture* (Manchester University Press, 2000).

Introduction

Matthew Rampley

This book is an introduction to visual culture. Its aim is to explore the various forms of visual culture, to analyse some of the key ideas used in its interpretation and to outline some of the social contexts in which the forms of visual culture are produced, distributed and consumed. It is intended as a primer that traces the life of concepts that have become central to the engagement with visual culture, in order then to point towards ongoing and possible future debates surrounding their present and further use. As an introductory text, it does not claim to give an exhaustive account of the topics; it aims rather to highlight salient points and indicate where the reader may wish to pursue more detailed and in-depth discussion.

The term 'visual culture' has had considerable prominence over the past five to ten years, and there are many excellent studies of the subject.[1] Why, then, add another book to an already burgeoning list? There are various reasons. First, many studies of visual culture equate it with the study of the image. Indeed, the study of visual culture has often been seen as identical to the theory of the image. Where art history is concerned with paintings, drawings and engravings, the proponents of visual culture argue that what is needed is a recognition of the role of the much broader range of images. In an age where the majority of images encountered will be photographs in magazines, on advertising hoardings, films, television and other technologies of mass-production and reproduction, including personal holiday photographs and, most recently, digital videos, the traditional concerns of art history have been seen as culturally elitist. Art long ago ceased to be the most important visual expression of cultural identity.

There is much force to this argument; while in Britain and America the term 'visual culture' (and 'visual studies') is most common, elsewhere, in France and Germany for example, the link between visual studies and the image is made explicit by the rise of so-called image theory or the science of the image (*Bildwissenschaft* in German).[2] The authors of this book, however, believe that this is too narrow a focus. Not only does art consist of practices *other* than the making of images – one should mention sculpture and, more recently, installation or text-based conceptual art – but also material artefacts play a crucial part in the visual articulation of cultural values and identity. These range from fashion designs to crafted objects, designed commodities or buildings and entire cities. Indeed, one could argue that visual culture begins with the human body, with bodily adornment and the language of bodily gesture. Most of these practices are usually absent from accounts of visual culture, with their focus on the mass media of photography, television, film and the Internet.[3] Where this book attempts, in its own modest way, to make an original contribution to the field, therefore, is in its interpretation of what the term entails.

It could be objected that such a notion makes visual culture an impossibly broad subject. Indeed, visual culture could be expanded to include other practices, including theatre, opera, ballet, musical performances, tourism, landscape design, road and motorway design, gardening, spectator sports, *haute cuisine*. All of these comprise, to a greater or lesser extent, visual display. There may well be other possibilities. There is undoubtedly some truth in this claim; visual culture might consequently encompass practically *everything*, and a theory of everything is neither possible nor necessarily desirable. Nevertheless, given that the generation of visual meaning involves complex interactions between images and material artefacts, and that the various practices of visual culture frequently rely on such interactions, exclusive attention to images is open to interrogation.

The question then arises as to where one draws the limits and why this book focuses 'only' on design, craft, art, cinema, television, the Internet and architecture. In one sense there is no such thing as visual culture. There is no cultural practice that is entirely visual. All cultural practices function using a variety of means, involving visual perception and communication, but also others, such as hearing, language, bodily and tactile experience, and taste. Fashion is meant not only to be seen, but also to be *worn* on the body. An opera or concert of popular music is as much a visual spectacle as a musical experience. A film may often involve spectacular visual effects, but it also relies on a soundtrack, not to mention a narrative script and dialogue between its cast. This book often highlights and analyses those 'non-visual' factors that inform the production and consumption of visual culture. There are two principal reasons why this book focuses on a narrower set of practices. The first is pragmatic; given the impossibility of providing an account of everything, this book limits its subject matter to something more feasible. The

second reason is to do with the landscape of cultural practice. For amongst the vast range of possibilities the term 'visual culture' might encompass, the practices focused on in this book have long shared histories. They have often been intertwined and have often borrowed from each other, conceptually, aesthetically and in other ways too. Early theories of film were consistently modelled on the theory of art, for example; indeed, a major preoccupation for early debates on film was its relation to art and its validity as an art form. More recently, art theory has borrowed heavily from film theory.

The study of visual culture has come to be dominated by certain theoretical approaches. These include: Lacanian notions of the gaze; Louis Althusser's notion of ideological interpellation; Walter Benjamin's conceptions of aura, fetishism and technology; semiological conceptions of meaning and representation; the feminist writings of Julia Kristeva, Judith Butler, Luce Irigaray and Bracha Lichtenberg Ettinger; the postcolonial writings of Gayatri Chakravorty Spivak and others. It is not that these theories are unimportant; they undoubtedly are, and they are referred to here. However, this book does not assume that these are the only or even principal methods by which one should explore visual culture. Indeed, many of the authors mentioned above concern themselves with solely visual *representations* – images – and given that this book understands visual culture as involving something more than this, it is clear why it does not necessarily offer an introduction to 'canonical' theorists in visual studies.

It is often argued that the fluid state of contemporary society has led to an erosion of traditional boundaries and concepts. Older concepts, including 'art' and 'architecture', can no longer be seen as beyond scrutiny, particularly in an era when the values of popular culture seem to be ubiquitous and when traditional forms of 'high culture' – opera, classical music, avant-garde art, experimental cinema – appear to struggle to survive economically. This is undoubtedly true, but at the same time it is premature to speak of the end of high art, for example, even if romantic ideas of art as somehow standing aloof from the run of popular culture are no longer credible. As James Elkins has argued: 'From a sociologist's point of view, the division between people who adhere to high art and those who consume low art is a readily demonstrable fact . . . statistically speaking, the division is endemic in Western society.'[4] The audience for the musical compositions of Pierre Boulez or Olivier Messiaen is distinct from the studio audience for the *Jerry Springer* show, for example. Indeed, art, or craft or architecture persist as distinct visual practices and social institutions. Even if they frequently interact, numerous factors ensure that they maintain separate centres of gravity. This begins with the process of formal education and continues on to professional associations, exhibition venues and various public bodies. The fact that there exists in Britain a Crafts Council separate from the Arts Council, for example, with parallel networks of galleries and dealers, suggests such a difference. Consequently, this book also

examines the ways in which the activities of visual culture are organised and defined both with and against each other, and how different practices have emerged as social institutions.

This book also makes its own exclusions. It could also have included medical imagery, astronomical charts, scientific diagrams, the charts of statisticians. There have been a number of important studies of these kinds of visual representations.[5] Yet, as with the case of the other possibilities mentioned earlier, attention to these would make this book impossibly broad and lacking coherence. Many of these representations are tied to specific scientific discourses, the analysis of those lies beyond the scope of visual studies.

In most cases this book will be referring to the visual culture of Britain and America, as befits its role as an introduction for an English-speaking readership. We readily acknowledge the limitations of this approach. In a postcolonial context the problems that beset such a focus on the West are very apparent. As Elkins has noted, visual studies has yet to engage seriously with non-Western cultures.[6] However, this book does not and should not aim at an all-encompassing, encyclo-paedic account; many of the social and historical developments that have impelled the interest in visual culture are unique to Western societies. It is doubtful that one could or even should speak of the visual culture of, for example, Mali, Indonesia or Zambia, as if it were comparable to Western notions of visual culture. We there-fore leave it for readers to decide the ways in which the issues explored in this book might be applied to the understanding of other cultures and societies.

Notes

1 Some of the more recent introductory books include: James Elkins, *Visual Studies: a Skeptical Introduction* (New York and London, 1993); Richard Howells, *Visual Culture: an Introduction* (Cambridge, 2003); Malcolm Barnard, *Approaches to Visual Culture* (London, 2001); Marita Sturken and Lisa Cartwright, *Practices of Looking: an Introduction to Visual Culture* (Oxford, 2001); Nicholas Mirzoeff, *An Introduction to Visual Culture* (London, 1999); John Walker and Sarah Chaplin, *Visual Culture. An Introduction* (Manchester, 1997). To this list one can also add the recently established *Journal of Visual Culture* (2002–).

2 See, for example, Hans Belting, *Bild-Anthropologie. Entwürfe für eine Bildwissenschaft* (Munich, 2001); Gernot Böhme, *Theorie des Bildes* (Munich, 1999); Gottfried Böhm, *Was ist ein Bild?* (Munich, 2nd edition, 1995).

3 An excellent recent anthology of texts, Stuart Hall and Jessica Evans' *Visual Culture. The Reader* (London, 1999), suffers from precisely this narrowness. It could easily be considered as an anthology of writings on photography.

4 Elkins, *Visual Studies*, p. 50.

5 See, for example, Barbara Maria Stafford, *Body Criticism: Imaging the Unseen in Enlightenment Art and Medicine* (Cambridge, MA, 1991); Jeremy Black, *Maps and History* (London and New Haven, CT, 2000).

6 See Elkins, *Visual Studies*, pp. 110 ff.

1. Visual Culture and the Meanings of Culture

Matthew Rampley

Introduction

Of the various questions raised by the emergent field of visual studies, undoubtedly the most complex is the understanding of the term 'visual culture'. Its meaning has been interpreted in various ways. This chapter will attempt to give some sense of the possible meanings of the term, but rather than becoming immersed immediately in recent debates about the sense of 'visual culture', it turns to a more basic question: What is the meaning of 'culture'?

Concepts of Culture

The idea of culture has a complex history, and debates about its meaning have been linked inextricably with the parallel concept of 'civilisation', regarded by many as synonymous with culture, and by others as its antithesis. The relation between them will be explored in greater detail shortly, but for the time being the two can be treated as having the same sense. The term 'culture' only began to appear in the English language in the late eighteenth century and came into use alongside a number of other ideas, such as 'industry', 'democracy', 'class' and 'art', which are still fundamental to how society is understood.[1] Within Britain the idea of culture arose partly in response to the impact of the Industrial Revolution in England and partly as a result of Enlightenment speculation on the origins and meaning of human society, but there was also a wider European context; the German equivalent *Kultur*

was also an invention of the late eighteenth century, while in France the term 'civil-isation' first appeared in 1766.[2] Yet while the idea of culture is relatively recent, the origins of the word are rather older, for it comes from the Latin *cultura*.

Cultura originally denoted the cultivation of nature. This may seem distant from the contemporary understanding of culture, but many terms associated with the development of nature still function as metaphors for human society. The notion of 'cultivation', originally describing land husbandry, has long been associated with the development of the individual; being 'cultivated' often implies a process of per-sonal refinement. Similarly, 'breeding' was traditionally used in Britain to denote the establishment and preservation of a distinct class identity. This metaphor also underpinned the association of culture and civilisation with progress and refine-ment. From the Enlightenment onwards, they have been seen as a process of devel-opment and perfection, both of society as a whole and of the individual. As the French historian François Guizot stated in *On Civilisation in France* (1829): 'the idea of progress, of development, seems to me to be the fundamental idea contained in the word "civilisation"'.[3] Furthermore, the meaning of 'culture' and 'civilisation' has also been shaped by their implicit opposition to barbarism or savagery; where civilisation is a process of refinement, 'savagery' is the raw state of nature or, liter-ally, living in the forest.

Although 'culture' initially denoted a *process* – the intellectual and spiritual cul-tivation of an individual or social groups – it came to be seen in the nineteenth century in material terms. No longer a quality of individuals, culture consisted of the outcomes of such cultivation: artworks, poems, philosophical texts, literature, and so forth. This shift has underpinned many of the most contentious debates regarding culture, which have often centred on the status of individual objects and forms, and on whether or not they count as examples of 'genuine' culture. Second, implicit in both the idea of culture as a process of cultivation and in its opposition to 'savagery' is its dependence on notions of value; within Western thought 'culture' has invariably functioned as an *evaluative* and hierarchical concept. A famous example can be seen in Matthew Arnold's *Culture and Anarchy* (1869), which described culture as involving the cultivation of 'sweetness and light'.[4] Only what improved the human condition was representative of 'true' culture, according to Arnold, a definition that relegated many social practices to the realm of popular entertainment. Indeed, for Arnold the greatest threat to genuine culture came from the Industrial Revolution, which, with its introduction of mechanical production and mass popular culture, threatened to plunge European society into barbarism.

Arnold's views may seem distant from our own, but they informed a long intel-lectual tradition. In Britain, for instance, the literary scholar F. R. Leavis' widely influential study *The Great Tradition* (1948) identified authors whose works formed the basis of a 'genuine' culture that would act as a bulwark against the dehumanis-

ing effects of modern industrial society.[5] Likewise, the American theorist Dwight MacDonald (1906–82) drew a sharp distinction between 'high' and 'mass' culture. Mass culture, argued MacDonald, is a debased form of high culture 'imposed from above. It is fabricated by technicians hired by businessmen; its audiences are passive consumers, their participation limited to the choice between buying and not buying . . .'[6] A similar critique was mounted by the Frankfurt School of critical theory; writers such as Theodor Adorno (1903–69) and Herbert Marcuse (1898–1979) stressed the role of mass popular culture in encouraging a state of unthinking passivity in the audience, inculcating unthinking acceptance of consumer culture and creating 'false' needs for consumer goods. Such a system also prevented the mass audience from being able to engage with 'authentic' art and culture, offering instead mindless escapism.[7] We may no longer see popular audiences as dupes, nor share Arnold's concerns about the growth of popular culture. Nevertheless, cultural practices still take place within a hierarchy, the mass products of popular culture regarded as 'lower' than high art, opera or literature. Thus the films of Jean-Luc Godard or Krzysztof Kieślowski count as examples of 'high' culture in contrast to *Dumb and Dumber* (1994) and other comedies by the Farrelly Brothers. Likewise the *Harry Potter* novels and films count as popular entertainment, in contrast to, for example, the poetry of Jeremy Prynne, which is counted as 'serious' literature. This hierarchy often feeds into basic debates about culture. An obvious example might be the recurrent argument about the 'damaging' effects of watching too much television, particularly in the case of children. Nobody would suggest repeated attendance at an art gallery might have negative consequences.

These illustrate a broader habit of thought, where 'genuine' cultural practices are expected to elevate their audiences and place intellectual and aesthetic demands on them. Those that do not are relegated to a lower place in the hierarchy or even denied the status of 'genuine'. Such expectations can be observed in many areas, and a potent case is the response to artworks; since the mid-nineteenth century there has been a recurrent tension between the challenge of avant-garde art and the expectations of the public. This can be seen in the initial public revulsion shown to Edouard Manet's painting *Olympia* when first exhibited in 1865, or in the outcry over the Tate Gallery's purchase in 1978 of Carl Andre's *Equivalent VIII* (Figure 1.1), or in reactions to Martin Creed, winner of the 2001 Turner Prize. Creed, whose work has included a ball of Blu-Tack (*Work # 79*, 1993), a piece of masking tape (*Work # 81*, 1993) and a light switching on and off every five seconds in an empty gallery space (*Work # 227*, 2001), was the source of considerable bemusement and dismay. While some of the criticisms of the 2001 Turner Prize were the result of a healthy scepticism towards its infatuation with the media – including the choice of Madonna to award the prize – much critical commentary drew on the tacit assumption that art should have a higher, purpose not immediately evident in Creed's work. Indeed, one of the most important art critics of the twentieth century, Clement

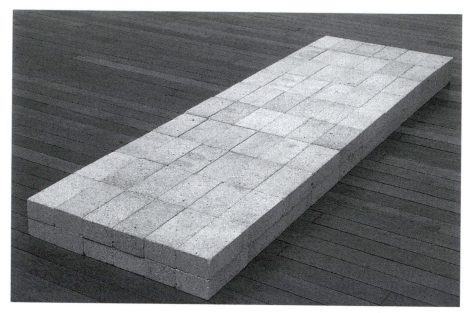

Figure 1.1 – Carl Andre, *Equivalent VIII* (1978). Tate Gallery, London. © DACS.

Greenberg (1909–94), coined the term *kitsch* to distinguish between 'bogus' culture and genuine avant-garde art. *Kitsch* was meant, he argued, for those who are 'insensible to the values of genuine culture', offering 'vicarious experience and faked sensation'.[8] In contrast, the role of avant-garde art was to 'keep culture moving' and hence maintain cultural progress.

As noted earlier, 'culture' has come to denote not merely the process of individual and social development, but also the *things* – novels, artworks, musical compositions, poems, buildings – a society has produced. They stand, in some sense, as its monuments, and according to this view the process of cultivation, of becoming 'cultured', consists in an ever-deepening acquaintance with these cultural artefacts. In Britain, the origins of this notion can again be placed in the eighteenth century, an important role being played by the Grand Tour. The purpose of the Grand Tour, which flourished between approximately 1700 and 1790, was to acquaint young aristocratic men with the great architectural and artistic monuments of Europe and, in particular, Italy. It functioned as a substitute for university education at a time when England had an underdeveloped university system in comparison with other European states. It was also designed to cement the central role of classical culture – in particular ancient Rome – in providing the standards of reference for all judgements of taste. It also afforded the gentry the opportunity to acquire through purchase or plunder the artefacts they encountered, thus confirming their 'cultured' status. Although the Grand Tour fell into decline in the late 1700s, the idea that acquisition of certain kinds of artefacts could confirm one's

own 'cultivated' status has remained a powerful and persuasive one within Western culture. Social status and class are no longer defined exclusively by wealth, but the term 'cultural capital', coined by the French sociologist Pierre Bourdieu (1930–2002), illustrates clearly the extent to which education and culture remain a form of *symbolic* wealth that continues to define and structure social hierarchies.[9]

There are numerous problems with this view. Most immediately, it has to be asked who decides what is to count as genuine culture. This has been a perennial issue; I have already mentioned Leavis's attempt to identify the great cultural tradition, and the issue was raised again in the 1990s by the American critic Harold Bloom, whose book *The Western Canon* (1995) included a list of the great and supposedly indispensable works of world literature.[10] This was a bold tactic, for it invited the reader to reflect on Bloom's criteria for inclusion and exclusion. I do not intend to criticise any of Bloom's individual judgements. It is the *possibility* of disagreement that highlights the central difficulty of his approach: it is questionable whether there *can* be a general consensus as to what counts as the great works of art and literature. There may be considerable areas of consensus – few would dispute the inclusion of Shakespeare or Picasso in such lists – but equally there will be huge areas for disagreement. When it comes to the paintings of Suzanne Valadon, for example, or the photomontages of Romare Bearden or the films of Jane Campion it is not at all clear that there would be universal agreement as to whether they formed part of the Western cultural canon or not.

Feminist writers have been particularly critical of the canon. It has tended to privilege male artists, architects, writers, and so forth.[11] Partly, this has reflected the fact that most histories of culture have been written by men and partly, too, the fact that the features valued in the formation of canons, have tended to be seen as 'masculine'. These have included, for example: a strong artistic identity; a stress on individual autonomy; an interest in narratives that privilege masculine actors (heroes). In addition, mass culture, and the consumerism associated with it, have often been regarded as 'feminine'.[12] Similar criticisms have been made of the canon in relation to the exclusion of the culture of ethnic minorities.

Such arguments highlight the fact that societies lack the uniformity that would be necessary to agree a common canon. Indeed, since the pioneering work of the Russian cultural theorist Mikhail Bakhtin (1895–1975) it has been recognised that no society has a single culture and that instead one must always think in terms of a plurality of cultural voices and values.[13] Bakhtin made such observations in the 1930s and 1940s, and if this was the case, then it is doubly so in the present, where cultural and economic globalisation have rendered societies increasingly diverse. Indeed, it has proved ever more difficult to identify a body of works recognised by all as constituting a shared cultural tradition. It is the anxiety that this seems no longer possible which ultimately motivates Bloom; an uncharitable interpretation would be that he was concerned by the fact that American East Coast literature

professors such as himself can no longer determine what counts as great art or culture, and that their judgements are no longer automatically followed or shared by others.

Culture without Values

Behind the notion of culture as something of quality to be achieved or possessed lies a complex set of social expectations and values. The Grand Tour again offers an important example, for its purpose was not only to educate the gentry and the aristocracy, but also to ensure that they retained social prestige and dominance through their access to a culture unavailable to others. It is no coincidence that the Grand Tour declined in importance in the late eighteenth century as it became affordable for larger numbers of the middle classes to visit Italy. Moreover, the weaknesses of this evaluative notion of culture are further evident when considered in the context of contemporary Western society. While we may all have varying degrees of familiarity with the canonical works of Western culture, far more influential and prevalent in contemporary European and American societies are forms of popular culture – from film and television to comic books or computer games – which writers such as Arnold, Leavis and Eliot would not even consider as examples of 'culture'. Yet few would maintain that ours is an age with no culture. Its values and concerns have changed in important ways – and many have deplored this fact – but that is a different question. In other words, the definition of culture needs to be separated out from questions of quality. This may appear to be a very contemporary issue, but it was already being articulated in the eighteenth century by the German philosopher Johann Gottfried Herder (1744–1803).

Herder objected to the fact that European culture was defined largely in terms of ancient Greece and Rome and its persistence in the literature and art of seventeenth- and eighteenth-century France, with a consequent disregard for national cultures from other, non-classical traditions. Herder proposed an alternative, more democratic notion of culture that was no longer linked to the classical tradition or more generally to judgements of quality. Indeed, until now I have tended to treat 'culture' and 'civilisation' as interchangeable terms, but in fact Herder introduced the notion of 'culture' (*Kultur*) in opposition to the dominance of the classically inspired civilisation of France. 'Culture' designated for Herder the way of life of a particular community, which included everyday customs and habits, beliefs and traditions alongside the great artistic and intellectual monuments associated with 'civilisation'. 'Culture' was now a purely descriptive term that made no judgement about the moral, intellectual or aesthetic quality of a cultural practice. One can think again of biological metaphors, for where the first definition of culture views it in terms of a process of cultivation, Herder sees culture as the organic and naturally growing expression of a given community. In other words, a culture grows

not by reference to some artificially imposed standards drawn from elsewhere – classical antiquity or France – but spontaneously according to its own impulses.[14]

Herder is often credited with being the first cultural relativist; in the place of civilisation as a singular achievement he proposed the idea of a *plurality* of societies, each of which has to be understood in terms of its own cultural values. Herder was concerned to legitimise German culture as different from the dominant classical tradition in Europe at the time, and he was writing at a time of a great upsurge of German national consciousness. Indeed, Herder's ideas have at times been linked with nationalist ideologies that emphasise both national *difference* and also the notion of ethnically 'pure' culture. Herder himself would not have remotely endorsed such ideals; he was concerned above all with promoting pluralism and resisting cultural domination. His approach also emphasised an *anthropological* definition of culture. I term it 'anthropological' because contemporary anthropology, with its roots in the study of non-Western cultures, has long sought to understand such societies on their own terms, without projecting onto them the values of Western societies. Of course, the idea of a neutral description of another culture is itself open to question, and as the anthropologist James Clifford has demonstrated, there are good reasons to doubt the authority of the ethnographic observer.[15] Nevertheless, the anthropological definition of culture has been valuable for two important reasons: it has ensured recognition of the plurality of cultures and values while also challenging long-held assumptions about the superiority of certain cultures over others.

Although such debates appear rooted in particular political and intellectual problems of the eighteenth century, their relevance to contemporary visual culture is of a very direct kind; the recent, unprompted outbursts by Italian prime minister Silvio Berlusconi, the British television presenter Robert Kilroy-Silk or George Carey, the former Archbishop of Canterbury, concerning the alleged inferiority of Arabic culture highlight the continued existence of deep-seated prejudices about cultural value and difference. The rise of the notion of visual culture is a further manifestation of these debates over the definition of culture. In particular, it has been taken up by various authors to counter the elitism of traditional scholarly concerns with high culture.

The idea of a visual culture was first explored systematically by the British art historian Michael Baxandall, in a widely read work, *Painting and Experience in Fifteenth Century Italy*.[16] The traditional art-historical approach to interpreting works of art was to establish its relation to other artworks, in order to ascertain the artistic influences on the painter or sculptor. In addition, if the work relied on complex symbolic imagery, contemporaneous literary sources, ranging from philosophical and theological texts through to classical works of mythology, would be consulted to establish its meaning. Frequently, the role of the aristocratic patron of the artist would also be examined in order to analyse the process of its production,

and the possibility of tracing an artwork back to its point of origin would demonstrate its authenticity (and enhance its monetary value).

Baxandall undertakes much of this kind of scholarly analysis, but in addition he suggests that we look beyond the confines of art and of the high culture of the Renaissance in order to understand the paintings of the fifteenth century. For example, he argues that the invention of perspective by Filippo Brunelleschi in the early 1400s, with its obsessive attention to mathematical proportion, has to be considered in relation to the dominance of the practical mathematics of commercial transactions of the time, in which merchants would need to perform complex calculations on a daily basis. In a society that invented double-entry book-keeping, a predisposition to attend to mathematical quantities and proportions also informed visual experience, including pictorial representations. Baxandall also compares representations of the human figure in painting with manuals on dancing of the same time.

Baxandall tried to change the context in which artworks were seen. Instead of the exclusive focus on 'high' artistic and literary culture, he brought in other aspects of cultural life that equally informed the making of artistic images. Of course, one has to be cautious here; in Renaissance Italy paintings *were* accorded a higher value than many other kinds of artefact. Nevertheless, Baxandall indicated how significant other apparently minor and peripheral cultural practices were when attempting to understand the art of the time, and numerous others have followed his example. Svetlana Alpers, for example, compared seventeenth-century Dutch paintings – the so-called golden age of Dutch art – to other kinds of visual representations such as maps and scientific illustrations, as well as examining various ideas about vision prevalent at the time.[17] Alpers was also the first to use the term 'visual culture'. However, for both Baxandall and Alpers, artworks remained the centre of interest, and the broader context of visual culture was explored in order better to illuminate the understanding of individual paintings or artists. In other words, both privileged works of art because they were seen to be more important expressions of a culture than other kinds of image-making. In addition, while he moves beyond the domain of art, Baxandall was ultimately concerned with the beliefs, ideas and values – in short, the culture – of the wealthy producers and consumers of painting in Renaissance Italy. We are therefore still in the shadow of the cultural elite of Italian society.

More recently, the idea of visual culture has come to involve a broader perspective, in which the object of study is no longer the concerns of a cultural elite, but rather the much wider set of ideas, beliefs and customs of a society *and the ways in which they are given visual expression*. This has a number of important consequences. Most immediately this means that visual culture is seen as consisting not only of works of art, but also of all other kinds of visual imagery; in relation to the twentieth century these would include, for example, cinema, television, advertising and

graphic design, comic books or photography. In attempting to understand a society, such popular forms of visual image-making offer just as important clues to its beliefs and values as the traditional sphere of high art. Thus, to take one or two recent examples, Anne Massey has examined the impact of Hollywood cinema on design and material culture in Britain, from architecture to make-up, fashion and hairstyles, while Kirstin Ross's study *Fast Cars Clean Bodies* has analysed the ways in which the design of cars, women's magazines, films, popular fiction and even washing machines offer a clue as to the formation of French cultural identity during the 1950s and 1960s.[18]

The art historian Heinrich Wölfflin (1864–1945) argued more than a century ago that the design of a shoe could be as important an index of the values of medieval European culture as the great Gothic cathedrals of Chartres or Strasbourg. Wölfflin was emphasising the importance of everyday objects; it is precisely *because* such items are taken for granted that they reveal so much about the tacit assumptions underlying a culture. A concern with the everyday also played an important role in the rise of cultural studies, with authors such as Henri Lefebvre and Raymond Williams explicitly turning to the ordinary, in contrast to elite cultural practices.[19] Wölfflin's mention of a shoe highlights the fact that dress and fashion are often some of the more widespread means of visual expression in a culture. This applies not only to the self-conscious products of *haute couture*, but also to clothing for all sorts of purposes, from casual dress to work wear or military uniforms. As Fiona Anderson argues in chapter 5, dress and fashion serve as powerful markers of cultural identity and difference world-wide, distinguishing between the sexes, between social classes and between generations.

Many have thus turned to the analysis of visual culture out of dissatisfaction with the elitist cultural values associated with the study of art. For the authors of this book art remains an important constituent of visual culture – although less important than a century ago – but what is required is to place it in a broader context in order to enable a properly critical analysis. It is also necessary to look beyond it to understand a culture in all its facets. It follows, therefore, that no cultural practice is to be discounted as a legitimate object of enquiry on qualitative grounds alone; the *Rocky* films starring Sylvester Stallone, for example, were as important barometers of American cultural values of the 1980s as the novels of Thomas Pynchon, the paintings of Julian Schnabel or the architectural projects of Michael Graves. This does not mean that one should suspend all judgements of quality; Martin Scorsese's *Raging Bull* (1980) undoubtedly offered a more penetrating study of masculine identity than the *Rocky* films, but as an index of American cultural values and taste it was probably less significant. Here we come to the recognition that cultural and historical significance are to be separated out from questions of artistic and aesthetic quality.

In certain respects the antagonistic attitude that the study of visual culture

adopts towards art typifies a much wider debate over the definition of culture, and the attempt to reassess what counts as 'legitimate' cultural practice has encountered fierce resistance. One particularly prominent example within Britain has been the widespread criticism of the growth of university degrees in media studies. At the root of such objections is the notion that the mass media – newspapers, radio and television – together with other forms of popular culture such as film, do not merit serious scholarly attention, that they are intrinsically 'inferior' to the great works of art and literature. The arrogance of such views hardly needs commenting on, but it is interesting to note that in the 1920s similar criticisms were made of the notion that the study of English literature was as valid as the study of the classical literature of Greece and Rome.

Visual Culture and the Culture of the Image

There is a further dimension to the idea of visual culture, and this is linked closely to the idea that the visual image has become central to contemporary cultural practice in the West. For most of its history Western society has been an oral society; the dominant forms of cultural expression were oral, the principal form of cultural transmission the passing on of stories, legends, histories by word of mouth. There are, of course, numerous written monuments from the oral period of European culture, but these were often the summation of a long oral tradition or, as in the great courtly epics and romances of the Middle Ages, transcriptions of poems originally composed to be recited to an audience. At a time of low literacy, and when the process of producing manuscripts was enormously costly and slow, cultural values and traditions were circulated and handed down primarily by oral means. The invention of printing in the fifteenth century increased the circulation of texts such that the written word gradually became the central form of cultural communication. This gave rise to cultural forms such as the novel, directed towards the *reader* as opposed to the listener, or the mass-circulation newspaper in the late 1800s, which could only have come into being with a general rise in literacy.[20] Of equal significance was the invention of the woodcut, and later of increasingly complex techniques for the mass production of printed images, including engraving, lithography and photography. Such technologies ensured that the distribution of images became increasingly widespread, from the political and religious pamphlets of the 1500s to advertising in the 1800s. This intensified in the twentieth century with the invention of cinema, television and the computer, and in particular the WYSIWYG interface familiar from Apple and Windows-based personal computers. One might add to this list the ubiquitous computer game, from the Nintendo Gameboy to the Sony Play Station.

Such media have not completely supplanted traditional 'literary' cultural forms; even computer games have a narrative structure that is not reducible to the

visual alone. Nevertheless, the novel, for example, no longer enjoys its former pre-eminence, and the continued popularity of many literary 'classics' is often dependent on the production of filmic adaptations, from *The Forbidden Planet* (1956), based on Shakespeare's *The Tempest*, to *Clueless* (1995), adapted from Jane Austen's *Emma*. Much of the history of postwar visual culture has been driven by the impulse to make it ever more visually spectacular. Here one might think of the invention of colour film or of the use, in the 1950s and 1960s, of the wide-screen format of cinemascope. More recently, too, the rise of digital technology has enhanced the visual spectacle involved in viewing the cinema. The conditions of viewing the cinema, from within a darkened room, also emphasise this aspect, and numerous writers have speculated on the way that this process engages with certain deep-seated psychological processes on the part of the viewer.[21] Television, too, having once been seen as involving a rather different kind of viewing experience from the cinema, is now moving in the same direction, with the development of 'home cinema', wide-screen television and the cinematic quality of the DVD. Furthermore, one need not refer only to the forms of entertainment provided by commercial producers. As Nicholas Mirzoeff has argued, contemporary life in general occurs on screen; in Western societies the ubiquity of the closed-circuit TV camera means that most of life is now carried out under some form of video surveillance.[22] Similarly, the proliferation of photography and the video camera either produces or gratifies an urge to record every detail of our individual lives, the most significant the most banal. The popularity of television programmes such as *You've Been Framed*, in which viewers submit footage of family accidents and pratfalls, testifies to an insatiable appetite to watch each other's on-screen lives.

In general, therefore, Western society has become a predominantly visual culture, facilitated and probably even initiated by certain technologies. Others have suggested that a further reason may be the dependence of consumerism on visual spectacle. Walter Benjamin (1892–1940) analysed the first shopping arcades in early nineteenth-century Paris, the primary function of which was to create a magical spectacle – what Benjamin termed a 'dream landscape' – to promote consumption.[23] This idea was taken up by others such as Guy Debord (1931–94), who highlighted the extent to which Western society has become in thrall to the image, which not only underlies the basis of contemporary consumerism, but also mediates all social relations. This thesis was popularised by Jean Baudrillard, who has argued that in all aspects of Western society *images* of the world have come to replace real experience of it.[24] Historical studies have confirmed such claims; Raymond Williams, for instance, explored shifts in the nature of advertising over the past two centuries. In the early 1800s advertisements were predominantly text-based but developed an increasing reliance on images.[25] Partly this shift is explicable in terms of the availability of technologies that permitted the easy

reproduction of images. But it is the significance of such a shift that is of primary interest, for in its current form consumerism would be unthinkable without the plethora of advertising imagery selling every imaginable product and service. This is evident, too, in the ubiquity of the logo, from the Nike *swoosh* to the golden arches of MacDonald's, which adds a distinctive visual marker to the product being sold, indeed has come to be more important than the commodity it denotes.

Conclusion

This transformed landscape of contemporary Western society is central to the approach of this book. Given such changes it is no longer tenable to hold on unquestioningly to traditional notions of culture, art or creativity. Nevertheless, while such older cultural forms and boundaries are increasingly open to question, we proceed on the assumption that they still play an active and vital role in the popular imagination and hence in popular culture. Although an artist such as Andy Warhol was already eroding the boundaries between art and popular culture in the early 1960s, 'art' is still a separate cultural practice, and there are numerous cultural institutions, from museums, public and commercial galleries to art colleges, academies and media representations, which treat it as such.

Further Reading

Eagleton, T. *The Idea of Culture* (Oxford, 2000).
Mirzoeff, N. *An Introduction to Visual Culture* (London, 1999).
Strinati, D. *An Introduction to Theories of Popular Culture* (London, 1995).
Williams, R. *Culture and Society 1780–1950* (London, 1958).

Notes

1 Raymond Williams, 'Culture', in R. Williams, *Keywords* (London, 1983), pp. 87–93.
2 See Lucien Febvre, 'Civilisation: Evolution of a Word and a Group of Ideas,' in L. Febvre, *A New Kind of History, from the Writings of Febvre*, ed. P. Burke (London, 1973), pp. 219–57.
3 Cited in Adam Kuper, *Culture: the Anthropologists' Account* (Cambridge, MA, 1999), p. 26.
4 Matthew Arnold, cited in John Storey, ed., *Cultural Theory and Popular Culture* (London, 1994), p. 8.
5 Frank Leavis, *The Great Tradition: George Eliot, Henry James, Joseph Conrad* (London, 1948).
6 Dwight MacDonald, 'A Theory of Mass Culture', in B. Rosenberg and D. W. White, eds, *Mass Culture: the Popular Arts in America* (New York, 1957), pp. 59–73.
7 See, for example, Theodor Adorno, *The Culture Industry* (London, 1991); Herbert Marcuse, *One-Dimensional Man* (London, 1964).
8 Clement Greenberg, 'Avant-Garde and Kitsch' [1939], in F. Frascina, ed., *Pollock and After: the Critical Debate* (London, 1985), p. 24.
9 See Pierre Bourdieu, *Distinction: a Social Critique of the Judgement of Taste* (London, 1984).
10 Harold Bloom, *The Western Canon: the Books and School of the Ages* (London, 1995).

11 See, for example, Griselda Pollock, *Differencing the Canon. Feminist Desire and the Writing of Art's Histories* (London, 1999).

12 See, for example, Andreas Huyssen, 'Mass Culture as Woman. Modernism's Other', in A. Huyssen, *After the Great Divide: Modernism, Mass Culture and Postmodernism* (Basingstoke, 1986), pp. 44–64.

13 See Mikhail Bakhtin, *The Dialogical Imagination* (Austin, TX, 1981).

14 For a clear outline of the work of Herder, see Isaiah Berlin, *Vico and Herder: Two Studies in the History of Ideas* (London, 1976).

15 James Clifford, 'On Ethnographic Authority', in *The Predicament of Culture. Twentieth Century Ethnography, Literature and Art* (Cambridge, MA, 1988), pp. 21–54.

16 Michael Baxandall, *Painting and Experience in Fifteenth Century Italy* (Oxford, 1972).

17 Svetlana Alpers, *The Art of Describing: Dutch Art in the Seventeenth Century* (Chicago, 1983).

18 Anne Massey, *Hollywood beyond the Screen* (Oxford, 2000); Kirstin Ross, *Fast Cars, Clean Bodies: Decolonisation and the Reordering of French Culture* (Cambridge, MA, 1996).

19 Raymond Williams, 'Culture is Ordinary', in B. Highmore, ed., *The Everyday Life Reader* (London, 2002), pp. 91–100; Henri Lefebvre, *The Critique of Everyday Life* (Cambridge, 1991).

20 On the impact of literacy and printing in European societies, see Walter J. Ong, *Orality and Literacy* (London, 1982).

21 A useful overview of such accounts can be found in Robert Stam, *Film Theory* (Oxford, 2000). See especially 'From Linguistics to Psychoanalysis' (pp. 158–68); 'The Birth of the Spectator' (pp. 229–34); and 'Cognitive and Analytic Theory' (pp. 235–47).

22 Nicholas Mirzoeff, *An Introduction to Visual Culture* (London, 1999), p. 1.

23 See Walter Benjamin, *The Arcades Project* (Harvard, MA, 1999). See, too, the more recent study by Thomas Richards, *The Commodity Culture of Victorian England. Advertising and Spectacle 1851–1914* (London, 1990).

24 Guy Debord, *The Society of the Spectacle* (Detroit, 1986); Jean Baudrillard, *Simulations* (New York, 1983).

25 Raymond Williams, 'Advertising, the Magic System', in R. Williams, *Problems in Materialism and Culture* (London, 1980), pp. 180–96.

2. Definitions of Art and the Art World

Neil Mulholland

Introduction

If someone calls it art, it's art. (Donald Judd)[1]

Donald Judd's statement seems self-evident. If someone wants to call something 'art', who can stop them? While such an assumption appears common sense, it leads into challenging disputes. Today, many people would consider Martin Elliott's poster *Tennis Girl* of 1970 (Figure 2.1) to be in poor taste. They may or may not regard this attribute positively, but they would generally be unlikely to think it was an example of a serious work of art. We may decide to make precisely the same evaluation of Jeff Koons' sculpture *Michael Jackson and Bubbles* (1988) (Figure 2.2). A senior art world representative, such as the Director of New York's Museum of Modern Art (MOMA), would, however, be very likely to accept Koons' sculpture as a significant work of art, while rejecting Elliot's poster. We may object to the art world representative's views, but what would this objection achieve? If it is really a case that if someone says it's art, it's art, why is the art world representative taken more seriously on such matters than most? Who or what has the power to proclaim some things works of art and not others?

These are difficult questions to answer in the abstract, since what can be said to be art has changed throughout history along with its conditions of display and consumption. Today's professional art representative is very different from someone

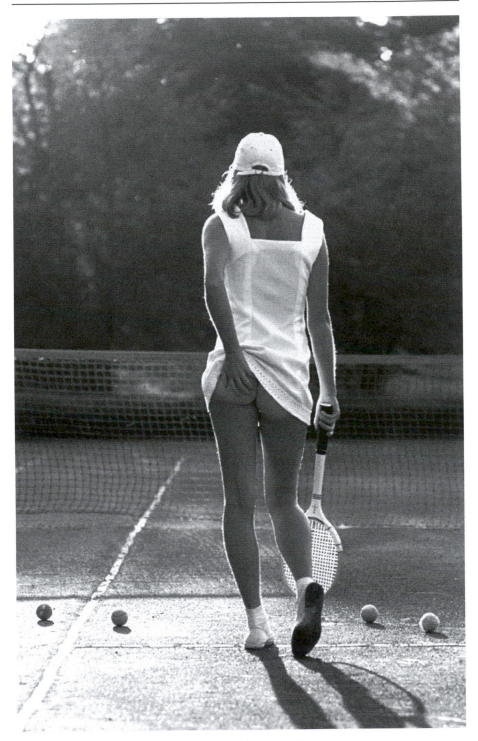

Figure 2.1 – Martin Elliott, *Tennis Girl* (1970). © Martin Elliott.

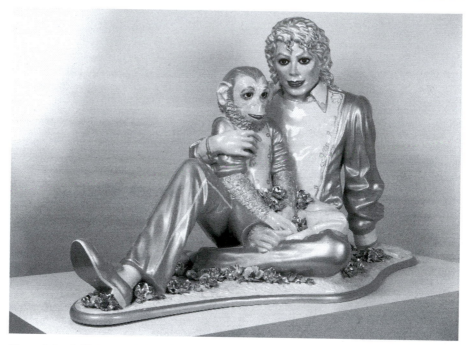

Figure 2.2 – Jeff Koons, *Michael Jackson and Bubbles* (1988). San Francisco Museum of Modern Art. © Jeff Koons.

who would have been in a position to commission an artist 500 years ago. The audiences for Elliot or Koons also differ dramatically from earlier audiences. When audiences and institutions mutate, art changes as different cultural possibilities emerge. What is important to note is that these possibilities are *finite* at any given historical moment. This is one reason that only a limited number of people have been able to proclaim something to be art and have their opinion taken seriously. Moreover, this authority has only been vested in artists themselves for a relatively short period of history.

The Rise of the Idea of Art

In the early modern era, large mural commissions provided by the Church and rich merchant patrons gave artists greater responsibility for the production of intellectually and technically ambitious works. In Rome, Michelangelo Buonarroti produced murals for the *Sistine Chapel Vault* (1508–12), paintings that were symptomatic of the artist's new sense of authority. Michelangelo's control over the intellectual content and practical execution of the murals signified that he was not simply a proficient technician, but an *individual* who could respond to Christian doctrine on his own terms. By conceiving and painting his work alone,

Michelangelo distanced his practice from that of fellow craftsmen and collective workers such as masons, house builders, locksmiths, tinkers, weavers, spinners, tailors, watchmakers and jewellers. Michelangelo was seen to perform in an independent realm, unconstrained by rules.

In part, this sense of independent 'genius' was an illusion. Like today's gallery directors and collectors, rich patrons were in a position to give artists such as Michelangelo a sense of freedom. At the same time, financial autonomy from church patronage began to allow artists to explore secular themes. Given this, it is unsurprising that during the early modern era, painting and sculpture began to be counted amongst the liberal arts such as poetry.[2] Art became separated from other craft skills, skills which were now perceived to be the province of merchants and the labouring classes. This division of labour marks the origins of the way many people today use the term 'art', yet to many, art is still shorthand for 'well crafted', a relic of a much older understanding of the term.[3] To a Renaissance artist such as Michelangelo, however, this was insufficient. Art was above craft; it was part of a higher order of human production. This division between secular art (scholarly and independent) and religious art (a tool of Christian propaganda) was aided by the Protestant attack on images in the 1500s. Bolstered by the wealth of Protestant merchants, iconoclasm created the locale for the urbane art-lover to break away from the need for art to serve an overt ideological function, in search of artistic freedom.

Forms of display in the early modern period hindered this quest. Art galleries did not come into existence until the mid-eighteenth century;[4] today's ubiquitous 'white cube' exhibition venues are a product of twentieth-century conspicuous consumption.[5] Stimulated by the rebirth of humanist scholarship and its insights into natural history in the early sixteenth century, princely courts, scientific societies, religious orders and laypersons started to collect curiosities.[6] Further encouraged by the developments in transport that led to the European exploration of 'new' worlds, they collected objects from around the world and placed them in their 'cabinets of curiosity' (also often referred to by their German name, *Wunderkammer*).[7] The majority of the cabinets in the sixteenth and seventeenth centuries consisted of composite objects and seldom contained only works of art. Works of art were not valued as highly as some curios and often fetched lower sums. These cabinets formed synopses of the world, allowing the produce of the earth, sea and air to be compared with the produce of mankind, using wonder to imagine humanity and nature. The cabinets of curiosities were collections of rare or odd objects representing the three elements of *naturalia*: the animal world, the vegetable world and the mineral world. In addition, collectors would accumulate *artificialia*, or human achievements. Amassing the most curious artefacts in the world, collectors sought to illuminate the secrets of nature by reproducing its spectacle and fantasy in microcosm. The cabinets were non-scientific in the sense that

they primarily encapsulated the sense of wonderment that lay at the heart of Christian creationist doctrine. As such, the objective of the early modern cabinets was *not* to produce a logical, encyclopaedic map of everyday *naturalia* and *artificialia*, but to support and promote religious knowledge. The early *Wunderkammer* were primarily produced for spiritual and ritualistic purposes.

Curiosity cabinets began to disappear in the following centuries when their contents became subsumed as explicable objects of scientific enquiry rather than religious relics or puzzling wonders. The objects considered most interesting were relocated to museums of art and natural history. The transformation of the princely galleries of Europe into museums was one that served the ideological needs of the middle classes and nation states, providing secular civic rituals. Museums became one means by which emergent imperial states such as Britain, France and Germany could represent, justify and take pride in their global authority. Public museums not only displayed the nation's power and wealth, in the form of objects taken from colonies, but provided a platform upon which to establish an historical canon of 'national' culture.[8] Viewing 'indigenous' artefacts imparted a strong sense of civic and national continuity, ritualising the acquisition of national identity while surreptitiously nurturing the colonial logic of international cultural superiority. Museums applied enlightenment logic to these collections, classifying them scientifically and placing them into appropriate departments. Such museums were public rather than private; they were often state-owned and had an educational role and responsibility. They were credited with the ability to escort an unsophisticated public into a new comportment and higher echelon of moral and civilised behaviour. Public and moral policies nursed the modern museum out of the curiosity cabinet, to take part in new schemes of biological categorisation and museological spectacle illuminated by exuberant collisions of visual techniques and concepts.

By the late 1700s, therefore, artists were given further reason to define their activities systematically in terms of what they were *not*. Like natural science, art became increasingly exclusive, a professional activity engaged in as a form of specialist knowledge. The formation of artists' academies, following the model of the Académie Royale founded in Paris in 1648, also cemented this process. Modern industrialised society of this period was dedicated to the pursuit of knowledge to achieve order. Modernity relied increasingly on establishing binary oppositions between 'order' and 'disorder', constructing 'disorder' as a foil. As the Polish sociologist Zygmunt Bauman has pointed out, a central recurring feature of modern society has been its attempt to marginalise the ambiguous, the ambivalent.[9] Art occupied a complex position in this situation. In choosing the terms by which they wished their work to be received, artists rejected numerous unwarranted associations. In the Renaissance, this meant differentiating 'high' art from the merely artisanal. By the late eighteenth century, it meant separating art from 'science'. Rather than support the totalising claims of science and the industrial 'progress' of enlight-

enment reason, Romantic conceptions of art and the artist held that the world was too complex to be mapped out in its entirety.[10] Faced by the demystifying challenge of rigorous scientific method, art increasingly became a haven for the imagination, the irrational and the sublime, it became a means of dealing with things not easily understood or represented in rational terms, providing distraction from the cultural, political, social and economic changes wrought by the industrial revolution. For example, in *Critique of the Power of Judgement* (1790), one of the most important works of modern aesthetics, Immanuel Kant (1724–1804) made imagination central to aesthetic experience and the production of art, insisting, too, on the impossibility of reducing judgements of beauty or the sublime to logical concepts.[11] At the same time, for Kant, aesthetic appreciation of art denoted taste, and although not deliberately so, it was socially exclusive, a rejection of the democratising claims of modern knowledge. It has been argued that his emphasis on the free imaginative play involved in art represented the ideals of the late eighteenth-century middle classes.[12] It has also been pointed out that it was racially motivated; Kant explicitly states that non-Europeans are incapable of appreciating art aesthetically.[13]

Aesthetics and Art Theory

The conditions of the production and reception of art were further mutated by the development of mercantile capitalism spawned by the industrial revolution. New money created new tastes, bringing an even greater sense of the artist's autonomy from the world. Artists were able to split from their patrons with the introduction of art dealers and the art market. Patronage no longer had to be sought from rich merchants, the Church or the state; artists could begin to make works speculatively for the market. Towards the end of the nineteenth century, artists became vocal in their rejection of the established academies of art. Artists were also increasingly successful in establishing their own systems of support and education such as the Pre-Raphaelite Brotherhood, the New English Art Club, the so-called *Salon des Refusés* and the Vienna Secession. In all, these developments had the effect of amplifying the sense that art was a separate realm from the rest of culture, generating the related illusions of aesthetic autonomy and artistic self-sufficiency.

Artists and philosophers also made increasing efforts to separate aesthetic questions from moral and political debates. By the mid-nineteenth century, these aesthetic concerns – having been developed to an immensely sophisticated level – began to materialise explicitly in the fine arts. This quest for artistic self-sufficiency reached a sophisticated state of self-awareness when artists began to think of their works as having no relationship with the outside world. As one of the characters of Oscar Wilde stated: 'Art never expresses anything but itself . . . She develops purely on her own lines. She is not symbolic of any age. It is the ages that are her symbols, her reflections, her echoes.'[14] James Abbott McNeil Whistler is a good

example of an artist seeking to make their work self-sufficient, demanding that it be observed by a gaze unobstructed by bourgeois values of practical efficiency (what does it *do*?) and morality (what does it *tell* us?). Whistler famously defended his painting in court, arguing that its main concern was not with the reliable depiction of the visible world, but with forms (colours, lines and masses) and relations of forms. He later stated that art should 'stand alone and appeal to the artistic sense of eye or ear, without confounding it with emotions entirely foreign to it, as devotion, love, patriotism and the like. All these have no kind of concern with it, and that is why I insist on calling my works "arrangements" and "harmonies".'[15] Conspicuously, Whistler's conception of art is based on a further set of exclusions: he excludes the sentimental, moralising literary content popular in his day, perhaps for fear that such associations are insufficiently *pictorial*. In place of literary elements, Whistler alludes to music, an art form he believed had no representational value, one appreciated for its formal or aesthetic values alone. Whistler was in favour of art being used to denote *visual* cultural production, and as such he explicitly rejected the intellectual, political and moral functions previously thought to be central to art.

This notion of formal visual experimentation can be found in many artworks in the ensuing century. For example, Morris Louis' 1960 acrylic painting *Beta Lambda* (Figure 2.3) was, in his own words, about 'colour and surface. That's all.'[16] Such a definition is related to the theory of aesthetic formalism, an idea associated with figures such as Kant and critics such as Clive Bell, Clement Greenberg and Michael Fried. Despite their insistence on pure form, their theories of art also tended to promote the idea that something becomes art because it performs particular *functions*. Indeed, numerous people hold 'functionalist' theories of art without realising it. For example, to claim that art should make one happy or should produce a feeling of elation is to require that it fulfil these functions in order to claim art status or 'arthood'. To come back to the specific case of formalism, the claim that art is defined and understood by sight alone seems relatively easy to understand. In this sense, it might have a democratising effect since it seemingly requires no knowledge of art history or theory, providing all with a system of comprehending art from all periods of history. As such, formalism also seems to confirm our most basic responses to art. As a universal theory of art, however, it is wrought with problems.

For Kant, an artwork was produced 'through a capacity for choice that grounds its actions in reason',[17] which is to say that artworks are man-made, deliberately *designed* objects. This suggests a dissimilarity between our experience of art and our experience of nature, namely, that the experience of nature involves the experience of 'free beauty', whereas art is produced by conscious human subjects. Hence, while the experience of nature is based on a non-conceptual aesthetic response, the experience of art cannot help but involve consideration of what kind of a thing the painting, sculpture or drawing is meant to be. Kant thus concluded that in contrast to

Figure 2.3 – Morris Louis, *Beta Lambda* (1960) New York, Museum of Modern Art. © Photo Scala, Florence.

nature, the aesthetic experience of art is not entirely 'free', since it is tied to non-aesthetic concerns. By the same token, it is clear that aesthetic effects, such as feeling elated, can be prompted by natural phenomena, such as noises, landscapes or rust, which possess formal properties but are not artworks. As such, the act of experiencing an artefact aesthetically would not justify classifying it as an artwork. Nor is it possible to claim convincingly, as Bell does, that 'significant form is the essential quality of a work of art, the quality which distinguishes it from all other classes of objects'. [18] To fail to experience an artwork aesthetically would not necessarily mean that we were not witnessing an artwork, since the way we experience objects aesthetically need have nothing to do with how we classify them.

Artists and critics such as Whistler, Bell or Greenberg saw themselves as part of an intellectual elite, regarding it as their duty to defend and promote challenging art in the face of 'popular' opposition. This attitude came from the growing sense amongst cultural elites in the nineteenth and twentieth centuries that the rise of the middle classes and the spread of democracy vulgarised and commercialised art (or *kitsch* as Greenberg described the popular productions of the culture industry). In this sense, claims for the autonomy of art were tied to covert claims of cultural autonomy or elitism perpetuated by a particular dominant or strategically located group in society able to project their views as impartial. Exclusion, the regulation

of art against weak imitations, was a dominant feature of such a theory of art. Although such decisions are clearly historically relative and specific, formalist theories tend to present such exclusions as inevitable. For example, according to Fried, 'the history of painting from Manet through Synthetic Cubism and Matisse may be characterised in terms of gradual withdrawal of painting from the task of representing reality – or of reality from the power of painting to represent it – in favour of an increasing preoccupation with problems intrinsic to painting itself'.[19] By providing a highly selective causal and continuous history of painting's separateness from the world, Fried inadvertently reveals that such values are *historically specific* products and practices rather than socially transcendent. To see such painting as something concerned mainly with its own problems, as Fried does, we would need to have recourse to a body of knowledge that lies outside what we see before our eyes. As such, the democratic claims made by some formalists are jeopardised, for we never do simply 'see what we get'.

As a theory of art, formalism turns out to be too narrow. Bell even went so far as to claim that most artefacts that we most commonly think of as art were not: 'I cannot believe that more than one in a hundred of the works produced between 1450 and 1850 can be properly described as a work of art.'[20] Bell's focus on the *appearance* of art over its *role* excludes works of art and ways of interpreting it that are primarily focused on issues of history, ideas, meaning and representation, seeing the past as an inevitable preview of his present-day interests. In this, formalism is *essentialist*, an attempt to isolate 'art' artificially from the way it is revealed to us in experience in order to locate its mystery ingredients. Works of art are not necessarily autonomous objects; they are records of culture, or the world as seen by particular people at specific times. Formalism systematically obscures and denies its social and historical determinants, perceiving art and artists as extraordinary and timeless. Clearly, art is *at least* the product of the historical events I have described. The simple fact that formalism cannot account for the way that art has *always* been experienced bears testimony to the fact that it is not a universal definition of art.

While formalism is thus flawed, it does at least provide a direction for artists to pursue by persuasively foregrounding certain developments in art as paradigmatic and seminal, at the expense of others, which are deemed unimportant. Where does this leave us in relation to Judd's definition of art? His exasperated comment was an attempt to validate and enfranchise the art of the 1960s, a period of rapid cultural and political experimentation in which a narrow and inhospitable modernism was supplanted by what Rosalind Krauss later called an 'expanded field' for art.[21] The so-called de-definitional impulse that swept through art practice in the 1960s led to a transformed conception of art based on alternative philosophical premises. Judd realised that formalist theories were inadequate to explain the status of works such as Piero Manzoni's *Artist's Shit* (1961), a tin can containing the artist's excre-

ment. The fact that Manzoni gave his signature to such an object as a means of pre-senting it as art suggests that he, and not just anyone, had the power to transform the mundane and everyday into a work of art. If we are to say that something is art, is it required that the meaning of the term 'art' have some limits? Must it be pos-sible to call something 'art' and be wrong if the word is to have any meaning at all? If this is so, then perhaps Judd was wrong in an important sense.

How things acquire names has puzzled philosophers for centuries. In his chil-dren's fable *Through the Looking Glass and What Alice Found There* (1872), Lewis Carroll famously formulated this logical problem:

> 'When I use a word,' Humpty Dumpty said in rather a scornful tone, 'it means just what I choose it to mean – neither more nor less.'[22]

Humpty Dumpty is a relativist, one who claims that there are no external or objec-tive standards of authority by which an individual might verify or refute the use of words. It may be that we cannot find an absolute form of authority, but, if we wish communication to take place, we can at least demand that there be some form of constraint upon the use of words. In this sense, the term 'art' must have constraints if it is to be useful. Manzoni's use of the term 'art' seems to have been constrained by his social investment in art institutions (signified by his desire to preserve his excrement for future generations to enjoy), its authorial signs (signatures) and his knowledge of the history of art (that Cubism and Dada were precedents for the use of found objects), factors which helped him manufacture his 'professional' repute as an artist. Anyone can claim arthood for what they do, but to do so *convincingly* would seem to demand the tailored acquisition of an air of authority. The ways in which this authority is acquired are far more complex and negotiable than in Judd's dictum, something that suggested that a new theory of art was necessary to explain art that was multiple and open-ended.

Art as an Institution

One important theory that emerged in the 1960s was known as the institutional theory of art, or proceduralism. Proceduralism is a theory of art most closely asso-ciated with the philosophy of Arthur Danto and George Dickie and the sociology of Pierre Bourdieu.[23] While these writers are contemporaries, they also differ in their views, although we could say that they share the idea that art can be defined only in an historical and critical context that makes it relevant to social institutions. Art is not, in this view, produced for *effect*; it is created by following a set of rules or procedures. 'To see something as art,' wrote Danto, 'requires something that the eye cannot decry — an atmosphere of artistic theory, knowledge of the history of art; an artworld.'[24] For Danto, art worlds have always been constructed from

the interrelated efforts of artists, the history of art, changing conditions of display, critical writings and the responses of audiences. For Danto, the production of art is highly dependent on such funded experience, what is possible in art now being reliant on what has come before.

Proceduralism has a number of benefits. First, it allows *anything* potentially to become art, although there are limitations. Danto claims that at any specific time, the art world allows only esteemed figures to propose something as art. In addition, *what* they might propose to be art will, in turn, be limited by the course that such an artist has directed the artworld. To illustrate this point, he argues that Paul Cézanne would not have been able to present his tie as a readymade, whereas Pablo Picasso might have been.[25] Proceduralism allows *anyone* potentially to become an artist by following rules. In this sense, it may be more egalitarian than formalist accounts since it does not seek to mystify art by referring the viewer or artist to the immeasurable *effects* of the work. This means that intuitive definitions of art are ruled out explicitly; the 'innocent eye' found in formalism is regarded as a socially produced myth. Moreover, it is able to account for conceptual artworks, works of art that had no tangible material or visual form and readily adapt to the expansive changing character of art. As Danto puts it:

> The greater the variety of aesthetically relevant predicates, the more complex the individual members of the artworld become; and the more one knows of the entire population of the artworld, the richer one's experience with any of its members.[26]

Such a theory eliminates the need to think of art as exclusive, since it transforms art into a descriptive rather than an evaluative term. Art is no longer 'fine'; it is simply a way of describing something that carries no sense of inherent value. Indeed, all art can be judged under the same criteria since proceduralism rejects 'realist' theories of representation, holding that all artworks refer to other artworks via the history of art and its social institutions rather than to the 'world'.

Proceduralism has it problems nevertheless. Since the theory is concerned with art as a form of communication, it rules out the notion that art might fail to signify. For Danto, the inability to interpret an artwork marks its failure to achieve art status. Artists have to prove that they intend to make statements through their work, that they are not simply manipulating signs for their own sake. There are two main problems with this causal view of art. First, it assumes that we can determine our judgements of artistic intention on the evidence of objects alone, when material effects and acts have no essential meaning other than those that we bring to them. This is particularly difficult when considering found art objects, many of which, being mass-produced and identical, bear little trace of intentional production. In this, Danto risks committing the 'intentional fallacy' explored in chapter

10 below on authorship. This is partly avoided, perhaps, by Danto's stress on the socio-historical character of art, but this endeavour to project 'meaning' into history merely contradicts his emphasis on cause. Second, Danto's criteria of meaningfulness have difficulty accounting for irrational and absurdist art that struggles to elude making sense, such as Dada, surrealism or Fluxus. Moreover, at a basic level, from a proceduralist point of view, *anti*-art is unquestionably regarded as *art*. This largely defeats the intentions of anti-artists of the 1960s and earlier in that it posits that the neo-avant-garde assault on the conventions of art constitutes a form of art in its own right.

Another obvious weakness lies in the assumption that the art world really is an institution. It cannot be claimed that it is regulated like other institutions such as the police, since it has no set consensual values. The art world is a loose configuration of artists, critics, dealers, curators, collectors, commissioners, administrators, politicians and others. Some of these individuals share some ideas, others do not. We discuss the art world as a monolithic institution, and this is a popular pursuit of the media when confronted by art that they do not like. Proceduralism is problematic in its emphasis on the power of the institutions of high art and in many ways could be seen to be responsible for the increased bureaucratisation of art that has occurred since the 1960s. In heralding the 'end of art' as far back as 1964, Danto's institutional theory contained the seeds of its own destruction, transforming art into rhetoric by encouraging a 'linguistic turn'. The ensuing period of artistic production questioned many of these assumptions, while showing that such ideas have entered into the realm of received artistic ideas.[27]

This raises the question of whether or not it is desirable to seek a general theory of art in contemporary heterogeneous visual culture. Since the early 1960s, proceduralist definitions of art have been thoroughly absorbed and taken to new levels of complexity. David Wilson's Museum of Jurassic Technology (MJT) in Culver, California, for example, 'has left visitors puzzling over the veracity of its exhibits as well as the question of whether it is an actual museum or some kind of elaborate art installation'.[28] Former special effects designer Wilson mixes together fact, overblown truths and hoax. In the MJT, emphasis is placed on objects 'that demonstrate unusual or *curious* technological qualities'[29] such as rainforest bats that can fly through lead walls, *Megolaponera Foetens* (fungally-infected, spore-ingesting pronged stink ants of the Cameroon) and a horn grown on the head of Mary Davis of Saughall, Cheshire. The MJT tackles a number of key issues in the history of display:

> To put sacred works in a secular setting assumes that these artefacts possess aesthetic significance over and above their religious meaning. Placing them in chronological order presupposes that this is the best way to understand the relation of earlier to later art. Segregating artworks from minerals, shells and

animals implies that artefacts have a special identity. Preserving these arte-
facts implies that they are best seen as historical records.[30]

The system of organisation found in the MJT questions these very assumptions by
aping the organisational system of the curiosity cabinets, drawing no clear line
between art and non-art, fact and fiction, authority and imagination. Wilson sees
no pre-existing, essential order to history; order emerges only within the MJT's
peculiar narratives. In this, Wilson aims to make seeing oracular again, to reinte-
grate people with wonder while drawing attention to the museum's ideological
role in a self-conscious way that has only recently become possible in wake of proc-
eduralist theories of art.

This has been explored by major modern and contemporary art museums such
as the predominately privately-funded MOMA in New York and the mainly state-
funded Tate Modern in London. Both institutions have abandoned the linear and
historical models of display that once dominated the historical exhibition and of
Western art, models that MOMA was influential in forming. In their place are the-
matic devices that seek to elaborate important issues within twentieth- and twenty-
first-century art practices, looking 'at the art of the last hundred years from the
vantage point of four separate themes that cut right through history'.[31] The
'Anxious Object' room in the Tate Modern, for example, displays works by major
artists in vitrines in order to rehabilitate and remind audiences of the cabinets of
past displays. The works in this space seem to be located between objects deliber-
ately fabricated as works of art and found objects of curiosity. To some, this exem-
plifies art as an institutional game to be played out by curators and organised like
a stamp collection, cut off from any sense of living culture in an entertaining state-
endorsed spectacle.[32] Perhaps this is an unfair criticism. Tate Modern has learned
its lessons from critiques of the authority and exclusivity of museums inaugurated
by the disciplines of art history, art theory and museology. Unfortunately, its
authoritative stance on its chosen issues seems to undermine the element of sur-
prise and anti-establishment readings of art that it seeks to achieve. This is evident
in Herzog & de Meuron's commanding architectural conversion of Giles Gilbert
Scott's Bankside Power Station and also in Tate Modern's propensity towards a
didactic curatorial approach.[33] Architecturally, Tate Modern is modelled on artist-
initiated warehouse exhibitions popular in London and elsewhere in the late 1980s.
In this, it attempts to ape more contemporary conditions of display favoured by
artists who found themselves excluded from the pantheons of art. However, like
many major contemporary art museums around the world, Tate Modern wants to
remain the official national British institution of contemporary art and be perceived
as a major world player, lending this power to everything it sanctions.[34]

Are such grandiose venues and their accompanying bureaucracies really required
for bestowing the appropriate context in which to produce or display works of art

today? In 1995 in the northern English city of Manchester, a group of artists, finding that they had little opportunity to exhibit their work in their municipality, decided to create their own institutions without the sanction of the leading art world figures. The artists saw themselves as their own best critics, a peer group that could award each other time and space in which to show their work on their own terms. Venues were varied and generally non-sanctioned, ranging from people's houses to the Town Hall. The events were organised around the ironically distinguished legend 'The Annual Programme', as a means of attracting attention.[35] As a group of self-organised, quasi-autonomous artists, 'The Annual Programme' were far from unique, but their strategy succeeded in Manchester, providing them with the infrastructure they needed to establish their own microcosmic art world, thereby allowing the rest of the world to know what they were accomplishing. Indeed, their strategy had its roots in the self-proclaimed autonomy to be found in avant-garde movements from the Vienna Secession of the late nineteenth century to punk's pop/anti-art 'do-it-yourself' attitude. This had a particularly strong heritage in Manchester.[36]

Conclusion

While Enlightenment models of institutional and theoretical authority still exist, today's local and global art worlds are bigger, more fluid, multivalent and fragmented than before. Due to travel and technology, artists can make work practically anywhere in the world, with virtually anything, for almost any perceived audience they wish to attract. Digital mass communication is rapidly transforming the world, allowing artists to disseminate their cultural productions to a global audience instantly. It would seem that today's artists are, more than ever, in a position to declare that what they do is art (persuasively or otherwise) without recourse to well-established, centrally sanctioned authorities or meta-theoretical justification. In some ways, perhaps, Judd wasn't so wrong after all. The power to nominate something as art has come to be seen as dispersed rather than possessed. Unlike Danto's idea of a limited and definable art world that is inhabited predominately by *theories* of art, today's art world is a rapidly expanding space occupied by an overabundance of *agents*, mediators who constantly seek to redefine the limits of their roles. In this climate, 'art' becomes an increasingly vacuous term, used to describe any number of activities, regulating art only at the moment of each new articulation. As such, the important questions presently do not (and cannot) continue to revolve around oblique and circuitous debates of how something achieves arthood. They cannot continue since, as Danto argues, continual broadening of art's definition will eventually make it impossible to define art semantically in terms of what it is not.[37] Today's highly visually literate audiences ask trusting and more challenging questions of artists and what they do, while artists continue to demand more of their ever-diversifying audiences.

Further Reading

Duncan, Carol. *Civilising Rituals: Inside Public Art Museums* (London, 1995).
Harrington, Austin. *Art and Social Theory* (Oxford, 2003).
Shiner, Larry. *The Invention of Art: a Cultural History* (Chicago, 2001).
Williams, Robert. *Art Theory: an Historical Introduction* (Oxford, 2004).

Notes

1 Donald Judd, 'Art after Philosophy I', *Studio International*, October 1969, pp. 134–7.
2 See Ernst Gombrich, 'The Renaissance Conception of Artistic Progress', *Norm and Form* (London, 1966), pp. 1–10.
3 In classical antiquity the terms for 'art' (*ars* in Latin and *technē* in Greek) denoted skill, and art was deemed one (low-ranking) skill amongst many others. For a brief sketch of the connotations of the term, see Roy Harris, *The Necessity of Artspeak* (London and New York, 2003), pp. 15–28.
4 See Susan L. Feagin and Craig Allen Subler, 'Showing Pictures: Aesthetics and the Art Gallery', *The Journal of Aesthetic Education*, Vol. 27 (1993), pp. 63–72.
5 See Brendan O'Doherty, *Inside the White Cube: the Ideology of the Gallery Space* (Los Angeles, 1999). See too Russell Belk, *Collecting in a Consumer Society* (London, 1995).
6 See Paula Findlen, *Possessing Nature: Museums, Collecting and Scientific Culture in Early Modern Italy* (Los Angeles, 1994); and Lorraine Daston and Katherine Park, *Wonders and the Order of Nature, 1100–1750* (New York, 1998).
7 See Tom Barringer, *Colonialism and the Object* (London, 1998). See too Tony Bennett, *The Birth of the Museum: History, Theory, Politics* (London, 1995); and Oliver Impey and Arthur MacGregor, eds, *The Origins of Museums: The Cabinet of Curiosities in Sixteenth- and Seventeenth-Century Europe* (Oxford, 1985).
8 For a recent account of museum in relation to the nation state, see Nick Prior, *Museums and Modernity* (Oxford, 2002).
9 Zygmunt Bauman, *Modernity and Ambivalence* (Cambridge, 1993).
10 See Andrew Bowie, *Aesthetics and Subjectivity* (Manchester, 2003).
11 See Immanuel Kant, *The Critique of the Power of Judgement*, trans. Paul Guyer and Eric Matthews (Cambridge, 2002).
12 See Terry Eagleton, *The Ideology of the Aesthetic* (Oxford, 1990). See especially 'Free Particulars' (pp. 13–30) and 'The Kantian Imaginary' (pp. 70–101).
13 A thorough critique of the racial bias of eighteenth-century aesthetic theories, including that of Kant, has been offered by David Bindman, *From Ape to Apollo: Aesthetics and the Idea of Race in the Eighteenth Century* (London, 2002).
14 'Vivian', in Oscar Wilde's satirical manifesto, 'The Decay of Lying: A Dialogue', in James Knowles, ed., *The Nineteenth Century: a Monthly Review*, Vol. XXV (January–June 1889), p. 51.
15 James Abbott McNeill Whistler, *Ten o'Clock Lecture at Princes Hall, Piccadilly, London* (London, 1885).
16 Cited in Ellen H. Johnson, *American Artists on Art: From 1940–1980* (New York, 1982), p. 50.
17 Kant, *Critique of the Power of Judgement*, § 43 p. 182.
18 Clive Bell, *Art* (Oxford, 1987), p. 8. First published in 1914.
19 Michael Fried, *Three American Painters: Kenneth Noland, Jules Olitski, Frank Stella* (Cambridge, MA, 1965), p. 5.
20 Bell, *Art*, p. 46.

21 See Rosalind Krauss, 'Sculpture in the Expanded Field', *October*, No. 8 (1979), pp. 31–44.

22 *The Penguin Complete Lewis Carroll* (Harmondsworth, 1983), p. 196.

23 See George Dickie, *Art and the Aesthetic: An Institutional Analysis* (Ithaca, NY, 1974); and Pierre Bourdieu, *Distinction: a Social Critique of the Judgement of Taste* (Cambridge, 1984).

24 Arthur Danto, 'The Artworld', *Journal of Philosophy*, Vol. 61 (1964), p. 580.

25 See Arthur Danto, 'The Last Work of Art. Artworks and Real Things', *Theoria*, Vol. 39 (1973), pp. 1–17.

26 Danto, 'The Artworld', pp. 583–4.

27 See Reesa Greenberg, *Thinking about Exhibitions* (London, 1996).

28 Ralf Rugoff, 'Rules of the Game', *Frieze* (January/February 1999), p. 49. Wilson founded his first permanent Museum of Jurassic Technology in a small windowless store-front on Venice Boulevard, Culver City, California in 1988, opening a second branch at the Karl Ernst Osthaus Museum in Hagen, Westphalia, Germany in 1994. See Lawrence Wechsler, *Mr. Wilson's Cabinet of Wonder* (New York, 1996).

29 David Wilson, *Introduction to The Museum of Jurassic Technology* (Los Angeles, 2002).

30 David Carrier, 'The Display of Art: An Historical Perspective', *Leonardo*, Vol. 20, No. 1 (1987), p. 83.

31 Lars Nittve, 'Director's Foreword', *Tate Modern: The Handbook* (London, 2000), p. 10.

32 See Matthew Collings, *Art Crazy Nation* (London, 2001).

33 See Carol Duncan, *Civilizing Rituals: Inside Public Art Museums* (New York, 1995).

34 '[Tate Modern] aims to be "a flagship for London", "a new landmark for the nation", and one of the premier global centres of modern art.' Doreen Massey, 'Bankside: International Local', *Tate Modern: The Handbook*, p. 27.

35 See Richard J. Williams, 'Anything is Possible: The Annual Programme 1995–2000', in *Life is Good in Manchester* (Manchester, 2001).

36 See Howard Slater, 'Graveyard & Ballroom: A Factory Records Scrapbook', *Break/Flow*, Issue 3 (1998).

37 As Danto states: 'When philosophy's paintings, grey in grey, are part of the artworld, the artworld has shaded into its own philosophy, and by definition, grown old.' Arthur Danto, *The Transfiguration of the Commonplace* (Cambridge, MA, 1981), p. 148.

3. Concepts of Craft

Juliette MacDonald

Introduction

The meaning of the term 'craft' has undergone numerous transformations. Its variable senses have had long-term implications for both practitioners and for subsequent critical analysis. One of the most difficult problems for the crafts centres on the evolution of the meaning of the word itself. Long established in the English language, the word *cræft* can be traced back to early medieval times where it suggested a combination of intelligence, skill and strength, a set of connotations retained in the cognate term 'crafty'. Although craft is now usually equated with applied art, decorative art or even handicraft, these notions are relatively recent. Even in the late the eighteenth century it had a much broader set of meanings. As Paul Greenhalgh has stated: 'Craft did not imply specific methods, or trades or object types . . . It had no constituency, it could be applied to any form of practice within the culture. It was not a thing in itself.'[1] The concept of craft is thus a modern one, even if many of the practices it refers to have a much longer history; indeed, the concept of craft signifies a fundamental re-interpretation of the meaning of the applied and decorative arts prompted by the advent of industrial modernity.

Craft, Art and Modernity

During the course of the nineteenth century 'craft' gradually become more specific such that by the end of the 1800s it denoted something made by *hand*, in con-

trast to being industrially produced, and 'craftsman' a person whose living was based on manual production. Indeed, the term 'manufacture', which is now generally associated with industrial output, originally denoted the small-scale, hand-based production of the craftsman.

During this period, too, the hand-crafted object came to be endowed with values relating to ideals of a pre-industrial society in which vernacular processes, historical continuity and the sense of communal belonging had yet to be displaced by the growth of modernity. On this account alone 'craft' has undergone an often complex and tense relationship with modern culture and many of the values of twentieth-century art and design. In addition, craft is frequently seen as little more than a private hobby that functions as an outlet for private creativity. A significant consequence of this is that craft is widely perceived as a rather insignificant activity, in contrast to fine art, for example, which has long been regarded as forming a central part of cultural and social life. A further dimension to this is the fact that, as many feminist critics have pointed out, 'craft' has been seen consistently as an inherently *feminine* pursuit linked to the sphere of domestic life, a characterisation which has again made it difficult for craft to be seen as of equal importance to the more 'masculine' practices of art.

These multiple definitions have often been the source of confusion and have raised numerous problems within the practice of craft itself. Some practitioners have objected to being referred to as a 'craftsperson', or to their work being designated as craft, because they feel the term is patronising and belittles their skill. They prefer instead to be known as artists or designer-artists because these terms enable them to distance themselves from notions of amateur activity and to avoid the expectation that what they produce will be traditional, utilitarian objects. Others have found the term less problematic and indeed, are proud to be described as a craftsperson. As the Canadian ceramicist, Paul Mathieu, has argued, for example: 'I am a potter, and what I do is craft: I have no problem with those words, which belong to a long history that has no reason to envy any other craft or art, even now. Just as the gay community has appropriated the term "queer", so it is time for us to celebrate anew certain terms that define what we do.'[2] The debate concerning the terminology for makers continues. What is clear, however, is that craft as a practice continues to develop and change, and as a consequence what the term denotes has been subject to the same shifts in meaning.

The meaning of 'craft' is given further complexity by the fact that it has most often been defined in terms of its relation to two other concepts: 'fine art' and 'design'. At times, craft has been seen as indistinguishable from one or the other, and at other times it has been defined through its *difference* from them. Undoubtedly the most important development was the genesis of the distinction between art and craft. In classical antiquity and the Middle Ages the separation of the arts and crafts was unknown; indeed the Latin term *ars* from which 'art' is

derived denoted a particular skill or craft. Within the medieval system of knowl-edge what we would now consider to be art and craft both fell under the category of the liberal arts (*artes liberales*), which included grammar, rhetoric, dialectics, music, arithmetic, geometry and astronomy. As Umberto Eco has stated, art 'meant construction, whether it was of a ship or of a building, a painting or a hammer. The word *artifex* applied alike to blacksmiths, orators, poets, painters and sheep-shearers.'[3] A division between fine and decorative art, or between art and craft, emerged during the Renaissance in the fifteenth and sixteenth centuries, but it was not until the eighteenth century, the age of Enlightenment, that an absolute division between the two began to open up.[4] This was given philosophical legiti-macy in Kant's *Critique of the Power of Judgement*, which insisted on the distinction between the 'fine art' of 'genius' on the one hand, and the applied arts, or what Kant terms 'handicraft', on the other, which he regarded as based on mere tech-nical skill, undertaken primarily for financial remuneration.[5] This process had also been evident at an institutional level when, during the same period, painters and sculptors left the long-established medieval guild system and joined the newly formed Academies of fine art.

By the early 1800s an established hierarchy was in place which distinguished between painting and sculpture on the one hand, and the decorative arts on the other.[6] At the same time, however, the relative position of the decorative and the fine arts remained a subject of constant debate. Many writers on craft or the dec-orative arts argued eloquently in their defence and agitated for their inclusion within the field of fine art and high culture. For example, the art critic John Ruskin (1819–1900) even went as far as to state: 'There is no existing highest-order art but that it is decorative. Get rid then at once of any idea of decorative art being a degraded or a separate kind of art.'[7]

It is impossible to talk of the formation of modern discourse on craft without mentioning William Morris (1834–96). Morris was a designer, social reformer and poet, and he remains the most famous and influential figure in the British crafts movement. He agreed with Ruskin's assertion that decorative arts were as valuable as fine arts, and he also fought vociferously against the division between the two. Following Ruskin's ideas, he looked back nostalgically to the Middle Ages when there was no difference of prestige among the arts and crafts, and he warned of the dangers to all forms of art from this hierarchy. Linked to this was a social concern with the dehumanising effects of modern mass production, in the face of which Morris argued for a return to a more organic, non-alienated form of work. In an attempt to put his ideas into practice, he formed what was to become a highly suc-cessful craft business, Morris and Co. The aim of this firm was to bring together artists, designers and architects with complementary skills to work on decorative art projects. The ambition of Morris and his colleagues (who, when the firm was first set up in 1861, included the Pre-Raphaelite artists Dante Gabriel Rossetti,

Edward Burne Jones and Ford Madox Brown) was to set new standards in the decorative arts and to influence the general public in terms of good taste, as well as highlighting the equality of craft production with that of art.

In a lecture entitled 'The Lesser Arts', Morris spoke of his concerns about the dangers to all forms of art from the split between arts and crafts:

> I shall not meddle much with the great art of Architecture, and still less with the great arts commonly called Sculpture and Painting, yet I cannot in my own mind quite sever them from those lesser, so called Decorative Arts, which I have to speak about: it is only in latter times and under the most intricate conditions of life, that they have fallen apart from one another: and I hold that, when they are so parted, it is ill for the Arts altogether: the lesser ones become trivial, mechanical unintelligent, incapable of resisting the changes pressed upon them by fashion or dishonesty; while the greater, however they may be practised for a while by men of great minds and wonder-working hands . . . are sure to lose their dignity of popular arts and become nothing but dull adjuncts to unmeaning pomp or ingenious toys for a few rich or idle men.[8]

Clearly, Morris believed that if the division continued, crafts would become subject to the whim of fashion – and also lose their intellectual basis – thereby losing their value within society. Meanwhile, art would simultaneously cease to be rooted in the popular culture because it would become no more than an idle amusement of the cultural elite. Here one sees the restatement of a familiar conceptual distinction that has persisted in Western culture, whereby art was seen as an intellectually rigorous practice in contrast to craft, which was oriented primarily to the question of materials.

It cannot be denied that Morris succeeded in injecting a new vitality into the crafts, particularly through his renewed emphasis on the importance of retaining the essential characteristics of the medieval idiom. Yet his attempts to create craft of the highest aesthetic standards were perceived by many as merely idealistic and utopian and, despite the force of his arguments, he failed to raise the status of craft practice to that accorded to the fine arts.

Why did Morris and his supporters not succeed in achieving their objective? One of the principal difficulties was that during the nineteenth century the relative merits of hand- and machine-made products were a subject of fierce debate.[9] By the 1850s the Industrial Revolution had transformed British economic and social life; the feudal structure and dominance of agricultural, rural life was replaced with capitalist and industrial mode of production, engendered by an entrepreneurial middle class and urban centres. The artisan or craftsman providing communities with everyday domestic, utilitarian goods quickly became redundant, his products replaced by mass-produced commodities. Competitiveness in trade promoted an

increased consciousness of the range of machine-made products and of both the speed and cost at which they could be produced. It was no longer commercially viable to produce well-crafted hand-made goods when they could be mass-produced by machine much more cheaply. Furniture which had once been hand-crafted from solid wood could now be made from cheap deal, nailed together and covered with a thin, machine-cut veneer. Ruskin and Morris regarded such practices as immoral, and emphasised the value and morality of well-made and, more often than not, hand-produced goods, whether those objects be furniture, textiles or ceramics.

Although it was arguably the demand for cheaper goods that led to an expansion in the quantity of mass-produced, machine-based production, it was frequently the technology itself that was criticised. Furthermore, debate between the respective values of craft versus mass production was in turn linked to a division between vernacular and industrial urban society. For critics of industrial development, towns gradually became synonymous with deprivation, sordid depravity and the destruction of beauty. More generally, industrialisation was seen as a threat to society, progressively eroding long-cherished customs and traditions. Thomas Carlyle's condemnation of industrialisation's reduction of humanity to mere 'cogs' in a machine, a society 'grown mechanical in head, heart and hand',[10] proved to be popular and found echoes across Europe and North America. It was a view that Ruskin developed further in *The Seven Lamps of Architecture*:

> He who would form the creations of his own mind by any other instrument than his own hand, would also, if he might, give grinding organs to Heaven's angels, to make their music easier. There is dreaming enough, and earthiness enough, and sensuality enough in human existence, without overturning the few glowing moments of it into mechanisation; and since our life must be at best a vapour that appears for a little time and then vanishes away, let it at least appear as a cloud in the height of Heaven, not as the thick darkness that broods over the blast of the Furnace, and the rolling of the Wheel.[11]

The countryside came to represent the antithesis of this and, despite the dreadful squalor endured by countless rural workers, it was perceived as abundant, healthy and morally sound. As a result of the perceived dichotomy between the town and country, the craft object became for Ruskin and his followers the physical incarnation of this difference. For Ruskin, Morris and the proponents of the Arts and Crafts Movement, the crafts were the ideal tool for fighting the evils of industrialisation and building a better, utopian world. For them, industrially produced objects represented the division of labour, the loss of creative freedom and the suspension of mental processes, whereas crafts signified the culmination of individual production, independent creativity and even moral virtue.

Craft in the Twentieth Century

It has been argued that this emphasis on the vernacular by nineteenth-century social critics was largely responsible for the dislocation of craft practice from contemporary culture. Throughout the twentieth century craft practitioners have had to deal with the notion that craft is the expression of an essentially conservative outlook. Whilst avant-garde artists, designers and theorists from the Futurists to the Bauhaus, Dada and others sought to free themselves from tradition and engage with contemporary society – in particular, the possibilities of modern technology – craft practice and theory appeared to be static, caught up in nostalgia and ideals of ruralism. Instead of keeping pace with developments in art or architecture, craft practice became the vehicle for a retreat from the present, a genre best thought of in terms of its adherence to local, vernacular and historical traditions rather than to social and aesthetic innovativeness and originality. In the first decades of the twentieth century, many craft workers tended to use only the simplest tools and procedures in order to follow Morris's vision of a 'glorious art, made by the people and for the people, as a happiness to the maker and the user'.[12]

This location of craft in the imaginary pre-industrial past of Western cultures continued to have a profound effect on its practitioners, and indeed on the popular reception of craft objects. Both Raymond Williams and Andreas Huyssen have drawn attention to the fact that protagonists of the avant-garde of the first half of the twentieth century focused on radically transforming everyday life through 'technological imagination'.[13] Modernist artists and designers utilised technology, chance, spontaneity, assemblage and originality in their work. These elements were crucial to the identity of modernism and the avant-garde inasmuch as they were deemed to be diametrically opposed to tradition and craft practices, which seemed to be 'too indebted to the past, and too lacking in spontaneity to produce "original" objects'.[14]

Such beliefs made it difficult for craft to gain acceptance in the contemporary art world, and craft and critical practice were, on the whole, ignored. While the twentieth century witnessed an enormous growth in the volume of avant-garde theoretical writing on the nature, scope and function of art and, later, design, writers, curators and theorists tended to overlook craft work. Moreover craft was bypassed within traditional art criticism. Connoisseurship, once the mainstay of art-historical practice, relied on the establishment of the artist's signature and the provenance of the individual work. The anonymity of much craft production ensured that it could not be easily accommodated within the boundaries of traditional art-historical discourse. This lack of attention resulted in a marked lack of serious critical and theoretical writing on craft, a consequence of which is that craft as a whole has been devalued. As Rowley has argued:

. . . the modernist history of modern art organised the experience of artists at the same time as it *disorganised* and negated the mode of experience of the crafts practitioners. In this way, twentieth-century craft has either been excluded from historical and critical study or transformed in the process of incorporation. . . . A visit to almost any book shop will demonstrate the outcome of this process. Counterpoint to the many, many different kinds of historical, critical and theoretical studies of art are the endless handbooks and manuals of craft. . . . What is lacking is the reflective, critical, theoretically-informed dialogue that lies at the heart of a discipline.[15]

Craft practice was seen as involving the production of objects intended merely for practical use in contrast to art, which has often been regarded as a vehicle for communicating important insights into the social and human condition. This division between the two has also created a dilemma for many practitioners, affecting how they perceive themselves, how their work is funded and the status it achieves within the world of art and in the eyes of the public.

As early as the 1970s the Crafts Advisory Committee – now known as the Crafts Council – acknowledged this problem and attempted to establish high-level critical discourse on the subject, which would in turn improve the standing of craft. Following the advent of conceptual art in the 1960s art practice often seemed indistinguishable from art theory, whereas it was apparent that writing about crafts was lagging far behind, indeed that craft was in general under-theorised. An exchange of ideas on craft practice did take place, but it tended to be within small enclaves, involving, for example, ceramicists writing about their work in journals for other ceramicists. It is true that journals aimed at specific disciplines within craft practice provided an arena for like-minded individuals to discuss their work and the state of their own particular discipline, but there was little room for progression and expansion and, more importantly, little evidence of a cross-pollination of ideas from other related cultural practices.

The Crafts Advisory Committee aimed to provide better critical coverage for the crafts, not just in what might be argued as parochial single-discipline craft publications but in fine art journals and on the arts pages of newspapers. This aspiration proved to be an uphill struggle, with continuing resistance from the media to give significant space and attention to craft practice. It proved immensely difficult to convince the national press of the true nature of the work being produced by the contemporary artist-craftsman. Craft was rarely reviewed in the same critical terms as painting and sculpture; its perception, intensity and relationship to a changing social order were seldom considered.[16] Instead, the crafts were (and sadly still are) viewed as ideal subjects for lively relief features on the womens' pages of magazines or in consumer-oriented publications such as *Country Living* or *Women and Home*.

The Crafts Committee set about improving the situation by initiating a new way of presenting and writing about the crafts, partly through its own exhibitions, through the encouragement of regional exhibitions and through its bi-monthly publication *Crafts* which was launched in 1973. The aim of *Crafts* was to create a discourse, with curators and commentators able to frame and answer constructive questions for an appropriate audience. The model was essentially that of avant-garde fine art practice and criticism, and whilst the great ancestral figures of the crafts, such as William Morris or Charles Robert Ashbee, were occasionally referred to, craft history was of little interest and the focus was firmly on contemporary craft. *Crafts* magazine was an important and much needed public attempt to remove nostalgia and ruralism from the crafts.

In spite of such difficulties, however, craft theory is gradually developing and gaining recognition alongside other critical discourses within visual culture. Attempts are now made to bring to bear various analytical insights to the crafts, using methods drawn, for example, from feminism, semiology or Marxism. Craft practices are now acknowledged as being firmly embedded within multiple cultural contexts, and the rise of interdisciplinary research has further promoted the notion that craft has an equally valid place alongside fine art and design. The move to raise the standard of critical debate and the crafts coincided with a 'Crafts Revival' and a renewed sense of professionalism. Makers began to challenge long-held clichés concerning craft, gender, materials, function and utility.

Gender in particular has long been a problematic issue with which craft has had to contend, and, more specifically, the notion that craft practice is a specifically female activity in terms of both aesthetic and production. Rozsika Parker interrogated this assumption some twenty years ago in her book *The Subversive Stitch*, which considers the classification of embroidery as a skilled craft rather than a significant art form.[17] She argues that the crux of the problem lies in the belief that when women embroider it is seen not as art but rather as entirely an expression of their femininity. Because of this patriarchal view, such work is crucially categorised as craft. Parker argues that the corollary of this thinking is that a hierarchy is instituted whereby 'art made with thread and art made with paint are intrinsically unequal: that the former is artistically less significant'.[18] Parker's comments are fortunately not as accurate as they once were; tapestry and textiles have slowly come to be recognised as 'serious' art forms, but this is not universal.[19]

The view of needlework as craft (and therefore as less consequential than art) has had grave repercussions for women. The prejudice stems from the fact that sewing, embroidery and many other crafts are produced in the home, by women for family needs, and therefore not for money, whereas painting was predominantly, though not exclusively, produced by men in the public sphere and for money. Of course, there are huge differences between painting and embroidery, but rather than acknowledging that simple difference, embroidery and indeed the

Figure 3.1 – Janet Morton, *Cozy* (1999). Ward Island, Toronto. Photograph © Bruce Duffy.

wider practice of crafts came to be associated with the 'second sex' and with lower social classes, and were accorded a lower value.

Rethinking Craft

There remain many misconceptions and misplaced prejudices about the place of craft, domesticity and gender even today. Canadian textile artist Janet Morton (Figure 3.1) frequently addresses these issues in her work. *Cozy* was an event that took place on Ward Island, Toronto, in November 1999. In much of her work, Morton reconsiders the traditional relationships between knitting, domesticity, family, function and craft. For *Cozy* she gathered numerous discarded, hand-knitted garments and sewed them together to form a complete covering (rather like a giant tea cosy) for one of the single-storey houses on the Island. The result was a combination of craft, sculpture and parody. The completed object had a nostalgic quality about it, the house resembled a childhood fantasy, reverberating with notions of security and nurture; in other words, sentiments that tend to come so easily to mind when thinking about craft practice within the 'feminine' arena. Yet this 'cozy' was exposed to the elements for over a week and left to stretch and disintegrate: the resulting object was a far cry from the hackneyed expectation of female domestic craft. The discussion of textiles, their processes and their connections with materials and contemporary culture in the light of feminism, continues

to be an active area of research for both makers and theoreticians.[20] As well as challenging preconceived ideas on craft and gender, *Cozy* also questions the function of craft and its status as art. In particular, it can be seen partly as a parody of the work of the Bulgarian artist Christo, renowned for wrapping large buildings and sites, ranging from the Pont Neuf in Paris to the Reichstag in Berlin. *Cozy* thereby questioned the traditional boundary between art and craft.

Function has always been a key issue for the crafts. After all, what is the use of a container that is incapable of holding anything, or a teapot that doesn't pour? This notion of utility both defined and limited the crafts, and played a key role in preventing crafts from being included within the spheres of critical thinking and practice of avant-garde art and architecture. An insistence on function as the ultimate outcome of any practice is bound to have a limiting effect on the intellectual content and the tangible form of the finished object. For many makers working in the last quarter of the twentieth century, a thorough questioning of form, meaning and function and their relationship to art and craft practice was an essential starting point. The ceramicist Alison Britton and textile artist Caroline Broadhead have both interrogated the idea of function and its relationship to craft. Britton's comment in *The Maker's Eye* catalogue highlights her concern with notions of function:

> My work in the future may be seen to have belonged to a 'group' . . . I would say that this group is concerned with the outer limits of function; function, or an idea of a possible function, is crucial, but is just one ingredient in the final presence of the object, and is not its only motivation. I think that this preoccupation, which can be perceived in various fields and materials, stands out as a distinct contribution of the last ten years.[21]

Britton's *Black and Green Pot* of 1999 (Figure 3.2) demonstrates her interest in playing with ideas of tradition, function and innovation as well as commenting on the long-standing dichotomy between art and craft. *Black and Green Pot* certainly functions as a container, but the two disparately shaped funnels lead the viewer to question the nature of its function. Indeed, the pot seems to be more concerned with subversion and re-organisation; it is more akin to a three-dimensional sculpture than a utilitarian object.

The critic David Whiting has described her work as consisting of 'nonfunctional domestic objects'.[22] Because of her deliberate move away from function, combined with an interest in integrating architectural form with decorated ceramic surface, she not so much confronts the art/craft divide as suspends it. In an essay for the catalogue of the *Beyond the Dovetail* exhibition Britton commented:

> In many people's minds there is a split between skills and ideas that is comparable to the split between craft and art. Furthermore, they think that skill

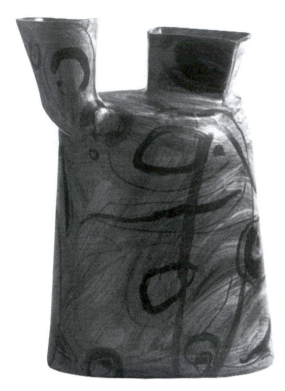

Figure 3.2 – Alison Britton, *Black and Green Pot* (1999). Photograph courtesy of Barrett Marsden Gallery, London.

belongs to craft and ideas belong to art. And tradition belongs to skill and craft, and innovation belongs to ideas and art. To sustain these notions you need to be thinking of skill as a manual thing, the gnarled and noble hand. But in reality the manual and the mental are seamlessly combined in the operation of skill whether you are ploughing a field or painting the Sistine Chapel.[23]

Caroline Broadhead's work has also examined function, and in particular the relation between objects and the human body. Her initial enquiries centred on items of jewellery, but she progressed to cloth and her work has became more sculptural in form. *Suspend* (Figure 3.3) formed part of an installation that reflected Broadhead's interest in cloth and how it might function as a metaphor and memory of the body (or at the least, a human presence). All the garments in the installation were barely palpable, dissolving into painted shadows and highlighting the relationship between visible and invisible, questioning the real and the tangibility of memories. One element of the installation *Web* consisted of a fragile net barely visible to the naked eye; the outline of a garment could just be perceived, whilst *Suspend* was a tulle piece crudely hung by a large number of threads. This garment also had a ghostly presence

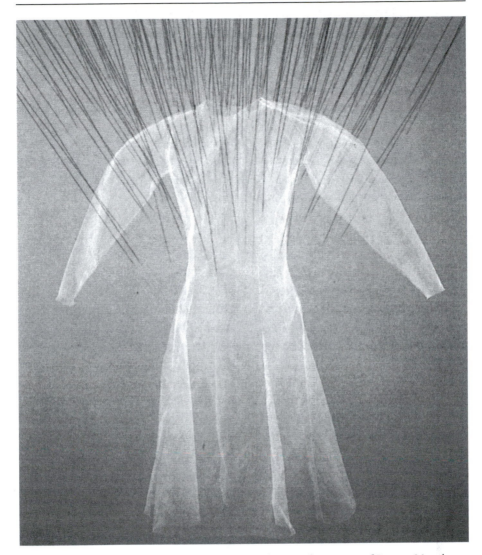

Figure 3.3 – Caroline Broadhead, *Suspend* (2001). Photograph courtesy of Barrett Marsden Gallery, London.

and asked the viewer not only to reconsider its apparent function but also to question the nature of memories as either fixed and indelible or, like the ghostly garments of this installation, fragile and precarious, gradually fading from sight.

Another significant maker is Karin Muhlert, who creates organic, cochlear-shaped objects from a wide range of materials including brass and sandstone, but many of the forms are created from rolls of paper which were destined for recycling. The size and the density of the roll of paper tends to dictate the working process; the paper can be twisted by hand or hammered with mallets and shaped

Figure 3.4 – Karin Muhlert, untitled small works from *Sea Cell* series (1999). Photograph ©
K. Muhlert.

with angle grinders and chisels. Some of the sculptures are small, shell-like shapes,
such as the *Sea Cell* series (Figure 3.4). These three-dimensional paper objects were
created as non-functional containers, but whilst they look like bowls, they could
never function as such. When asked what they are, their creator Karin Muhlert
replied, 'I don't like to label these things, they are non-figurative pieces guided by
nature and chance.'[24]

As can be seen from the few examples given here, function is no longer a nec-
essary constituent of craft; craft objects are now frequently sold for their aesthetic
'look' or concept rather than their function. This move away from function has had
economic as well as critical and aesthetic repercussions. By freeing themselves
from the ties of functionalism, craft practices have liberated themselves from the
traditional definition of craft, to the point where they are frequently indistinguish-
able from art. This in turn has allowed practitioners to break free from perceived
class boundaries. No longer a trade, craft has taken up a place within visual culture
in which it is seen as the expression of artistic identity, produced for an audience
with a desire for functionless objects demanding complex aesthetic and conceptual
engagement. Such a description could easily be applied, of course, to art.

Gradually, the critical development of makers and the perception of consumers
has changed, and long-held beliefs are continually being challenged. These new

Figure 3.5 – Helga Reay-Young, *Autumn Feelings*. Photograph from installation at Cochrane Gallery, London (1999).

approaches have resulted in a broader experimental synthesis of traditional and modern materials and forms. Practitioners and theorists have been interrogating the spaces between art and craft, and their work has ensured that the boundaries are no-longer so easy to map. For example, *Autumn Feelings* (Figure 3.5) was created by Helga Reay-Young as part of a glass installation for the Cochrane Gallery in London. *Autumn Feelings* consists of 19 metres of float-glass, wire and leaves specially created for the space. Hung on the first floor of the gallery and overlooking the pavement, buildings, road and trees, Reay-Young's intention was for the work to bring together the opposing ideas of nature and the city. The identification of a work such as this as craft depends primarily on where it is exhibited. Indeed, while the objects themselves may be indistinguishable in terms of medium, aesthetic and intellectual form and content, craft still operates within a network of galleries, exhibition spaces and other institutions quite distinct from that of art. In this regard, therefore, there remain limits to the overcoming of boundaries between the two, and these may persist in spite of the properties of individual craft practices and artists.

Conclusion

Craft histories are being deconstructed and reconstructed by makers, critics and theoreticians who are trying to dispel the myths that have built up around craft 'celebrities' such as William Morris, Charles Rennie Mackintosh or Bernard Leach,

and high-profile groups including the Bauhaus and de Stijl. They have also set out new agendas for crafts not based on old arguments but questioning wider socio-cultural issues. Craft practice has endlessly redefined itself and developed new forms in new media as a response to fine art, design, modernism, postmodernism, education, patterns of consumption, class, politics and all sorts of currents in social and cultural history. The identity of craft is very fragile, but its practices have continued to command respect. Debates over its meaning and definition continue, and it is precisely this protean and fragile quality that also makes it so interesting.

Further Reading

Dormer, Peter, ed. *The Culture of Craft* (Manchester, 1996).
Greenhalgh, Paul, ed. *The Persistence of Craft* (London, 2003).
Harrod, Tanya. *Crafts of Britain in the Twentieth Century* (London, 1999).
Pye, David. *The Nature and Art of Workmanship* (Cambridge, 1968).
Rowley, Sue. *Craft and Contemporary Theory* (St Leonards, New South Wales, 1997).

Notes

1 Paul Greenhalgh, 'The History of Craft', in Peter Dormer, ed., *The Culture of Craft* (Manchester, 1997), pp. 20–52, at p. 22.
2 Paul Mathieu, 'The Space of Pottery: an Investigation of the Nature of Craft', in G. A. Hickey, ed., *Making and Metaphor: a Discussion of Meaning in Contemporary Craft* (Quebec, 1994), p. 27.
3 Umberto Eco, *Art and Beauty in the Middle Ages* (London and New Haven, CT, 1986), p. 93.
4 See Paul Greenhalgh, 'The History of Craft'.
5 Immanuel Kant, *The Critique of the Power of Judgement*, trans. Paul Guyer and Eric Matthews (Cambridge, 2002) § 43, pp. 182–3.
6 On the development of the modern system of the arts, see Paul Oskar Kristeller, *Renaissance Thought and the Arts* (New York, 1965).
7 John Ruskin, 'Modern Manufacture and Design', in *Sesame and Lilies* (London, 1859), p. 137.
8 William Morris, 'The Lesser Arts of Life' (1882), in W. Morris, *The Collected Work of William Morris, Vol. 22* (London, 1910–15), p. 27.
9 See Adrian Forty, 'Design and Mechanisation', in A. Forty, *Objects of Desire. Design and Society since 1750* (London, 1995), pp. 42–61.
10 Thomas Carlyle, quoted in G. Naylor, *Arts and Crafts Movement* (London, 1980), p. 26.
11 John Ruskin, 'The Lamp of Life', from *The Seven Lamps of Architecture* [1849], quoted in Naylor, *Arts and Crafts Movement*, p. 26.
12 William Morris 'The Art of the People' [1879], quoted in T. Harrod, *The Crafts in Britain in the 20th Century* (New Haven, CT and London, 1999), p. 16.
13 Susan Rowley, 'Craft, Creativity and Critical Practice', in *Reinventing Textiles: Tradition and Innovation* (London, 2000), pp. 1–16.
14 Ibid., p. 2.
15 S. Rowley, *Craft and Contemporary Theory* (St Leonards, New South Wales, 1997), p. xviii.
16 See Harrod, *The Crafts in Britain*, p. 386.
17 Roszika Parker, *The Subversive Stitch* (London, 1984).

18 Ibid., p. 5.
19 See, for example, the catalogue of the exhibition held at the Barbican, *The Woven Image. Contemporary British Tapestry* (London, 1996).
20 Texts such as *Material Matters: The Art and Culture of Contemporary Textiles* offer further critical discussion within this area. See Ingrid Bachman and Ruth Schueing, eds, *Material Matters: The Art and Culture of Contemporary Textiles* (Toronto, 1998).
21 Alison Britton, *The Maker's Eye* (London, 1981).
22 David Whiting, 'Alison Britton's New Ceramics', in *Crafts*, No. 169 (March/April 2001), p. 53.
23 Alison Britton, *Beyond the Dovetail* (London, 1991).
24 Karin Muhlert, 'Sea Changes', in *Crafts*, No. 162 (January/February 2000), p. 3.

4. Design and Modern Culture

Juliette MacDonald

Introduction

The very word 'design' is a mystery to the common man.[1]

This comment, made in 1938 by the British critic Anthony Bertram, is initially puzzling given that 'design' had long been in common use. Yet his comment remains apposite: design remains an elusive term. Not merely concerned with the surface appearance of things, it may be a value-free expression to describe all products, or it can convey luxury, exclusivity and elitism. The dichotomy will provide the context for this discussion as it raises the most pertinent issues relating to design and the understanding and expectations of it over the last 150 years. This chapter commences with a brief consideration of the common meanings of design and how approaches to the profession have altered. It then considers the relationship between design and society in the early decades of the twentieth century by focusing on the pioneering work of industrial designers and their collaboration with large American corporations. Finally, it assesses the emergence of design as an icon of wealth and good taste, concluding with an examination of consumer culture and the role of design within global power structures and consumerism.

The Concept of Design

'Design' has multiple meanings, which can shift depending upon the identity of the user and the context of use. The word itself is derived from the Latin *designare* which meant to draw, but had connotations of planning, composing and producing. The ability to produce well-drawn concepts (*disegno*) became vital in the Renaissance when the rise of trade between distant urban centres necessitated the use of models and plans. China, for example, produced large quantities of porcelain which were exported to India, the Middle East and, from the sixteenth century onwards, Europe.[2] It was, therefore, crucial that concepts could be clearly represented before being produced for a particular market or a specific customer.

There have been numerous attempts to provide pithy descriptions of the term and one of the most eloquent was formed by theorist Richard Buchanan, who defined design as a unifying system:

> Design is what all forms of production for use have in common. It provides the intelligence, the thought or idea – of course, one of the meanings of the term *design* is a thought or plan – that organizes all levels of production, whether in graphic design, engineering and industrial design, architecture, or the largest integrated systems found in urban planning.[3]

In addition to its definition as a process, 'design' can connote luxury, modernity and desirability and as such is found in the 'lifestyle' pages of weekend papers and magazines. Television programmes that centre on home improvements portray design as an everyday way of life accessible to all. Each interpretation and representation of design, whether it is as a plan, a concept or commodity, is valid because they offer a particular facet of meaning, and together they contribute to the overall use of the term.

The disciplines of design history, design studies and material culture have provided the theoretical discourses used to describe the connections between design and the processes of a given society. The early study of design was preoccupied with the history of style and decoration, and was heavily influenced by formalist histories of art as a conceptual model.[4] More recently, however, it has become a broader field and encompasses interdisciplinary interest in the social sciences, including cultural studies, sociology and anthropology. In *The Culture of Design* Guy Julier argues for it to be understood within the context of an increasingly pervasive 'design culture', which 'appropriates and employs a wide range of discursive features: not just ones of modernity, but also risk, heritage, sub-cultural, public space, Europeanity, consumer empowerment and many others'.[5] For example, his discussion of branded leisure such as theme parks and visitor attractions shows how the visitor's whole experience has become the subject of design strategies. Julier notes:

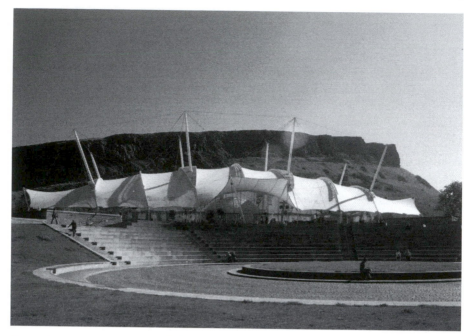

Figure 4.1 – *Our Dynamic Earth*, Edinburgh. Author's photograph (2004).

'leisure spaces provide a veritable *gesamtkunstwerk* [total art] of experiences'.[6] The exhibition centre *Our Dynamic Earth* created in Edinburgh in 1999 (Figure 4.1) is a prime example of such an experience. In addition to text, video clips and static exhibits, the interactive displays including work by Michael Wolchover's company, A Slight Shift, simulate events in the Earth's evolution, whilst the striking music and sound design by Pete Stollery and sophisticated lighting design fuse the encounter into an impressive whole. The visitor's ongoing experience is also considered as part of the design process; the exhibition contextualises some global phenomena in terms of the local landscape, such as Arthur's Seat, the volcanic hill that forms the backdrop to the centre which visitors see when they leave. The building itself, designed by Michael Hopkins and Partners, contains a large fore-court that functions as a public space as well as a foyer for the exhibition. The space can be used as an amphitheatre for performance events, and here again *Our Dynamic Earth* promotes the architecture as having an extended role: just as 'Holyrood Palace and the new [Scottish] Parliament building use architecture to suggest polit-ical evolution, so the Dynamic Earth Project uses architecture to connect natural history to human and civic life'.[7] Taken together, these elements provide a care-fully designed content and context for the visitor. Designers have a crucial role in shaping the media *content* as well as the user interface and it is clear from this, and from other examples, that design possesses a wide-ranging role in contemporary Western society that arguably penetrates all spheres of life.

Design, Consumption and Capitalism

Design owes much of its ubiquity to the fact that Western society is a liberal, capitalist one where consumerism relies on design to fuel ever greater consumption. For example, within the fashion industry every 'season' requires the consumer to restock their wardrobe in the seasons 'new' colours. It would be wrong, however, to think that Western-style consumerism only began with the Industrial Revolution of the nineteenth century. Consumerism had become an established way of life for many Europeans by the seventeenth century.[8] Consequently a relationship between consumerism and design in the West was already established. Yet, as the design historian Adrian Forty points out, capitalism brought its own particular problems to designers:

> What is described as progress in modern societies is in fact largely synonymous with the range of changes brought about by industrial capital. Among the benefits are more food, better transport and a greater abundance of goods. But it is a peculiarity of capitalism that each beneficial innovation also brings a sequence of other changes, not all of which are desired by all people so that, in the name of progress, we are compelled to accept a great many distantly related and possibly unwanted changes.[9]

The success of such progress, despite its attendant problems, can be attributed to its ability to inspire a desire for change. Any new product, whether it be a steam engine in the nineteenth century or nanotechnology in the twenty-first, depends upon the creation of a mood of acceptance for the product and any changes it may induce. Again, Forty notes that: 'Among the ways in which this acceptance is won, design, through its capacity to make things seem other than they are, has been most important. Design alters the ways people see commodities.'[10]

In Europe in the first decades of the twentieth century many designers began to concern themselves with the moral and political dimensions of design. Within the modernist movement utility, standardisation and mass production became the predominant issues, and the relation between form and function provided their basic design vocabulary. The phrase 'form follows function' derived from an essay by the American architect Louis Sullivan (1856–1924), who argued that 'It is the pervading law of all things organic, and inorganic, of all things physical and metaphysical, of all things human and all things super-human, of all true manifestations of the head, of the heart, of the soul, that life is recognisable in its expression, that form ever follows function.'[11] In terms of the design process, the utility or practicality of an object was paramount and the form was a consequence of achieving functionality. Surface detail was not allowed to impinge upon the functional design of the object.

Designers such as Walter Gropius, the head of the Bauhaus School in Germany, Pierre Jeanneret (better known as Le Corbusier) in France, members of the De Stijl group in the Netherlands and the Constructivists in Russia formed a repertoire of abstract geometric forms from modern materials which they believed were the most suitable functional design for standardised mass production. For example, Warwawa Stepanova, a leading proponent of Russian Constructivism, believed that art and design could be combined to create potent, progressive forces in the new machine-age society and her textile and clothing designs reflected this aim. Amongst the many designs she created were sports clothes adorned with bold geometric designs which could be easily mass-produced in clothing factories. Avant-garde furniture similarly reflected these utilitarian beliefs and chromium-plated tubular steel became a popular choice of material because it was light, durable and produced in standardised parts. These parts were then formed to shape functional chairs, tables and lamps, which again required no additional decoration. Modernist aesthetic notions of form and function were gradually superseded. None the less, these ideas were significant because they provided an ideology for the role of design in a modern industrialised society.

Whilst designers in early twentieth-century Europe concerned themselves with a body of design theory which emphasised form and practicality, and their significance for society, in the United States the emphasis centred more on the potential of technology itself. The key factor was the unshakeable belief in technology and its ability to transform the world into a better place to live. The theme of the New York World's Fair of 1939 was 'Design for Tomorrow', and it provided an ideal opportunity for industrial designers and large American corporations to work together to sell their ideas to the general public and 'to situate themselves as powerful economic forces in the quest to stimulate consumer demand'.[12] Many of the displays were concerned with speed and travel. In the 'Transportation Zone' visitors could view Raymond Loewy's ideas on improving travel between London and New York in the form of a passenger rocket being fired from a gun, with the projected journey time being one hour. Inside the Ford Motor Company Building, Walter Dorwin Teague's 'Ford Cycle of Production' was on view, and vehicles such as Lincoln-Zephyrs were available for road-testing on the spiral 'Road of Tomorrow'. Visitors could witness the benefits of a Westinghouse electric dishwasher in Westinghouse's 'Battle of the Centuries'. Having been welcomed into the exhibit by the seven foot-high robot, Electro, and his robotic dog Sparky, visitors were invited to watch a dishwashing contest between Mrs Modern, who used the company's latest model dishwasher, and Mrs Drudge, who washed by hand.

The collaboration between industrial design, corporate identity and branding was clearly evident in the Fair. There were, of course, financial benefits to be gained from this relationship, but design had an additional role to play in American society through its contribution to the formation of a national and cultural identity. The

United States had witnessed large-scale immigration at the end of the nineteenth and beginning of the twentieth centuries. America was thus composed of a wide range of races and nationalities each with their own traditions, culture and language, but all of whom wished to be considered American. It was, therefore, important to establish an American ideal with which everyone could identify. Hygiene, cleanliness and comfort came to represent important characteristics of this ideal. In 1933 Hazel Kryk wrote *Economic Problems of the Family* in which she set out key American values:

> Protection of health – everything promoting physical health, bodily vigour and longevity – is also undoubtedly on the list of values rated relatively high. This motive without question justifies any expenditure of time and money. Physical comfort and bodily cleanliness too, . . . rank relatively high in the American standard of living. . . . The physical comfort motive shows itself in the widespread systems of central heating, electric fans, refrigeration and easy chairs.[13]

Alongside hygiene and health sat a fundamental belief in material wealth and the abundance of commodities.[14] Design played a central role in creating objects that reflected these ideals and thus appealed to the many minority groups through an emphasis on characteristics which immediately made them identifiable as American. Such common denominators made the objects into desirable commodities capable of achieving mass sales and promoting the idea of prosperity

Raymond Loewy's design for a new refrigerator for Sears Roebuck offers a good example of the way a designer could incorporate such ideals into a domestic object. He received the commission in 1935 and by this time refrigerators were a well-established commodity on the American market. The advertising relating to them generally focused on the hygienic and health-giving properties the refrigerators could provide. However, they were normally encased within a wooden cabinet and, whilst they worked efficiently and effectively, their appearance did not readily reflect the hygienic image of the advertising campaigns. Loewy's solution was the *Coldspot* of 1936. In place of the large, angular wooden cabinet Loewy produced a taller, streamlined version made from pressed steel. It also had a smooth finish with concealed hinges. Certainly, without the extrusions of hinges and numerous door handles, this appliance was much easier to clean. More importantly, the sleek façade and brilliant white finish exaggerated the elements of hygiene and purity. The design's emphasis on cleanliness coincided with the modernist ideas of Le Corbusier, and it was the epitome of the American design ideal described above. It also laid down the parameters for the design of all subsequent kitchen appliances from refrigerators to washing machines and dishwashers.

Between the first and second world wars such innovatory designs inspired not only other designers but Western society in general. Several writers, for example,

have noted the influence of the streamlined shapes of aircraft, trains and domestic appliances of Normal Bel Geddes, Raymond Loewy and Walter Dorwin Teague on the imagined spaceships of science fiction. As Woodham notes in his book on twentieth-century design:

> Concepts such as speed and change, and the exploration of the possibilities of new materials, together with the development of new modes of transport and appliances were also common to both the more extravagant futures portrayed by Bel Geddes and many science-fiction writers, illustrators and film makers.[15]

Henry Ford's Motor Company clearly articulated the relationship between society's fascination with speed, technology, mass production and consumerism. Established in 1901, Ford's Model-T cars were highly sought after. Their popularity necessitated changes in production which were to have a profound effect throughout the industrialised world. In 1908 Ford introduced the production-line to replace nodal assembly. Tasks were divided into smaller units and machines replaced handwork wherever possible. The single-purpose dedicated machinery resulted in a vastly increased scale of production, which, in turn, resulted in cheaper cars. By 1927 a total of fifteen million cars had rolled off the assembly line.[16] The workers were awarded higher wages as compensation for the deskilling and monotony they endured, but the real change to consumer history brought about by Ford was not so much the production of the Model T, but rather the company's introduction of the eight-dollar, five-day working week. What lay behind the pay-packet was the recognition that mass production required mass consumption; Ford was creating a market for his goods within his own workforce since they could now afford to buy his cars. The consequences of Fordism for design were enormous and it transformed numerous sectors of manufacture from food and clothes to furniture and farming. It also had an impact on advertising, corporate identity and branding, all of which were required to ensure the steady consumption of goods.

Superficially, the extravagant exhibits at the World Fair and contemporary domestic commodities reflected the benefits of the collaboration between dynamic designers and magnanimous corporations. It was also apparent, however, that the 'well-designed future' would increase a company's profit margins. As a result, companies in the 1930s frequently used a strategy of 'consumer engineering' which shortened the cycle of consumption by placing an emphasis on style rather than function.[17] Not everyone, however, agreed with this overt dependence of capitalist production on design. In the 1950s the sociologist Vance Packard argued that advertisers were manipulating public desire for new goods by creating artificial needs in consumers. Describing advertising companies with the now

famous notion of the 'hidden persuaders', Packard analysed the ways in which they used psychology as a means of stimulating the consumer into desiring and buying whatever the advertiser wished them to.[18] Similarly, Richard Buckminster Fuller, one of America's most radical designers of the period, was particularly critical of both the growing trend towards built-in obsolescence – goods were not intended to last a lifetime but rather to become outdated within a limited space of time – and also the superficial styling of many consumer products.[19] He put his energies into developing a 'design science' that would offer maximum human benefit from minimum use of material and energy. His concept, which he termed 'Dymaxion', attempted to combine a visionary view of design with science and mathematics to produce vehicles and houses which were economical to use and ecologically sound. Unfortunately, the majority of Fuller's design projects failed to achieve widespread acceptance. Perhaps of more use were his many publications in which he articulated his strong beliefs that industrial design, advertising and marketing were too closely associated with each other and dishonest. For example, in 1950 he argued that:

> industrial design is a very tarnished affair . . . I assure you that no aircraft company will let an industrial designer through its engineering front door. Industrial designers are considered to be pure interior and exterior decorators. And yet, I've listened to industrial designers assert that they designed the steamship, *United States*. If you were to exhibit schematically all the items that the industrial designers created for the *United States*, you would have sailing down New York Harbour an array of window curtains, chairs, paint clouds and bric-a-brac floating in space, with nothing to really hold it together.[20]

The second world war curbed the tendencies of styling for profit and built-in obsolescence, but it also encouraged much more efficient modes of production. Similarly, design continued as a useful tool with which manufacturers could develop new markets. Scandinavian countries, for example, promoted 'Scandinavian Design' for overseas consumption. The objects they produced for export emphasised functional simplicity. Italy similarly attempted to cultivate its identity as the design centre of Europe. The Italian government actively promoted its country's designs through the establishment of three-year design exhibitions (Triennale) in Milan, and in 1950 it raised the profile of its designers by sending a major travelling exhibition entitled 'Italy at Work: Her Renaissance in Design Today' to the United States.

However, the success of Italian design brought its own problems and throughout the 1950s and 1960s members of the Italian avant-garde began to dislike what they perceived as capitalist expectations of their work. Their accusations had much in common with Packard's beliefs that design had become a cheap marketing ploy,

and as a result they were trapped into producing fashionable, elegant domestic commodities. Manufacturers, they argued, were merely 'responding to the economic dictates of the market-place rather than the imaginative and creative possibilities of design as a means of enhancing the quality of life'.[21] As a result, avant-garde designers such as Ettore Sottsass Jr and Gaetano Pesce set out to redefine Italian design by rejecting rationalism and elegance and exploring *kitsch*, eclecticism and nostalgia. Yet this solution was merely a change of design rather than a change of the nature of design and its relationship to manufacture and consumption. Many of the designs produced as a part of this anti-design movement were decidedly un-chic. Pesce's *Sit Down* chair of 1970 for the Milan-based company Cassina is an ideal example of the anti-design attempt to undermine market-led expectations. Inspired by Claus Oldenberg's work and anthropomorphic in form, the *Sit Down* attempted to deflect attention away from style, form and blatant consumerism, and focus instead on design's broader socio-cultural functions. Similarly, Sottsass's questioning of the status and meaning of objects also played a pivotal role in the avant-garde climate of the late 1960s and 1970s. He forged a long-standing relationship with Olivetti for whom he designed office furniture and machinery. His works combined technical adjustments with an exploration of the nature of taste and the perceived status of objects. His *Valentine* typewriter of 1969, for example, was small, compact and made of red plastic. This meant it was light, easy to move and keep clean and, therefore, ideal for the office environment. Yet its decorative appearance suggested it was more of a fashion accessory than a functional office appliance.

Sottsass's establishment of the design group Memphis in conjunction with Michele De Lucchi similarly provided a stimulating ethos for design throughout the 1980s. Founded in Milan in 1981, Memphis never formulated an established design philosophy but none the less attempted to respond to the culture of the time by disassociating itself from established notions of design and the homogenisation of mass markets: 'For Sottsass the use of imagination and a rich visual language in design was both a means of enhancing the consumer experience and of persuading manufacturers to re-examine their understanding of the aesthetic possibilities inherent in everyday products.'[22] Memphis has been described as the ultimate 'fruit salad' and Sottsass himself commented: 'Anything that is tamed by culture loses its flavour after a while, it's like eating cardboard. You have to put mustard on it or take little pieces of cardboard and eat them with tomatoes and salad. It's a lot better if you don't eat cardboard at all.'[23] Many of the objects created by Memphis designers were produced from plastic laminate materials in bright 'tutti-frutti' colours. In addition, the form of the objects themselves revealed a profound anti-functionalist attitude, and ideas for their designs were drawn from a wide range of sources encompassing everything from ancient civilisation to American consumerism as well as making reference to both high and popular culture.

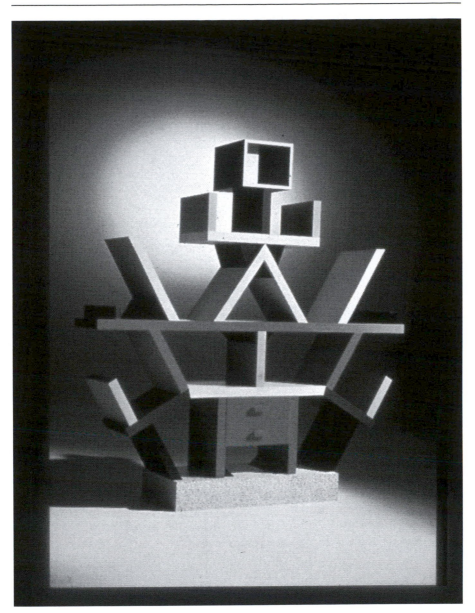

Figure 4.2 – Ettore Sotsass, *Carlton Bookcase* (1981). Photograph © MEMPHIS.

Sotsass's *Carlton Bookcase* (Figure 4.2), created in 1981, is the epitome of the group's ideas: the bookcase hardly looks capable of supporting books and the emphasis is sharply focused on its aesthetic qualities.

Memphis designers worked in a variety of media, including textiles, glass and ceramics, and between them they produced a disparate range of objects. However, they were united in the belief that design was an integral part of the fashion process.

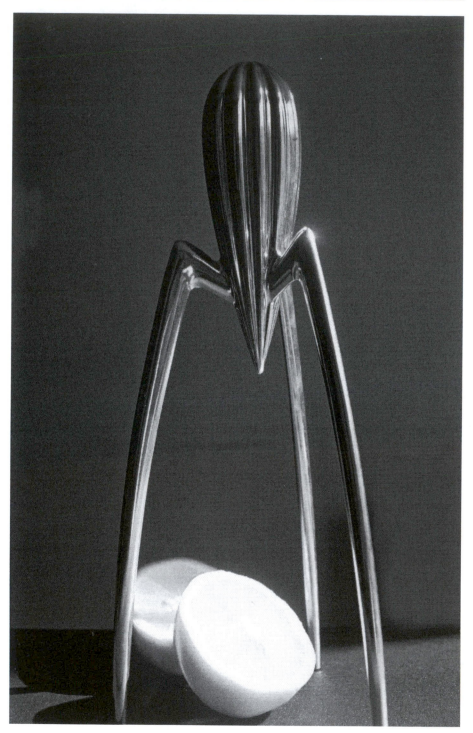

Figure 4.3 – Philippe Starck, *Juicy Salif Lemon Squeezer* (1990). Author's photograph (2004).

In the catalogue accompanying the group's first exhibition in September 1981 the designers stated that they believed that Memphis furniture would soon go out of style. The irony, as some critics noted, was that the design group's ideas were widely imitated, resulting in the commercial conformity they had attempted to escape.[24]

This New Design, as it was termed, also laid more emphasis on the authorial voice. Objects containing a celebrity designer's signature came to be understood to have a particular mark of distinction. These objects generally fall within the designation 'high design' where 'conscious designer intervention and authorship, along with the price-tag, play a large role in establishing the cultural and aesthetic credentials of an artefact'.[25] Such objects blur the boundaries between designed objects for display and designed objects to be consumed, as they are not only to be found in museums and fashionable galleries but they may also be purchased for everyday use. Michael Grave's *Kettle with Bird* produced for Alessi in 1985 and Philippe Starck's lemon squeezer, *Juicy Salif* (Figure 4.3) from 1990 (also for Alessi) are representative of this trend. *Juicy Salif* has a striking form, but as a functional kitchen device it does not perform well; users comment that it is difficult to prevent pips from falling into the glass along with the juice and the juice tends to spatter until one learns exactly how much pressure to exert.

Critiques of Design

Novelty has thus apparently overtaken function as prime concern within the design process and consequently design is often perceived as shallow and superficial. It can, however, be argued that these elements of *kitsch* represent more than superficial styling. Such objects function as metaphors; their utilitarian role is overshadowed by their symbolic role as an official item of contemporary culture. This in a sense is a privilege, because the owner has something that is functional and aesthetically conspicuous but more importantly it sets her/him apart as a person of good taste and culture. This notion of object as metaphor is explored in a later chapter of this book, and it has led to an important critical reassessment of design. While the chief function of a fur coat, for example, appears to be protection from the elements this is merely an excuse, 'a way of naturalizing the cultural order, of making something as culturally arbitrary as a status symbol appear to have a natural and rational function (protection) and one that is motivated by reality'.[26] The coat's cultural value lies in distinguishing very wealthy men and women from others. Thus here, and in the case of *Juicy Salif,* it can be argued that function has been mythologised.[27] It represents far more than utility, in that it signifies affluent and style-conscious consumerism.

Jean Baudrillard fashioned similar claims in the 1960s, arguing that we no longer consume objects, only signs. He contended that by buying a fridge-freezer, for example, the consumer is not so much buying a utilitarian object as invoking an

entire system of meaning.[28] A streamlined Loewy *Coldspot* refrigerator, through employing a code of modern functionality, can be said to have signified domestic modernity. The sociologist Dan Slater has suggested that Baudrillard demonstrates that 'this systematic semiotic relatedness gives the underlying dynamic of contemporary consumer culture, as production, marketing and retailing are increasingly oriented to provide consumers with coherent, coordinated and appealing life-style concepts, . . . which give both the consumer and consumer goods a firm social identity within a meaningful universe'.[29] In other words, design can be understood as a symbolic activity representing the consumption of signs (such as function and utility) rather than the consumption of the objects themselves.

Over the past few decades consumer culture has witnessed a shift from the Fordist mass production of standardised goods for a homogeneous consumer to a more fragmented culture of specialised production of commodities for a precise consumer group which is defined by lifestyle or niche markets rather than by class, age or gender. This post-Fordist system is less concerned with industrial designers and more reliant on design consultants and producers of 'concepts'. Consumption, not production, is the dominating force. It is also clear that through an emphasis on lifestyle and consumerism design has become a global commodity. This is unsurprising since design consultants and the design press have worked hard to give it a critical economic role within the market-place. Design has played a central role in creating corporate identities, logotypes and branding associated with specific products and companies. This in turn has 'been a powerful testimony to the perceived ability of design to communicate particular cultural values, as well as to engender corporate profitability'.[30]

Global brands are said to be the top wealth creators in the world. However, their ability to enrich society has often been challenged. In Seattle in 1999 at the World Trade Organisation talks, the street protest at the dominance of global brands erupted into violence. Naomi Klein's book *No Logo* also offered a challenge to global consumerism and raised the level of debate regarding the worth of global branding and the role of multinational corporations.[31] The role of designers became a crucial issue. It was widely recognised that design was a powerful tool. As the designer Tibor Kalman commented, for example, design has the potential to make oil companies look clean or a tomato sauce appear to be made by someone's grandmother.[32] The Adbusters Media Foundation based in Canada similarly issued a challenge to the international design community by creating 'uncommercials' and spoof advertisements (Figure 4.4). They also published the manifesto *First Things First 2000*. The manifesto proposed a reversal of priorities; rather than being concerned with branding and product promotion, designers were asked to consider how they might contribute to creating 'more useful, lasting, and democratic forms of communication – a mindshift away from product marketing and toward the exploration and production of a new kind of meaning'.[33]

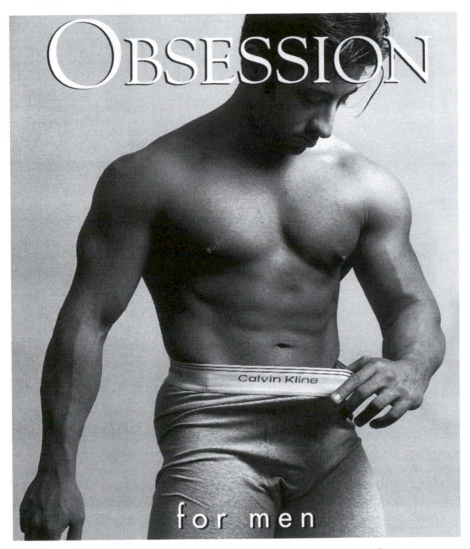

Figure 4.4 – *Obsession for Men*. From *Adbusters* magazine (1993). Photograph © Adbusters.

Whilst Adbusters in general, and the *First Things First 2000* manifesto in particular, drew much support they also had their critics. In England, a small group of designers retaliated by producing their own manifesto entitled *A Call to Arms Against Future Retro-Manifestos from the Disillusioned*, which pointed out the inextricable links between design and capitalism and argued that this relationship would not change even if designers themselves were to re-evaluate their aims and objectives.[34]

Some of these issues concerning the relationship between design and the ideology of the culture that produces it have been addressed by the design historian Peter

Dormer, who has often spoken up in defence of design. In *The Meanings of Modern Design* he argued that design and manufacturing do not have their roots in advertising or television but in human experience, and that achieving the continuity of progress should be the fundamental desire of every designer. 'The point for designers is that, in an age of scepticism, more and more weight is being given by societies to the social rules, obligations and institutions that provide continuity and service in all its moral complexity.'[35] In other words, Dormer was highlighting the need for design to offer practical service to institutions and communities and to truthfully represent the ideals and values of people within those groups.

Design's social responsibility has also been debated in relation to the environment. This aspiration is clearly articulated in the following comment which appeared in *Green Pages: The Business of Saving the World*: 'The green consumer is likely to be an increasingly important influence in the world of product design. Designers who ignore the fact, or who allow their clients to ignore it, risk losing out on some of the most exciting marketing opportunities of the eighties and nineties.'[36] Such awareness has resulted in the development of environmentally driven design agencies such as o2, a global collective that focuses on ecological concerns such as sustainability, and works with trade and industry to minimise any destructive impact.[37] Designers within the group have produced a wide variety of products. These range from Droog Design plant pots made from cattle dung, which simultaneously use waste material whilst fertilising plants as they grow, to Trevor Bayliss's wind-up radios for countries in Africa, where batteries are not always available, but where dissemination of information to combat AIDS, for example, can be crucial.

Conclusion

Clearly, design is integrated into the wider patterns of consumerism and society. Yet designers can be active participants in debating these critical issues through a combination of theoretical discourse and design practice. Despite the numerous criticisms, design is clearly not merely a matter of the surface appearance of objects; it is deeply rooted in the structure and the evolution of society. It shapes and, indeed, is shaped by the cultural, political, economic and social environment in which it evolves.

Further Reading

Forty, Adrian. *Objects of Desire: Design and Society since 1750* (London, 1995).
Heskett, John. *Toothpicks and Logos: Design in Everyday Life* (Oxford, 2002).
Julier, Guy. *The Culture of Design* (London, 2000).
Margolin, Victor, ed. *Design Discourse: History, Theory, Criticism* (Chicago, 1989).
Woodham, Jonathan. *Twentieth-Century Design* (Oxford, 1997).

Notes

1 Anthony Bertram, *Design* (London, 1938) p. 11.
2 On the rising trade between Europe and Asia, see Craig Clunas, *Chinese Export Art and Design* (London, 1998); Lisa Jardine and Jerry Brotton, *Global Interests. Renaissance Art between East and West* (London, 2000); Jerry Brotton, *The Renaissance Bazaar: From the Silk Road to Michelangelo* (Oxford, 2003).
3 Richard Buchanan, cited in Victor Margolin, ed., *Design Discourse: History, Theory, Criticism* (Chicago, 1989), p. 3.
4 On the development of design history as a discipline, see John Walker, *Design History and the History of Design* (London, 1989).
5 Guy Julier, *The Culture of Design* (London, 2000), p. 3.
6 Ibid., p. 147.
7 See www.dynamicearth.co.uk.
8 Simon Schama, *Embarrassment of Riches: an Interpretation of Dutch Culture in the Golden Age* (London, 1987) offers a good account of the consumerist boom in the seventeenth-century Netherlands.
9 Adrian Forty, *Objects of Desire: Design and Society since 1750* (London, 1995), p. 11.
10 Ibid., p. 11.
11 Louis Sullivan, 'A Tall Office Building Artistically Considered' (1896), in I. Athey, ed., *Kindergarten Chats (revised 1918) and Other Writings* (New York, 1947), pp. 202–13.
12 Jonathan Woodham, *Twentieth-Century Design* (Oxford, 1997), p. 73.
13 H. Kryk, cited in Forty, *Objects of Desire*, p. 245.
14 Ibid.
15 Woodham, *Twentieth-Century Design*, p. 71.
16 See Aldous Huxley, *Brave New World* (1932), which attacks such mechanisation and standardisation by imagining a mechanistic society devoid of emotion. Also, the Charlie Chaplin film *Modern Times* of 1936, which similarly attempts to portray these ideas.
17 See Ray Sheldon and Egmont Arens, *Consumer Engineering: A New Technique for Prosperity* (New York, 1932).
18 See Vance Packard, *The Hidden Persuaders* (Harmondsworth, 1977). First published in 1957.
19 See James Meller, ed., *The Buckminster Fuller Reader* (Harmondsworth, 1971).
20 R. Buckminster Fuller, 'The Comprehensive Man', revised text of a lecture given at the University of Oregon in 1959, in Meller, ed., *The Buckminster Fuller Reader*, p. 134.
21 Woodham, *Twentieth-Century Design*, p. 191.
22 Ibid., p. 196.
23 Ettore Sottsass, cited in Michael Collins, *Towards Post-Modernism: Design since 1851* (London, 1986), p. 122.
24 See Volker Fischer, ed., *Design Now: Industry or Art?* (Munich, 1989), p. 74.
25 Julier, *The Culture of Design*, p. 69.
26 Don Slater, *Consumer Culture and Modernity* (Cambridge, 1997), p. 145.
27 See Roland Barthes, *Mythologies* (London, 1986).
28 Jean Baudrillard, *The System of Objects* (London, 1996). First published, Paris, 1966.
29 Slater, *Consumer Culture and Modernity*, p. 146.
30 Woodham, *Twentieth-Century Design*, p. 149.
31 Naomi Klein, *No Logo* (London and New York, 2000).
32 Allen Casey, 'Tibor Kalman: An Interview by Allan Casey', in *Adbusters*, No. 23 (Autumn, 1998), p. 25.
33 *First Things First Manifesto 2000*, www.adbusters.org.

34 'The Readers Reply to First Things First Manifesto 2000', in *Emigré*, No. 25 (Fall, 1999).
35 Peter Dormer, *The Meanings of Modern Design* (London, 1990), p. 181.
36 Elington, Burke and Hailes, cited in Woodham, *Twentieth Century Design*, p. 239.
37 See www.o2.org.

5. Fashion: Style, Identity and Meaning

Fiona Anderson

Introduction

Fashion is one of *the* fastest changing sources of new ideas in contemporary visual culture. It also has widespread popular appeal; even designer-level fashion has much greater accessibility than the equivalent products, images and texts of equivalent designer industries. Since the mid-1980s fashion has also enjoyed a higher profile within academic thought, international exhibitions and popular media than ever before. This chapter looks at multidisciplinary approaches to the study of fashion that have developed during this period, and discusses the work of key writers in the area such as Elizabeth Wilson, Fred Davis, Joanne Entwhistle and Christopher Breward. Their work will be used to highlight debates on all aspects of self-fashioning, from its role in the negotiation of gender relations to its power to communicate and challenge accepted social and political ideals. It explores the significance of fashion as both a historical and contemporary phenomenon, along with the realities of fashion as a commercial industry and economic concern.

Definitions

Before exploring fashion in greater depth it is useful to consider some definitions. Should the term 'fashion' be applied to all means of adorning the body throughout history? Certainly, all human cultures and societies have decorated or adorned the body in some way, as Elizabeth Wilson states:

In all societies the body is 'dressed' and everywhere dress and adornment play symbolic, communicative and aesthetic roles. Dress is always 'unspeakably meaningful.' The earliest forms of 'clothing' seem to have been adornments such as body painting, ornaments, scarifications (scarring), tattooing, masks and often constricting neck and waist bands. Many of these deformed, reformed or otherwise modified the body.[1]

The question of whether these earlier forms of 'dressing' the body should be viewed in a similar way to historical or contemporary fashionable dress deserves further investigation. This is particularly due to the recent popularity of 'tribal' adornments such as tattooing and multiple piercings within mainstream contemporary appearances. Most contemporary writers describe fashion as a specific system of dress that emerged within Europe in the late Middle Ages. Its development was linked to the expansion of cities and the growth of mercantile capitalism. Whilst earlier forms of dress and adornment have something in common with fashion – they also express important meanings within specific societies and cultures – one should not consider them in the same way as the distinctive system of dress known as fashion. So what is unique to fashion as a way of adorning the body? Elizabeth Rouse has suggested that 'fashion seems to be about change for change's sake, and the illusion of novelty'.[2] Ulrich Lehmann has made a similar point, arguing that 'In itself, sartorial fashion stands, almost by definition, for the absolutely new – for permanent novelty and constant, insatiable change.'[3]

This appears to be a highly appropriate way to distinguish between Western dress from the late Middle Ages onwards and modes of apparel such as the Indian sari or Japanese kimono, which have remained relatively unchanged for centuries. Yet although Western fashion has unquestionably been based on a ceaseless and rapid turnover of styles, dress in the rest of the world has not remained completely untouched by change. Nevertheless, in broad terms such a characterisation of fashion remains extremely useful. It also leads to further questions, such as whether *all* Western dress from the fourteenth century onwards should be considered as fashion. Surely there must be some exceptions that stand outside the relentlessly changing cycle of new styles. For instance, we all are aware of individuals who take little interest in their appearance or who through taste, age or occupation seem to be rather disconnected from contemporary fashion styling. But even if one considers an example like British police uniforms since the 1960s, it is easy to identify changes in design informed by developments in fashion. The need for the police to communicate social authority means that their uniforms have to show symbolic links with the society being policed. The most logical way to do this is to adhere to some of the codes of contemporary fashion design. Consideration of such an example makes it easy to concur with Elizabeth Wilson's view that

in modern western societies no clothes are outside fashion; fashion sets the terms of *all* sartorial behaviour . . . Even the determinedly unfashionable wear clothes that manifestly represent a reaction against what is in fashion. To be unfashionable is not to escape the whole discourse, or to get outside the parameters.[4]

This is certainly true of contemporary dress and society, but unlimited access to fashionable dress and information about new styles became a reality for most consumers only some time after the late Middle Ages. From the mid-eighteenth century the expansion of the mass consumption of fashionable styles and commodities took on new momentum. Fashionable dress began to move away from its earlier restriction to court society and wealthy merchants. This process continued until the 1930s, by which time it was possible to speak of fashion as something in which everyone, or almost everyone, could and did take part.

Debates on Fashion

The increasing importance of fashion has inspired considerable debate and negative criticism from moralists, government and religious figures and political cartoonists. Between the fourteenth and sixteenth centuries its emergence led to the creation of sumptuary laws in several European countries. These were designed to restrict the consumption of certain textiles to the upper echelons of society. In practice they were rarely enforced, but their introduction is indicative of conflicts between the spread of fashion consumption and existing social and moral structures.[5] Criticisms of fashion took on a particularly extreme and aggressive character within mid-seventeenth-century Britain, as illustrated by a pamphlet of the period, which states:

> A woman which is faire in shew, is foule in condition: she is like unto a glow worme, which is bright in the hedge, and blacke in the hand; in the greenest grasse lyeth hid the greatest serpents: painted pottes commonly hold deadly poyson: and in the cleerest water the ugliest Tode; and the fairest woman hath some filthiness in her.[6]

Such criticisms had scant effect on the rise of fashion consumption as a popular pursuit, but they helped to create a pervasive view of fashion as immoral, wasteful, trivial and *feminine*. Subsequently, theorists such as Thorstein Veblen (1857–1929) or Georg Simmel (1858–1918) formulated more sophisticated approaches, but their writings were often underpinned by negative stances that echoed earlier criticisms of fashion. For example, Veblen's writings depict women as objects of fashion, as feeble beings whose prime motivation is to decorate themselves as a

means of displaying their husband's wealth.[7] Negative views of fashion have persisted even until relatively recent times, and this has been despite the declining influence of religious moral views on the body and the fact that in the West they have largely been replaced by a consumerist-inspired celebration of bodies, pleasure and erotic visual display. The following excerpt from *The Face* of August 1997 highlights the contradictory views on the body, consumption and pleasure prevalent in contemporary society. It states:

> Many people have been paying fashion more and more attention throughout this fast, bright, jumbled-up decade . . . Thanks to the designer boom, oft-controversial fashion photography, in the form of adverts, now looms large in our towns and cities. Catwalk shows are no longer the province of the cognoscenti, but staple light-entertainment fare. Reporters analyse the shows and the stories and turn them into news, so often that we now think nothing of seeing a story about a model's age or weight on the front page of a national newspaper. All this means that fashion has now accrued all the celebrities, merchandising, empty spectacle, dubious morality and media coverage that it now takes to become a fully-fledged entertainment medium.[8]

Despite the continued prominence of similar views in contemporary media, recent critical and theoretical writing on fashion has tended to move away from such condemnation. The so-called 'new fashion history' has focused on a more rounded analysis of fashion, acknowledging negative aspects such as the exploitative nature of clothing production, but also embracing its positive characteristics. Elizabeth Wilson's work, in particular, *Adorned in Dreams: Fashion and Modernity* (1985), has been identified as something of a turning point in the development of new approaches to fashion. It typifies the tendency within recent research to explore fashion's ability to articulate identities in a pleasurable and empowering way, as well as its potential to provoke debate about wider social and political concerns. Such writing draws on a range of academic disciplines, including sociology, cultural studies, material cultural studies, psychology and gender studies.[9]

Fashion and Identity

Our public and private selves are experienced on a daily basis as inseparable from fashionable dress and adornment. Even in the most intimate moments we are usually 'dressed' through hairstyling, jewellery or other bodily adjustments related to display, such as hair removal, dieting or exercise. Thus when one considers the formation and expression of social identities, fashionable appearances play a crucial role. Fashion has the potential to interact with primary social categories such as gender, age, race, class and nationality. Self-fashioning also has the potential to help

articulate more subtle, though equally important, aspects of ourselves such as moods, aspirations and emotions. As Fred Davis states:

> By social identity, I mean much more than the symbols of social class or status to which some sociologists are inclined to restrict the concept. I include within the concept's purview any aspect of self about which individuals can through symbolic means communicate with others, in the instance of dress through predominantly non-discursive visual, tactile, and olfactory symbols, however imprecise and elusive these may be. In any case the concept of social identity points to the configuration of attributes and attitudes persons seek to and actually do communicate about themselves (obviously the two are not always the same).[10]

Fashion encapsulates complex and contradictory aspects of our identities, but as with other characteristics of fashion this needs to be considered in connection with specific historical developments. The development of industrialisation from the mid-eighteenth century onwards led to the movement of vast numbers of people from the countryside to large urban centres. This happened first in Britain, although by the nineteenth century it was occurring throughout most of Europe. Individuals, whose experience of social contact had hitherto largely been on a highly personal basis within small village communities, were thrust into a world of radically new experiences. Most people one encountered were complete strangers, unknown and anonymous, apart from the signals and impressions obtained from their dressed outer selves.[11] These changes, along with the wider access to fashion made possible by relatively larger incomes and an expansion in the ready-to-wear clothing industry, helped to position fashion as playing a crucial role in the new forms of social life.

A related phenomenon was the emergence of the crowd in urban contexts. This led to widespread anxieties amongst city dwellers, who became increasingly fearful about the possibility that the individual might be overwhelmed by the mass. In his essay 'Fashion' (1904), Simmel pinpoints the role of fashionable dress as a means to negotiate the new tensions between fitting in with the crowd, and expressing a distinctive, sense of individuality. He states:

> fashion is the imitation of a given example and satisfies the demand for social adaptation . . . at the same time it satisfies in no less degree the need of differentiation, the tendency towards dissimilarity, the desire for constant change and contrast.[12]

As our bodies circulate within society, the fact that they are dressed and how they are dressed provides the opportunity either to conform socially or to express

our individuality. In practice, most people aim to satisfy both these contradictory social and psychological drives simultaneously. Fashion provides a means of forming and articulating identity in relation to the various social groups we encounter in our lives, as well as the wider social community. As Lehmann states, 'it is precisely sartorial fashion that establishes the depicted as a *social* being, as a woman or man who is set within progressing time'.[13] This social dimension of fashion has been explored by other authors, including Norbert Elias (1897–1990) and Pierre Bourdieu, who trace the links between distinctions in bodily adornment and the maintenance of class, status and power by certain groups.[14] Adorning the body provides a means of connecting with others, but it may also be used to exclude them if their appearance indicates that they do not belong to the appropriate social group for a specific context. When attending a public school parents' day, a pub after a football match, or a hip hop club, most people dress to fit in, for fear that they might otherwise be excluded from social contact by the rest of the gathering. Even when people deliberately set themselves apart by exhibiting a particular taste, they also often simultaneously show membership of specific social groups. A good example of this is youth subcultures in which individuals use style as a means of asserting a group identity that is in some way different from mainstream tastes and values.

It is also important to consider the constantly *shifting* nature of the relationship between social identity and fashion. This has become increasingly complex since the 1960s, when traditional social categories of class, race, gender and sexuality began to be debated and contested by political movements such as feminism and the civil rights movement in America. The appearance of the punk girl at the centre of Richard Braine's photograph of *The Roxy Club* vividly illustrates punk's rejection of established notions of femininity and feminine beauty. (Figure 5.1).

The radical campaigns by these movements for greater social status and freedom for minority groups have to a large extent now become accepted within mainstream society. Elizabeth Wilson argues that fashion is an important means by which we negotiate the complexities of contemporary society, stating that 'our culture of global mass media feeds us so much information that a massive cultural eclecticism is the only possible response'.[15] The attempt to form a cohesive sense of identity within this environment becomes extremely difficult, and hence self-adornment becomes a means of articulating a sense of ambiguity and ambivalence.

However acute the sense of relentlessly shifting reality in contemporary life, in earlier periods fashion displayed a crucial ability to knit together contradictory aspects of our social selves into visual and tactile form. Probably the most important social category defined by dress is gender. Despite significant changes in the gender roles of men and women since the 1960s, maintenance of gender identity remains a predominant feature of contemporary social life, and this is primarily gauged through appearances. Unisex garments such as jeans, trainers and T-shirts

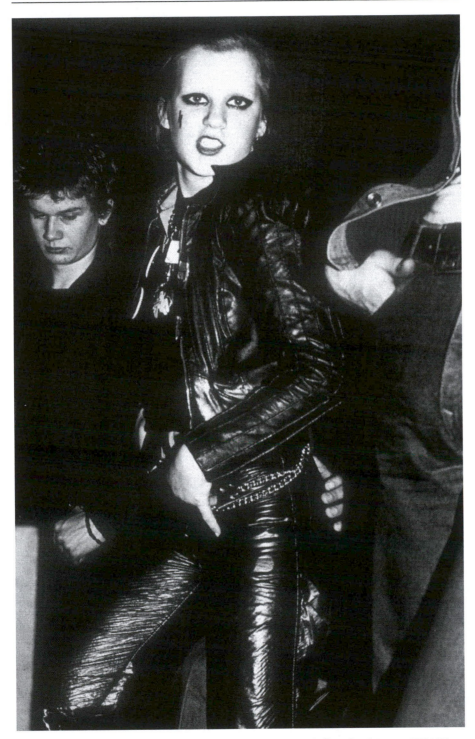

Figure 5.1 – Richard Braine, *The Roxy Club* (1977). Photograph © Richard Braine-PYMCA.

are now worn and accepted within a variety of social contexts. However, most people wearing these types of garments use hairstyling, make-up, jewellery or other items of clothing as a means of reasserting a specific male or female gender identity. From the 1970s onwards, and particularly since the 1980s, prominent fashion designers such as Jean Paul Gaultier and Vivienne Westwood have explored the persistence of gender coding conventions and stereotypes through their designs. In most contexts nonconformity to gender roles through dress tends to signal lack of social conformity in a broader sense.

Because of its crucial role in communicating gender, dress has had a strong presence within political and social campaigns to change the status of women. This has included the early American feminist movement of the mid-nineteenth century which, through the campaigns of Amelia Bloomer, directly challenged the inevitability of men being the only gender literally and also metaphorically to 'wear the trousers'.[16] The second wave feminist movement of the 1960s and 1970s took at best a rather disdainful view of fashion. Most writers were of the opinion that fashion objectified women and that it played a key role in reinforcing female stereotypes and therefore female oppression by men. However, a significant shift in feminist thought in the 1980s encouraged new attitudes to sexual pleasure, which were soon translated into new approaches to a range of media connected to female pleasure, including cinema, romantic fiction, make-up and fashionable dress.[17]

Most writing on dress and adornment has until recently focused on the relationship between the female gender and fashion. Furthermore, the majority of writing on men's dress has tended to 'underplay if not deny the phenomenon of men's fashion'.[18] Since the 1980s, however, such assumptions have been challenged, for fashionable consumption has had an equally important role in the formation and expression of male identities. Most research in this area has focused on the period after the second world war, highlighting the role of fashion in men's lives in an era of expanding consumerism. The key debate has been whether this shift was linked purely to new commercial strategies on behalf of marketers, advertisers and retailers, or whether it reflected genuine shifts within mainstream masculinity. Much has revolved around the concept of the 'New Man', a model of caring, nurturing and narcissistic masculinity widely touted in media and advertising of the 1980s. These challenges to the simplistic and all-embracing assumptions that fashion is primarily a feminine pursuit, and that men enjoy a predominantly practical relationship with their clothes, led, in the late 1990s, to a wider re-examination of the historical relationship between men and fashion. This centred principally around a questioning of the theory of the 'Great Masculine Renunciation' proposed by the psychologist J. C. Flugel in 1932. Flugel argued that from the late eighteenth century onwards men renounced any interest in fashion and fashionable display: 'Man abandoned his claim to be considered beautiful. He henceforth aimed at being only useful. So far as clothes remained of importance to him, his utmost

endeavours could lie only in the direction of being "correctly" attired, not of being elegantly or elaborately attired.'[19]

This idea has recently been questioned. For example, Christopher Breward has revealed the previously hidden connections between working-class and lower-middle-class male consumers and fashionable display. Alongside a certain sobriety in male dress of the period there also existed a lively engagement with fashionable novelty and sartorial display.[20] This has led to new perspectives on the relationship not only between men and fashion, but also between men and women and fashion. Due to the binary relationship between gender and dress, changing views on men and masculinities cannot help but affect our views on femininity and feminine engagement with fashion. If fashion cannot be seen as an exclusively feminine domain in the period from the late eighteenth century to the 1950s, then our views on the relationship between women and fashion must change too.

The Fashion System

A focus on the capacity of fashion to encapsulate complex, intangible but highly significant social and cultural meanings can sometimes lead to myopia about the fact that it is also *very* big business. In order to study fashion in any kind of apposite way it is essential to acknowledge that it is a commercial industry and therefore an economic concern. Large fashion companies such as Calvin Klein, Gap and Gucci make huge profits from the precarious business of appealing to consumers' desires for fantasy, self-realisation and the next big thing. How, then, when studying fashion, does one begin to embrace an understanding of both the realities of the fashion business and also its wider social and cultural significance? For a more developed understanding of the complex series of roles that fashion plays within society, the model of the fashion system is a useful starting point. Entwhistle discusses it in the following way:

> Understanding fashion requires understanding the relationship between these different bodies operating within the fashion system: fashion colleges and students, designers and design houses, tailors and seamstresses, models and photographers, as well as fashion editors, distributors, retailers, fashion buyers, shops and consumers . . . without the countless seamstresses and tailors there would be no clothes to consume; without the promotion of fashion by cultural intermediaries, such as fashion journalists, 'fashion' as the latest style would not be transmitted very far; and without the acceptance of consumers, fashionable dress would lie unworn in factories, shops and wardrobes.[21]

This model is particularly revealing as it traces the complex series of interconnecting individuals, institutions and preoccupations potentially involved with

fashion. The fashion system is also useful as it embraces both the positive and neg-
ative aspects of fashion. It allows us to conceive of an industry that shamefully
exploits Asian workers in ugly sweatshops, whilst at the same time creating objects
of great beauty, elegance and charm. This model also provides a good starting point
for thinking about how to study fashion. Although Entwistle's examples mainly
relate to the contemporary fashion system, she also maps out the broad parame-
ters for researching historical fashion, namely design, production, consumption
and social and cultural contexts. Within fashion studies the word 'consumption'
implies the whole sphere of activity connected to the sale of fashion from market-
ing, advertising, distribution and retailing to how the consumer chooses to use or
think about it after purchase.

Roland Barthes (1915–80) undertook the first significant study of the represen-
tation of fashion, or the translation of clothing into language in *The Fashion System*,
which was first published in 1967. In this semiotic analysis of fashion texts in mag-
azines, Barthes provides a detailed interpretation of one specific slice of the fashion
system.[22] However, the term 'fashion system' here embraces wider aspects of the
fashion industry and clothing in everyday use. It is therefore important to examine
briefly some key developments within the fashion industry from the mid-
eighteenth century to the present. This is not an attempt to provide a comprehen-
sive analysis of a vast and complex set of interconnecting developments. It is merely
to highlight how various aspects of the fashion system are shaped by and also help
to shape the wider dynamics of social, economic, political and cultural change. This
also helps reinforce the notion that the study of fashion is a hybrid subject, which
involves consideration of consumption, technology, economics, politics and social
and cultural contexts, as well as the actions of individuals.[23]

From at least the 1750s, fashionable consumption began to shift from being
centred almost exclusively on court society and wealthy merchants, to being a
widespread popular concern. New developments in manufacturing and technol-
ogy also began to impact on the production of fashion.[24] Recent research on
industrialisation has led to a reassessment of classic notions of the Industrial
Revolution, as involving rapid and widespread mechanisation in Britain in the late
eighteenth century. Many industries were in fact slow to mechanise, and the
widespread domination of machine manufacturing within British industry did not
happen until the nineteenth century.[25] However, the fashion textiles industry, par-
ticularly cotton, was rapidly transformed by the introduction of powered machin-
ery in the late eighteenth century. At this time the ready-made clothing trade also
emerged, which initially involved the production of simple, unfitted garments
such as chemises, aprons, caps and sleeve ruffles. Fashionable novelties of this kind
became widely accessible to the middle and lower social classes. This formed part
of an overall expansion of fashionable consumption amongst the middle sections
of society. This was in part facilitated by greater levels of wealth and was also

driven by new, more sophisticated means of distributing, retailing and advertising goods.[26]

The nineteenth century brought further technological changes, enhancing the development of a modern, democratic fashion system. Around the beginning of the nineteenth century the tape measure came into use, which subsequently led to the development of scientific cutting systems. In these systems a certain measure such as the chest is used to calculate others more difficult to measure, such as the curves around the underarm. These advances helped to make standardised patterns and clothing sizes a possibility and, along with the introduction of the sewing machine in the 1840s, greatly contributed to the growth in the mass production of clothing. By the late nineteenth century, the ready-made clothing trade had expanded to involve potentially the entire wardrobe for working-class and lower-middle-class consumers.[27]

Since the early twentieth century, the fashion industry has been increasingly distinguished by its low level of technological development compared to other industries. This is due to the dominance of the individually-operated sewing machine, which remains at the centre of clothing production today.[28] It has also done much to shape the global structure of the contemporary fashion industry, with most production focused in the Far East, where labour costs are cheap, and most design and marketing activities carried out close to the consumer markets of the West.

The relatively backward status of fashion manufacturing stands in marked contrast to the aggressive and innovatory profile of modern fashion marketing and advertising. From the late nineteenth century fashion consumption was further stimulated by the development of increasingly sophisticated marketing, advertising and retailing techniques, as epitomised by the new overwhelmingly luxurious department stores of the era (Figure 5.2).

In *Shopping for Pleasure* Erika Rappaport explores the rise of shopping as a popular leisure activity central to modern conceptions of public life.[29] In the late nineteenth century there was also an expansion in the profile of fashion within a variety of popular media, which had a significant impact on the nature of the fashion industry and the way that consumers engaged with fashion. Increasingly, fashion was not just about clothes; the idealised illustrations offered by fashion magazines became inseparable from the heady experience of fashion as part of daily social life. By the early twentieth century publications such as *Woman's Own*, *Vogue* and *Vanity Fair* offered women regular opportunities to engage with fashion imagery and its potential to provide fantasy, escape or self-realisation.[30] These publications were crucial to the development and promotion of the values of twentieth-century consumer culture, to which new conceptions of beauty, gender, the body and sexuality were integral.

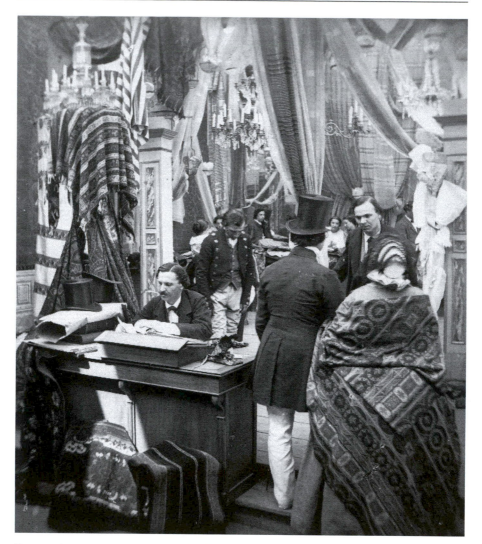

Figure 5.2 – Anonymous photograph of a Parisian drapery store (*ca.* 1860).© Roger-Viollet, Paris.

The Fashion System and Contemporary Fashion Consumption

The model of the fashion system leads away from notions of the fashion industry as an inescapable controlling force that dominates our thinking about our bodies and ourselves. Although the fashion industry and allied media have a powerful and persuasive influence on the public, it is incorrect to assume that people simply swallow wholesale the images, attitudes and actions proposed to them by fashion marketing. For example, Diesel clothing may currently be fashionable, yet few people wear it head to toe or strive to look precisely like the models in the company's

advertisements. Another leading example of how consumers play an active role in the fashion system by contesting the mainstream meanings and values proposed by the fashion industry, is the phenomenon of youth subcultures.

After the second world war, youth subcultures and youth came to be treated as a distinctive social category, as a group with its own tastes, styles and values. Since the 1950s, a host of different youth subcultures have emerged such as teddy boys, mods, skinheads, punks and skaters. These have been characterised by the formation of specific group identities, based not merely on age, but also on sets of values in some way oppositional to mainstream culture and society. They have thus exemplified the potential of dress to express dissidence and social critique. As Celia Lurie argues:

> Youth cultures are thus seen here as the sites of struggles over the control of meaning in a rapidly developing consumer culture, struggles played out in dress, demeanor, music and language. The notion of resistance was central to these early interpretations of youth sub-cultures – style was seen as a form of defiance, political protest or semiotic guerrilla warfare.[31]

However, subcultures are often viewed in a rather romanticised way, as a form of pure or 'authentic' resistance against mainstream social, political and cultural values. This was particularly the case in the early studies of subcultures undertaken in the 1970s, such as Dick Hebdige's *Subculture the Meaning of Style*.[32] A central issue in these debates was the role of the media in relation to youth subcultures. Early writers tended to see the media as having an antagonistic and ultimately destructive influence on subcultures. However, it has been recognised more recently that various forms of media play an integral part in the formation and spread of subcultures. As McRobbie states:

> youth cultures make an explosive entrance into the world of the image and the text through a frenzy of communication, in style, in sound, in posters, fanzines, video, and in flyers and other publicity information. Without all of this and alongside the pretensions of preferring to remain pure and uncontaminated by the media, youth cultures require this kind of self-publicity to provoke the reaction they do.[33]

The relationship of youth subcultures to consumption is also far more complex than has been acknowledged in most texts on the topic. In his analysis of the emergence of *The Face* and *ID* magazines, subsequently termed the 'style press' in the 1980s, Frank Mort identifies a form of youth culture obsessively focused on elite consumption. The close relationships between youth, style, media and consumption are indicative of the fact that 'the history of post-war British youth culture

Figure 5.3 – Corinne Day, *Kate Moss, the Third Summer of Love* (1990). © Corinne Day.

displayed an ongoing association between commerce and popular aesthetics'.[34] In other words, youth culture has always taken place within the sphere of consumption, and sub-cultural, or other youth identities have never existed without some kind of engagement with consumer markets. Lurie takes this argument further by placing youth at the centre of new developments in consumerism and contemporary culture.[35]

The complex links between media, youth cultures and fashion consumption have also had significant, if not transformative, effects on the nature of fashion photography since the late 1980s.[36] In that period Susan Sontag's erudite and oft-quoted statement that 'fashion photography is much more than the photography of fashion' became more apt than ever before.[37] The increasing tendency of fashion photography to display a significant and self-conscious element of social and cultural comment grew out of and was facilitated by earlier groundbreaking developments in magazine publishing. *The Face* and *ID* emerged in 1980 as the first magazines to feature 'street-style' fashion, popular music, political comment and club culture in one publication. In the early years of publication, despite their strong commitment to a focus on style, they had a somewhat distanced relationship from the mainstream fashion industry and from fashion advertising. By the end of the 1980s these magazines began to emerge as the breeding ground for challenging new approaches to fashion photography that were to become firmly established in the 1990s.

The commissioning policies of magazines such as *The Face, ID, Dazed and Confused* and *Dutch* have highlighted the work of a young artistic and cultural elite of fashion designers, photographers, stylists, make-up artists, art directors and journalists. Many of these individuals have taken up the opportunity to make critical comment on contemporary society by raising issues such as racism, drugs, child pornography, violence, death and confused sexual identities through their work. In the 1990s, the neo-realist work of Corinne Day and Davide Sorrenti coexisted alongside aspirational, idealised advertising imagery from firms like Versace and Chanel in the pages of *The Face* and *ID* magazine, thus epitomising the complex and contradictory nature of the relationships between fashion and young people (Figure 5.3). Hence, fashion encapsulates the desires and anxieties connected to consumer culture, yet it may also articulate a refusal of, or challenge to, its inherent values.

Conclusion

Fashion is defined by its ephemerality and constant dynamic of change, whilst at the same time it plays the contradictory role of 'fixing' or grounding our fragile sense of individuality or self-identity. The use of fashionable commodities by consumers to fashion an identity that is attractive or acceptable to others was integral to the development of industrialisation. From the mid-eighteenth century onwards

Figure 5.4 – Nick Knight, Aimee Mullen wearing Alexander McQueen, from *Dazed and Confused* Magazine (1998) © Nick Knight.

fashion became increasingly available to all as a means by which to express, or contest, accepted social norms relating to gender, wealth, status, ethnicity or sexuality. Fashion has been central to the development and promotion of the values of Western consumer culture to which conceptions of gender, beauty, the body and sexuality are integral. However, the objects and images of fashion may also involve potent critiques of mainstream values and ideals. Hence the tendency of some contemporary fashion designers and photographers, such as Alexander McQueen and Nick Knight (Figure 5.4), to use an ephemeral medium to comment on fundamental issues such as death and the vulnerability of the body.

Further Reading

Breward, Christopher. *Fashion* (Oxford, 2003).
Entwistle, Joanne. *The Fashioned Body. Fashion, Dress and Modern Social Theory* (Cambridge, 2000).
Taylor, Lou. *Establishing Dress History* (Manchester, 2004).
Wilson, Elizabeth. *Adorned in Dreams: Fashion in Modernity* (London, 1985).

Notes

1 Elizabeth Wilson, *Adorned in Dreams: Fashion and Modernity* (London, 1985), p. 3.
2 Elizabeth Rouse, *Understanding Fashion* (London, 1989), p. 69.
3 Ulrich Lehman, *Tigersprung: Fashion in Modernity* (Cambridge, MA, 2000), p. 9.
4 Wilson, *Adorned in Dreams*, p. 5.
5 Negley Harte, 'State Control of Dress', in N. Harte and K. Ponting, eds., *Cloth and Clothing in Medieval Europe* (London, 1983), pp. 139–47; Christopher Breward, *The Culture of Fashion* (Manchester, 1995), pp. 54–5.
6 Archer, 'The Arraignment of Lewd, Idle, Froward and Unconstant Women,' cited in Christopher Breward, *The Culture of Fashion*, pp. 91–2.
7 Thorstein Veblen, *The Theory of the Leisure Class: An Economic Study of Institutions* (New York, 1899).
8 Editorial in *The Face*, August 1997, p. 18.
9 See Joanne Entwistle, *The Fashioned Body: Fashion, Dress and Modern Social Theory* (Cambridge, 2000); and Lou Taylor, *The Study of Dress History* (Manchester, 2003).
10 Fred Davis, *Fashion, Culture and Identity* (Chicago, 1992), p. 16.
11 Entwistle, *The Fashioned Body*, pp. 115–16.
12 Georg Simmel, 'Fashion', in D. Levine, ed., *On Individuality and Social Forms* (London, 1971).
13 Lehman, *Tigersprung*, pp. 6–8.
14 Norbert Elias, *The Civilising Process* (New York, 1978); Pierre Bourdieu, *Distinction: A Social Critique of the Judgement of Taste* (Cambridge, MA, 1984).
15 Elizabeth Wilson, 'Fashion and the Postmodern Body', in Juliet Ash and Elizabeth Wilson, eds, *Chic Thrills* (London, 1992), p. 6.
16 Entwistle, *The Fashioned Body*, p. 164.
17 See Jane Gaines, 'Introduction: Fabricating the Female Body', in J. Gaines and C. Herzog, eds, *Fabrications: Costume and the Female Body* (London, 1990), pp. 5–7.
18 Jennifer Craik, *The Face of Fashion* (London, 1993), p. 176.
19 John Carl Flugel, The *Psychology of Clothes* (London [1931], 1966), pp. 110–11.

20 Christopher Breward, *The Hidden Consumer: Masculinities, Fashion and City Life 1860–1914* (Manchester, 1999).

21 Entwhistle, *The Fashioned Body*, p. 1.

22 Roland Barthes, *The Fashion System* (London, 1985). See too Paul Jobling, *Fashion Spreads: Word and Image in Fashion Photography Since 1980* (Oxford, 1999), pp. 65–83.

23 Ellen Leopold, 'The Manufacture of the Fashion System', in Juliet Ash and Elizabeth Wilson, eds, *Chic Thrills* (London, 1992), pp. 110–15.

24 Beverly Lemire, 'Developing Consumerism and the Ready-made Clothing Trade in Britain, 1750–1800', in *Textile History,* Vol. 15, No. 1 (1984), pp. 21–44; John Brewer and Roy Porter, *Consumption and the World of Goods* (London, 1993).

25 Maxine Berg, *The Age of Manufactures 1700–1820: Industry, Innovation and Work in Britain* (London, 1994).

26 Beverly Lemire, 'Developing Consumerism and the Ready-made Clothing Trade in Britain, 1750–1800', in *Textile History,* Vol. 15, No. 1 (1984), pp. 21–44; John Brewer and Roy Porter, *Consumption and the World of Goods* (London, 1993); Breward, *The Culture of Fashion,* p. 110.

27 Lemire, 'Developing Consumerism and the Ready-made Clothing Trade'; Christopher Breward, 'Manliness, Modernity and the Shaping of Male Clothing,' in Joanne Entwhistle and Elizabeth Wilson, eds, *Body Dressing* (Oxford, 2001), pp. 165–81.

28 Ellen Leopold, 'The Manufacture of the Fashion System', in Juliet Ash and Elizabeth Wilson, eds, *Chic Thrills,* pp. 110–15.

29 Philippe Perrot, *Fashioning the Bourgeoisie: A History of Clothing in the Nineteenth Century* (Princeton, NJ, 1994), pp. 58–79; Erika Rappaport, *Shopping for Pleasure: Women in the Making of London's West End* (Princeton, NJ, 2000).

30 Christopher Breward, *Fashion* (Oxford, 2003), pp. 115–27.

31 Celia Lurie, *Consumer Culture* (Cambridge, 1996), p. 197.

32 Dick Hebdige, *Subculture: the Meaning of Style* (London, 1979).

33 Angela McRobbie, *Postmodernism and Popular Culture* (London, 1994), p. 214.

34 Frank Mort, *Cultures of Consumption: Masculinities and Social Space in Late Twentieth-Century Britain* (London, 1996), pp. 27–8.

35 As Lurie states, 'the stylization of consumption is in large part the outcome of creative practices by young people'. Lurie, *Consumer Culture* (Cambridge, 1996), p. 197.

36 Charlotte Cotton, *Imperfect Beauty: the Making of Contemporary Fashion Photographs* (London, 2000), p. 6.

37 Susan Sontag, 'The Avedon Eye', in British *Vogue* (December, 1978), pp. 104–7.

6. Photography and Film

Glyn Davis

Introduction

Photographic and cinematic technological advances continue to occur at a rapid pace. Digital forms of image capture, for instance, have planted a firm foothold in the Western cultural sphere and elsewhere, with films shot on digital video – such as *ivansxtc* (2000) and *This is Not a Love Song* (2002) – screening in cinemas, older forms of film stock such as 16 mm heading towards obsolescence, and the cost of 'home entertainment' digital cameras constantly dropping. Indeed, filmic and photographic technology is now widely available, accessible at fairly affordable prices. This ubiquity – which engenders a 'point and click' culture in which a large percentage of the world's population has access to the means of image production – problematises any attempts to identify 'artistic' examples of film and photography. For if taking photographs and making movies are now open to many, identifying the markers of photographic or filmic 'art' becomes increasingly difficult. This chapter introduces a range of specific questions that have been, and continue to be, debated about the 'artistic' nature of photography and cinema, in the process highlighting the difficulties of attempting to make concrete claims regarding either medium. Taking them in the chronological order of their development, the first half of the chapter examines photography, the second cinema.

Photography: The Artist's Tool?

Many fine artists since the development of photography in the first half of the nine-teenth century have used photographs as records to assist them, aids to the process of working in stone, on a canvas, and so on. To take just one example, Eugène Delacroix used photographs of a nude female model as a visual tool when painting his 1857 *Odalisque* (Figure 6.1).

Similar records of working practice exist for Paul Gauguin, Edgar Degas, Paul Nash and many others. For some critics, writing in the mid-1800s, this was a fair use of the camera: photography could not be seen as an emergent art form, but merely a mechanical recording device. Sir William Newton, for instance, in the inaugural issue of the *Journal of the Photographic Society of London*, published in 1853, argued that the limited types of images that could (at that time) be produced by photographers militated against the medium's artistic status. Indeed, he suggested that only images that were purposefully out of focus, or that had been tinkered with in the darkroom, might stake some claim to an 'artistic impulse'. Otherwise, photographs were best conceptualized as an artist's tools:

> I do not consider it necessary that the whole of the subject should be what is called *in focus*; on the contrary, I have found in many instances that the object is better obtained by the whole subject being a little *out of focus*, thereby giving a greater breadth of effect, and consequently more *suggestive* of the character of nature. I wish, however, to be understood as applying these observations to artists only, such productions being considered as private *studies* to assist him in his compositions . . .[1]

Despite such scepticism, photography was admitted into gallery spaces fairly swiftly: photographs appeared in the 1859 Paris Salon, for instance. However, many of the photographic images attempting to attain artistic credibility for the medium were 'High Art' photographs – a specific form of photograph that had scorn heaped upon it by contemporary commentators such as Charles Baudelaire. As Mary Warner Marien writes:

> High Art photographs blended theatre, printmaking, and painting with photography. Actors or other players were posed singly or in a *tableau vivant*. Interestingly, specific paintings were only occasionally replicated in High Art photography. For the most part, these images rendered original conceptions, illustrating religious or moral precepts often in the manner of maudlin genre painting and popular Victorian prints. By partaking in the established didac-tic function of the fine arts, High Art photographers attempted to skirt objec-tions to the medium's inartistic verisimilitude.[2]

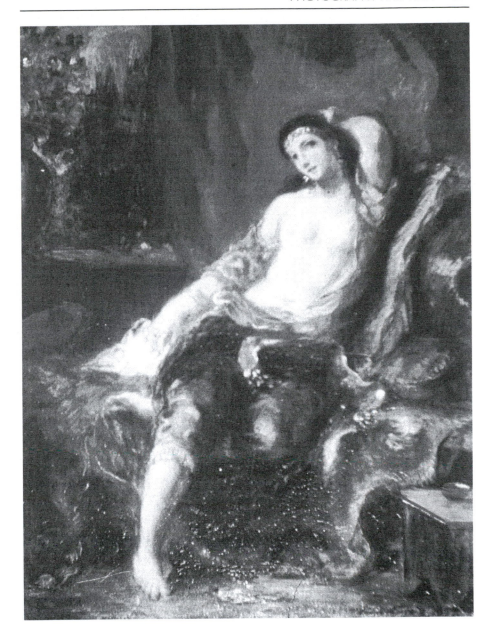

Figure 6.1 – Eugène Delacroix, *Odalisque* (1857). Private collection.

Although 'High Art' photographs tried to display some of the key characteristics of fine art, they tended to resemble little more than painters' photographic studies. Their pale imitation of artistry failed to capitalize on the specific characteristics of photography as a medium.

Photography and Painting

Throughout photography's history, the artistic status of individual images has often been judged according to criteria drawn from the critical discourses used to evaluate painting. Terms such as 'tone', 'composition', 'contrast', 'framing' and 'texture' recur in comments on the work of specific photographers. In one sense this is understandable: due to its extensive history, painting has long remained the yardstick by which all still, framed images tend to be measured, and many of the critical terms used *can* be applied to both media. Relating photographs to the realm and lineage of fine art may also result in the attribution of 'artistry' to the work of particular photographers – thus according (to some degree) a 'respectable' status to the medium.

The work of some photographers can clearly be compared with, or related to, specific fields of fine art practice: these images may thus be more open to interpellation as 'art'. For instance, the photographs of Bill Brandt include a large number of studies of nudes shot in a surrealist fashion. Resembling the distortions of fairground mirrors, these pictures position women's bodies – and the camera – in such a way that specific facets of the body seem to swell in size: a hand and forearm loom across a table in front of a passive sitter; the curve of a buttock monopolises the framed space. In a related manner, the decision of respected artists to use photography as a facet of their working process may also help in raising photography to the critical status of fine art. David Hockney's photomontages, for example, build complete collaged images from photographic fragments. The photographs provide the completed pieces of work with a glossy texture – a shine arguably appropriate for the pictures of cinematic American landscapes and city spaces that Hockney has produced utilising this method.

Such uses of photography, however – in relation to established art movements or as a tool available for use by known artists – fail to acknowledge the characteristics that mark photography as a distinct medium. Exploitation of *these* can result in striking imagery no other medium is capable of producing, requiring evaluation *as* photographs. Moreover, if the critical terminology and discourses available for such evaluation remain somewhat limited, still at an immature stage in their evolution, this is due to the persistence of photography's historical positioning as fine art's lesser relative.

One of photography's key characteristics is its ability to capture instantaneous, fleeting moment; exposure times have been calibrated in fractions of a second since the 1880s. Not only can photography reveal details imperceptible to the human eye – the movement of a bullet as it passes through an apple in Harold Edgerton's famous image (Figure 6.2), or the splash of fluid as a droplet hits a placid surface – it may also capture symbolic, significant events in a manner beyond painting, for instance, due to its necessarily lengthy production time.

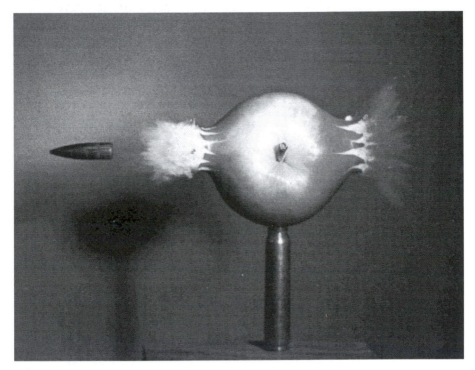

Figure 6.2 – Harold Edgerton, *Shooting the Apple* (1964). Photograph courtesy of Gus Kayafas and Palm Press.

Photographs of the Hindenburg disaster at Lakehurst in 1937, for example, document the spectacular fire and fury of the airship's destruction, while Robert Capa seemingly captured the moment of death of a soldier fighting in the Spanish civil war in 1936.[3]

Indeed, photography's documentary capacities are, as Francis Frith noted in 1859, among the medium's 'chief peculiarities':

> It is an attribute, to which, we believe, there is, in the whole range of Art, no parallel; to whose uses and delights we can assign no limits, and shall, of course, not attempt to enumerate them. . . . We protest there *is*, in this new spiritual quality of Art, a charm of wonderful freshness and power, which is quite independent of general or artistic effect, and which appeals instinctively to our readiest sympathies. Every stone, every little perfection, or dilapidation, the most minute detail, which, in an ordinary drawing, would merit no special attention, becomes, on a photograph, worthy of careful study.[4]

Certainly, the ability of photography to capture swiftly a record of a person's physiognomy and appearance, or to document a specific landscape, was quickly

recognised as one of the medium's strengths. It has often been argued that artists, accustomed to producing paintings of landscapes and portraits of sitters, among other subjects, were liberated from their role as recorders of visual reality. The invention of photography allowed painters to diversify and experiment.

In recent years, the idea of the photograph as impartial document – indeed, documentary's 'rhetoric of immediacy and truth' – has been subjected to sustained interrogation by critics. As John Tagg has argued, for example, photographs are deeply enmeshed within the society that produced them; even apparently 'objective' images, such as police identity photographs or medical records, are informed by the systems of power and representation that produce them.[5] Likewise, historical photographs now look unavoidably 'dated' and 'aged', due to a combination of factors including camera technology, film stock and the aesthetic and intellectual preferences of the time in which they were taken. Photography's position as marker of authenticity, as evidence, is thus often approached sceptically. Readers question the truth-value of photographs that appear in newspapers and magazines, but paradoxically this has not undermined the use of photography as a medium of reportage, creating or capturing images of people and places.

It is perhaps no surprise that among the most renowned contemporary photographers there is a large number of individuals who work predominantly in the field of portraiture: David LaChapelle, Annie Leibowitz, Mario Testino, Bruce Weber. Each has a recognisable style: LaChapelle, for instance, stages gaudily coloured scenarios inflected with a pop sensibility, often placing his models in provocative poses. And yet the status of these photographers *as artists* is open to dispute: their pictures circulate widely in the press and in magazines. Leibowitz regularly shoots for *Vanity Fair*, Testino for *Vogue*, Weber for *Interview*, and this mass availability interferes with the purported non-reproducibility and the often desired uniqueness of art. Even blowing up some of these photographs to gigantic sizes, as occurred with some of Mario Testino's images in an exhibition held at the National Portrait Gallery in London and the National Gallery of Modern Art in Edinburgh in 2003 – as though it is an artwork's sheer size that commands cultural respect – cannot entirely transmute them into art.

The Photographer as Artist

Images produced by portrait photographers such as Testino are often commissioned – and thus, potentially, 'tainted' by commercialism. Indeed, Testino's pictures of wealthy, beautiful people dressed in expensive clothing can seem to flaunt overtly a celebration of materialism. In contrast, the artist-photographer, it is often assumed, is driven by different imperatives: the desire to make a statement, raise awareness, promulgate a specific message, to enlighten and enhance the lives of

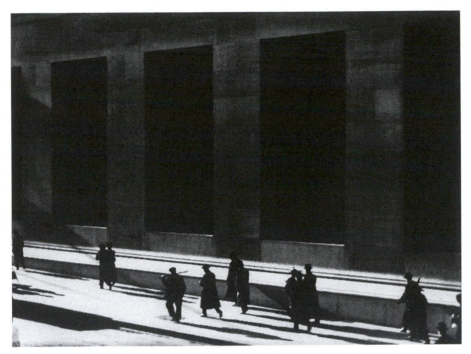

Figure 6.3 – Paul Strand, *Wall Street* (1915). Philadelphia Museum of Art: Gift of the Paul Strand Foundation. © Aperture Foundation Inc., Paul Strand Archive.

those who come into contact with the developed prints. In other words, what makes a photographer an artist is, perhaps, the *intention* of the snapper. This idealistic model of the artist-photographer is neatly encapsulated by Graham Clarke, in a discussion of the images of Paul Strand. Clarke describes photography, according to this paradigm of artistry, as

> a revelatory process in which the photographer, through the camera, lifts the subject out of a historical context into its potential ideal condition. The photographer does not record, he creates, and the material world is, effectively, no more than the outward manifestation of a spiritual other waiting to be discovered. The photographer is a seer, with all that implies in relation to a romantic tradition based on the artist as inspired philosopher who transforms a dull literal reality into something new and ideal.[6]

Thus, Paul Strand's 1915 image of Wall Street in New York (Figure 6.3) is both aesthetically pleasing and politically charged. Workers scuttle across the bottom of the frame, low sunlight stretching their shadows into dramatic diagonal smears; above the human figures towers an imposing bank, an edifice to the status and power of capitalism. The image is harmonious and neatly balanced,

verging towards the abstract in its composition. And yet it also has a comment to make regarding the position of the human subject in relation to the financial imperatives driving the modern world: Wall Street, a global symbol of monetary might, dwarfs the nameless and faceless individuals exiled to the lower limits of the image.

The segregation of 'art photographers' from 'commercial photographers' is, of course, a false one: to some extent, the pictures produced by both groups are intended to make money. And yet, throughout photography's history, a drive to divide up photographers into specific sub-groups has often surfaced, each population identified by markedly different aims and desires. For example, as Nicholas Mirzoeff identifies, Ernest Lacan, writing in 1852 in the photography journal *La Lumière*,

> sub-divided photographers into four classes, corresponding to social class: the basic photographer (working class or artisan); the artist-photographer (bourgeois); the amateur, in the sense of connoisseur, hence aristocrat; and the distinguished photographer-savant, who claimed the classless status of the artist. Thus those who saw themselves as the photographic elite argued that 'legitimate photography' was that which could be identified as belonging to a specific place, time and class.[7]

Although the boundaries are increasingly blurred, this attempt at division continues today: art photographers tend to be segregated from commercial photographers, images by the latter rarely appearing in galleries or photography journals. In addition, there is a separate realm of 'amateur photographers' – consumers of monthly publications that explore the techniques of taking photos, a group that could be seen as photography's equivalent of the 'Sunday painters'. And then there are the rest of us – camera owners, with some degree of technical proficiency, whose image production and circulation occur solely at the local level. That this hierarchy exists is evidence of the critical need to categorise the users of a specific creative tool into recognisable groups; what is difficult to discern is exactly *who* works to maintain this specific hierarchy.

Certainly, art dealers, gallery curators and so on play a significant role in attributing artistic status to the work of specific photographers. Richard Billingham's pictures of his parents, taken in their cramped, filthy council flat – overweight mother dressed in a thin nightdress, engrossed in a jigsaw; thin father, face creased with lines (Figure 6.4) – sit on the cusp between 'family snaps' and socially motivated documentary images of working-class life in Britain.

And yet these images appeared in the *Sensation* exhibition of young British Artists (or 'yBAs') held at the Royal Academy in London in 1997, which led to Billingham's work being discussed in relation to that of Damien Hirst, Tracey

Figure 6.4 – Richard Billingham, *Untitled* (1995). © Richard Billingham. Photograph courtesy of Anthony Reynolds Gallery, London.

Emin, Sarah Lucas and others. Billingham, self-effacingly, has claimed that the pictures are simply 'snaps of his folks'; he followed these images, however, with a series of bucolic landscape photographs, suggesting his desire for his photography to be taken seriously as art.

Film as Art: Realism versus Fantasy

Throughout the brief history of cinema – its birth is usually dated to 1896 with the screening of images captured by the Lumière brothers – arguments regarding the medium's artistic status have regularly resurfaced. One of the central axes around which such discussions have revolved concerns cinema's *ideal form*; as with similar debates over painting, a variety of commentators have claimed cinema's defining characteristics proscribe both what film is *for* and the *form* it should take. On the whole, these arguments tend to propose *either* that cinema should be a conduit for realistic types of representation, *or* that it should aim to produce fantasy narratives.

As cinema is rooted in photographic technology, projecting a succession of still frames at such a rapid rate that the human eye perceives the illusion of motion – a trick of perception known as 'the persistence of vision' – the potency of film arguably lies in its ability to capture and re-present what is placed in front of the recording camera. That is, as with photography, cinema's aptitude for documenting the real may be its key characteristic – the feature from which it derives its force. Certainly, there are (possibly apocryphal) reports of early cinema audiences watching Lumière brothers footage of a train arriving at a station and running from the auditorium in fear that the vehicle was about to career into them. Whether or not these stories are true, they attest to the power that has often been attributed to cinema's documentary capacities.

An alternative perspective on this topic argues that film, due to its temporal unfurling, its intimate connection to the passage of time, is an inherently narrative medium. Cinema should be used to tell stories: in order to make best use of the medium's capacities, it should be utilised for the transmission of fantastical (and other) tales. In this regard, it is worth noting that probably the most important contemporary of the Lumière brothers was Georges Méliès, also a Frenchman, whose short films used trick effects (time-lapse, multiple-exposure and so on) and elaborate staging and set design to relate imaginative yarns. The lasting impact of Méliès' *Voyage to the Moon* (1902) is marked; the film provided cinema history with one of its most enduring and iconic images – a grinning, winking moon (Figure 6.5).

These two opposing modes of conceptualising the purpose of cinema, realism versus fantasy – both in place, notably, at the inauguration of the medium – have been adopted and developed by a range of writers and filmmakers over the past century. Perhaps most famously, André Bazin (1918–58) – the author of numerous essays on cinema, and the co-founder of the French film journal *Cahiers du Cinéma* – claimed that cinema's force was allied to its documentary potential. In his writings, Bazin argued in favour of film directors whose shooting methods produced footage that approached or approximated reality, and whose style resembled, or made use of, the specificities of human vision. Thus, Bazin praised Italian neo-realist directors such as Roberto Rossellini for filming on the postwar, rubble-

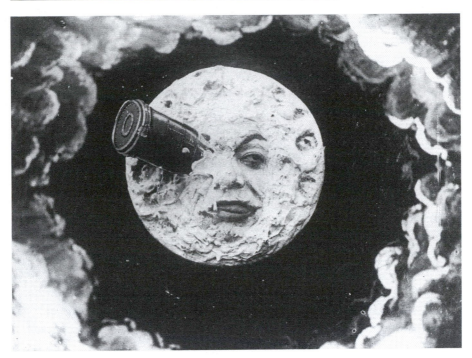

Figure 6.5 – Still from Georges Méliès' *Voyage to the Moon* (1902). © BFI stills.

strewn streets of Rome and other cities. He also eulogised Gregg Toland's contri-
butions to *Citizen Kane* (1941) – Toland developed a 17 mm camera lens for shoot-
ing Welles' film, which more closely approximated the curve of the human eye than
the 16 mm industry standard. Bazin exalted both the lengthy take and the long shot;
with the latter, he claimed, the spectator's eye must rove around the cinema screen,
in a simulation of 'real' vision, searching for the most relevant or important facets
to latch onto.[8] Although he died before they were made, Bazin would thus perhaps
have been a fan of several of Robert Altman's films, such as *M*A*S*H* (1970) and
Nashville (1975), with their long takes, overlapping dialogue and rejection of con-
ventional narrative form. And yet there are problems with Bazin's support of the
realist model of cinema. Revisiting Bazin's arguments from the perspective of the
present, it is notable that many of the films he praised for harnessing cinema's
powers of realism now seem hopelessly staged and melodramatic – Roberto
Rossellini's films, for instance, often resorted to using a syrupy orchestral score
that undercut the verisimilitude of some of their images.

 Bazin contrasted his own belief in the power of the realistic image with the films
and opinions of the Russian formalist Sergei Eisenstein. The director of *Strike*
(1925), *Battleship Potemkin* (1925) and *October* (1927), among others, Eisenstein
argued in favour of manipulating film stock through editing: for him, the creative
potential of cinema as a medium could be properly expressed only through the

directorial assemblage of shot footage. For Eisenstein, cinematic montage was a predominant concern: he believed that the disjunctive juxtaposition of specific shots caused spectators to forge a meaning from the fragments – a meaning not inherent in the images themselves.[9] Thus, in *October*, a senior official's vanity is exposed by intercutting images of the man with shots of a peacock. Similarly, in a sequence from *Battleship Potemkin*, several shots of stone lions (lying down, starting to rise, fully alert) follow on from the infamous Odessa Steps battle sequence: the intimation deduced by the spectator is that the lions symbolise the political awakening of the Russian peasantry. For Bazin, such montage editing was manipulative, almost heretical, interfering with film's ability to capture, unexpurgated, the wonder of God's world (Bazin was a very religious man); for Eisenstein, it constituted and encapsulated the true power of cinema.

Debates regarding cinema's relationship to reality and fantasy – and pertaining to cinema's 'true form', to what could be called 'pure cinema' – have not disappeared. Indeed, to take just one example, they can be seen to underlie the criticisms of Hollywood film raised by the Dogme film movement. Dogme – initiated by the Danish filmmakers Thomas Vinterberg and Lars von Trier in 1995 – outlined a ten-point programme for making movies, a manifesto that attempted to strip away the artifice of Hollywood. Only natural light and sound were to be used; cameras had to be hand-held; optical trickery was not allowed; only diegetic sound and music could be employed. Films produced according to this agenda – an agenda that continues to attract devotees – include Vinterberg's *Festen* (1998), Von Trier's *The Idiots* (1998) and Harmony Korine's *Julien Donkey-Boy* (1999). As Vinterberg has stated, highlighting Dogme's preference for a realist model of cinema:

> We wanted to seek a moment of truth, not provoking it too much, not involving our own tastes; just to see what happens between actors when we put them in this situation. Still it is fiction, we've got the script, we've got the casting, we say 'action', we say do this and that, but we try and see ourselves as regarding, and not directing too much, if you understand. So it is like a reaction against the auteur thing . . .[10]

Auteurism

In the search for film art, the attribution of authorial intention and creativity to specific contributors to the filmmaking process is often attempted, with certain individuals isolated as making more significant contributions than others. Crucially, it is now largely taken for granted in both popular and critical discourse that the person responsible for a film's contents and aesthetics is its director. Further, from the large number of directors presently working, only a small percentage of those are deemed to be 'artists', or 'auteurs', worthy of comment; this is, to some

extent, why Ridley Scott's name is well known, but the director of, say, *Bulletproof Monk* (2003) is unheralded.[11]

The term 'auteur' originated in France in the 1950s in the writings of the journalists for *Cahiers du Cinéma*. Many of these authors – such as Jean-Luc Godard, François Truffaut and Eric Rohmer – eventually became filmmakers in their own right. The 'politique des auteurs' developed by the journal's critics was rooted in two crucial arguments. First, they claimed that French cinema had become stagnant in contrast to that of America, dependent on dull, stodgy adaptations of literary texts: American cinema, it was argued, was qualitatively *better*, more *cinematic*. Second, the postwar glut of American films – held back during the war, then screened *en masse* in France in a tidal wave – enabled viewers to watch several John Ford westerns in one sitting, or a number of Howard Hawks films. The *Cahiers* critics noticed that some directors working in Hollywood were able to stamp their own identity into the films they worked on: over several different films, the trace of the director was evidently present, most obviously identifiable in relation to surface *style*. These directors were labelled 'auteurs' and contrasted with more 'artisanal' directors, termed 'metteurs-en-scène'.

These terms of debate were subsequently picked up, argued over and refined by a number of critics in other countries. The British author Ian Cameron, for instance, writing in the magazine *Movie*, criticised the 'politique des auteurs' for prioritising the input of the director over that of the hundreds of other individuals – from set designers to costumiers, cinematographers to hairdressers – who contributed to a finished Hollywood film.[12] This remains a significant concern: film scriptwriters are largely unknown, for example, a fact that is only partly explained by cinema's visual impact. In contrast, the American critic Andrew Sarris attempted in the journal *Film Culture* to apply pseudo-scientific methods of investigation to the practice of film production: he drew up tables and graphs, and constructed lists of 'the best directors' – in the process, inadvertently managing to reveal the subjective nature of ranking 'film artists'.[13] More recently, the film theorist Timothy Corrigan has argued that the 'auteur' is simply a useful marketing tool for Hollywood, a valuable device for seducing audiences into cinemas.[14] Certainly, this helps to explain why Quentin Tarantino was predominantly used to promote *Kill Bill: Volume 1* (2003), rather than the film's lead actress, Uma Thurman; and why Francis Ford Coppola's name was so prominently featured on posters for the horror film *Jeepers Creepers* (2001), of which he was the executive producer.

On the whole, debates about auteurism have focused on Hollywood cinema. Due to the overwhelmingly industrial nature of Hollywood film production – the preponderance of genre movies, sequels churned out due to their lucrative box office return, stars paid exorbitant fees in proportion to their audience draw, a preoccupation with 'opening weekend' figures – the possibility of any individual 'making their mark' can seem miraculous. And yet there *are* directors working within

Hollywood who have distinctive authorial styles – Paul Thomas Anderson, Michael Mann, M. Night Shyamalan, John Woo. The latter serves as a useful example: Woo's handling of generic action material – *Hard Target* (1993), *Broken Arrow* (1996), *Face/Off* (1997), *Windtalkers* (2002) – does not prevent him from inserting his own preoccupations and favoured symbolism. In almost every Woo film, for instance, there can be found: a slow-motion gun battle, choreographed like a ballet; imagery of doves taking flight; a hero and villain firing weapons through a wall separating them from each other, with the wall placed in the dead centre of the frame; Christ-like poses adopted by key protagonists. However, these directors are rare examples: on the whole, Hollywood cinema is usually seen as faceless, repetitive, mass-produced, made solely for the purpose of 'entertainment' rather than any higher or alternative aim. Of course, it should also be noted that the studios may occasionally produce 'prestige pictures' such as *Monster's Ball* (2001) and *The Hours* (2002) – that is, the sort of films that are awarded Oscars and used to justify claims for Hollywood as a respectable cultural institution. However, for substantial traces of artistry in cinema, it is perhaps most useful to look beyond the confines of the 'dream factory'.

Art Cinema

Outside Hollywood's powerful 'vertically integrated' system of film production, distribution and exhibition, in which Hollywood product ends up being shown to mass audiences in cavernous multiplexes also owned by the studios, there is an alternative scheme. Smaller companies (such as Metro Tartan) distribute non-Hollywood films ('independent' American cinema, 'foreign language' titles) to 'art house' exhibition venues, attracting less sizeable audiences. On the whole, these films lack the trappings of Hollywood: enormous budgets, overpaid stars, a reliance on digital trickery, generic storytelling, huge crews. They also have identifiable formal characteristics that differ from those of Hollywood films.

The distinctions between Hollywood cinema and 'art films' were clearly articulated in the late 1970s and 1980s by David Bordwell and Steve Neale, and the terms of debate they outlined remain dominant conceptualizations even today. As Julian Petley notes, the term 'art cinema' was used by Bordwell and Neale to refer

> to films such as those of the French new wave, the New German Cinema, Bergman, Antonioni, Fellini, Kurosawa, Ray (Satyajit not Nicholas) and the like, but it was also employed retrospectively to denote such disparate cinematic phenomena as Italian neo-realism, German silent cinema, the Soviet classics, and the pre-war French cinema, from *films d'art* through surrealist works such as Germaine Dulac's *La Coquille et le clergyman* (1928), Buñuel's *Un Chien Andalou* (1928) and *L'Âge d'Or* (1930) to the *oeuvres* of Cocteau, Renoir, Carné, Prévert and others . . .[15]

Clearly, 'art cinema' is largely a director's cinema. The preponderance of names listed by Petley highlights a crucial distinction between Hollywood and 'art cinema'. Although the occasional auteur may leave their mark on films produced for American studios, 'art film' is more evidently the work of its directors. Working with smaller crews enables more control over the finished product; the commercial imperative is not as marked, enabling directors (who may also have written the scripts) to explore their concerns and preoccupations with less interference.

Art cinema is also evidently a form of filmmaking with some affiliations to already established fields of artistic practice, such as fine art – fields, in fact, which confer art film with a degree of cultural legitimacy. Thus, instances of Dada and surrealist cinema – from Salvador Dali and Luis Buñuel's work to, perhaps, many of the films of David Lynch – are discussed in relation to the traditions of surrealist painting and sculpture; similarly, the cinema of the German Expressionists (Robert Wiene, Fritz Lang, F. W. Murnau, and others) produced during the 1920s and 1930s is compared with, and connected to, Expressionist painting of the same era. Andy Warhol's films – many of them, by his own admission, unwatchably dull – are taken seriously due to his status as an artist. Indeed, when fine artists 'try their hand' at making movies, expectations are high and often disappointed: Robert Longo's *Johnny Mnemonic* (1995) and Cindy Sherman's *Office Killer* (1997) were both critical and box office disasters.

Perhaps most significantly, however, David Bordwell claims that the content and form of 'art cinema' are distinct from those of 'conventional' Hollywood cinema – that is, from what is often referred to as the 'classical realist text'. It may thus appeal only to an elite audience looking for an alternative to the generic mainstream. Art films might, then, display the following characteristics: an interest in social, cultural and political problems such as unemployment and poverty, as in the Dardennes brothers' *Rosetta* (1999); an 'objective', 'truthful' representation of characters and geographical locations, such as the depiction of life in the Scottish coastal town Oban, and the unpredictable actions of the heroine, in Ramsay's *Morvern Callar* (2002); open-ended narratives; the use of certain formal flourishes, such as the long take, used rather extravagantly in *Japón* (Reygadas, 2002), for instance; a preference for autobiography, as in many of the films of Nanni Moretti, or self-reflexive narration.[16]

Of course, dividing the world of cinema into 'Hollywood' and 'art film' is sweeping and reductive. Such an attempt at categorisation neglects the extent to which many countries (including France and, most obviously, India) produce popular, generic cinema modelled on the template of Hollywood examples. It also ignores the significant amount of Hollywood theft of 'art cinema' stylings that occurs; the French new wave 'jump cut', for instance, is now an accepted part of American studio films' language. Exhibition is no longer as clear-cut as it once was: multiplexes in Britain may now regularly show foreign language titles, and regional

film theatres, in order to stay financially solvent, may have to screen studio block-busters. 'Independent' American cinema, as the film critic Kim Newman has observed, has become almost impossible to identify.[17] And the spread of DVD technology seems to be inaugurating a new system of film connoisseurship – one crucially that erodes the boundaries between 'mainstream' and 'art house' films and their audiences – in which the plethora of extra information packed onto discs provokes an enhanced interest in moving image culture.

And yet, of course, the 'mainstream/independent', 'art house/multiplex', 'mass/elite audience' divisions continue to influence general understandings of the field of cinema. Such is the dominance of Hollywood that it is necessary to concep-tualise a space outside, or beyond the clutches of, the machinations of the studios: this 'space' is often given the label 'art film'. As Petley argues:

> However difficult it may be to define art cinema in positive terms, that is, to say what it actually is, it is relatively easy to define it negatively as simply being 'not Hollywood' or even 'anti-Hollywood'. . . . It may be, then, that art cinema is best conceptualized not as a certain historical period of mainly European output . . . nor as a directorial canon, nor as a set of distinctive sub-jects and styles, but, as Tom Ryall has suggested, as an institution in which certain films are 'assigned a position within the general film culture and are defined in terms of a particular mode of consumption'.[18]

Conclusion

As was noted at the beginning of this chapter, photographic and filmic production is becoming increasingly digital. This brings notable benefits to the users of the technology: digital cameras can store more material, the editing out of low-quality material can be done inside the device, and so on. For the artist-photographer, pix-ilation reduces the captured image to thousands of tiny fragments, each capable of manipulation. That is, the digital photograph can, arguably, be said to resemble a painting: it can be worked on within a computer, using an array of specific tools, before the final image is complete. This removes photography from its hallowed position as a documenter of facts. As a relatively new field of image production, the implications of these developments for photography as an art form remain to be seen.

For cinema, the proliferation of digital effects also complicates discussions of film artistry. If a film is shot digitally, with every frame open to digital manipulation, 'real' footage begins to blur with the realm of digital animation. The latter has itself swiftly become the dominant method of industry animation, replacing the hand-drawn variety in films such as *Finding Nemo* (2003). The addition of computer-

generated imagery may enhance realism – James Cameron gave 'cold breath' to his characters on the prow of the *Titanic* (1997) – or to envisage and bring to life fantastical creatures – as in Peter Jackson's *Lord of the Rings* trilogy (released in 2001, 2002 and 2003). Such is the pace of development in this field, that a critical language capable of assessing its form and impact is yet to be fully developed.

Further Reading

Clarke, Graham. *The Photograph* (Oxford, 1997).
Hollows, Joanne and Jancovich, Mark, eds. *Approaches to Popular Film* (Manchester, 1995).
Lemagny, Jean-Claude, ed. *The History of Photography* (Cambridge, 1986).
Stam, Robert. *Film Theory: An Introduction* (Oxford, 2000).

Notes

1 William Newton, 'Upon Photography in an Artistic View, and its Relation to the Arts', in Charles Harrison, Paul Wood and Jason Gaiger, eds, *Art in Theory, 1815–1900: an Anthology of Changing Ideas* (Oxford, 1998), p. 653.
2 Mary Warner Marien, *Photography and its Critics: A Cultural History, 1839–1900* (Cambridge, 1997), p. 87.
3 It is worth noting that there are allegations that the image may have been faked.
4 Francis Frith, 'The Art of Photography', in Harrison, Wood and Gaiger, *Art in Theory*, pp. 663–4.
5 John Tagg, *The Burden of Representation: Essays on Photographies and Histories* (London, 1988).
6 Graham Clarke, *The Photograph* (Oxford, 1997), p. 170.
7 Nicholas Mirzoeff, *An Introduction to Visual Culture* (London and New York, 1999), p. 72.
8 See André Bazin, *What is Cinema? Volume 1* (Los Angeles, 1967).
9 See Sergei Eisenstein, *The Film Sense* (London, 1943).
10 Thomas Vinterberg, quoted in Wendy Ide, 'No Lights, One Camera, Action', in *Dazed and Confused*, No. 52 (March 1999), p. 67.
11 For those concerned to know, the man responsible was Paul Hunter.
12 Ian Cameron, 'Films, Directors and Critics', in John Caughie, ed., *Theories of Authorship* (London, 1981), pp. 50–8.
13 Andrew Sarris, 'Notes on the Auteur Theory in 1962', in Gerald Mast and Marshall Cohen, eds., *Film Theory and Criticism: Introductory Readings* (New York, 1974), pp. 500–15.
14 Timothy Corrigan, *A Cinema without Walls: Movies and Culture After Vietnam* (New Brunswick, NJ, 1991).
15 Julian Petley, 'Art Cinema', in Pam Cook and Mieke Bernink, eds, *The Cinema Book* (London, 1999, 2nd edition), p. 106.
16 David Bordwell, *Narration in the Fiction Film* (London, 1985), pp. 205–33. The illustrative examples suggested are not Bordwell's.
17 Kim Newman, 'Independents Daze', in Jim Hillier, ed., *American Independent Cinema: A Sight and Sound Reader* (London, 2001), pp. 268–72.
18 Petley, 'Art Cinema', pp. 107–8.

7. Architecture and Visual Culture

Richard Williams

Introduction

Architecture is the most public of the arts. It is inescapable on a daily basis for anyone living in an urban society. Works of architecture frame our lives; we inhabit them; they define our movement through cities; they moralise and discipline, or attempt to. They are one of the principal means by which the public realm is materially represented and for that reason, they are of huge social importance. Throughout the industrialised world, this relationship has been intensified in recent years. An immense amount of spectacular new architecture has been built in the past two decades, a product of the desire on the part of social and political authority to update the public realm in the context of unprecedented prosperity. Important recent examples include the Guggenheim Museum in Bilbao, the new parliaments or assembly buildings in Berlin, Cardiff, Edinburgh, London and Strasbourg, the plans by Daniel Libeskind for the reconstruction of Lower Manhattan after September 11, and the completion of the so-called *grands projets* in Paris. None of them has been cheap. The public role of works of architecture, not to mention their size and complexity, means that they can be fantastically expensive, and more than any other practice of visual culture they require public patronage. At the time of writing, the new Scottish Parliament in Edinburgh, by Enric Miralles, was estimated to have cost £400 million. The Millennium Dome in London, by Richard Rogers, cost approximately £750 million. These figures eclipse those in any other field.

The scale, cost and public presence of contemporary architecture demand attention, and as a result we occasionally raise our eyes to look at it in detail. But as the critic Walter Benjamin asserted, it is more likely that we apprehend it in a 'state of distraction', unlike other practices, which we consume with due attention in appropriate surroundings – or try to.[1] This is just one of the problems in considering architecture, a difficult, sometimes daunting area of visual culture. It is, for example, notoriously hard to define: How does it relate to building, or to urbanism, or to town planning, or any of the other mysterious professions of the built environment? It is a profession, and as such it is inherently exclusive, resisting interrogation from non-initiates. It comes with special institutions and social rituals, not to mention an arcane and exclusive technical language, acquired during a seven-year training. How can we relate to a practice like this? We may lack the technical skills taught on an architecture degree, the professional experience and, perhaps, the confidence inculcated by a middle-class background, the social class that still dominates the profession. In what way can they participate in debates about architecture? How might they stand in relation to such a complex, difficult and seemingly exclusive field?

I address these questions through a consideration of buildings, but I examine rather more what has been said about them; in other words, the *discourse* around them. As will become clear, architecture is as much a philosophical, social or professional realm as it is a material one, and it is through the consideration of architecture as discourse that one can engage with it as visual culture. I suggest how by exemplifying three related, but distinct, approaches to architecture: architecture as a form of art; architecture as a symbolic realm; and architecture as spatial experience.

Defining Architecture: Architecture as Art

What is architecture? This used to be a straightforward question, with a straightforward answer. For the art historian and critic Nikolaus Pevsner (1902–83), there was little ambiguity: 'a bicycle shed is a building' (Figure 7.1), he wrote in the introduction to *An Outline of European Architecture*:

> Lincoln Cathedral [Figure 7.2] is a piece of architecture. Nearly everything that encloses space on a scale sufficient for a human being to move in is a building; the term architecture applies only to buildings designed with a view to aesthetic appeal . . . the good architect requires the sculptor's and the painter's modes of vision in addition to his own spatial imagination. Thus architecture is the most comprehensive of all the visual arts and has a right to claim superiority over the others.[2]

This is architecture as art. The architect is a special kind of artist who works in three dimensions, but unlike the sculptor, he – and this is still an overwhelmingly

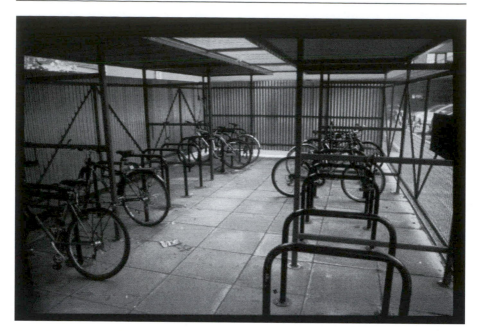

Figure 7.1 – Bicycle shed, Western General Hospital, Edinburgh. Author's photograph (2003).

masculine profession – works to enclose space as well as simply making objects in space. It includes elements of the other arts, but it is superior to them because it is a synthesis of them all. As an art, architecture demands a certain kind of apprehension from the beholder, which parallels that of the other visual arts. Thinking of painting, one may be especially concerned with the treatment of the two-dimensional aspects of buildings, above all the stylistic treatment of the façade, or exterior. This is an approach with a long history. John Ruskin, for example, saw in the architecture of Venice a moral purpose that provided a model for his compatriots.[3] His concern was exclusively with the façades of the buildings. In their Gothic decoration he found forms he regarded as morally superior to the neoclassical alternative. Precisely why depended on reasoning that now seems arcane. But what is important is that Ruskin's interest in architecture was a typically art historical one: it began and ended with style.

The work of Heinrich Wölfflin does something very similar. His formalist analysis of art makes architecture a central component, but his interest stops when architecture no longer accedes to the condition of art.[4] He was deeply interested in the stylistic qualities of building façades and in how they articulate formal ideas in the same way as relief sculptures, or paintings. Pevsner adopts a similar approach in his popular series *The Buildings of England*.[5] His emphasis is that of an art historian; he is concerned with the way a building as a set of two-dimensional planes in space, whose stylistic forms articulate an aesthetic purpose related to a broader

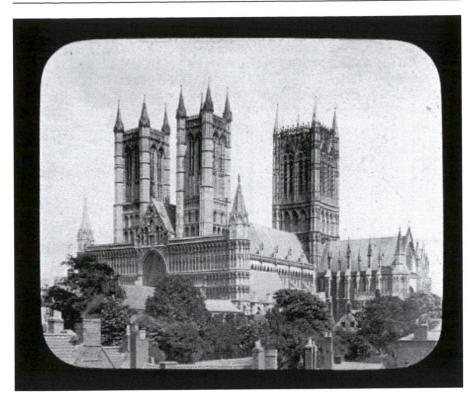

Figure 7.2 – Lincoln Cathedral, twelfth to fourteenth century. Photograph, Edinburgh University (2003).

stylistic pattern. Like Ruskin before him he is not much interested in the spatial aspects of architecture, its relationship with its surroundings or its use.

Architecture as art is in many respects the default mode of architectural writing. Most critics continue to work in this way. The contemporary reviews by Jonathan Glancey in the *Guardian* or Deyan Sudjic in the *Observer* or Herbert Muschamp in the *New York Times* appear on those newspapers' arts pages. In this mode, we are led to think about buildings as individual works of art. We expect them to be unique expressions of a single creative mind, a genius artist of the same kind as a painter or sculptor, or author. We expect them to exist as discrete objects that have their own integrity regardless of site. We expect them to be permanent and unchanging. We expect them to be expressions of their time as well as of their individual creator. We expect them to be legible as images, that is to say, as a single sign. We expect them, if they are modern buildings, to be revolutionary in some way, to challenge existing assumptions about architecture. We expect a kind of greatness that is achieved in spite of the world. We expect aesthetic brilliance, in other words, and we are disappointed when buildings do not achieve it.

The idea of architecture as art has been manifest in various ways. It continues to

exist, although attention may perhaps have shifted from the building façade, which, with modernism, has mattered less and less, to what the architectural historian Kenneth Frampton has called the 'tectonic', which is to say, an aesthetic concern with the *structure* of buildings. For Frampton, a building's skin ought not to conceal the structure, but be integral to it, yet his concerns are no less aesthetic, for he is interested primarily in the look of a building and how it is achieved.[6]

Architecture as art is underwritten by the work of such art historians as those cited above. It is underwritten too by educational institutions, including universities. Architectural training still frequently imagines architects essentially to be artists, who will not be much involved with the construction of buildings, but will be drawing and talking about ideas: doing, in other words, those things that other kinds of visual artists might do. This is further underwritten by certain kinds of professional journals, which propagate the same idea. Pre-eminent in the Anglophone world is undoubtedly the *Architectural Review*. In continental Europe *Domus* (Italy) and *L'Architecture d'Aujourd'hui* (France) perform the same task.[7] These journals all function in similar ways. Their interest in architecture is limited, by and large, to two building types: the large, generously funded, public project, and the small private house; which is to say, the types of building architects would like to design, and the ones they would like to live in. The journals tend to imply that the building is a product of a single (genius) mind, personifying the building's aesthetic in an individual or group of individuals. They relate the building art-historically to other buildings in the author's *oeuvre*, and to formally similar buildings by other architects. They illustrate buildings profusely, and in colour. Their use of photography specifically avoids the depiction of the building in use, except for where this itself confirms the aesthetic intentions of the architect; indeed, there is a long tradition of architectural photography of this kind.[8] They discuss the buildings in mostly aesthetic terms, as formal propositions that must be criticised within their own terms; they include plans and costings, but these unspectacular and unaesthetic things are relegated to the back of the article.

Architecture as art is nevertheless an incomplete definition of architecture. Although perhaps the most familiar definition, it is the preserve of a handful of star architects and their pet projects. It explicitly rejects the mass of buildings in the world. For Frampton, global capitalism has such power that its generic shopping malls, petrol stations, motorways, skyscrapers and speculative housing have utterly swamped the business of architecture. Architecture is not to be found in these things; quite the reverse: it is the business of *resisting* them. Unlike the petrol station, the shopping mall, the motorway or the speculative house it must necessarily be marginal and avant-garde, a force for moral critique from the sidelines. He quotes the words of the Spanish architect Ignacio Solà-Morales, one of those responsible for the reconstruction in 1986 of Ludwig Mies van der Rohe's German pavilion, originally made for the International Exhibition of 1928–9 held in Barcelona (Figure 7.3). Solà-Morales regards architecture as a

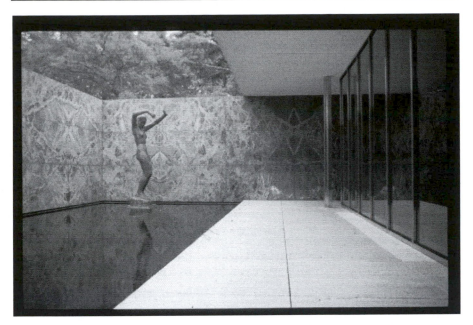

Figure 7.3 – Ludwig Mies van der Rohe, German pavilion at the International Exhibition, Barcelona, (1928–9). Reconstructed 1986. Author's photograph (2003).

kind of reality reserve, a place where man can still find material and spiritual repose; a kind of enclave capable of resisting as *other* the destructive onslaught of technological modernisation.[9]

Here, architecture is a tiny but morally vital practice, fighting a desperate, and perhaps futile, rearguard action against the *tsunami* of global capital.

It is important that the business of architecture should not be solely represented in these terms. Architecture is, after all, not only the business of a handful of individuals and their prestigious commissions for art galleries, it is also a deeply complex social and professional practice. There are many other ways in which architecture may exist. It should be understood first as a practice that involves much more than the material production of an individual. Architecture, because of its unique position in the public realm, is a uniquely compromised art, if it is an art at all. It exists because a client allows it to exist. Unlike the novel, the poem, the play, the painting, the print or even most sculpture, architecture can scarcely exist without patronage. And it is generally the client who determines the function of a project, its specification, its location and above all, its cost; the architect works within these parameters. Further, the architect must work within the limitations of a location. A city does not function without some kind of planning régime. In most of the industrialised world, this will be exceedingly restrictive, specifying the size and shape of buildings that may be erected on a specific site, their colour and materials, and their

purpose. Furthermore, the architect, unlike any other artist, works in a way that is utterly dependent on a variety of other professionals: engineers, quantity survey-ors, building contractors, electricians, property consultants. The architect's work is never his, or hers, alone. Furthermore the idea of authorship in architecture is highly complex. Even without the presence of these other professionals, the architect is invariably part of a team. Norman Foster and partners, the firm responsible for so many recent London buildings (the Greater London Assembly, the Millennium foot-bridge across the Thames, the 'erotic gherkin' tower for Swiss Re, the reconstruc-tion of Trafalgar Square and Stansted Airport) employs several hundred people its London office, only some of whom will be involved in each project. The meaning of Foster as author of the Greater London Assembly headquarters is very different from the meaning of Vincent van Gogh as author of *Starry Night*.[10]

Hence architecture is compromised in ways that other arts are not. The para-digm of architecture as art may persist, but it is a highly misleading way of think-ing about the practice. Architecture needs to be thought of less as a set of special material products and rather more as range of social and professional practices that sometimes, but by no means always, lead to buildings. They are practices that involve social and commercial networks and institutions as much as they do indi-viduals. Above all, architecture needs to be analysed as *discourse*. It then becomes possible to think about architecture as something in which all can participate. One can begin to free it from its professional ties. Crucially, one can begin to think about it from the point of view of its consumption as much as its production. It is here that the field of visual culture as an approach may have the most to offer in our understanding of architecture. The consumption of architecture may be thought about in two ways: first, in terms of the understanding of it as sign, or symbol; second, in terms of it as spatial experience.

Architecture as Sign

When I refer to the consumption of architecture, I mean its apprehension by a non-specialised public. It is important to distinguish between this and the apprehension of architecture by the art historian. The attentive reader might say that neither Ruskin, Pevsner nor Wölfflin were specialists, being art historians interested in architecture for their own aesthetic ends. But none of them read architecture *against* the intentions of the architect. None of them produced, in other words, a critical reading of it. All assumed that they were constructing a story about archi-tecture that had to do with the intentions of an architect, which could be revealed by careful examination of the building in questions and other historical sources. Theirs was a conventional art-historical approach in other words. It was concerned above all with intention as far as it could be known, and one that did not wish to complicate the business of looking.

Since the second world war, numerous social and cultural critics have interrogated this rather simple idea of consumption, and their work has been profoundly influential in the way that architecture has come to be understood. One figure is of particular significance: Roland Barthes (1915–80), most often associated with semiology. For Barthes, the world was a forest of signs that could be interpreted by those with the requisite intellectual tools. Visual practices had been thought of in these terms before. The iconographical work of art historian Erwin Panofsky (1892–1968), for example, was also preoccupied with the symbolic meaning of art.[11] But Barthes and Panofsky differ crucially in *what* they considered important, and in *where* they thought meaning resided. For Panofsky, art alone rewarded attentive looking; nothing else greatly mattered. The meaning of an artwork was stable and contained within it; the job of an art historian was to reveal it by careful investigation, and once revealed, the meaning was not expected to change (although, clearly, further research might lead to revisions). For Barthes by contrast, not just art, but the entire cultural domain was a legitimate object of analysis, and unlike Panofsky, he felt that the meaning of an object, whether an artwork or some other image or artefact, was dependent on its relation with other things around it at the time and on what the beholder brought to it. Meaning was therefore not fixed or stable, but the reverse: it was mutable, contingent and arbitrary. What this implies in terms of architecture is an approach quite distinct from that of architecture as art. Specifically, it holds architecture as open to interpretation, not only by those with a professional interest, but by *anyone*.

A sense of how this radical view might work in practice is provided by his short anthology *Mythologies* (first published 1957), in which a great architectural work, a medieval cathedral, is regarded with an equal gaze as the Citroën DS21 car (Figure 7.4).[12]

These things take their place in a de-hierarchised world in which all-in wrestling, Hollywood cinema, striptease and *steak frites* are all regarded with equal fascination. In a later essay he writes on the Eiffel Tower. An art-historical approach to the Tower might say something about its origins, its author (the engineer, Charles Eiffel) and its form, perhaps relating it to a variety of earlier works by the same engineer/artist. Barthes by contrast produces a reckless list of reference points which suggest a radical openness to interpretation, contingent on the position of the beholder. 'Its simple primary shape', he writes,

> confers on it the vocation of an infinite cipher: in turn and according to the appeals of our imagination, the symbol of Paris, or modernity, of communication, of science or of the nineteenth century, rocket, stem, derrick, phallus, lightning rod or insect, confronting the great itineraries of our dreams, it is the inevitable sign; just as there is no Parisian glance which is not compelled to encounter it, there is no fantasy which fails, sooner or later to acknowledge its form and be nourished by it.[13]

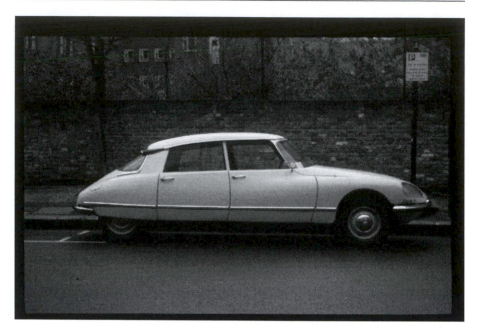

Figure 7.4 – Citroën DS21 (1972). This is an updated version of the car that Barthes described on its appearance in 1956. Author's photograph (2003).

The Tower, as Barthes suggests, means anything. I would not want to argue here that any architects have directly taken on the challenge of Barthes, although he was increasingly widely read, but there is no doubt that during the 1960s, there was increasing criticism of traditional approaches to architecture from a similar point of view. Some of this was made from a stance sympathetic to Pop Art, which undertook a provocative blurring of the boundaries between so-called high and low culture. In England, important figures in this context include the architects Peter (1923–2003) and Alison Smithson (1925–93), Cedric Price (1934–2003), Archigram (formed in London 1962) and the critic Reyner Banham (1922–88), all of whom attacked the divide between high and low culture, and sought to incorporate the popular realm into their work, even if only in the form of quotation.

Banham's 1971 study of Los Angeles is particularly instructive.[14] At the time, the Californian metropolis was regarded with abject horror by European aesthetes, who thought its heterogeneous sprawl the antithesis of civilisation. What Banham showed was that there was not only a pattern to its urbanisation, but that its built form was of considerable interest. His treatment of the commercial architecture of the freeways, of speculative housing, of informal architectural phenomena such as the Watts Towers, not to mention the freeways themselves, showed great complexity, imagination and symbolic value in parts of the built environment that critics usually ignored. Most of what Banham described could not be accounted for

in terms of architecture as art. But it undoubtedly had symbolic value, and could be described in terms of an expanded view of architecture.

In the United States, a comparable development could be seen in the work of the architects Robert Venturi (born 1925) and Denise Scott-Brown (born 1931). Like their English counterparts, they sought to incorporate a pop sensibility into their work. And like them, they were certain that architecture ought to function on the level of sign, as well as anything else – and crucially, that as signs, they were open to multiple interpretation. The meaning of architecture was therefore not single, authoritarian and closed, but multiple, democratic and open.

Venturi and Scott Brown's architecture includes such works as Guild House (1963), a sheltered home for the elderly in Pennsylvania, the façade of which includes a non-functional TV aerial as part of a symbolic composition. A later and much more monumental work was the Sainsbury wing of the National Gallery in London (1991), which makes playful reference to the formal neo-classical architecture of the original building, but also departs picturesquely from it as if to say that they do not simply underwrite the moral message of the original building, but allow multiple readings. Venturi and Scott Brown were responsible for two vital works of architectural theory, *Complexity and Contradiction in Modern Architecture* (1966) and *Learning from Las Vegas* (1972). Paralleling Barthes and Banham they proposed that architecture acknowledge the factual existence of the modern world, in all its complexity, in all its ugliness as well as beauty. It could not confine itself to the rarefied world of art buildings illustrated in the magazines, because the context for whatever architects did was a complex and heterogeneous modernity. And they allowed that a building would inevitably be open to multiple interpretations by the public – whatever architects desired. Instead of closing down such possibilities, the architect should acknowledge them and provide material that was symbolically rich, but located within a widely understood vernacular of signs. Hence their advocacy of what they called 'honky-tonk' elements in architecture, by which they mean the crude signs and symbols on commercial buildings:

> They are what we have. Architects can bemoan or try to ignore them but they will not go away. Or they will not go away for a long time because architects do not have the power to replace them (nor do they know what to replace them with) and because these commonplace elements accommodate existing needs for variety and communication. The old clichés involving both banality and mess will still be the context of our new architecture, and our new architecture, significantly, will be the context for them . . . Architecture is evolutionary as well as revolutionary.[15]

In *Learning from Las Vegas*, they argued that the temporary, ephemeral and extraordinarily brash urbanism of the Las Vegas 'strip' should be regarded as an

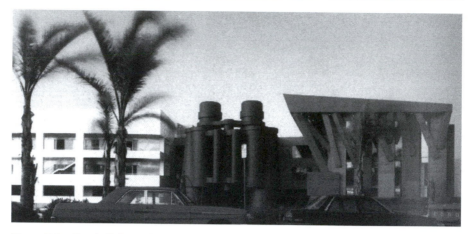

Figure 7.5 – Frank Gehry, *Chiat Day Mojo Advertising Building*, Venice, California (1991). Author's photograph (2003).

architectural phenomenon as important and worthy of study as ancient Rome. What was emerging along the highways of the then still infant city was not to be dismissed as 'sprawl' but was in fact a new kind of urbanism, radically unlike anything produced in Europe.[16] Caesar's Palace, then the biggest and most spectacular of the casino hotels, was photographed in detail. Its faux Roman sculptures, its *David* and its pastiche Bernini sculptures were all examined with seriousness and presented as evidence of a new and important phenomenon.

In summary, this tendency in architecture shows a development of the category of architecture beyond the convention of architecture as art to include all kinds of building never intended as 'art'. This broadening of architecture allows for different kinds of interpretation, and led to what was later called postmodern architecture, which in the view of the critic Charles Jencks (born 1939), allowed 'double coding' – in other words, a dual set of symbolic references, one for interpretation by 'high' architects, the other by the general public.[17]

The developments in postmodernism since the 1960s show that architecture can be expanded to allow for multiple readings and, ostensibly at least, a more egalitarian approach. But they still presuppose that the terms of the debate are set by architects. If there is double coding in postmodern building, as Charles Jencks has suggested, then the architect, it seems, decides which symbolism is appropriate for which public. This is a patronising approach that classifies jokes according a prejudged intelligence: Doric columns for the informed architects, hamburger-joint art deco for the masses. Or in the case of Frank Gehry's Chiat Day Mojo offices at Venice, California (Figure 7.5), a multi-layered joke: the binoculars recall the daft commercial architecture of the LA freeway world, but they also refer knowingly to pop art and a highbrow take on modernity. It is, on the one hand, therefore a loving recreation of a now nostalgic form of vernacular building, on the other, an

ironic signifier of art. The surreal, arbitrary quality of the sign, its dislocation from any *product* communicates exceptional aesthetic sophistication.[18]

Architecture and Urban Experience

The interest in architecture as sign therefore opened up some new possibilities, but curiously it assumes a traditional position between viewer and object. It is therefore important to consider an approach – or more accurately, collection of approaches – that examines architecture in terms of the experience of the urban environment. I am referring here not so much to a tradition or discipline as to a number of authors who put forward similar ideas and whose writings have often been used by historians and theorists. What they have in common is a concern for architecture as experienced by the user, or inhabitant, rather than the architect, in a manner paralleling Barthes' privileging of the reader over the writer. They form a discourse that may be said to have its beginnings in the mid-nineteenth century and the development of the modern metropolis. All see the metropolis as both a novelty and a shock, an unnatural phenomenon that produces new kinds of social behaviour. Its profound implications for architecture include the idea that the architectural façade – in other words, the repository of architecture-as-art – may not in fact matter much at all. These writers continue to provide a challenge to architectural criticism to the present day.

The earliest example is perhaps Friedrich Engels (1820–95), whose *Condition of the Working Class in England* was written during the author's stay in Manchester in 1842–4.[19] Engels' detailed account of the world's first industrial city provides some important hints of how a critical approach to architecture might evolve. In a famous passage, he describes Manchester in dystopian terms as a boomtown whose very success generates extraordinary poverty. This finds spatial expression along its southern suburban corridor (the present-day Oxford Road) where a wealthy man may be made oblivious of Manchester's horrors on his journey to and from work, so effectively does the city conceal them behind a corridor of respectable façades.[20] This account, on the most basic level, is about architecture: but instead of art-historical style, its focus is space, and in particular the relationship between space and society.

Engels goes on to speculate about the effect that urban spatial conditions may have on human behaviour, a concept much developed in the late twentieth century. The German sociologist Georg Simmel (1858–1918) took up this theme in a widely read essay 'The Metropolis and Mental Life', first published in 1902. Simmel tries to account for the curious behaviour of inhabitants of very large cities, themselves a recent and still rare phenomenon; there were only a handful of cities in the world with a population of over a million. London at the time was very much bigger than anywhere else. Simmel notes that in contrast to the small town, the metropolis produces a state of willed anaesthesia in its inhabitants whereby the perception of city

life is consciously dulled. This is necessary, Simmel argues, because the new conditions of the city have produced such a multitude of sensations, that to accept them all would be to lose control. To survive, the city dweller must limit his experience. This consciously limited state Simmel terms the 'blasé outlook'. His definition of the term merits quoting at length:

> There is perhaps no psychic phenomenon which is so unconditionally reserved to the city as the blasé outlook . . . just as an immoderately sensuous life makes one blasé because it stimulates the nerves to their utmost reactivity until they finally can no longer produce any reaction at all, so, less harmful stimuli, through the rapidity and contradictoriness of their shifts, force the nerves to make such violent responses, tear them apart so brutally that they exhaust their last reserves of strength and, remaining in the same milieu, do not have time for new reserves to form. This incapacity to react to new stimulations with the required amount of energy constitutes in fact the blasé attitude which every child of a large city evinces when compared with the products of the more peaceful and more stable milieu.[21]

Simmel's essay is no conventional study in architectural history, still less the passage quoted above, which barely refers to architecture. But it is important in the discussion of architecture because it describes the point at which debate expands from consideration of buildings alone, to consider the psychological (and indeed other) effects that an accumulation of buildings might have. Simmel argues that architecture might have odd, perhaps unexpected effects. They have nothing whatever to do with style or an architect's intention, but they still belong to the realm of architecture. The importance of this passage is exemplified by the frequency with which subsequent authors have put forward similar accounts, clearly influenced by Simmel's argument. Notable amongst them is Siegfried Kracauer (1889–1966) and his essays on the public spaces of the metropolis, particularly the hotel lobby, which he argues is a metropolitan substitute for the church. Where in the town, he writes, the church is a place of gathering for believers, its metropolitan equivalent, the hotel lobby, is a godless, purposeless congregation, without ritual, purpose or, for that matter, God.[22] Or a little later, one might consider the work of Walter Benjamin, whose unfinished account of Paris, the *Arcades Project*, attempted to understand a city through its existing architectural spaces; not the spaces of the imagination produced by architects, but those actually used, traversed and inhabited, full of debris and traces of the past.[23]

The work of these writers led to an equally critical tradition of French writing on the city, in which architecture as a field of enquiry was expanded to mean the entire urban experience, of which the architect's work is only a small part. Crucial in this regard is the work of Henri Lefebvre (1901–91), whose book, *The Production*

of Space, has been enormously influential.[24] Lefebvre argues that urban space is not so much an architectural production as a social one; architects, he writes, produce little more than façades, which can be inhabited in an infinity of ways according to their social context. Experience is crucial he writes, but the role of architects *per se* is tiny in relation to the whole; their desire for order in the urban realm is essentially authoritarian and idealising, and the realm of social space is where the city may be properly understood. More recently, American writers such as Mike Davis and Richard Sennett have considered the experience of contemporary urban space, reading it in the light of larger social and economic developments.[25]

These writers represent a strand of architectural thinking that is highly critical of its ostensible subject. They are deeply concerned with architecture, but they seek to expand its norms and to interrogate its assumptions. They provide the most direct critique of architecture-as-art: for them, the art-historical concern for the façade provides a hopelessly narrow reading of architecture, limited in both scope (a handful of canonical buildings) and method (a concern for style). Their project by contrast tries to locate architecture in a broader context, to make it legible as a social and political practice, and above all as something open to interpretation, question and use.

Conclusion

From the outside architecture is a daunting field, with its private language, its terminology, its sense of propriety and its professional rules. To approach it from the outside is not easy, but as this chapter suggests, there is much scope for the non-expert to engage with it, and by so doing, provide alternative readings of it. A truly critical approach should be precisely one that is *not* professionally compromised. Above all, architecture ought to be seen as discourse. Buildings as material facts are a small part of the overall field of architecture, a field which is better regarded as a network of practices and debates about the built environment. In this sense, the study of visual culture ought not simply to reiterate the professional discourse of architecture-as-art, but make use of the critical approaches that have emerged over the past century. The consideration of architecture as sign is one; architecture as urban and social experience another. Both emphasise the reception of architecture over its production, and it is this fact above all that makes them useful means of engagement.

Further Reading

Banham, Reyner. *A Critic Writes* (Berkeley and Los Angeles, 1996).

Forty, Adrian. *Words and Buildings* (London, 2000).

Leach, Neil, ed. *Rethinking Architecture* (London, 1997).

LeGates, Richard T. and Stout, Frederic, eds. *The City Reader* (London, 1996).

Venturi, Robert and Scott-Brown, Denise. *Learning from Las Vegas* (Cambridge, MA and London, 1972).

Notes

1 Walter Benjamin, *Illuminations* (London, 1973), p. 241.
2 Nikolaus Pevsner, *An Outline of European Architecture* (Harmondsworth, 1942), p. 9.
3 John Ruskin, *The Stones of Venice* (London, 1976).
4 Heinrich Wölfflin, *Renaissance and Baroque* (London, 1964).
5 Nikolaus Pevsner, *The Buildings of England* (Harmondsworth, 1951–74), 46 vols. For information on the series, including plans for further publications, see http://www.pevsner.co.uk.
6 See Kenneth Frampton, *Studies in Tectonic Culture: The Poetics of Construction in Nineteenth- and Twentieth-Century Architecture* (Cambridge, MA, 1995).
7 Both are published in international editions, with summaries in English.
8 For discussions of architectural photography, see Robert Elwall, *Photography Takes Command* (London, 1994); also R. J. Williams, 'Representing Architecture: the British Architectural Press in the 1960s', *Journal of Design History*, Vol. 9, No. 4 (1996), pp. 285–96.
9 Frampton *Studies in Tectonic Culture*, p. 343.
10 The principal designer of the GLA building was in fact Ken Shuttleworth.
11 Erwin Panofsky, *Meaning in the Visual Arts* (New York, 1955).
12 Roland Barthes, *Mythologies* (London, 1972). First published Paris, 1957.
13 Roland Barthes, in Neil Leach, ed., *Rethinking Architecture* (London, 1997), p. 173.
14 Reyner Banham, *Los Angeles: The Architecture of Four Ecologies* (London, 1971).
15 Venturi, in Kenneth Frampton, *Modern Architecture: A Critical History* (London, 1992), pp. 290–1.
16 Venturi *Learning from Las Vegas* (London, 1972), p. xi.
17 Charles Jencks, *Modern Movements in Architecture* (Harmondsworth, 1985), p. 373.
18 The building is in fact a collaboration with the pop artist Claes Oldenburg. For examples of the roadside architecture to which it refers, see what Venturi describes as 'duck' architecture in *Learning from Las Vegas*, p. 17.
19 Friedrich Engels, *The Condition of the Working Class in England*, ed. David McLellan (Oxford, 1993). The book was first published in German in 1845. An English edition did not appear until 1872.
20 Ibid., p. 59.
21 Simmel, in Leach, *Rethinking Architecture*, p. 73.
22 Kracauer, in ibid., pp. 53–8.
23 Walter Benjamin, *The Arcades Project*, trans. Howard Eiland and Kevin McLaughlin (Cambridge, MA, 2000).
24 Henri Lefebvre, *The Production of Space* (Oxford, 1991). First published in 1947.
25 Mike Davis, *City of Quartz. Excavating the Future in Los Angeles* (London, 1992); Richard Sennett, *Flesh and Stone. The Body and the City in Western Civilization* (London, 1994).

8. Representation and the Idea of Realism

Neil Mulholland

Introduction

First follow Nature, and your judgement frame
By her just standard, which is still the same.
Alexander Pope, *An Essay on Criticism* (1711)

'Realism' is one of the most commonly used cultural terms and exercises a partic-
ularly powerful hold over the ways that people judge and exploit visual culture.
Today, it is very often used encouragingly as a way of praising a particular work of
art, photograph, television programme or film. To most people, its meaning is
common sense and uncomplicated. For some, 'realism' conjures up connotations
of truth, straightforwardness, sincerity and honesty. For others 'realism' takes its
cues from the present; it is based upon everyday experience rather than myth.
'Realism' may be characterised by its gritty social or political message, an interest
in 'ugliness' or contemporary urban living. Such readings of the term 'realism'
might originate in the literary and artistic movement correlated with the revolu-
tionary events of 1848, which was associated with French radicals such as the
socialist painter Gustave Courbet, the republican caricaturist Honoré Daumier or
writers such as Emile Zola and Charles Baudelaire.[1]

As an artistic movement, Realism was tied closely to the steady growth of faith
in modern political and natural sciences, to the belief that the world could be
observed objectively and factually. Gustave Courbet painted *The Stonebreakers* in

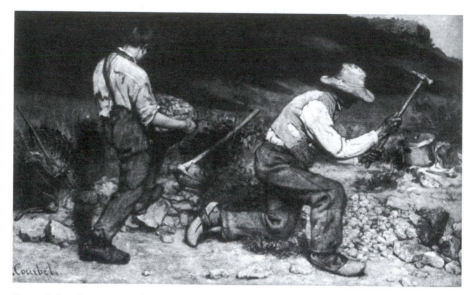

Figure 8.1 – Gustave Courbet, *The Stonebreakers* (1851). Now destroyed.

1851 (Figure 8.1) from direct observation of the rural labouring classes, while Emile Zola's novel *L'Assommoir* (1876) was based on facts and figures relating to the poverty and squalor suffered by people living in the slums of Paris.

Writers and artists such as Zola and Courbet used their empirical observations to make barbed political commentary on contemporary society. Courbet's painting depicts two ragged rural labourers breaking rocks, a physically demanding task for which they are clearly unsuited, the boy on the left being too young to lift his basket and the man on the right being too old to wield his hammer. Although the painting purports to represent life exactly as it is lived, the juxtaposition of the figures and the loaded subject matter render it an obvious rhetorical assault on the reification of humanity.

Both Courbet and Zola saw their subject matter and its 'truthful' depiction in radical political terms. As committed social reformers, they sought to produce a new art relevant to the masses flooding into huge cities engorged by the Industrial Revolution, dealing with complex contemporary issues of modern living in a direct, non-mythical fashion. While conceptions of urbanism were central to many Realist artists and writers in this period, an equally significant number of cultural producers associated Realism with naturalism. Realism in its naturalist guise was often used to evoke the authenticity of unspoiled nature, of honest agricultural toil, of an ancient pastoral way of life destroyed by migration to the affected 'modern' multiculturalism of large cities. The naturalism found in the paintings of Jean-François Millet and the novels of George Elliot presented an alternative to the contaminations of industrialised life, and as such jars with the urban Realist genre.

In both its urban and rural guises, Realism was clearly an artistic convention, a predetermined way of looking at an industrialised culture. Realists obstinately assumed that they could incorporate everything in their scope and reveal the whole truth about the present.[2] The notion that any representation can give an *unmediated* impression of totality is, at the very least, over-ambitious. Given that all representations are partial accounts, are there any ways that visual culture might helpfully be said to be 'realistic'? To gain such an accolade would also seem to be a question of meeting arbitrary and shifting standards. What individuals judge to be 'realistic' depends very much upon social, economic, ideological, geographical and historical circumstances. What a resident of present-day Hong Kong might consider to be 'real' could differ dramatically from Zola's vision of Paris during the Second Empire, the 'reality' of a Politburo member in 1950s Moscow or of a wealthy merchant in fifteenth-century Florence. Given that the 'real world' continues to mean different things to different people, 'realism' is far from being a transparent or settled term. Cultures acquire the mode of representation that their ideological presumptions support. In order to have a clearer understanding of how the meanings of realism are preconditioned by different cultural, technological, ideological and philosophical legacies, we need to look at a number of instances of its use.

The notion of mimesis – the concept that pictorial representations bear a resemblance to what we see in the world – has enjoyed a considerable hold over the Western imagination. The idea that artists should seek this role has not always been encouraged. In *The Republic* (360 BCE) Plato famously decried what he regarded as the mimetic role of the visual arts. According to Plato, artists were mere copyists who diverted people from true reality, a truth higher than empirical experience and beyond the physical world.[3] Artists were a corrupting force upon the populace, one that Plato wished to see eliminated from his ideal Republic. Despite his protestations, many artists have sought to mirror their world. An influential advocate of the idea that visual representation is ever in pursuit of greater illusionism was the art historian Ernst Gombrich. In *Art and Illusion* Gombrich held that illusionistic conventions such as perspective and foreshortening were continually checked against perceptions of the real world.[4] When found wanting, these conventions, or 'schemas', were altered or swapped for new ones. Thus, Gombrich argued, there is a clear sense of schemas being adapted gradually over the history of art. In early fifteenth-century Italy, medieval painting, which often represented the human countenance in profile, gave way to fully modelled recreations of the three-dimensional figures on flat surfaces. Renaissance artists certainly had a greater interest in producing studies directly from observation and were informed of bodily structure by anatomical dissections – facts which, for Gombrich, signalled that they were checking the schemas of medieval art against the evidence they saw with their own eyes. There are, nevertheless, other factors that complicate this issue. It was also during this period that the rules of linear perspective

were developed in Florence by the artists and architects Filippo Brunelleschi and Leon Battista Alberti, a system of rules that were to have a profound effect on the work of artists such as Tomaso Masaccio, Paulo Uccello and Leonardo da Vinci. Linear perspective was a mathematical system designed to aid artists create the illusion of three-dimensional space and volume. Producing an artificial horizon line within the window created by the canvas creates the illusion. Lines retreat from the edge of the canvas to converge at a central 'vanishing point', a point which forms both an artificial horizon line and the main compositional focus for the viewer of the work. For Gombrich, the system of linear perspective was non-arbitrary, an unsurpassable means of representing space.

On reflection, Gombrich seems to have underestimated a number of important aspects. The fact that linear perspective was actively developed as a scientific system rather than arrived at through a process of gradual osmosis signals that it must be yet another theoretical schema, a model for representation. As a system it is far from perfect; it is unable to deal with certain shapes such as cones and spheres, and it does not tally with the way in which the human eye receives light. In linear perspective, light is (virtually) projected from a single vanishing point onto the flat surface of the canvas, whereas in the human eye, light is received by two pupils and projected onto the curved surfaces of the eyes. Today, physicists argue that space is curved rather than linear; the notion of a vanishing point may therefore be obsolete. Most importantly, Gombrich underplays the agency or active selectivity involved in representation. When someone attempts to produce a representational drawing, they cannot possibly represent everything before them. Such a goal is impossible, and perhaps not even desirable if pictorial representation is to fulfil the task of standing in for its object. Pictorial representation stands in semantic relation to the world; it is an equivalent. When we draw we interpret, and this means that we are never being 'true' to the 'real world'. This suggests that other active factors and conventions structure the consciousness and play a significant part in determining how people translate.

In *Perspective as Symbolic Form* (1927) Erwin Panofsky argued that perspective was a system of cognition intimately tied to the Renaissance vision of the world.[5] This vision differed dramatically from the medieval conception of the world. Renaissance perspective put humanity, not God, at the nucleus. Humanism held the universe to be ordered, understandable, measurable and mappable, through the application of human reason. For Panofsky, the converging lines of linear perspective perfectly encapsulated this way of seeing. Panofsky noted that the seemingly non-arbitrary character of linear perspective results not from its perfection, but from the fact that it has come to condition our perceptual devices. This can be seen in the way that the box-like recessional spaces of Albertian perspective have been readily adopted and adapted by other powerful representational systems such as photography, television, cinema and computer graphics. This suggests that such

systems of representation are not a simple 'reflection' of the world, in the sense that mirror images are, but an active *producer* of meanings. Representations structure how we view the world. If we return to consider medieval painting in light of this, we might see it less as an imperfect realism and more as a means by which Christians accurately expressed their distinctive beliefs and knowledge of the universe. Medieval art served the function of representing the spiritual world of European Christians, a world they regarded to be very 'real'.

Representation and Cultural Difference

We currently live in a global society that is sceptical of the utopian ideas of the European Renaissance, a post-nuclear age that does not share a belief in scientific progress and mappable linear space. Despite this, many of the values of the Renaissance – such as its rejection of spiritual conceptions of the afterworld in favour of more materialist theories of the 'real known universe' – have a continuing hold over how many people commonly see and represent the 'real world'. Drawing remains a familiar activity that spans the globe and has existed over many centuries of human cultural endeavour. In the Western world, perspectival drawing is taught from a young age and has long been used as the primary benchmark for judging the virtues of promising artists. Although perspectival drawing may still be valued in the West today, in some academic and popular contexts, it has had little currency amongst the avant-garde since the late nineteenth century.

Beyond the West, the authority of linear perspective diminishes greatly. Contemporary followers of traditional *nihon-ga*, Indian ink painting developed at Tokyo Fine Arts School in the 1890s, for example, make no use of this Renaissance schema, despite being fully aware of the method and its implications. With government backing, *nihon-ga* stood opposed to Western influence during the early Meiji Restoration. Sinking its roots in China and the Japanese Eudo era, *nihon-ga* nevertheless incorporated the Japonisme of late nineteenth-century European Impressionism, a movement dedicated to the 'naturalistic' depiction of the world. In the sense that it is partly a product of a 'realist' European gaze informed by Japanese representation, judging *nihon-ga* against European models of representation is thorny. Before the advances of global transportation and communication in the twentieth century, such traditions in isolated geographic areas presented the dominant frameworks within which artists and their audiences would represent their worlds, almost to the exclusion of all other possibilities. *Nihon-ga* was clearly an attempt to maintain the idea of an 'uncontaminated' representational tradition, one that stressed the importance of respecting the harmony of the natural world. As with many national cultural revivals, there is a sense that *nihon-ga* was strengthened by being confronted by alternative schema. Cross-cultural exchanges now take place at breakneck speed in all corners of the globe. Despite this, Japanese art

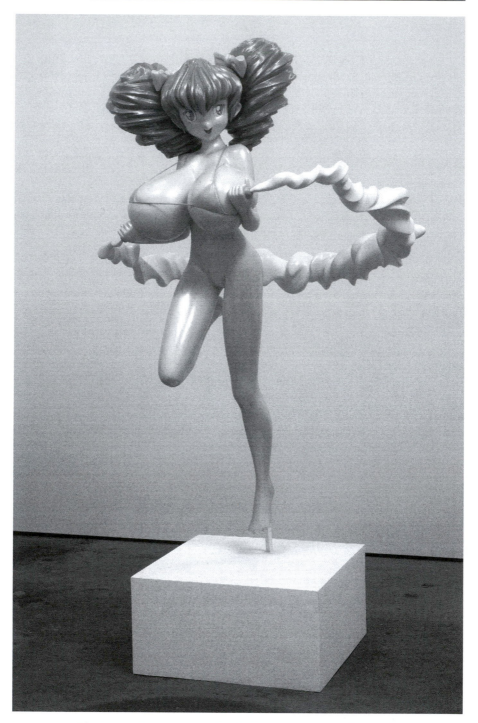

Figure 8.2 – Takashi Murakami, *Hiropon* (1997). Photograph courtesy Blum & Poe. Reproduced with permission. © 1997 Takashi Murakami/Kaikai Kiki Co., Ltd.

students still have to make the difficult choice of whether to learn Western classi-
cal and avant-garde forms of representation or devote their studies to the exacting
compositions and pictorial flatness that characterise the *nihon-ga* schema.

The contemporary Japanese artist Takashi Murakami seeks to unite these dis-
parate schemas by working with the points at which they intersect (Figure 8.2).
For Murakami, colourism and line drawing, imperative in *nihon-ga*, are also central
to the *manga* and *anime*-inspired visual culture of present-day Japan. Like *nihon-ga*,
Murakami's beloved *manga* is in subtle contradistinction to both Occidentalism and
Japanese ultra-traditionalism, conflating and confusing Oriental traditions with
Western ideas of modernity. *Manga* artists transformed the round eyes of Disney
cartoons that flooded Japan during American occupation of the 1940s into a collo-
quial 'post-Japonisme' Japonisme. These complex mixed metaphors of contami-
nation represent the cultural self-consciousness that Murakami explores in his
work. Although Murakami's art appears superficially innocent and escapist, it is an
index of the cultural and social whirl of postmodern Tokyo. Murakami's paintings
and sculptures plot a refined dialectic between *kawaii* (cute) and the schoolboy *angst*
found in geeky *otaku*, a masculine bedroom consumer culture of *manga* and com-
puter games. In this sense his work is closely related to the late nineteenth-century
European Realist project of mapping contemporary culture and social mores, par-
ticularly those that relate to urbanism and consumerism. As in late nineteenth-
century Europe, there is a political project here. Murakami and followers of his
superflat doctrine stress the insurgence of consumer-driven subcultures, equating
generational Japanese rebelliousness with voyeuristic passive aggression, sexual
fetishism and compositional dynamism. *Superflat* is a cultural oxymoron, a ritualis-
tic form of resistance against the perceived oppressiveness of the ritualistic
behaviour that dominates Japanese daily life.[6]

The Politics of Representation

In the twentieth century, what was representationally permissible (and therefore
'real') was often subject to coercive acts of censorship in Fascist and Communist
dictatorships, as well as in purportedly liberal democracies. The Soviet concept of
Socialist Realism, rigorously pursued during the Stalinist era, is a good example of
'realism' being used to describe a set of representational conventions. Socialist
Realism was designed to show the Communist government and state in a favourable
light, depicting happy collective farm workers, industrial labourers and soldiers
striving eagerly for a better future. What Socialist Realism depicted were the ideo-
logical ideals of the Party, rather than the day-to-day lives of ordinary Soviet citi-
zens.[7] The seemingly simple act of drawing, in this context, clearly has a political
outcome. Official art functioned purely in relation to socially established medians.
Any challenge to these medians was ruthlessly suppressed. Drawings produced by

starving political dissidents held in Soviet gulags attest to a brutal undesirable present hidden by the framing sensibility of state-endorsed realism.[8]

Many drawings have been used as a means of communicating across language boundaries in real time (airport signs) and for overtly utilitarian purposes (maps, architectural, engineering and scientific drawings), drawing that are judged by very different criteria from those of artistic drawing. Technical and design drawing might be said to evoke many of the connotations of 'realism', since they are used primarily to communicate and represent in ways which are, on the face of it, transparent, open and direct. This assumption, however, is problematic. The most commonly encountered communicative drawings, such as traffic signs, are the consequence of carefully established artificial conventions. Such customs are legally enforced through multilateral agreements such as the Geneva Convention Road Sign Treaty. Traffic signs are similar internationally, not because there is a naturally occurring order of signs, but because a system of representation has been carefully constructed. This representational assimilation has considerable impact on the way that we now view the world.

Around the world, people have become increasingly reliant on maps to provide them with information relating to the complex fabric of interconnected built and natural environments. To many, maps seem to be a perfectly transparent means of imparting information visually about parts of the world with which they are unfamiliar. Maps, however, are always incomplete. Pre-colonial maps produced in Europe are an obvious example of this partiality, many depicting the world as flat, Europe-centred and lacking the American or Australasian continents. The map of Edinburgh by Georg Braun and Franz Hogenberg, for example (Figure 8.3) is striking to the modern viewer because it is both a view of the city and also a representation of the layout of the town. It neither provides the information we expect of a map, nor adheres to the naturalistic conventions of the landscape. Yet even contemporary maps are highly edited schematic representations. What a map depicts differs radically from what is intended; a perfect map would have to be the very territory that it represents. The maps of large integrated urban transportation systems use a variable scale, emphasising the links between services rather than the actual distances travelled. An all-inclusive 'realism' is rarely desirable in such technical drawings. Different maps stress the importance of numerous dynamics, ranging from geological features to density of television sets, famous bars to most haunted sites. Maps can impart very specific forms of information, such as where and when people are online around the world, where to find an ATM in a metro station or how to navigate the design of a microprocessor.

Despite the ubiquity of such highly schematic post-industrial maps, different map-making traditions and possibilities continue to thrive. Australian Aboriginal mythological song lines, dots and serpentine traces made in the sand function as historical, narrative maps of nomadic ancestral territory. As with European naturalism

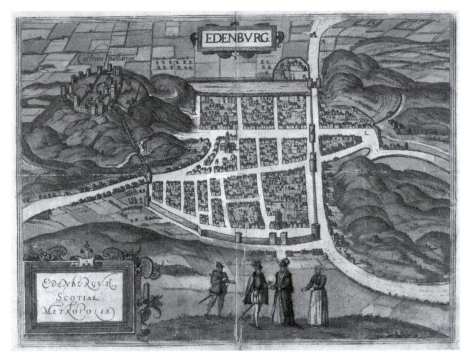

Figure 8.3 – Georg Braun and Franz Hogenberg, *Map of the City of Edinburgh* (1582). National Library of Scotland.

and Japanese *nihon-ga*, there is a strong sense of connection with and respect for the land's natural wealth. To the Aboriginals, the temporary drawings represent the creation songs of the ancestors who lived a period before humanity known as the Dreamtime, during which they sang the world into existence. The stories they represent allow geographical familiarisation with the waterholes, reed beds, gum trees, rivers, hunting ranges, salt-pans and sand-dunes of their land, permitting the continent to be mapped and navigated. In this sense the song lines represent something that is simultaneously physically tangible (the continent of Australia) and otherworldly (the Dreamtime). The song line schemas are passed down the generations and can be found amongst hundreds of different Aboriginal languages found across the whole continent. Non-Aboriginal understanding of the schemas is greatly limited since they are carefully guarded secrets that take place during sacred ceremonies. The schemas remain so closely tied to the context in which they are created that the uninitiated find them almost impossible to interpret. It is telling that many non-Aboriginal Australians value Aboriginal drawings as abstract 'art', despite the fact that the Aboriginals have no such concept. Since Japanese streets have no names, they are not very amenable to Western plan-view cartography. Navigating a Japanese city is akin to remembering a snail trail of stopping-off points and associations. Surfing the virtual world of the Internet is another activity that is difficult to

map in a conventional fashion given that it involves a non-linear associative journey. Lying somewhere between science and art, maps reveal the intentions of the map-makers more than anything else; they are active re-presentations of space rather than passive guides. Does this mean that all maps are merely subjective and there-fore of equal value? Clearly, a seventeenth-century East Asian cosmological map based on a Buddhist world view might not be as useful for navigating the Pacific Ocean as a contemporary satellite global positioning system (GPS), but a GPS might not be particularly valuable for spiritual purposes. Context is all-important; repre-sentations have to be judged in relation to their time and place, the relevant dimen-sions of resemblance differing from one representation to the next.

The Mechanical Eye

Evidently, visual representation is not confined to drawing or mapping. Since the mid-nineteenth century, mechanical forms of representation have been available to an increasing number of people. Photography differs dramatically from drawing and painting since it is produced by the physical action of light on chemically treated film. This means that a photographic image results directly from the light reflected by the object to which the camera is exposed. Does this mean that photo-graphic images are more 'realistic' than manually produced representations such as drawings? The issue is complex, but can be seen in terms closely related to the debates surrounding pictorial representation. Ostensibly, photographic images are more accurate forms of representation than those previously available, yet it is clear that photography is not wholly passive. A photographer always frames the image by choosing what to photograph. This means that photographs are summations of a larger world; they are edited accounts of the world outside the camera. The choices made by photographers are ideological in so far as they are consciously made. Professional photographers are often praised for their ability to compose pictures from the seemingly random assemblage of people and places that could confront their lenses. What is omitted is just as important as what is photographed. Amateur snappers tend to take photographs of scenes that remind them of good times or significant sights they have witnessed, photography being a staple ingredi-ent of holidays, birthdays, weddings, festivals and parties. 'Snapping' may possibly be seen as inappropriate in other spheres of social activity such as visiting a super-market, visiting a doctor or attending a funeral. Like the various pictorial schemas available to artists across the globe, this photographic conduct is dictated by implicit social mores.[9]

Technically, photography suffers from many of the problems associated with linear perspective. Given that light enters a camera from a single point, photogra-phers find it difficult to control the sharpness of the picture over the entire depth of field. The human eye compensates for this by continually refocusing over differ-

ing focal lengths, something that a stills camera cannot account for. Professional photographers are able to compensate for these failings by creatively manipulating lighting, aperture, film speed and development in innovative ways. Photographs are also highly susceptible to extraneous contextual forces. Since photographs are cheap and quick to reproduce, they often feature in mass-mediated forms such as newspapers and magazines. Captions and creative cropping dramatically alter how we read photographs in such contexts, the same image having very different connotations in different circumstances. Yet photography does maintain a major advantage over other forms of visual representation, namely its immediacy. Photography's reality effect stems largely from the fact that it can be produced quickly, documenting people, places and events with a vivacious sense of life as it is lived in real time. Such photographs can, as a result, become archetypal. Many photographs possess a near-mythical aura simply because they were taken in the right place at the right time. The processes through which they acquire this status, however, are far from instantaneous. Alberto Diaz Gutierrez's famous image of Cuban revolutionary martyr Ernesto 'Che' Guevara (1960) wearing a beret and gazing intently towards a bright new future is a good case in point. Gutierrez took the image of Guevara on the podium at a memorial ceremony in 1960 and placed a print on his studio wall. In 1967, the radical Italian publisher Giangiacomo Feltrinelli surreptitiously acquired the image from Gutierrez and cropped it to remove all signs of its context. Transforming Guevara into a Socialist Realist icon, Feltrinelli readily reproduced the image on posters, flags, T-shirts within weeks of Guevara's death. The image of Guevara as a Christ-like action hero has since come to stand for revolutionary intransigence around the world and is a powerful marketing tool for Cuba's Communist administration. Although he never made any money from the image, Gutierrez successfully won a lawsuit in 2000 protecting his photograph from being used to sell Smirnoff Vodka.

If photographs have always been susceptible to cropping, manipulation and multifaceted disputes over intellectual property, they are now even more vulnerable due to the rise of digital technology. Sales of amateur digital cameras now outstrip those of analogue cameras. As a result, an increasing number of people have the ability to manipulate their own images using cropping, Photoshop and captioning, freeing them from the hegemony of the film processing shop. Digital photography marks a distinct shift from reproduction of images to the *production* and direction of images, a shift that signals a new era in photography. 'Postphotographers' such as fashion photographer Inez van Lamsweerde, artist Paul Smith and video director Chris Cunningham make use of these processes to show how easily representations can be digitally transformed to meet their aesthetic requirements. Lamsweerde's *Final Fantasy* (1993) is a series of uncanny images of androgens featuring grown men with the hands of women and young girls with men's mouths. Smith and Cunningham are fêted for producing complex, digitally manipulated

compositions of cloned humans. Pictorially speaking, the digital posthumans and cyberspaces created by such artists are as convincingly 'real' as those depicted by analogue photography. With developments in genetic engineering, the scenes that they produce could become a tangible reality. Postphotography takes as read the supposition that 'realism' is wholly constructed. Indeed, postphotography is predicated on the theory that image-makers fashion and predict the ways in which the 'real' world behaves. Genetic engineering is an extension of this artisanal model, a grand aesthetic project to model the 'natural' world in our image.[10]

Realism is closely related to the development of technology in television and cinema. The film industry is famed for the rapid succession of innovative technologies all promising to bring us closer to real lived experience: the kinetoscope, the cinematograph, synchronised speech, Technicolor, Eastmancolor, Cinerama, deep focus, 70 mm widescreen film, 3D, Dolby stereo, IMAX, digital surround sound and Virtual Reality (VR).[11] Has the industry been driven by the dream of 'total cinema', the theory that technological boundaries are pushed ever further in a bid finally to solve aesthetic problems and win a global audience?[12] Total cinema is a teleological myth, a linear reading of technology, that it imagines we will one day perfect a universal format for reproduction of sound and the moving image.[13] The myriad types of competing home audio-video playback formats that have emerged since the 1970s, such as Video 2000, Betamax, VHS, 12" Laser Disk, Video 8, S-VHS, MPEG, DVI, MiniDV, DVD and MP4, would seem to confound this assumption. The only system that can be said to have dominated the home video market is JVC's VHS, a transitional technology that was inferior to its Sony Betamax competitor but which won out due to greater market saturation and range of titles.[14] Moreover, despite its overwhelming technical inferiority, VHS continues to survive alongside digital video.

Total cinema is an extension of the Renaissance pursuit of the hyperreal illusion; the ultimate schema that might stand in for lived experience itself. Of course, this must remain a dream. Not all new imaging technologies are allied with the pursuit of realism. Digital effects and animation, for example, are most readily associated with the fantasy and sci-fi productions of companies such as Pixar. The notion that full sensory immersion might occur through the development of interactive technologies such as VR is also questionable. Televisual, cinematic and virtual realities must be written. As such they require audiences to remain largely passive, the range of interactive choices controlled. True interactivity would lead to a mushrooming of possibility beyond the limits of the script and the hardware. Developments in technology are also not always to be welcomed unequivocally. High budgets accompany new technologies and restrict the creativity and mobility of filmmakers, as was the case with bulky sound-recording equipment in the late 1920s and enormous IMAX cameras today.

Many films produced for mass consumption are very obviously fictional and would not readily evoke values commonly associated with 'realism'. Documentary

involves a contradictory creative treatment of real events. As a genre, it revolves around a polarised tension, in order to hold the viewer's attention it has to be dramatic, yet it must also be factual. Documentary makers make use of point-of-view shots or fly-on-the-wall camerawork to eradicate the sense of intrusion being made by the camera and director, and thereby play on the widespread fallacy that the 'camera never lies'. This particular genre has enjoyed great success on television with the rise of 'docusoaps' in the 1990s, short weekly documentaries featuring 'ordinary' people such as vets, traffic wardens and air cabin crew at work. Such genres are fuelled by people's voyeuristic interest in others, and the commercial imperative to produce low-cost high-yield television in a cultural sector that has exploded since the onslaught of competition heralded by cable and satellite. In comparison with drama, Docusoap and hidden-camera TV are relatively cheap to produce and highly addictive.[15] Global interactive reality game shows such as *Big Brother*, feature uninterrupted and *seemingly* unedited footage of unfamiliar people interacting in groups. Of course, in such voyeuristic situations the camera is never neutral, people act very differently when they know they are being filmed. Footage is also ruthlessly edited for highlights in order to lure viewers and by creating identification and emotional engagement, turning the participants into household names while ensuring high returns from the expense of interactive voting. The line between fictional and non-fictional texts is further blurred in fictionalised sub-genres of documentary. Reality TV-based comedy movies such as *The Truman Show* (1998) and *EDtv* (1999) or fly-on-the-wall TV situation comedies such as *The Office* (2001) have flourished. Small 'factional' cable TV companies devoted to sentimentalised interpretations of real historical events and issues have produced a plethora of inexpensive docudramas, which use a mixture of real documents (such as audio tapes, photographic stills, interviews) and melodramatically staged narratives (the narrative genres of Hollywood cinema such as the thriller, the judicial drama, the romance and the war movie).[16] In such docudramas, emotive linear narratives and the need for resolution leave little room for the viewer to question the (often speculative) interpretation of events.

Many documentary makers, in contrast, emphasise their presence, using the direct address of a 'voice of God' narrator or directorial soliloquy. In the 1930s and 1940s, many directors sought to make highly poetic documentaries, seeing little reason to hide their credentials as artists or auteurs. Pare Lorentz's American Depression-era social documentary *The Plough that Broke the Plains* (1936), for example, made use of Virgil Thompson's highly emotive mood music to add great drama to the lyrical voiceover. Another 'transparency technique' involves transforming the director into the primary agent and star of the film itself. This treatment is most readily associated today with political documentaries such as Michael Moore's anti-gun *Bowling for Columbine* (2003) and with comedy interview documentaries such as *Louis Theroux's Weird Weekends*. Such documentarists enjoy playing

with the tension between fact and fiction, using their comedic talents to pierce the public relations façades they frequently encounter. This satirical realism can be readily witnessed in Moore's 2003 Oscar acceptance speech: 'We like non-fiction and we live in fictitious times. We live in the time where we have fictitious election results that elect a fictitious President. We live in a time where we have a man sending us to war for fictitious reasons.' Like many social realists, Moore holds that his films are more than a mere representational genre, insisting that we view his work critically and regard it as non-mythical in world of mass mediated spectacle.[17] Ultimately, these claims are difficult to defend outright. Like many directors and comedians, Moore is a shrewd manipulator of language and image, something that his political opponents such as the National Rifle Association continue to point out. None-the-less, now that they are institutionally esteemed representations of their time, Moore's films will long remain a focus for debate as people fight over the power to frame the political questions they raise, to determine what constitutes the 'real'.

The various genres of documentary film bear comparison with fictional film that takes its cues from mid-nineteenth-century realism. In the 1960s, French cinema challenged Hollywood blockbusters with *cinéma verité* – movies made on location with low-budget hand-held cameras and tape recorders. Lacking special effects and star actors, directors such as Jean-Luc Godard used non-professionals to improvise unscripted situations freely.[18] In terms of its politics and subject matter, *cinéma verité* shared qualities with Italian neorealist films such as *The Bicycle Thieves* (1949) and *Il Postino* (1995) and British new wave films such as *Saturday Night and Sunday Morning* (1960) and *Billy Liar* (1963).[19] European filmmaking continues to be characterised by its focus on the 'kitchen sink', dramas and comedies based around the routine lives of ordinary people and attendant issues of identity relating to sex, class and race. The predilection for the 'realist' genre Europe is partly due to the fact European film industries lack the financial resources available for special effects and set building in Hollywood. Yet, much European film maintains obvious ideological allegiances with the Realism of mid-nineteenth-century novelists. Moreover, a political and cultural will for low-tech realism to counteract the hegemony of Hollywood exists globally, from independent American cinema to Dogme the films made by Danish directors such as Lars von Trier and others.[20] Low-budget movies that make use of shaky, hand-held cameras such as *The Blair Witch Project* (1999), itself partly a parody of low-budget documentary films, can be more successful critically and economically than megabuck Hollywood blockbusters. The institutional contexts in which films are produced and consumed clearly influence the way in which audiences respond to them. Independent cinema's reputation for veracity precedes it, just as Hollywood cinema comes with cultural baggage that establishes a willingness in the viewer to succumb to fantasy. In all cases we should remember that we are confronting genres that trigger recognition and misrecognition.

Conclusion

It is evident from the numerous examples discussed in this chapter that realism is contingent, and must continually be redefined in relation to what we regard as 'the real' and in relation to the many other genres of visual culture. Consequently, too, the notions of realism and visual representation are inextricably tied to questions of cultural, social and historical difference.

Further Reading

Hall, Stuart. *Representation: Cultural Representations and Signifying Practices* (London, 1997).
Nochlin, Linda. *Realism* (London, 1970).
Panofsky, Erwin. *Perspective as Symbolic Form* (New York, 1992).
Williams, Christopher. *Realism and the Cinema* (London, 1980).

Notes

1 See, Frances Pohl, 'The Rhetoric of Realism: Courbet and the Origins of the Avant-Garde', in Stephen Eisenman, ed., *Nineteenth-Century Art: A Critical History* (London, 1994), pp. 206–24; and T. J. Clark, *Image of the People: Gustave Courbet and the 1848 Revolution* (London, 1973).

2 The Marxist literary critic Georg Lukács argued, for example, that the ability to penetrate the illusions of capitalism, to reveal the underlying logic and structure of capitalist society, was the key goal of realism. See Georg Lukács, *History and Class Consciousness* (London, 1990). First published in 1923.

3 Plato, *Republic* (Harmondsworth, 1955), Book X.

4 Sir Ernst Gombrich, *Art and Illusion* (Oxford, 1960).

5 Erwin Panofsky, *Perspective as Symbolic Form* (New York, 1992). First published in 1927.

6 For more on Murakami's work, see Takashi Murakami, *The Meaning of the Nonsense of the Meaning* (New York, 2000).

7 For more on Socialist Realism, see Matthew Cullerne Bown, *Socialist Realist Painting* (London, 1998).

8 See Alla Rosenfeld and Norton Dodge, eds, *Nonconformist Art: The Soviet Experience 1956–1986* (London, 1995).

9 For more on photography's relationship with everyday experience, see John Roberts, *The Art of Interruption: Realism, Photography, and the Everyday* (Manchester, 1998).

10 Some theorists of visual culture see such developments as heralding a global crisis. See Paul Virilio and Sylvère Lotringer, *Crepuscular Dawn* (New York, 2002).

11 See Raymond Fielding, *A Technological History of Motion Pictures & Television* (Los Angeles, 1984).

12 The technologically determinist theory of total cinema was fashioned by René Barjavel in *Cinéma Total: Essai sur les Formes Futures du Cinéma* (Paris, 1944).

13 For more on the social implications of the impact of technology in television, see Raymond Williams, 'The Technology and the Society', in R. Williams, *Television. Technology and Cultural Form* (London, 1975), pp. 9–31.

14 Betamax boasted better picture quality than VHS, while VHS tapes could record and play-back for longer periods of time. For more on this, see James Lardner, *Fast Forward: Hollywood,*

the Japanese and the VCR Wars (New York, 1987); and Eugene Marlow and Eugene Secunda, *Shifting Time and Space: the Story of Videotape* (New York, 1991).

15 See John Izod and Richard Kilborn, eds, *From Grierson to the Docu-soap: Breaking the Boundaries* (Luton, 2000).

16 See John Caughie, 'Progressive Television and Documentary Drama', in Tony Bennett et al., eds, *Popular Film and Television* (London, 1981).

17 For more on this, see Michael Moore, *Adventures in a TV Nation* (New York, 1998).

18 For more on *cinéma verité* and its aftermath, see Susan Howard and Ginette Vincendeau, eds, *French Films: Texts and Contexts* (London, 1999).

19 See David Overbey, ed., *Springtime in Italy: A Reader on Neo-Realism* (London, 1978); John Hill, *Sex, Class and Realism* (London, 1986); and R. Murphy, *Sixties British Cinema* (London, 1992).

20 The Dogme manifesto laid down the following filmmaking rules: A) All shooting must take place on the original set. B) The sound may not be produced independently of the image. C) Only handheld cameras are to be used. D) Special lighting for colour sets is forbidden. E) Optical gimmicks must be refused. F) Any gratuitous action is to be rejected. G) The films must take place in the here and now. H) Genre films should be avoided.

9. Visual Rhetoric

Matthew Rampley

Introduction

The idea of visual rhetoric is currently associated most commonly with the semiological investigations of writers such as Roland Barthes, Umberto Eco and Norman Bryson.[1] Semiology, originally a theory of the generation of meaning in language, has come to play a crucial role in informing the analysis of visual culture. Indeed, it has perhaps come to be *too* important. This is not to underestimate its value and achievements. It is, however, to emphasise that semiology is only *one* method for exploring the rhetorical dimension of visual culture. Rather than offering an overview of semiology – there are already many useful such accounts – this chapter considers some of the more basic issues that are raised when visual practices are viewed through the lens of rhetorical analysis.[2] Consequently, it is appropriate to begin by considering what is meant by the term 'rhetoric'.

The Concept of Rhetoric

In ancient Greece 'rhetoric' denoted the art of public speaking. In a society in which public debate became central to cultural, legal and political life, the ability to speak effectively and, above all, persuasively, was a highly prized skill. In Greece and, later, Rome rhetoric came to be an important constituent in the education of the upper classes and was also the object of numerous philosophical and technical treatises concerning both the theory of rhetoric and the practical analysis of the

various rhetorical techniques and figures available. Authors such as Aristotle, Cicero and Quntilian codified the art of speaking, producing complex taxonomies of rhetorical figures that remained definitive for centuries afterwards. Some of them are still well known today, including metaphor, simile and metonymy. Others, however, such as catachresis, prolepsis and hyperbaton, are now familiar only to specialists in the field.

In the Middle Ages rhetoric came to occupy a secondary place to logic, but in the Renaissance the revival of interest in classical culture led to a rebirth of the elevated status of rhetoric. Moreover, while Latin remained the language of learning and scholarship, vernacular languages such as English, Italian and French increasingly became the basis of national literatures in the fifteenth and sixteenth centuries, and their claim to being the equal of Latin and Greek was often based on their rhetorical eloquence.[3]

An important question to ask is: What does it mean to speak of a *visual* rhetoric, given that the term was originally concerned with speaking? In fact, the notion of a connection between image and discourse has been central to the understanding of visual art since antiquity. In classical Greece and Rome many of the artworks now admired for their representational realism or mimetic skill were more often concerned with the depiction of myth and legend, and thus had a primarily narrative function. This carried over into the Christian era where visual art was, for hundreds of years, almost exclusively concerned with the presentation of biblical narratives and Christian morality. As early as the twelfth century visual art was being referred to as the 'literature of the lay people' (*litterae laicorum*) and this reinforced the role of art in communicating to a largely illiterate congregation the message and values of Christianity. As a primarily communicative medium, art was thus clearly dependent on the rhetorical skills of persuasion and eloquence in addressing its audience.[4]

This conception of visual art continued into the Renaissance. The earliest treatise on painting, Alberti's *On Painting* of 1435, is often best known for its detailed exposition of perspective and the accurate depiction of three-dimensional space.[5] However, for Alberti painting's social status stemmed not from the painter's ability to copy nature but from its narrative and moral function, which set it on the same level as philosophy. His book contains an outline of the most appropriate ways of presenting a particular narrative (*historia*) which in many respects bears comparison with rhetorical instruction manuals of the same era. More generally, art theory, both during the Renaissance and after, centred on the narrative and rhetorical function of art, and in particular on the relation between verbal and visual rhetoric.

Within Western culture, therefore, visual art has long been regarded as a rhetorical practice, concerned with narrative and with persuading and moving its audience, rather than with the simple accurate depiction of the visual world. Yet in the last thirty or so years the notion of visual rhetoric has enjoyed renewed emphasis;

it has also taken on a different set of meanings from the eloquence associated with rhetoric in the Renaissance. At the heart of the contemporary idea of visual rhetoric is a questioning of the concepts of style, visual communication and visual representation; more specifically, considerable attention has been given to the *strategic* nature of both visual communication and representation. Indeed, where historians and critics once referred to visual style – the formal, aesthetic appearance of a particular practice – they now analyse visual culture in terms of its rhetorical and communicative strategies. In one sense, style remains an important means of describing many of the practices of visual culture, from architecture through to paintings or film; such visual practices all embody a distinctive aesthetic 'look'. However, the notion of rhetoric transforms entirely the significance of 'style'; a comparatively neutral term of analysis concerned with aesthetic appearance is replaced by a concern with the ways in which the practices of visual culture are intertwined with mechanisms of social power and ideology. Rhetoric plays a key role in this altered focus, and underpinning it is the concept of communication.

The Theory of Communication

The process of communication is commonly held to consist in the transmission of information from a sender to a receiver or addressee. A central part of this belief is the ideal of clarity, ensuring that the addressee receives unambiguous information, and that the channels of communication remain unimpeded. This idea is widespread, and within the field of visual culture in particular it has been of huge importance during the twentieth century for the practice of design. The American designer Paul Rand (1916–96), renowned for designing some of the most famous corporate logos in America in the 1950s and 1960s, was also a prominent exponent of values of clarity and simplicity which, he argued, enhanced both the design aesthetic and its communicative value.[6] Rand was not unique in holding to these ideas; in many respects he was perpetuating design values first espoused by the Bauhaus in Germany in the 1920s. These values often still underpin practices of design education today, and they parallel many of the values of the modern movement in architecture, with its insistence that form should be dictated primarily by function or that non-functional ornamental features should be stripped away, or at least reduced to a minimum.

Such a notion of communication is open to scrutiny for several reasons, however. It assumes, first, that if the information reaches the receiver unimpeded, the task of interpreting the *meaning* of the information is straightforward. In contrast, much contemporary thinking emphasises the extent to which this is *not* the case; even the most simple icons and symbols can be interpreted in various ways. This becomes especially apparent in the case of cross-cultural interpretation: there are numerous instances of American and European corporations, for example,

overlooking the possibilities of alternative interpretations of quite ubiquitous logos in other cultures. The name of the mobile telephone company Orange, for example, has a set of connotations in Northern Ireland and certain parts of Scotland – Protestant cultural identity – absent elsewhere.

The idea of a universal, unambiguously clear design language has been a recurrent dream since the invention of ISOTYPE, the pictographic information system by Viennese philosopher Otto Neurath in 1920s, but it is based on a one-dimensional understanding of meaning, communication and interpretation.[7] One of the most important recent movements in critical thought, deconstruction, the linguistic philosophy associated with Jacques Derrida, argues that ambiguity and uncertainty lie at the core of language and meaning. In particular, Derrida argues that language is structured around metaphor; even the most basic description draws on metaphor, and as any student of literature knows, metaphors introduce the possibility of multiple meanings and interpretations.[8] While it has always been a dream of Western thought, from Plato to the present, to produce clear, unambiguous communication, and to discard rhetoric and metaphor, this is an impossible task. Indeed, a hallmark of the works of Derrida has been to analyse the supposedly conceptually simple and clear texts of both historical and contemporary philosophers and to expose the extent to which they are open to multiple meanings and interpretation precisely because of their reliance on metaphor; even the term 'metaphor' is a metaphor. And while Derrida has been concerned primarily with debates about linguistic meaning and communication, it is clear that the *ideal* of clarity is one which, in Western society at least, has been entertained not only by philosophers, but by the culture as a whole. This includes the discourses of design and architecture. Indeed, the lessons of Derrida's thinking for design has not been lost on theorists, practitioners and educators in the field; in the United States Katherine McCoy of the Cranbrook Academy of Art introduced deconstruction into graphic design education in the late 1970s and early 1980s, with numerous designers subsequently working under the influence of the ideas developed at the Academy.[9] As Lupton and Miller have pointed out, the implications of deconstruction for graphic design practice have been far-reaching, impacting on the most basic assumptions about, for example, layout, punctuation, typographical design and spacing.[10]

The example of cross-cultural miscommunication is indicative of the second difficulty with traditional theories of communication, namely, the assumption that it is a simple, one-way process of transmission. Over the past forty or so years various critics have tended to stress the extent to which that transmission is framed by numerous factors – social, political and economic – which shape how it is received. In other words, even the simplest form of communication takes place within the social and political world, and as such it is part of that world. In the same way that basic social relations are shaped by the respective roles of the participants, so too

any communication between them is equally framed by the same factors. For example, even relations within the family, between parent and child, for example, are framed by the tacit assumptions and expectations held by each of the other. Indeed, difficulties in communication often take place not through the ambiguity of what is being said, but because the individuals are no longer conforming to their usual allotted roles. Wider social norms inscribe themselves into what are seemingly the most private forms of social interaction and communication, and this frequently involves questions of social power. As Michel Foucault has argued, the speech of the doctor, lawyer or psychiatrist takes on a specific significance not merely because of its content, but because of the authority of the profession. In a culture of 'experts', the communications of certain professionals have a social authority that determines in advance how they will be received.[11] In some cultures it is the pronouncements of the elderly that have the same social weight, while in many cultures it is the pronouncements of *men* that have the most weight, as many feminist critics have argued. More generally, communication is now seen in terms of its role in confirming or subverting existing structures of social authority and power, and this means that the simple transmission model fails in accounting for the social and political dimension of communication.

The third point of criticism of the transmission theory of communication comes from the suggestion of the British philosopher Paul Grice (1913–88) that the aim of communication is not, in any case, to impart information, but to elicit a certain kind of response in the addressee.[12] Anyone who has had the experience of a deadpan response from the partner in a conversation will be able to identify the unsettling nature of such a failure. At a most basic level communication desires some form of recognition from the other, and at a more complex level one communicates with others in order to prompt or produce some kind of behaviour on their part, whether the continuation of a dialogue, humour, misery or some form of action. Communication consists not simply in the transmission of information, but the presentation of it in order to elicit a desired response. In this sense communication can be seen to be strategic, in that it relies on a variety of skills and techniques, both linguistic and non-linguistic, to achieve an ulterior goal. Problems and breakdowns in communication often occur not through a misunderstanding of the information being imparted, but through a failure to respond in the anticipated manner.

With the suggestion of Grice we are back to the classical notion of rhetoric as the employment of skills aimed at moving, persuading or humouring an audience. However, in the light of the first and second critiques outlined above, this model has been modified by stressing, first, that rhetoric is not a particular type of communication, but rather that *all* communication is rhetorical and, second, that rhetoric is enmeshed within structures of social, economic and cultural relations and power. As an example to illuminate the first point, there has been a series of television

advertisements over the past four or five years by the DIY product company Ronseal. A common strategy in all of the advertisements, regardless of the particular product, has been to stress the no-nonsense dimension to their products. The common catchphrase – now parodied elsewhere – is: 'It does exactly what it says on the tin.' In an era of scepticism towards advertising, this comes across as an appeal to older virtues of honesty and straightforwardness, eliciting a sense of trust in the consumer. However, this *lack* of rhetorical flurry is itself a strategy, using a rhetoric of simplicity and straightforwardness, even employing an average man-in-the-street actor in the advertisements. This advertisement is as carefully calculated and strategic as any more obviously 'staged' advertising strategy.

Visual Communication and Visual Rhetoric

The Ronseal advertisement highlights the particular suitability of advertising to this type of analysis. Advertising by its very nature is a strategic form of visual communication, of which its audience has also become all too aware. The last time an audience seriously sought 'objective' information about the product being advertised was probably in the 1950s. Now we are all used to being presented with advertisements that evoke imaginary lifestyles associated with the products or that emphasise the fashionability of the product (from paint to mobile phones) or which indicate the nature of the ideal and typical consumer of the good in question, thereby appealing to the audience's own imagined sense of identity. The advertising industry has developed a massively complex machinery devoted just to this task of strategic communication. It is no surprise, therefore, that when questions to do with visual communication and rhetoric are explored, it is frequently the imagery of advertising that is turned to first. Perhaps the best-known and earliest such exploration was Roland Barthes' *Mythologies*.[13] The essays are now somewhat dated, but Barthes' study provided a model for subsequent analyses of advertising imagery which focused on the strategic techniques and effects of advertising.[14]

Barthes' essays were important because they explored both the ways in which advertising in particular aims to seduce the audience into consuming the particular product (or, more generally, into an attitude of affirmation of consumer culture) and the ways in which strategic visual communication in general becomes enmeshed within structures of social and political power. One of the most celebrated examples was his analysis of the cover of the French magazine *Paris Match*, which featured a young African boy saluting the French tricolour. For Barthes, this image presented the French Empire in a particularly appealing and persuasive manner: 'I see very well what it signifies to me: that France is a great empire, that all her sons, without any colour discrimination, faithfully serve under her flag, and that there is no better answer to the detractors of an alleged colonialism than the

zeal shown by this Negro in serving his so-called oppressors.'[15] In other words, this image aimed to affirm the legitimacy of the Empire.

The general implication of Barthes' essays was that rhetorical strategies have a particularly important role to play precisely when power structures and hierarchies are at stake; such hierarchies often make carefully calculated rhetorical appeals in order to gain the consent of others, and often to *mask* the actual operations of power. In this sense strategic communication has a supremely ideological function. A recent classic example of this is the rhetoric adopted by George W. Bush in the wake of the 9/11 hijackings, in which the 'war' between the United States and al-Qaeda was cast in terms of freedom versus unfreedom. It was difficult to resist the appeal to such an emotive term as 'freedom', particularly given the odious and nihilistic ideology supported by Osama bin-Laden. At the same time, however, there was a notable *curtailment* of civil liberties in both the United States and Britain, and it occurred to few at the time that the 9/11 attacks might themselves have been undertaken in the name of freedom, this time freedom *from* American interference in Middle Eastern affairs.

This is a particularly emotive issue, and it is still very immediate. It is often easier to get a sense of the strategies in operation when analysing texts from which one has slightly greater distance. Figure 9.1, for example, is a photograph from a magazine published in France in 1931 entitled *L'Illustration*. It is part of a report on colonial affairs, and in particular on the *Exposition Coloniale* held in Paris during 1931. From the perspective of the present the strategic, rhetorical nature of image is obvious. It draws a series of distinctions between the French aviator and the Cambodian reception party. For example, there is the gender divide in which the masculine explorer is greeted by female 'natives'. An important distinction is made between the modernity of the Frenchman emerging from his aeroplane, the latest symbol of Western technological progress, and the tradition-bound nature of Cambodian culture. This image confirms the perception of the Empire in 1930s France as a progressive modernising force, in which the colonial cultures are seen as passive feminine recipients of such enlightenment. This is a generalisation, of course, and I make it only because this image fits into a pattern that one sees repeated in numerous other examples. It is also reinforced by what are known to have been widely held views of masculine and feminine identity in the 1930s. From the perspective of the present, where our sensibilities are somewhat different, we will view this image in a different light. Where, in its own time, the image is celebrating colonisation as a progressive force, we might see in it the erosion and destruction of local cultures by the West. Where the modern French aviator is celebrated as bringing technological progress to a tradition-bound society, we might well see inequality and colonial exploitation. There are numerous other possibilities, and the key question is not which of those possibilities is 'correct', but rather the more general point that this photograph is interpreted not in terms

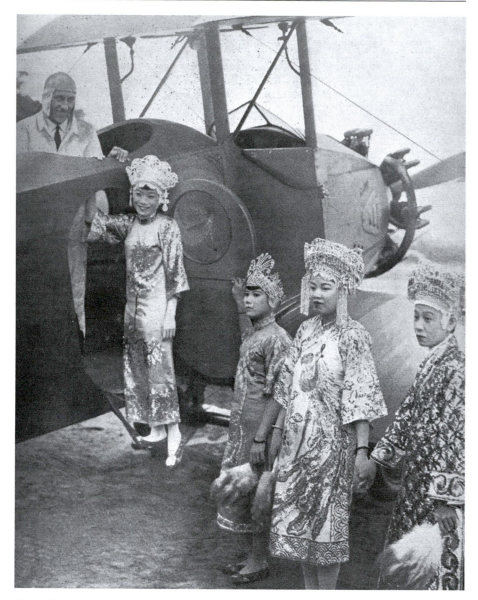

Figure 9.1 – Anonymous, *An Aerial Baptism for Dancers from Indochina* (1931). From
L'Illustration magazine.

of the information being transmitted, but in terms of its strategic and rhetorical
functions.

So far I have spoken in general terms of the rhetorical nature of images, but it
is possible to draw more precise parallels between visual and verbal rhetoric.
Metaphor, for example, the depiction of one thing by means of another, is one of
the most familiar rhetorical devices, and it is possible to speak as much of meta-

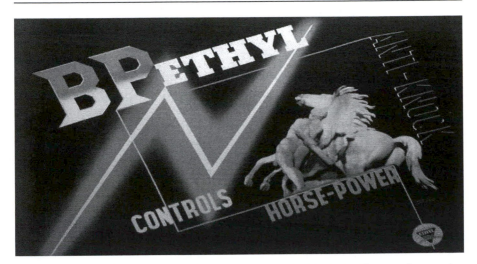

Figure 9.2 – Edward McKnight-Kauffer, *Advertising Poster for BP* (1934). Photograph courtesy of Paul Rennie.

phor in visual terms as it is in verbal terms. The 1925 advertisement by Edward McKnight-Kauffer for BP (Figure 9.2) is a clear example. Instead of offering descriptive information about the price, quality or some other aspect of petroleum oil, the advertisement surrounds it, together with the Shell company, with a series of associations evoked by use of metaphoric imagery. The image of the horse connotes strength and nobility, and the chain suggests the security and reliability of the product.

While horsepower had long been a measure of energy and dynamism, this measure is raised to a further level by the use of horse motif replete with suggestions of classical antiquity. Thus a commodity central to the modern and swiftly evolving technologies of the internal combustion engine (the aeroplane, the automobile, the engine or the ship) is promoted by appeal to an altogether different set of values that suggest permanence, timelessness. The prosaic task of selling petroleum is given an altogether different set of meanings through the metaphor of the classical horse. Indeed, this is a well-established advertising technique: to endow a product with authority or 'cultural capital' by means of metaphoric association. It can be seen in the way that Old Masters' paintings are regularly included in advertising and marketing to suggest the cultural level of both the commodity and of the targeted audience (Figure 9.3).

Metaphor is undoubtedly one of the most powerful and common rhetorical devices used in visual representations, but there are others, too, including antithesis: the employment of exaggerated contrasts. The image of the French pilot and the Cambodian women offers a clear example of this, and it is employed not only within advertising imagery but in other kinds of image, including works of art. A

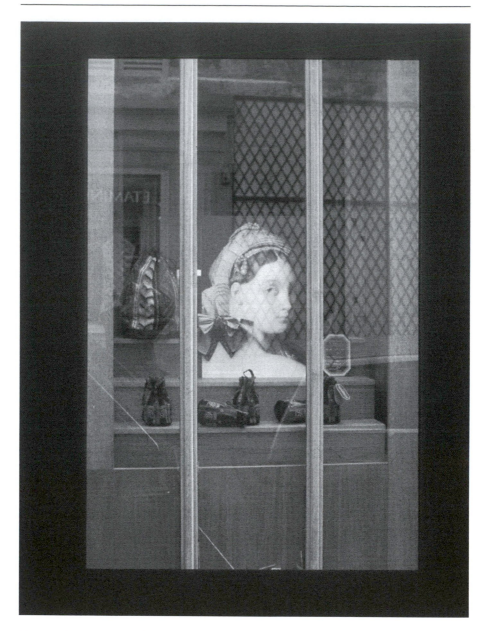

Figure 9.3 – A window of a shoe shop in Paris, with a painting by Ingres as part of the display. Photograph: Ruth Pelzer (2003).

much-cited historical instance of the latter is Jacques Louis David's famous painting of 1784, *The Oath of the Horatii* (Figure 9.4), which is based on an early Roman legend. The painting depicts three brothers (the Horatii) swearing loyalty to Rome before going to do battle with three brothers, the Curiatii, from a neighbouring city.

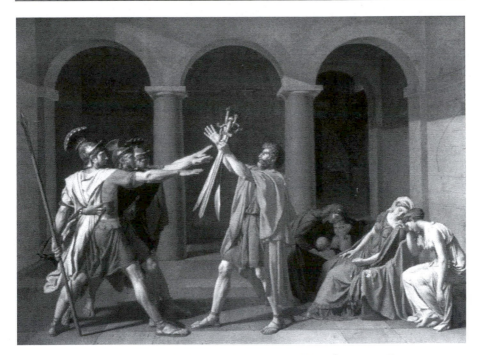

Figure 9.4 – Jacques Louis David, *The Oath of the Horatii* (1785). The Louvre, Paris.

The legend gains a tragic dimension from the fact that two of the Horatii will die in the combat, and also that one of their sisters, shown swooning on the right of the picture, is betrothed to one of the Curiatii. She is thus faced with the possible double loss of lover and brother. The contrast between the brothers and their sister and her companions could not be more marked. The women seem absorbed in private grief, their bodies bent over, in contrast to the upright, almost robotic stance of the brothers. Indeed, the brothers have ceased to be individuals in David's painting, and have relinquished individual concerns in order to fulfil their duty to the city. In part, this painting puts forward a striking image of the difference between the sexes – masculine civic duty versus feminine private emotion. It is also, however, an exhortation to civic and political activism; David was a supporter of the revolutionary politics of the time, and this painting is clearly the product of a highly politicised age. The idea of political struggle and martial duty is centred in particular on the swords for which the brothers are all reaching, which also function, perhaps, as phallic symbols of masculine strength; their ageing father seems to be handing over the role of patriarchal authority to his sons. There is an epilogue to this painting, too, in that after the battle the remaining brother catches his sister mourning her slain lover and kills her for her disloyalty. Everything about the legend exhorts one to put aside private feelings and loyalties in the name of civic and political duty, and David's painting is an extraordinary exercise in visual rhetoric.

The Rhetoric of Material Artefacts

So far I have focused in particular on representational images. When analysing visual rhetoric, however, it is crucial to consider material artefacts and the practices of design and architecture. For much of the twentieth century this dimension was systematically neglected; the dominant ideology of modern design and architecture stressed their functional basis, it being almost a moral imperative to base the formal design on the demands of the function. Ornamentation was deemed unnecessary and aesthetically impure; in 1910 the architect and designer Adolf Loos famously declared the criminality of all modern ornament.[16] With the demise of such values since the 1970s, critical attention has turned to the communicative and rhetorical dimension of design and the built environment. Indeed, the first object of analysis can be the modernist practices that declared themselves to be entirely functional. Marcel Breuer's celebrated *Wassily* armchair from 1927/8 (Figure 9.5) has often been seen as an iconic modernist design in which the form of the chair has been conceived in terms of its function; in addition, in place of the reliance on the skills of the individual craftsman, the chair has been designed for ease of mass production. In the place of superfluous 'styling', Breuer presents a wholly functional design.

However, this standard modernist account leaves out the rhetorical character of the design. Most immediately the materials, and in particular the chrome steel tubing, are not only functional, they are metaphors of modernity. The steel tubing connotes technological progress, with its clear dependence on processes of modern industrial manufacture. Furthermore, the simple geometrical structure of the chair also suggests technological efficiency, its use of standardised forms again strips away the vagaries of the individual maker. Not merely an instance of modern design, Breuer's chair is also an *argument* for the virtues of the modern movement; to express this in a slightly different vocabulary, the chair's *lack* of styling is itself a style.

The example of Breuer indicates how even ostensibly 'functional' design practices ultimately employ rhetorical strategies; functionalism was an ideological outlook that employed a visual rhetoric in the advancement of its claims. Recognition of this dimension within design and architecture has been widely associated with the rise of postmodernism. As Richard Williams has pointed out, Robert Venturi and Denise Scott Brown played a crucial role in highlighting the symbolic and metaphorical character of the urban environment. In *Learning from Las Vegas* they stress the extent to which the architecture of Las Vegas departs from modernist norms; in the place of pared-down functionalism there is a prevalence of elements – large-scale signs, advertisements, images – which, though not *structurally* necessary, are integral to the overall meaning of the designs.[17] The principal reason is that the architecture is designed to be seen from the car. In Las Vegas there

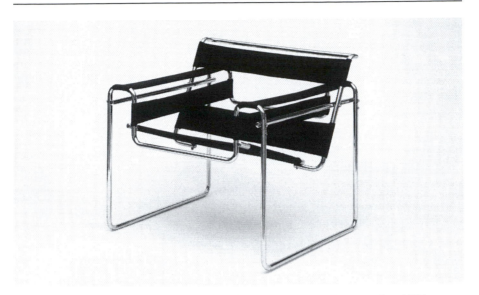

Figure 9.5 – Marcel Breuer, *Wassily* armchair, Model B3. Dessau, Germany (late 1927 or early 1928). New York, Museum of Modern Art. Photograph © Photo SCALA, Florence.

has emerged an architectural rhetoric tailored for the automobile age, and the resulting urban environment lays bare the extent to which architectural design is a form of visual communication and rhetoric.

A similar argument was advanced by the architectural critic Charles Jencks. In *The Language of Postmodern Architecture* Jencks placed considerable importance on the rediscovery of symbolism and rhetoric in 1970s architecture, evident in its rediscovery of past forms and revival of local traditions.[18] Examples could be found in the classicism of architects such as Venturi, Quinlan Terry or Leon Krier, or in the references to local 'adobe' mud-brick native American dwellings of the south-western United States in the work of American architect Antoine Predock. For Jencks the failure of modern architecture to gain popular appeal was due to its neglect of rhetorical figures and motifs that would be meaningful to its users. It failed to communicate with its intended audience.

In one sense attention to the rhetorical dimension of architecture is not partic-ularly new; there has been a long-established tradition of drawing analogies between architecture and language, dating back to the seventeenth century.[19] However this often amounted to little more than a comparison of architectural structure with the grammar and syntax of language. To stress the role of architec-ture as a form of visual rhetoric implies a more complex process in which archi-tecture becomes a strategic, ideological medium of communication. Much the same can be said of design in general. The examples of the Breuer chair or the Ronseal advertisement discussed earlier suggest that there is no such thing as an entirely neutral or rhetoric-free design. The question is not, therefore, *whether* the

designed objects of contemporary culture have a communicative, rhetorical dimension, but rather what the *form* of that dimension is. One response to this question has focused on the consumer culture of Western societies. Where 'styling' and design were once viewed simply as forms of embellishment, they are now viewed as rhetorical ploys to promote consumption. The selling and marketing of commodities is often thought of as a process external to the commodities themselves, whereas from another perspective the process of marketing is integral to the design process. Central to this explanation is the theory of commodity fetishism developed by Karl Marx in *Capital* (1867).[20] On the one hand, Marx argues, the commodity is a mass-produced artefact, a result of human labour, exchangeable for any other of its type. On the other hand, it becomes endowed with its own properties, as if it were more than a product. As Marx states, there is a parallel with the religious world, for in that world, 'the products of the human mind become independent shapes, endowed with lives of their own, and able to enter into relations with men and women. The products of the human hand do the same thing in the world of commodities'.[21] In other words, we blank out knowledge of how the artefact came to be produced, thereby fetishising the commodity, as if it had a life of its own.

Marx himself did not pursue the implications of this notion much further but others, such as Walter Benjamin, have pointed out the role of commodity fetishism in sustaining consumption. In the era of mass industrial production commodities lose their distinctiveness, but fetishism endows them with an aura as if they were unique; although we know that this car, this suit or this bottle of perfume is one of many identical copies, we still behave towards commodities we own *as if* they were more than this.[22] Hence, rather than meeting basic 'needs', commodities address a wide range of desires, wishes and anxieties on the part of the consumer. Commodities play a crucial part in the formation of individual identities, whether it is the clothes one wears, the music one listens to, the books one reads or the car one owns, for example. It is here that design plays a key role in the promotion of commodity fetishism, in presenting a kind of rhetoric of the object. Packaging, for example, says rather less about the product and rather more about the lifestyle values to be associated with it, and, ultimately, the identity of the consumer. Supermarket own-brand products, for instance, often tend to be extremely plain and simple, employing bold primary colours, a limited colour scheme, and bold and plain typography, all of which connote a no-nonsense, 'honest' approach to consumption. This stands in implicit contrast to the over-designed packaging of other brand names.

As with design in general, packaging also impinges on questions of social class and taste. For many consumers, such supermarket brands imply cheapness, poor quality and a specific social class. This connotation is as much a function of the packaging design as it is a reflection of their actual quality. It is also a function of

how consumers identify themselves socially. High-quality goods are expected to have sophisticated packaging design. Indeed, it is one of the triumphs of packaging design to suggest that the mass-produced commodity is in fact a distinct, limited series, desirable object. In contrast, the packaging of supermarket own-brand makes no secret of the mass-produced basis of the items on sale. In this regard it is also significant that some supermarkets promoting their own 'deluxe quality' products adopt the same techniques as other known quality brands: distinct but sophisticated use of typography and imagery, understated pastel colours, and so forth.

The example of packaging may seem to confirm the idea of design as external to the actual product. However, a similar argument can be made about almost any commodity, from the design of cars to furniture. An important basis of the recent popularity of Shaker-style or minimalist furniture, for example, comes from the way in which such objects present a rhetoric of sophistication; in contrast to the over-designed 1980s and early 1990s we are presented with furniture that communicates a subtle, understated and contemporary sense of design. This enhances the desirability of the products themselves and also communicates how the consumers see themselves. All of these connotations are functions of the visual rhetoric employed.

It may be contentious to link design rhetoric so unambiguously with consumption; certainly design is not reducible to rhetoric. Objects are also designed with aesthetic and functional considerations in mind, but as Juliette MacDonald argues, there have been important connections since the nineteenth century between the history of design and the vicissitudes of modern consumer culture. This parallel development is not a mere historical coincidence, for rhetoric has been central to the role of design as an engine of consumption and hence to the development of design in general.

Conclusion

Recognition of the rhetorical dimension of visual culture has fundamentally altered the ways in which the visual imagery, forms and designs encountered on a daily basis are interpreted. In the place of passive objects and images we find ourselves surrounded by a visual environment that is constantly addressing us, inviting us to interact with it and to define our own place within it. The notion of visual rhetoric therefore highlights the need to see past apparently innocent qualities such as 'style', 'aesthetics' or 'function' in order to attend to the ways in which the visual environment, visual culture, attempts to draw us into its arguments, into its value systems. We may ultimately accept those values and arguments, but the point is to recognise that we are doing so consciously, rather than being seduced by the rhetorical brilliance of its seductive surfaces.

Further Reading

Bryson, Norman. *Vision and Painting* (London, 1981).

Chang, Briankle. *Deconstructing Communication* (Minneapolis, 1996).

Kress, Günter and Van Leeuwen, Theo. *Reading Images. Grammar of Visual Design* (London, 1995).

Vickers, Brian. *In Defence of Rhetoric* (Oxford, 1988).

Notes

1 An important and much-cited essay by Roland Barthes is 'The Rhetoric of the Image', in *Image, Music, Text*, trans. S. Heath (New York, 1978), pp. 32–51.

2 A useful introductory text is Daniel Chandler, *Semiotics: the Basics* (New York, 2002).

3 For a concise account of the role of classical rhetoric in the Renaissance, see Brian Vickers, 'Rhetoric and Poetics', in Charles Schmitt and Quentin Skinner, eds, *The Cambridge History of Renaissance Philosophy* (Cambridge, 1988), pp. 715–45.

4 On the medieval theory of art, see Umberto Eco, *Art and Beauty in the Middle Ages* (London and New Haven, CT, 1986).

5 Leon Battista Alberti, *On Painting*, trans. C. Grayson (Harmondsworth, 1991).

6 See, for example, Paul Rand, 'From Cassandre to Chaos', in *Design, Form and Chaos* (London, 1993), pp. 207–17.

7 See Otto Neurath, *International Picture Language. The First Rules of Isotype* (London, 1936). The acronym 'ISOTYPE' stands for 'International System of Typographic Picture Education'.

8 The classic discussion by Derrida of metaphor is 'White Mythology. Metaphor in the Text of Philosophy', in *Margins of Philosophy*, trans. A. Bass (Hemel Hempstead, 1982), pp. 207–72.

9 See *Cranbrook Design: The New Discourse* (New York, 1990).

10 Ellen Lupton and Abbott Miller, 'Deconstruction and Graphic Design', in E. Lupton and A. Miller, *Design Writing Research* (London, 1996), pp. 3–23.

11 Michel Foucault produced numerous studies of different kinds of professional knowledge emphasising their enmeshing within systems of power. See, for example, *Madness and Civilisation*, trans. R. Howard (London, 1971). Foucault explains his ideas clearly in an interview entitled 'Clarifications on the Question of Power', in *Foucault Live. Collected Interviews 1961–1984*, ed. S. Lotringer (New York, 1996), pp. 255–63.

12 See Paul Grice, *Studies in the Way of Words* (Cambridge, MA, 1989).

13 Roland Barthes, *Mythologies*, trans. A. Lavers (London, 1973).

14 An important such example was Judith Williamson, *Decoding Advertisements* (London, 1978).

15 Barthes, *Mythologies*, p. 116.

16 Adolf Loos, 'Ornament as Crime', in I. Frank, ed., *The Theory of Decorative Art* (New Haven, CT, 2000), pp. 288–94.

17 Robert Venturi, *Learning from Las Vegas* (Cambridge, MA, 1972).

18 Charles Jencks, *The Language of Postmodern Architecture* (London, 1977).

19 See Adrian Forty, 'Language Metaphors', in A. Forty, *Words and Buildings. A Vocabulary of Modern Architecture* (London, 2000), pp. 62–85.

20 Karl Marx, *Capital*, trans. E. and C. Paul (London, 1932), Vol. I, pp. 43–58.

21 Ibid, p. 45.

22 The key essays by Benjamin on this topic can be found in Walter Benjamin, *Charles Baudelaire. A Lyric Poet in the Age of High Capitalism* (London, 1997).

10. The Rise and Fall and Rise of the Author

Matthew Rampley

Introduction

In the Victoria and Albert Museum in London there is a self-portrait (Figure 10.1) by the Swiss artist Henry Fuseli (1741–1825). It depicts the artist in a state of inner reflection. The furrowed brow suggests not merely contemplation, but also a state of concern, anxiety even, which is matched by the penetrating gaze of the eyes – especially the artist's right eye – and the sparsely rendered hair, all of which combine to connote mental unease. Those familiar with Fuseli's work will be able to place this image in a broader pattern; Fuseli became enormously popular in London in the 1780s and 1790s for producing paintings of gruesome myths and nightmarish visions that presented a cruel and terrifying mythic underside to the rational surface of human culture and behaviour. Fuseli was an early romantic artist whose self-image accords with a wider set of imaginative representations.

There is, however, another way of viewing this image, which takes into account Fuseli's portrait of himself as an *artist*. Here the mental unease and anguish implied in the drawing are a function not merely of the troubled state of the human condition, but also of Fuseli's identity as an artist. If we view Fuseli's portrait in this way, it falls into a different pattern, gaining its meaning less from other works in Fuseli's *oeuvre* and rather more from a motif that became widespread in the late eighteenth and early nineteenth centuries. According to this reading, Fuseli's self-portrait is a marked example of a particular mythology of the artist associated with Romanticism. Following that mythology artists occupy a marginal place in society,

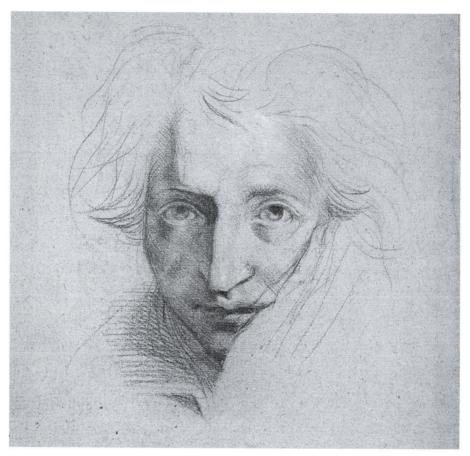

Figure 10.1 – Henry Fuseli, *Study for Self-Portrait* (1780s). Photograph courtesy of Victoria and Albert Museum, London.

driven by an irresistible creative urge that sets them apart from their everyday fellow humans, one that makes conformity to social norms difficult if not impossible, and one that is often the cause of inner mental turmoil. This notion of the artist is paralleled by an equal mythology of art, which sees it primarily as the expression of the subjective thoughts, emotions and beliefs of the artist. The artwork acts as a conduit, as it were, to the inner mind of the creator.

Romantic Myths

This has been a widespread idea which, though evident in the work of an artist of more than 200 years ago, remains active to the present day. The fascination with individual artists is apparent in a wide variety of forms. Artists' biographies remain popular, as do films about well-known artists; recent examples include *Pollock*

(2000), *Frida* (2003), *Surviving Picasso* (1996) or *Artemisia* (1998). Indeed, it is testament to the power of this myth that we are often drawn to those artists whose life and work seemed most characterised by struggle, whether in the form of mental illness (Vincent van Gogh) gender (Artemisia Gentileschi), sexuality (Caravaggio) or physical disability (Frida Kahlo). And where the artist's work does not manifest signs of such inner anguish, we feel compelled to create a biography of struggle, as was displayed most dramatically, perhaps, in Peter Schaeffer's play about Mozart, *Amadeus*, which was subsequently made into a highly successful film in 1984. A similar fascination with individual creativity can be seen in other areas of visual culture, too. As mentioned earlier in this book, a number of critics writing in the French cinema journal *Cahiers du Cinéma* in the late 1940s argued for the need to analyse the creativity of individual film directors, a plea which eventually led to the auteur theory. This elevated directors such as John Houston, Howard Hawks or Ingmar Bergman to the status of 'artist', with all of the connotations implied by that term.[1] Within design, too, there has been a tendency for certain designers to be raised to this same mythic level. Although this tendency is not nearly as well established as in the sphere of art, for example, 'star' designers have become the subject of the same fascination. One might cite Neville Brody or David Carson, both of whom were celebrated for having broken the 'rules' of graphic design of the 1980s and 1990s in the name of individual creative freedom.

These examples are all recent, and a fascination with the artist can be traced back to earliest times; legends to do with admiration of artistic skill can be found in the mythology of ancient Greece, creation myths of the Near East and also ancient sources in China and eastern Asia.[2] However, the particular mythology I mean here, in which creativity is valued as a source of individual expression, has a more recent origin in the Italian Renaissance when, for the first time, artists ceased to be mere 'craftsmen' undertaking paid commissions and came to be recognised as individual creators in their own right. Undoubtedly, the first such celebrity artist was Leonardo da Vinci, but many others followed, including Titian, Raphael and Michelangelo. As Martin Warnke has argued, an important role was played by the patronage of the courts of Europe, which bestowed upon artists a status they had hitherto been denied, granting the most successful artists considerable material wealth and, in some cases, ennoblement.[3]

The rise of the romantic idea of the artist is due to three primary factors. First, the establishment of the artists' academies in the late sixteenth century, which served to elevate the status of the artist, separating him (and it was a primarily masculine profession) out from the 'mere' artisan or craftsman. Following the founding, in 1568, of the Accademia del Disegno in Florence, and especially after the establishment of the Académie Royale in Paris in 1648, academies became widespread across Europe and the Americas during the seventeenth and eighteenth centuries and confirmed the status of artist as a distinct calling.[4] Second, the

importance of *individual* creativity, which had been given increasing prominence during the sixteenth century, was given a lasting philosophical grounding by Immanuel Kant's *Critique of the Power of Judgement* (1790), which presented a number of ideas that would prove to be highly significant for subsequent artistic theory.[5] Chief among these was his claim that artistic creativity consisted in the exercise of originality, using a naturally endowed talent Kant described as 'genius'. As has been pointed out in the discussion of craft in chapter 3 above, Kant also contributed to the hierarchy of fine art and the applied arts or craft, by insisting on the difference between the craftsman's dependence on repetitive mechanical formulae and the artist's spontaneous and original production. Third and finally, the rise of modernism in the mid-nineteenth century led to a valuing of art practices that departed from tradition, in which the artist expressed his subjective ideas against the weight of the tradition of the Old Masters. Beginning with Gustave Courbet, this process gained momentum throughout the second half of the nineteenth century and into the twentieth, leading to what American critic Harold Rosenberg termed the 'tradition of the new' and what Donald Kuspit described as the cult of the avant-garde artist.[6]

Historical and Social Criticisms

Hitherto I have referred to the post-Renaissance notion of the artist as a mythology. This is deliberately contentious, but while it remains influential even today, it has been the subject of numerous criticisms. In particular, it has been accused of over-looking the social basis of visual culture and of operating with an unhistorical conception of the self, in which notions of personal freedom and expression have been mythologised and illegitimately raised to the status of absolutes. Commentators have emphasised the extent to which the individual artist operates at a certain time and in a certain place. Michael Baxandall, for example, has demonstrated how intention is framed and shaped by a complex set of historical and social expectations.[7] Other historians and critics, motivated by Marxist and feminist social theories, have made this point even more forcefully. T. J. Clark, for example, famously argued for a 'conjunctural' approach that emphasised the complex relations between artists, artistic institutions, politics, history at a particular point in time, in which the artist becomes merely one of several factors to be taken into consideration.[8]

Social theorists have made similar points. In *Art Worlds*, for example, Howard Becker stresses the collective character of art, which consists not simply in the production of artworks by an individual artist, but also their reception by an audience familiar with the particular artistic conventions, supported by the various institutions of distribution, from galleries and museums to cinemas, publishers and media enterprises.[9] For such critics, the activity of the artist is always circumscribed by what seems possible at the time and in the culture in which they are operating. They

are often acting within a framework determined by a variety of external forces, some of which are perceived by the artist as obstructions and constraints on their creative freedom, but many of which are so deeply embedded that they have become internalised or second nature, and are no longer felt to be a constraint.[10] For instance, the tradition of the new had become so deeply enmeshed within the self-image of modern art and the artist by the mid-twentieth century that it was no longer possible to be considered a serious artist and to make traditional figurative paintings and sculpture. Yet few would have perceived this as an external constraint because the requirement to be new, original and groundbreaking had become internal to the idea of art. Indeed, Pierre Bourdieu has explored precisely this domain of social experience: the extent to which social constraints and structure become internalised and accepted as natural by individual social agents.[11]

It is widely recognised that a fascination with individual artists developed only in the fifteenth century. The names of identifiable artists become ever sparser the further one delves back historically. This may in part reflect incomplete historical records, but it equally indicates the nature of creative practice before the Renaissance. In pre-Renaissance Europe, artists were skilled craftsman, concerned less with personal expression and originality than with employing their skills in the successful completion of the requirements of the contract. Indeed, the only other era in the history of Western culture prior to the Renaissance that artists achieved a measurable status as individuals was in classical and Hellenistic Greece of the fifth and fourth centuries BCE, when sculptors such as Praxiteles and Pheidias, architects such as Iktinos and legendary painters such as Zeuxis and Apelles achieved a high degree of social recognition. Even in these cases, however, artists and architects worked within highly prescribed parameters that dictated choice of materials, subject matter and iconography. A parallel situation can be seen in many non-Western cultures. Although there are now numerous recognised artists, filmmakers and architects in Africa and Asia, the apparent similarity with Western culture is largely due to the global impact of the North American and European art world, and is a quite recent phenomenon. The greater part of the visual and material culture of many African and Asian states has been produced by anonymous makers, whose primary goal has been to implement the received canon of traditional rules, techniques and skills of production rather than set themselves as individuals *against* tradition. Likewise, both during the European Renaissance and for long after, art was produced according to set canons of quality and technique, in which emulating the past was as important as asserting one's individual identity as an artist. Even for Leonardo art was a matter of objective mirroring of nature in which the self was transcended. It was anything but a matter of mere personal expression.[12]

While many artists in the West gained recognition thanks to their undoubted skills and often on account of their novel treatment of traditional themes, novelty *per se* has only been foregrounded in the past 150 years. Moreover, the fact that the

larger part of the production of art was made to commission, in which the format, content and even the materials were often specified with an extraordinary degree of detail, highlights the need to be wary of projecting contemporary notions of art and artistic creativity onto the visual culture of our own past, not to mention that of other cultures.[13] The comparison with design is instructive in this regard, for the fact that very few designers have become as well known as artists or architects is undoubtedly an indication of the different basis of design production, which is largely client- rather than producer-led, and in which individual designers frequently work within larger agencies rather than as individuals.

Within architecture, too, excessive significance has been attached to the figure of the architect, even though the construction of a building is the outcome of collaboration between numerous agents, including the architect, building contractors, engineers and many others. While the architectural profession is largely organised into practices, it is still frequently the senior architect – one might think here of Norman Foster, Richard Rogers or Daniel Libeskind – who will be given credit for projects that will have been the work of other designers and architects within the same firm. There is a parallel, too, with the history of artistic production. While the popular and romantic idea of artists such as Leonardo is of the artist as a lone individual working in a studio, until well into the nineteenth century, most successful artists ran workshops with numerous apprentices who would undertake much of their work commissioned. While the head of the workshop may have executed more demanding elements of the work, such as hands or faces, much was completed by apprentices. There are numerous examples of contracts that stipulated what was to be completed by the artist and what could be left to their apprentices. This again means that in looking at images of the past it is often problematic to see them as the result of one artist and of a single creative vision. Of course, many works *were* produced by the individual artist, but it is unwarranted to project this model onto all artistic production. A similar criticism can be made of auteur theory; while the director is a key figure in the determination of the eventual form of a film, it is the result of a much more complex collaboration, involving the actors, producers, financiers, camera operators and other technical staff. To single out the director is a relatively arbitrary choice and testifies to the continuing power of the modern myth of the artist in shaping a need and desire to identify a single source of creative production.

Feminist Critiques

The modern mythology of the artist has also been a target of feminist criticism. The philosopher Christine Battersby argued in a well-known book, *Gender and Genius*, that the concept of genius has always been seen in exclusively masculine terms.[14] In her essay of 1971 entitled 'Why Have There Been No Great Female

Artists?' the American art historian Linda Nochlin posed the pointed question as to why women artists have such a small presence within standard histories of art.[15] (One could equally ask why there have been so few women architects or film directors.) Nochlin's essay was written at a crucial time in the history of feminist thought, and one answer to the question posed was to critique the authors of traditional histories of art. These, it was argued, had tended to be written by male authors whose attention was drawn only to the work of male artists, architects and so forth. As late as 1981 the *Oxford Companion to Modern Art*, for example, saw fit to direct the reader wishing to research into Frida Kahlo to consult the entry for her husband, Diego Rivera.[16] Much feminist writing has thus been concerned to retrieve the work of many female artists who had been invisible in traditional histories simply on account of their sex. Thus artists such as Kahlo, Sophonisba Anguissola (1532–1625), Angelica Kauffmann (1741–1807) and Suzanne Valadon (1865–1938) have belatedly received the recognition they deserve.

Nochlin's answer to the question is rather different, however. While acknowledging the importance of such projects of retrieval, she argues that these should not distract from the basic historical fact that the majority of artists have, in the past, been men. This has to be understood, she argues, in terms of the social framework within which artists have traditionally established their careers. Multiple obstacles lay in the path of any woman seeking to become an artist. Access to education was often restricted; even in the late nineteenth century female students were barred from taking part in life drawing classes, a central instrument of art education. Likewise, artists were dependent on the support of patrons and institutions of distribution, who were often not particularly sympathetic to aspiring women artists. In general women were, until comparatively recently, accorded other social roles – as mother, wife, homemaker – which made it difficult for them to achieve acceptance as professional artists. An interest in art could be tolerated as an amateur pursuit, but not if it interfered with other social expectations. Those few women who did succeed in gaining professional recognition, and Nochlin cites the example of the French painter Rosa Bonheur (1822–99), frequently did so by diminishing their social identity as women. In Bonheur's case this involved wearing men's clothing and cropping her hair in a process of personal 'de-sexing'.

This account might be construed as highlighting the various social and historical obstacles that have constrained the creativity of women. However, Nochlin argues that becoming an artist is not a matter of satisfying an inner impulse to create, but is rather the function of a complex set of social expectations and structures. For many women the very idea of becoming an artist would never have been seriously entertained as a possibility. Likewise the profession of artist was often continued from father to son; Picasso's decision to become an artist was prompted not only by the fact that his father was an artist but also that his father encouraged him in that direction. Had he been a daughter, Nochlin speculates, it is unlikely he

would have received the support. Artemisia Gentileschi's success was considerably indebted to the backing of her father, Orazio; his enlightened support proved to be a notable exception to the usual pattern.

The feminist critique, of which Nochlin's essay is an important early example, has thus debunked the mythology of the artist, emphasising artists' rootedness in the social conditions and expectations of their time. Where the myth speaks in terms of a timeless artistic impulse, feminism highlights the social and historical specificity of artistic production. A related critique has been undertaken by Marxist critics, who have emphasised the enmeshing of artistic production within structures of social power and class. Nochlin herself indicates the links between feminism and other social theories of art by pointing out the dominant role of the middle classes in forming the profession of artist. As such, social theorists have emphasised the extent to which what are often presented as timeless impulses to artistic expression are rather more the consequences of the outlook of the European and North American bourgeoisie, for whom individual freedom and expression became iconic forms of self-definition from the late eighteenth century onwards. This has become especially evident with the rise of modernism in the 1850s, where the myth of the artist as a bohemian outsider has been seen subsequently as the reflection of a middle-class unease with the 'vulgarities' and 'anonymity' of mass popular culture.

Theoretical Critiques and the Question of Interpretation

The criticism of the mythology of the artist parallels an equally important question that focuses on the process of interpretation. Traditionally, the interpretation of artworks has been seen as involving a reconstruction or retrieval of the intentions of the maker. An important branch of the philosophy of interpretation – hermeneutics – has revolved around precisely this notion and there have been numerous variations on this theme.[17] But if being an artist involves being enmeshed within a complex social structure, relying solely on the intention of the maker of an artwork gives at best a partial account of its social and historical meaning.

The earliest histories of art – Pliny the Elder's *Natural History* (first century CE) and, later, Giorgio Vasari's *Lives of the Artists* (1550) – used the biographies of famous artists as the basis for an account of the development of art. Vasari's *Lives* in particular became the model for numerous subsequent histories of art. However, as early as 1764 this approach was challenged by the German scholar Johann Winckelmann, whose *History of the Art of Antiquity* was based on an outline of the successive artistic styles rather than on the lives and intentions of the artists.[18] In part, Winckelmann was compelled to adopt this approach by the nature of his source material – the anonymous Greek and Roman sculptures in the Vatican – but his work suggested an alternative approach to art in which reference to the

intention of the maker played a minimal role. By the end of the nineteenth century this 'formalist' approach had become dominant within art criticism and history. Heinrich Wölfflin made 'art history without names' a central objective of his method, and numerous others adopted a similar approach. What was important for Wölfflin was not the intentions of the artist, but rather the place their work occupied in the evolution of broader historical stylistic categories. In his best-known work, *Principles of Art History* (1915), Wölfflin drew up a series of formal and stylistic opposites that were to serve as the basis for a map of the terrain of the history of art.[19]

Wölfflin's formalist approach was widespread in the first decades of the twentieth century, but the biographical method – the notion that criticism consists in a retrieval of the intentions of the maker – has continued to exercise considerable influence. It has also been the object of continued critique up to the present. In the 1940s an important counter to the biographical approach was articulated from within what has come to be termed the 'New Criticism' in literary theory. In a now famous essay first published in 1946, the American critics Monroe Beardsley and W. K. Wimsatt took to task the very notion that knowledge of the artist's biography has anything to do with a critical understanding of their output.[20] Instead, they stress the centrality of the artwork to any interpretation, rather than any imaginary – and ultimately invisible – intentional motives. They point out that crucial to understanding the artwork is a knowledge of the particular genre it belongs to – novel, sonnet, tragedy, comedy, epic, romance, and so forth – and how it conforms to or extends the characteristics of the genre (or indeed whether it blurs the boundary of its genre). As Beardsley later argues: 'what the sentence means depends not on the whim of the individual and his mental vagaries, but upon public conventions of usage that are tied up with habit patterns in the whole speaking community.'[21] And what counts for literary meaning is valid for the question of artistic meaning *per se*: the intentions of the individual maker are of less significance than the wider linguistic and other patterns within which the artwork was produced.

The New Criticism was subsequently, and rightly, criticised for its excessive attention to the artwork at the expense of consideration of the social dimension to the production of meaning. This point was made especially by Marxist and feminist scholars. Artworks are produced within social and cultural conditions which do not simply form an exterior 'context', but which reproduce themselves *within* the artwork, in formal, aesthetic and semantic terms. Indeed, art is itself a social construct.[22] Nevertheless, New Criticism was an important first attempt at formulating a coherent attack on the mythology of the artist. In its critique of the biographical approach it also pointed out that in many instances there does not necessarily exist an indication on the part of the artist as to their intentions. In other words, the supposed 'intention' of the artist is itself the result of speculation on the part of the interpreter. In any case, even where artists may have stated their intentions, the

interpreter is then faced with the situation of interpreting their statements. How would one know if one had interpreted the statement of intent correctly? By recourse to some further statement clarifying the intention underlying the statement of intent? There is the possibility of an infinite regress in which there would never be a final statement that was not in need of some supplementary clarification. And this is assuming that the artist is actually trying to explain their real intentions. Many artists have issued statements about their work in order to throw critics and readers off the trail, in order to make interpretation more complex and difficult.

Some writers, notably E. D. Hirsch, attempted to ward off such criticisms by distinguishing between the 'inner' authorial *meaning* of the work and its *significance*. The latter, which Hirsch deems to be the object of criticism, is the work's historical, social and literary relevance, while true interpretation should aim at authorial meaning.[23] At the root of Hirsch's concern was the worry that by abandoning the biographical approach and by giving up the idea of the artist's intention as a source of authority about the meaning of the artwork, the uncomfortable spectre of relativism appears, in which the meaning of the artwork becomes largely a function of individual interpreters. The difficulty lies in determining such authorial meaning for, as Hirsch admits, it remains inaccessible; the interpreter does not have access to the author's inner mental states. Moreover, Hirsch's own solution to the problem – using values such as coherence, probability and clarity as a basis for reconstructing the 'meaning horizon' of the author and hence for producing 'valid' interpretations – is hardly satisfactory, since it takes for granted that these values are the appropriate ones. Hirsch's book was published in 1967 and appeared in response to a widespread change in the way interpretation was viewed. In particular, Roland Barthes became associated both with a forceful emphasis on the role of the interpreter as the primary determinant of the meaning of artworks and with a celebration of qualities of ambiguity, contradiction and *in*coherence in interpretation.

In his most polemical statement, a celebrated essay provocatively entitled 'The Death of the Author' (1968), Barthes argues that the author has no role in the make-up of meaning of the artwork, and that it entirely the creation of the reader.[24] Drawing on the structural linguistics of Fernand de Saussure (1857–1913), Barthes also states that the meaning of artwork is dependent on its difference from and identity with other texts and, further, that the text should itself be seen as a collage of citations and motifs derived from other works. Barthes is not talking here about conscious borrowing, but about the way that texts unconsciously operate with a stock of motifs, images and words which have often been coined elsewhere and became disseminated within language as a whole. Barthes had in mind literary texts; an obvious example might be the extent to which imagery from Shakespeare or the King James Bible reappears in literary texts and everyday conversation, often without any awareness of this origin on the part of the speakers. A similar point has been made about visual culture however, for visual images, designs and motifs circulate freely in and

through a variety of different practices. Artworks are produced within what Barthes refers to as an 'intertextual' space; the author is at best an assembler of fragments of other texts, and certainly not a point of origin. Instead, the meaning is as variable as the readings made of it. In a further essay entitled 'From Work to Text' (1971), Barthes tried to abandon the notion of the artwork, too. With its connotations of closure, completion and boundaries, Barthes argued for the need to replace it with that of the 'text', a more open conception that conveys the extent to which the meaning of artistic 'texts' is dependent on their 'intertextual' relation to other 'texts'.[25] A similar approach was adopted by the Italian cultural theorist Umberto Eco, who coined the notion of the 'open work' both to elaborate a theory of interpretation and to highlight a specific kind of twentieth-century art practice that actively solicited the involvement of the audience.[26] More recently, the German sociologist Niklas Luhmann has formulated a similar argument in a complex and abstract work, *Art as a Social System*, which puts forward as its central thesis the notion that art consists not of individual expressions or utterances, but of 'communications' which take on a life of their own and develop into a self-sustaining system.[27] In other words, artworks are the events or operations of an anonymous 'intertextual' system; the meaning of artworks is determined by their role as communicative responses to previous artistic communications (artworks) rather than by their role in expressing the inner mental state or beliefs of the artist.

Return of the Author?

Barthes' work represents an extreme formulation of the critique of the mythology of the artist. It is not without its own problems, however. For it has been argued that by placing the reader at the centre of the interpretative process, Barthes is not so much critiquing the romantic myth as merely refocusing it. All the powers of spontaneous creative production traditionally accorded the artist are now given to the reader instead. Barthes can thus be accused of simply replacing the romantic myth of the artist with an equally romantic myth of the reader (and, by extension, of the critic). Moreover, even if the artist is merely an assembler of intertextual borrowings, the romantic mythology of the artist could be maintained by valuing the originality with which such borrowings are put together. This was a problem that faced the so-called appropriation art of the 1980s, in which artists such as a Mike Bidlo, Louise Lawlor and Sherrie Levine produced direct copies of famous images of the past. For all their attempts at undermining notions of authorship, they gained considerable critical recognition, as individuals, for the originality with which they undertook this act of copying. While Barthes was making a general theoretical point, he was arguably simply responding to a particular feature of late twentieth-century Western culture, namely, its tendency to plunder and recycle existing motifs, images and forms. This is certainly how his thinking

has been interpreted by critics such as Jon Savage, who has written evocatively of the 1970s and 1980s as an 'age of plunder'.[28]

There are thus certain difficulties with the 'strong', anti-romantic (or anti-humanist) stance of writers such as Barthes. Nevertheless, it is now widely accepted that an appeal to notions of genius and creativity is no longer credible, and that interpretation is as much a projection of the perspective of the interpreter as it is an 'objective' teasing out of the 'meaning' of the text. The appeal to genius neglects the mediation of creative intention by external social factors. Not only is it inappropriate for an understanding of the social basis of artistic production during much of the history of Western cultures, not to mention non-Western cultures, it also places artistic creativity in an ahistorical, asocial vacuum. In fact, the myth of creative genius is itself arguably the product of a specific set of social and historical factors, and reflects an ideology of personal freedom, spontaneity and expression that arose among the European and North American bourgeois classes in the late eighteenth century. Visual culture is a shared, public and social phenomenon, in contrast to the romantic mythology which too often stresses its private, expressive dimension.

These constitute important criticisms, but emphasis on the social dimension need not entail the complete redundancy of the idea of the artist, merely a debunking of one particularly prevalent, and problematic, version. Although many practices of visual culture are undertaken on a collaborative basis, many are also the products of individuals. It is possible to give recognition to the role of these individual social agents without subscribing to a romantic ideology of creative genius. This lies at the heart not only of the question of authorship but of social theory in general; namely, the relative significance attached to the individual on the one hand, and broader social expectations, norms, structures and systems on the other. The authors discussed above have tended to privilege one or the other side of this divide. However, some, including Pierre Bourdieu or the British social theorist Anthony Giddens, have formulated accounts that give equal importance to the individual and the social.[29] For both, the dynamic of cultural production consists in the interaction between these two, in which individuals negotiate their position within a pre-existing set of social expectations, norms and institutions, while also contributing to change and development of those same structures.

Conclusion

Ultimately, the names of significant individual cultural producers will continue to be of central importance, from Leonardo to Picasso to Truffaut to Carson; the key question is whether and to what extent it is possible to acknowledge their specific quality while also giving due account of the wider impersonal social and historical factors framing their work. Giddens and Bourdieu suggest it is possible to combine

the two. It is worth considering, however, a final, unsettling possibility put forward by Luhmann. For Luhmann, the idea of a comprehensive or 'totalising' interpretation of the kind implicit in Giddens or Bourdieu is itself a peculiarly modern kind of myth. Instead, Luhmann suggests, it should be relinquished in order to adopt a 'postmodern' recognition of the plurality of partial perspectives. The closer we come to the individual author the more we lose sight of the social dimension, and the more we observe broader social and historical factors, the more the individual author moves out of focus. We can adopt one or the other perspective when interpreting the practices of visual culture, but not the two at the same time. If we follow Luhmann, the nature and function of the author will thus always remain a source of contention and debate, for ultimately it is not necessarily a problem to be overcome or solved. Rather, it is something to be negotiated by the particular perspective of the interpreter.

Further Reading

Becker, Howard. *Art Worlds* (Los Angeles, 1982).
Burke, Sean, ed. *Authorship: from Plato to the Postmodern – a Reader* (Edinburgh, 1995).
Burke, Sean. *The Death and Return of the Author* (Edinburgh, 1999).
Soussloff, Catherine. *The Absolute Artist* (Minneapolis, 1996).

Notes

1 For a brief outline of auteurism, see Robert Lapsley and Michael Westlake, 'Authorship', in *Film Theory: an Introduction* (Manchester, 1988), pp. 105–28.
2 See Otto Kurz and Ernst Kris, *Legend, Myth and Magic in the Image of the Artist* (London and New Haven, CT, 1979). First published in 1934.
3 Martin Warnke, *The Court Artist: On the Ancestry of the Modern Artist* (Cambridge, 1993).
4 On the rise of the Academy, see Carl Goldstein, *Teaching Art* (Cambridge, 1996).
5 Immanuel Kant, *The Critique of the Power of Judgement*, trans. E. Matthews (Cambridge, 2002).
6 Harold Rosenberg, *The Tradition of the New* (New York, 1960); Donald Kuspit, *The Cult of the Avant-Garde Artist* (Cambridge, 1993).
7 Michael Baxandall, *Patterns of Intention. On the Historical Explanation of Pictures* (London and New Haven, CT, 1985).
8 T. J. Clark, 'The Social History of Art', in *Image of the People: Gustave Courbet and the 1848 Revolution* (London, 1973), pp. 9–20.
9 Howard Becker, *Art Worlds* (London and Los Angeles, 1982). For a recent outline of sociological theories of artistic production and reception, see Victoria Alexander, *Sociology of the Arts* (Oxford, 2003).
10 For a general discussion of this issue, see Robert Witkin, *Art and Social Structure* (Cambridge, 1995).
11 See Pierre Bourdieu, 'Structures and the Habitus', in *Outline of a Theory of Practice*, trans. R. Nice (Cambridge, 1977), pp. 72–95.
12 See Robert Williams, 'Style, Decorum and the Viewer's Experience', in *Art, Theory and Culture in Sixteenth-Century Italy* (Cambridge, 1997), pp. 73–122.

13 For a brief discussion of this, see Evelyn Welch, 'Defining Relationships: Artists and Patrons', in *Art and Society in Italy 1350–1500* (Oxford, 1997), pp. 103–30.

14 Christine Battersby, *Gender and Genius* (London, 1987).

15 Linda Nochlin, 'Why Have There Been No Great Women Artists?', in L. Nochlin, *Women, Art and Power* (London, 1989), pp. 145–78.

16 Harold Osborne, ed., *The Oxford Companion to Modern Art* (Oxford, 1981), p. 283.

17 See, for example, R. G. Collingwood, *The Principles of Art* (Oxford, 1947).

18 Excerpts from Winckelmann's *History* are contained in Johannes Winckelmann, *Writings on Art*, ed. D. Irwin (London, 1972).

19 Heinrich Wölfflin, *Principles of Art History* (New York, 1953). First published in 1915.

20 Monroe Beardsley and W. K. Wimsatt, 'The Intentional Fallacy', in *Sewanee Review*, Vol. LIV (1946), pp. 468–88.

21 Monroe Beardsley, *Aesthetics. Problems in the Philosophy of Criticism* (New York, 1958), p. 25.

22 On the political critique of formalism, see Jonathan Harris, *The New Art History* (London, 2002).

23 See E. D. Hirsch, *Validity in Interpretation* (New York, 1967).

24 Roland Barthes, 'The Death of the Author', in R. Barthes, *Image, Music, Text* (London, 1980), pp. 142–8. A critical appraisal of Barthes' central theses is made by Peter Lamarque in 'The Death of the Author. An Analytical Autopsy', in *British Journal of Aesthetics*, Vol. 30 (1990), pp. 319–31.

25 Roland Barthes, 'From Work to Text', in *Image, Music, Text*, pp. 155–64.

26 Umberto Eco, *The Open Work* (London, 1989).

27 Niklas Luhmann, *Art as Social System*, trans. E. Knodt (Stanford, CA, 2000).

28 Jon Savage, 'The Age of Plunder', in M. Bierut, J. Helfand, S. Heller and R. Poynor, eds, *Looking Closer 3: Classic Writings on Graphic Design* (New York, 1999), pp. 267–72.

29 See Anthony Giddens, *The Constitution of Society* (Cambridge, 1986); Pierre Bourdieu, *The Field of Cultural Production*, trans. R. Johnson (Cambridge, 1993).

11. The Ideology of the Visual

Glyn Davis

Introduction

During the second world war, one of the routes by which the animation departments of major American film studios such as Warner Brothers contributed to the war effort was by producing racist, jingoistic shorts. Enlisting the services of popular characters including Bugs Bunny and Daffy Duck, these cartoons marshalled public opinion against the leaders and populations of other countries, most notably Germany and Japan. In 'Bugs Bunny Nips the Nips' (1944), for instance, Bugs annihilates a horde of Japanese soldiers by handing them out ice lollies containing hand grenades; and in 'Daffy – The Commando' (1943), Daffy meets Hitler and cracks him on the head with a mallet. These animated narratives were driven by a propagandistic impulse and disseminated a specific and deliberate message: the United States (represented by iconic characters that continue to be associated with the US) shored up nationalist pride and sentiment by depicting the denizens of distant countries as evil, 'other', worthy of attack and elimination. As the animation historian William Moritz has commented:

> The use of figures that are widely respected – Bugs Bunny, Daffy Duck, whoever – can make a real impression on people, because it's a cartoon. You're more likely to watch it through than you might be if you saw live action . . . When you see the cartoon you think 'Oh well yeah, I'll watch this. Bugs can't be wrong: he's always victorious . . .'[1]

Animation, suggests Moritz, can operate as a form of propaganda – and audiences may be more receptive to a cartoon's blunt messages than those appearing in live action material. And yet, of course, fictional 'live action' cinema may also serve to expound or enforce particular political perspectives and nationalist agendas: in recent years, for instance, the war movies *Black Hawk Down* (2001), *Pearl Harbor* (2001), *We Were Soldiers* (2002) and *Tears of the Sun* (2003) have all been lambasted by critics for their overt racism and imperialism.

Examples such as these – racist cartoons, gung-ho American war films – may be the first thing to come to mind when the word 'ideology' is mentioned. Certainly, propaganda *is* ideological: it serves to convey, usually very directly, specific positions, arguments and opinions. However, ideology is a much broader, more complex and labyrinthine subject. This chapter introduces the concept of ideology, exploring definitions and the history of the term, as well as identifying the significance of ideology to the study and interpretation of visual culture.

Defining Ideology

It is almost *de rigeur* in writings on ideology to accentuate the difficulty of defining the concept. 'Ideology', claims David McLellan, somewhat hyperbolically, 'is the most elusive concept in the whole of social science',[2] while Terry Eagleton begins his book on ideology by outlining sixteen potential uses of the term.[3] And yet concise, valuable definitions of ideology have been proffered, such as the following:

- sets of ideas which give some account of the social world, usually a partial and selective one;
- the relationship of these ideas or values to the ways in which power is distributed socially;
- the way that such values are usually posed as 'natural' and 'obvious' rather than socially aligned.[4]

In the light of this tripartite outline – which will be adopted as a working definition throughout this chapter – the Bugs Bunny and Daffy Duck cartoons mentioned above can be seen as ideological. The animated shorts provide one perspective on the world at the time that they were produced, a perspective that is stylised, restricted, delimited; the dominant status of America is implicitly assumed by their creators; and the representation of the Japanese soldiers is almost posed as 'natural' (they are depicted as short and vicious, a stereotyped portrayal that draws on received racist opinion of the 'real nature' of Japanese people).

This definition – despite its looseness – brings into play key aspects of the broader understanding of ideology and the ways in which it operates. Central among these is power: commentaries on ideology often assume or presuppose that individuals

with power have more interest in wielding, and impact in disseminating, ideological influence on or against those *without* status and power. People without power may in fact willingly collude in this process: ideological messages often pose themselves as 'correct', as 'common sense', and are thus assimilated by the mass, through a dynamic or process labelled 'false consciousness' by Friedrich Engels.

The problem with this conception, as Eagleton notes, is that 'not every body of belief which people commonly term ideological is associated with a *dominant* political power'. Indeed, he argues that it would perhaps be more useful to define ideology 'as any kind of intersection between belief systems and political power'.[5] Yet, the association of ideology with social and political power persists. This is due in part to Karl Marx, whose foundational writings occupy a crucial position in the history of the concept and continue to influence present-day understandings.

A History of Ideology

The term 'ideology' was first coined by Antoine Destutt de Tracy in 1797, shortly after the French Revolution of 1789. De Tracy's call for a new 'science of ideas' initially attracted the support of Napoleon, until a difference of opinion led him to accuse de Tracy of contributing to France's political problems. De Tracy was not the first writer to consider the origins, causes and uses of social and political ideas. Niccolò Machiavelli's book *The Prince* (1513), for instance, in its appraisal of the four-year reign of the monk Girolamo Savonarola in Italy in the late 1400s, claimed it was imperative for leaders to circulate and perpetuate illusions among a country's citizenry in order to remain in power.[6] The association of deception with social and political power that Machiavelli made was highly influential, such that his name swiftly became an antonym for guile, deviousness and chicanery. This notion that political power involves duping a state's subjects is also present in the writings of Marx.

Many of Marx's key ideas about ideology were expressed in an early book he co-authored with Friedrich Engels, *The German Ideology* (1846). He also discussed ideology in what is often considered his masterwork, *Capital (Das Kapital*, 1867).[7] For Marx, capitalist society was primarily a culture of two classes: the elite capitalist class, or bourgeoisie, who asserted their power through wealth, and the working class, or proletariat, who, Marx believed, had the power to change history through united effort. Within this system, people either owned the means of production or earned a meagre living by working for those owners. Marx utilised the concept of ideology to explain how the elite class managed to retain its privileged position; he claimed that the dominant ideas of a society – which may be accepted by that society's citizens as 'common sense' – are constructed and disseminated by the capitalist minority in order to maintain their dominant status. Or as Marx and Engels themselves put it:

The ideas of the ruling class are in every epoch the ruling ideas, i.e. the class which is the ruling *material* force of society, is at the same time its ruling *intellectual* force. The class which has the means of material production at its disposal, has control at the same time over the means of mental production, so that thereby, generally speaking, the ideas of those who lack the means of mental production are subject to it. The ruling ideas are nothing more than the ideal expression of the dominant material relationships, the dominant material relationships grasped as ideas . . .[8]

According to Marx, these dominant ideas are expressed and transmitted via 'meaning-making bodies', a raft of diverse institutions that, in our era, would include the mass media of newspapers, television, radio and cinema. As all major institutions – from government to the press – are owned and/or controlled by members of the elite capitalist class, the messages these individuals (and they are almost always white men) diffuse to the populace through such organisations are *their* ideas. Members of the proletariat are told what to think and believe by the institutions, but also come to believe that these messages and ideas are 'true', as they 'make sense'.

To some readers, this formulation may seem like the brainwashing of a population by a Fascist state. However, it is a system that persists today – and within supposedly liberal Western countries. Indeed, one can take a relatively recent example of this dynamic in operation, the cover of the *Sun* newspaper from 26 November 1993 (Figure 11.1) whose headline implores readers: 'For the sake of ALL our kids . . . burn your video nasty'.

James Bulger, a two-year-old, had been murdered by two young schoolboys. The horrific nature of the killing, and the seeming inexplicability of Bulger's death, led this tabloid newspaper to claim that the boys had recently watched the horror film *Child's Play 3* (1991) on video, and that this viewing had contributed to the killing. The newspaper constructed this movie as what Stanley Cohen would term a 'folk devil'.[9] *Child's Play 3* became the fulcrum of a moral panic regarding both children's access to screen violence within the home and the censorship of videotapes. As a result of the *Sun*'s handling of this topic – and, at the time, the *Sun* was a notoriously reactionary and right-wing newspaper – stricter legal guidelines relating to the circulation and content of videotapes were implemented in 1994. It subsequently transpired from police reports that there was absolutely no proof that Bulger's killers had seen *Child's Play 3*. From a Marxist perspective, the *Sun* propagated a clear ideological message – mass audiences (including children) cannot sensibly and safely regulate their own uses of video technology, making state intervention necessary – that, having been accepted by a significant percentage of the British population, was used by the Conservative government to justify a repressive form of legislation.

Since the publication of his major works, Marx's ideas relating to ideology have

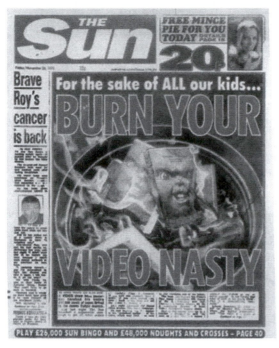

Figure 11.1 – The front cover of the *Sun* newspaper, 26 November 1993. Photograph courtesy of News International.

been taken up by a host of other thinkers. Arguably, however, the most noteworthy developments can be found in the writings of the Italian intellectual and agitator Antonio Gramsci (1891–1937). Imprisoned for his involvement in political demonstrations and conflicts – he was the head of the Italian Communist Party – Gramsci examined a broad array of topics in the thirty-three volumes of his *Prison Notebooks*, written between 1929 and 1934. One key subject to which he repeatedly returned was the clash of opposing parties or groups, and their attempts to attain political dominance. Reflecting on the Italian *Risorgimento* of the 1860s, for instance, Gramsci argued:

> a class is dominant in two ways, namely it is 'leading' and 'dominant.' It leads the allied classes, it dominates the opposing classes. Therefore, a class can (and must) 'lead' even before assuming power; when it is in power it becomes dominant, but it also continues to 'lead.' . . . Political leadership becomes an aspect of domination, in that the absorption of the élites of the enemy classes results in their decapitation and renders them impotent. There can and there must be a 'political hegemony' even before assuming government power, and in order to exercise political leadership or hegemony one must not count solely on the power and material force that is given by government.[10]

Gramsci argued that, at any one time, a number of groups – all with access to vital economic resources – will vie with each other for social and political power; each group carries, represents and attempts to disseminate specific ideologies. Thus, even at the level of elite political factions, different views or perspectives war with each other to achieve domination, a position of power that Gramsci termed 'hegemony', a dominance achieved by both persuasive and coercive means. This state of affairs – with a range of powerful rival forces battling for the attention and consent of the masses with differing messages – opens up Marx's understanding of ideology to a degree, enabling some space for debate and discussion.

Gramsci's model of the workings of ideology can be clearly observed in operation when political factions disagree on the 'correct' method of handling specific (potentially controversial) situations. In Britain, for instance, the appropriate way to 'manage' the number of immigrants and asylum-seekers has been the subject of political debate for some years. Right-wing arguments (often shot through with thinly disguised racism and xenophobia), suggesting that immigrants will exacerbate Britain's problems with housing and employment shortages, have been countered in part by left-leaning humanitarian and democratic points of view. Related to this debate, a minor resurgence of nationalism has occurred, with the British National Party attaining some public support in specific political constituencies. The Labour government has maintained its position of power by warily occupying a middle ground: expressing sympathetic concern for the plight of displaced persons while introducing a programme of registration policies, occasionally redefining and recalibrating its perspective in relation to the arguments of other political parties, media opinion and public sentiments and concerns.

A third crucial figure in the tradition of Marxist writings on ideology is the French philosopher Louis Althusser (1918–90), who outlined a rather pessimistic structuralist model of the system by which ideology is enforced by the dominant ruling body. For Althusser, ideology is not a mass illusion, as Marx suggests, but simply the system of cultural representations whereby social groups and classes make their lived experience meaningful. Crucially, Althusser identified two mutually supportive and structurally imbricated forms of control: Repressive State Apparatuses and Ideological State Apparatuses. The former – which include such institutions as the military, the police force, the prison system, law courts, and so on – attain power through force. The latter – incorporating, among other things, religion, the educational establishment, the family and the mass media – operate predominantly at the level of ideology.

The all-pervasive nature of this widespread array of intertwined apparatuses causes it constantly to impinge on the individual subject. To take just one example, the birth of a baby is accompanied by the drafting of a birth certificate. This document not only registers and legally recognises the infant as a legitimate member of the society to which it belongs, but also names its parents, thus slotting the child

into a network of familial relations. In addition, a birth certificate decisively names the newborn – a name that is often further sanctioned by the Church in a precise ritual such as the Christian tradition of christening. At birth, then, a child is immediately – through a complex web of legal, familial, medical and religious forces – 'interpellated', made into an 'acceptable' subject of society. Althusser's rather depressing deterministic conceptualisation of the workings of capitalist society suggests that the individual is born into ideology, and that there is no way to escape its clutches.

Aside from the Marxist approach, psychoanalytic theory provides a second notable tradition in the literature on ideology. Sigmund Freud, for instance, as David McLellan writes,

> believed that the basic factor in politics was the erotic relationship of the group to the leader and that the function of ideology was to reinforce libidinal ties between rulers and ruled which would result in a positive attitude towards authority.[11]

Thus, in *Totem and Taboo* (1913), Freud related the genesis and persistence of political power to the Oedipus complex; and in *Group Psychology and the Analysis of the Ego* (1921), he claimed that 'artificial' groups such as armies require single, dominant, charismatic leaders.[12] As a stark contrast to the Marxist model, Freud's position is an intriguing one. How was Bill Clinton's ideological power as a leader affected by his dalliances with Monica Lewinsky? Was Arnold Schwarzenegger's success in being elected Governor of California influenced by the ready availability of sexualised images of the film star? Other authors have subsequently attempted to employ psychoanalytic concepts in their explorations of ideology; Slavoj Žižek, for instance, has drawn heavily on Lacan's writings.[13] Despite the significance of this second strand of 'ideology theory' – and, in addition, one might mention writers who do not fit into the Marxist or psychoanalytic traditions, such as John Thompson[14] – it is the Marxist approach which is most often adopted in critical writings on the subject. Indeed, since the second world war, when Fascism attained political dominance in both Germany and Italy, 'ideology' has largely been interpreted pejoratively, and its workings explored through a Marxist mode of comprehension. However, there are key difficulties with this approach which deserve consideration.

Criticisms of the Marxist Tradition

From the perspective of the twenty-first century crucial problems are raised by the Marxist model. Primary among these is the altered class system in contemporary capitalist societies. According to a number of critics – including David Harvey,

Fredric Jameson and Jean-François Lyotard – there has been a fundamental trans-
formation in the nature of Western society and culture since the war.[15] Central to
this shift, according to Jameson, is a move from the market capitalism of the age of
imperialism to multinational or consumer capitalism. This, he writes, is 'the purest
form of capital yet to have emerged, a prodigious expansion of capital into hith-
erto uncommodified areas'.[16] This phase of capitalism is also sometimes known as
post-Fordism or post-industrialism. Under such a system, corporate power is
increasingly concentrated in the hands of a minor elite – primarily, the bosses of
globalised multimedia conglomerates. The realm of employment is also signifi-
cantly reconfigured: job security wanes, casual work intensifies, new types of jobs
emerge and multiply (many of these in the 'culture industry'), and corporations
farm out a great deal of their repetitive manual labour to non-Western countries.

With these changes, the dualistic model of the class system (elite bourgeoi-
sie/mass proletariat) underpinning Marxist analyses is problematised. The United
States has been described as a 'classless society', for example, though this has also
been contested.[17] In a similar vein, according to some of its leading politicians,
Britain has become a predominantly middle-class society, with the lines between the
classes now significantly blurred. Further, old class divisions have been somewhat
undermined in Britain by the rise of a 'celebritocracy'. Although old networks of
power persist to a significant degree, many of those at the top of the social scale, such
as the footballer David Beckham, born into a working-class family, are likely to be
there due to their celebrity status rather than their blood lineage or class origins.

A second problem for the Marxist tradition is the current widespread cynicism
in Western countries regarding the efficacy of political protest and revolution.
Consumers may acknowledge and object to the working practices of such exploi-
tative corporations as Gap, McDonalds, Coca-Cola and Nestlé, but this does not
necessarily prevent them from purchasing their goods. Such knowing indifference
is an example of what the cultural critic Peter Sloterdijk has termed the 'enlight-
ened false consciousness' of contemporary society.[18] Moreover, even when vocal,
disruptive dissent is expressed against those in positions of power – as with the riots
in Seattle against the World Trade Organisation, or the widespread rallies and
marches condemning the war in Iraq – it is swiftly contained, having little subse-
quent impact on the decisions of the elite. The fragmentation of the old class system
that has occurred in the postmodern era, allied to a concomitant concentration of
power in the hands of a smaller group of people, has resulted in most citizens
feeling alienated from, and irrelevant to, the workings of politics. Žižek has also
taken issue with the traditional Marxist notion that emancipation is attained simply
by pointing out the falsehoods of ideological illusion. For Žižek ideological beliefs
are adhered to precisely *because* they are illusions, and are invested with psycholog-
ical significance in that they provide a structure of meaning. Ideological beliefs,
when confronted with their contradictions, have an uncanny ability to use such

contradictions to strengthen their position. Hence the anti-Semite, to use an example often employed by Žižek, when confronted by the fact that Jewish people are indistinguishable from everyone else, will conclude that they are all the more cunning and devious for maintaining the *appearance* of normality.[19] Likewise, the American dream that *anyone* can 'make it' rules supreme despite the mass of evidence to the contrary; the vast numbers of homeless, destitute Americans are interpreted as examples of failed *individuals* rather than a larger problem of the society itself.

A third difficulty for Marxism relates to the proliferation of the mass media – a spread that continues unabated. According to Marx, such systems of communication could be classified as 'meaning-making bodies' by which the elite transmit messages to the proletariat. For Althusser, the mass media serve as an Ideological State Apparatus, keeping citizens in their place. However, a counter-argument would be that the multiplication of channels of communication opens up space for the expression of alternative and/or dissenting ideologies: this can be seen in operation, for instance, with the 'underground' publication of 'zines, 'homemade' television programmes on cable television channels and the enormous amount of material available on the Internet. Access to the means of production has become ever easier, less financially burdensome.

Recent decades have seen numerous critical challenges to the notion that individuals attaining *pleasure* from media texts are 'dupes' of the system, unwittingly seduced into submission by those in power. Specific authors, including Dick Hebdige, Ien Ang, Angela McRobbie and Terry Eagleton, have explored the sophisticated workings of ideology in popular culture, attributing consumers of the mass media with more knowledge, skill and erudition than allowed for by older Marxist theorists.[20] Although Marxist concepts and politics have often underpinned the assessments and observations of these authors, their writings expand understandings of ideology to allow for the complexities of its workings in the postmodern era. As a small contribution to this ongoing project, the remainder of this chapter will examine specific examples of visual culture which, on the surface, may appear anodyne and free of ideological content: as will be shown, ideology is a crucial concept for the exploration of even the most seemingly banal instances of visual culture.

The Case of Landscape Painting

It could easily be assumed that every painting attempts to transmit a message and thus carries an ideological meaning. If an artist decides to devote time to the production of an image, then surely he or she must desire to make a statement with that picture. To take just one example, portraits of monarchs, aristocrats or landowners, produced through the centuries, announce in the size of the canvasses – and the chosen finery in which the sitters are dressed – that the likenesses of *these*

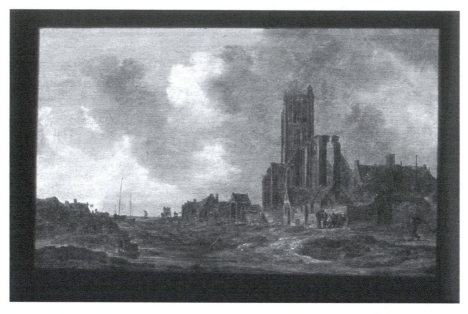

Figure 11.2 – Jan Van Goyen, *Ruined Church at Egmond van Zee from the East* (1633). Private collection.

people are worth recording for posterity. In this regard, pictures such as Jean-François Millet's *The Gleaners* (1857), which depicted 'everyday' agricultural workers at the bottom of the social ladder, attempted to afford gravitas, status and posterity to their activities; notably, however, Millet did not reveal the names of the people he depicted, thus leaving them anonymous. Of course, portraits may be commissioned and, as such, their ideological force might reflect the perspective of the purchaser rather than that of the artist.

Landscape paintings are a little more problematic to assess. Take, for instance, Jan Van Goyen's painting of the *Ruined Church at Egmond van Zee from the East* (Figure 11.2) produced in 1633. This image may seem a document of its time, a 'realistic' representation of a specific part of the Dutch countryside. It is difficult to conceptualise such an image – or, indeed, any of the other landscape paintings produced by Dutch painters during the seventeenth century – as having an ideological message. Yet the picture raises a number of substantial questions. Why was this specific location and viewpoint ('from the east') chosen? What is of specific interest about Egmond van Zee – that is, does it occupy a historically significant position in Dutch history? What were the political intentions of the artist? If Van Goyen chose this view for aesthetic reasons, his attribution of 'beauty' to the landscape implies he believed other people would benefit from witnessing his reproduction.

It is also necessary to ask why an artist would choose to depict a ruined church. Although such iconography could be interpreted negatively (as mourning the dimi-

nution of the status of religion), the use of colour and framing combine with the painting's content in seeming celebration. In fact, Van Goyen's painting could be seen as a depiction of the 'return to Eden', an image of a rural idyll – and thus as a utopian rendering of a pastoral ideal. Although the age of industrialisation was almost two centuries away, this painting seems to reify – by rendering in paint, for the pleasure of subsequent generations – a romanticised vision of the agrarian landscape.

Of course, from a contemporary vantage point, it is impossible to discern whether Van Goyen enhanced his image, moved elements around or idealised the view – that is, whether this painting is 'realistic', faithful. Many Dutch landscape paintings framed their contents according to the 'golden ratio' – that is, the line of the horizon was positioned exactly a third of the distance between the top and bottom of the canvas. Supposedly, this system of representation accorded harmony to the painting, producing a specific aesthetic impact in spectators. Evidently, the desire to elicit such a response is an ideological desire, a wish to make audiences recognise the beauty of the depicted landscape. Thus, even an image that seems innocuous at first glance can be revealed as ideologically slanted. Indeed, it has been argued that *all* paintings carry ideological implications. As Janet Wolff has written:

> Works of art . . . are not closed, self-contained and transcendent entities, but are the product of specific historical practices on the part of identifiable social groups in given conditions, and therefore bear the imprint of the ideas, values and conditions of existence of those groups, and their representatives in particular artists.[21]

In other words, reading art ideologically necessitates taking into consideration the historical period in which it was produced, the social and political affiliations of the artist, and so on. This applies equally to landscape images, still lives, portraiture, abstract works – and every other genre of painting.

Documentary Television

Although documentaries have always occupied a central position in British television broadcasting history, recent years have witnessed a proliferation of 'factual' programming across the schedules. Indeed, over the last ten years or so, the percentage of 'factual' television available to audiences has increased markedly in both daytime and primetime slots, often at the expense of other genres of television such as quizzes, game shows and sitcoms.[22] Many older formats have been revitalised or reinvigorated via an injection of 'reality' content. The volume of 'reality TV' now being screened stands in stark contrast to film: aside from the odd success story such as *Bowling for Columbine* (2002), *Être et Avoir* (2002) or *Touching the Void* (2003), documentaries are rarely screened in cinemas.

The relationship of documentary television to ideology merits sustained exploration. A first impulse might be to equate documentary with objectivity, veracity, honesty, truth – and thus a lack of ideological content. However, film and television documentaries (in the broadest sense of the term) are never 'objective'. The unedited presentation of 'reality' is rarely available to us in documentaries: the unexpurgated 'live' footage from the *Big Brother* house that airs on Channel 4's subsidiary E4 during the programme's run serves as a rare exception. Rather, documentaries are carefully constructed: the shots they contain are usually planned, and their sets and lighting often manipulated. Moreover, once the footage has been shot, the actual content of a documentary is ordered, placed in sequence. As Paul Wells writes: 'It is important to stress then that, just like any "fiction" film, the documentary is *constructed* and may be seen not as a recording of 'reality', but as another kind of representation of 'reality'. The documentary form is rarely innocent . . .'[23] In fact, this was recognised by one of the most significant figures in the history of documentary, John Grierson, who defined documentary form as 'the creative treatment of actuality'. To cite Wells again: 'Grierson acknowledges that the filming of "actuality" in itself does not constitute what might be seen as the "truth". He recognizes that "actuality" footage must be subjected to a creative process to *reveal* its "truth". This apparent manipulation of the material is both a recording *of* "reality" and a statement *about* "reality".'[24] And yet, if a documentary 'reveals' the 'truth' of its subject after manipulation by its director, whose 'truth' is this? Does the completed work uncover an objective perspective that 'honestly' documents a subject, or does it (intentionally or unintentionally) reflect the opinion of the documentary maker?

These questions can be explored through specific examples. The 'world of the sea' eight-part nature documentary series *The Blue Planet* (co-produced by the BBC and the Discovery Channel in 2001) utilised state-of-the-art technology to capture on film images of creatures and locations that had never been seen before by a wide public (Figure 11.3). The narrative voiceover – delivered by David Attenborough in his characteristically genial-yet-authoritative manner – provided viewers with a plethora of statistics and other factual detail. And yet the series also employed manipulative techniques, most evident in its use of musical score: the appearance of dolphins was usually accompanied by soaring, elegiac violins, seals by jaunty, major-chord bounce and sharks by sinister bass rumble and *Jaws*-like threatening cello. Such blatant anthropomorphism, harnessed to the natural history documentary's reliance on depicting hunter–hunted scenarios, undercut the series' claims to factual objectivity, reinforcing traditional assumptions regarding the morality and character of specific species.

As a second example, Martin Bashir's television interview with the reclusive pop musician Michael Jackson (screened on ITV1 early in 2003) was criticised for its ideological implications. Several months in the making, the documentary enabled viewers to witness the contents of Jackson's home and its grounds: it succeeded in

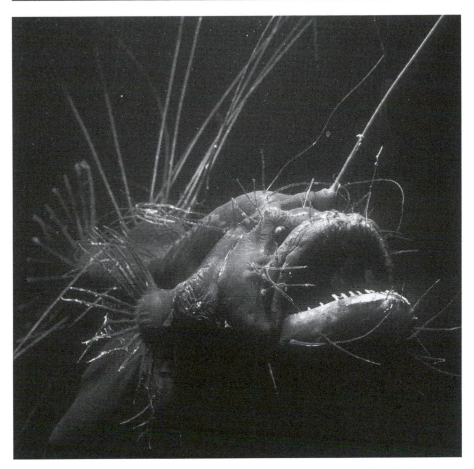

Figure 11.3 – The hairy angler fish – just one of many species documented by *The Blue Planet*'s camera crew when they descended into the 'dark zone', the deepest recesses of the seas. Photograph © David Shale/naturepl.com.

capturing a number of revelatory moments, such as Jackson ineffectively attempting to feed a small child while bouncing the infant on his knee. Bashir's status as a perceptive, probing interviewer hangs largely on a well-known television interview with Diana, Princess of Wales which he conducted shortly before her death, in which she spoke candidly about her life as a member of Britain's royalty. Expertly choreographed and stage-managed, the piece's depiction of Diana as a woman who had been manipulated and mistreated by the highest echelon of England's aristocracy seemed to substantially boost public empathy for her. Bashir's lengthy interview with Jackson was more ambiguous, its meaning less clear. Did the documentary make Jackson an object of ridicule? Did it truthfully expose his private life, or was it a cleverly orchestrated piece of recuperative publicity for a musician whose last CD, *Invincible*, had fared poorly, both critically and commercially? Bashir's

interview attained extremely high viewing figures in both Britain and the United States, and, subsequent to its airing, sales of Jackson's early albums were boosted by around 600 per cent. However, Jackson himself objected to the construction of the programme, claiming that he was depicted in a critical and pejorative manner. Jackson re-edited Bashir's footage: the musician's 'alternative' version of the documentary was aired in Britain with little fanfare, to low audience numbers.

These two examples – *The Blue Planet*, and Martin Bashir's interview with Michael Jackson – were both 'event television', 'must-see' viewing, 'watercooler TV.' The manner in which they were constructed serves to reveal how ideological messages may be prevalent even in supposedly 'objective', 'quality' documentary television. That is, whilst British factual television programmes may aim to educate, inform and entertain, as befits the 'public service broadcasting' remit required of this country's terrestrial channels, such shows could be ideologically loaded, skewed in favour of one specific perspective. This is evident even in more 'everyday' factual programming. House and garden makeover shows, for instance, such as the BBC's *Ground Force* and *Changing Rooms*, seem to legitimise a particular (class-weighted) design credo as 'the look' that the nation's citizenry should aspire to. Similarly, the rash of house-purchasing programmes that has recently spread across terrestrial schedules (such as *Location Location Location* and *A Place in the Sun*, both on Channel 4) may satisfy a voyeuristic desire to spy inside other people's abodes, but also serves to normalise home ownership, and to induce envious aspirationalism in those lower down the 'property ladder' (itself the title of a house-buying show). In a straightforwardly Marxist sense, television programmes about transforming or purchasing houses may serve to ensure that citizens subscribe to capitalist economic values, endlessly desirous of the capital and wherewithal to improve their station.

One marked characteristic of many of the examples making up the diverse array of factual television shows that have recently been aired, and continue to fill television schedules, is their seeming disdain for the traditional documentary's claims to objective 'truth'. Many 'docusoaps' and 'reality TV' programmes are shot on digital video (DV): this is economically wise, as it eradicates the need to spend money on film stock and enables directors and producers to reduce the number of personnel they require. The utilisation of DV also allows a (previously unthinkable) degree of complicity and proximity between cameraperson/director and the 'subjects' of the programme being recorded. The filming style that results is highly personal: its popularity with television audiences poses a challenge to those filmmakers and critics who persist in associating documentary practice with detachment and sobriety. As Stella Bruzzi has claimed:

> The emergence of the 'docusoap' signals very clearly the growing unhappiness with classic observational transparency and passivity, the absenting of an authorial voice and the abstention from any overt means of demonstrating the film-

makers' presence. The need to modify the observational mode has been a driving force behind British documentary film-making in particular. . . . What the doc-usoap has responded to . . . is the pervasive modern concern with the notion that documentary's most significant 'truth' is that which emerges through the inter-action between filmmaker and subject in front of the camera . . .[25]

In other words, media-savvy contemporary audiences – aware of documentary's constructed nature – may prefer to watch factual programmes that do not eradi-cate or ignore the presence of the team behind the camera.

Conclusion

As this chapter has demonstrated, the concept of ideology is a crucial tool for the analysis of visual culture. This applies not only to blatant examples of propaganda, but also to seemingly 'innocent' cultural texts. Our understandings of the work-ings of ideology are largely derived from a Marxist tradition – the writings of Marx, Gramsci, Althusser, and others – but, as has been noted, there are problems with applying such a perspective in the postmodern era. Indeed, once or twice since the end of the second world war, critics have attempted to announce 'the end of ideology'. In the United States in the 1960s, for instance, a number of authors equated ideology with totalitarianism, and saw the failure of Nazism, Soviet Communism and other political regimes as marking the death of ideology *per se*. In our present political and cultural climate, such an argument is untenable: the United States is in the process of attempting to assert its status as *the* world politi-cal force; Britain's Labour Party, due in part to Blair's support for President Bush, is rapidly losing public support; the European Union's future is uncertain; conflict continues to rage in the Middle East. And as the reach of the mass media spreads ever outwards, overt and covert ideological messages continue to infiltrate our daily lives. A knowledge of the workings of ideology has never been so crucial.

Suggested Reading

Eagleton, Terry. *Ideology* (London and New York, 1991).
Marx, Karl and Engels, Friedrich. *The German Ideology* (London, 1974).
McClellan, David. *Ideology* (Milton Keynes, 1986).
Thompson, John. *Ideology and Modern Culture* (Stanford, CA, 1990).

Notes

1 Interviewed in the documentary *Cartoons Kick Ass* (produced and directed by Stephen Lennhoff; shown on Channel 4 in 2000).
2 David McLellan, *Ideology* (Milton Keynes, 1986), p. 1.

3 Terry Eagleton, *Ideology: an Introduction* (London and New York, 1991), pp. 1–2.

4 Gill Branston and Roy Stafford, *The Media Student's Book* (London, 1996), p. 117.

5 Eagleton, *Ideology*, p. 6.

6 Niccolò Machiavelli, *The Prince*, ed. Q. Skinner and R. Price (Cambridge, 1988).

7 Karl Marx, *Capital* (London, 1976).

8 Karl Marx and Friedrich Engels, *The German Ideology* (London, 1974, 2nd edition), p. 64.

9 Stanley Cohen, *Folk Devils and Moral Panics: the Creation of the Mods and Rockers* (London, 1972).

10 Antonio Gramsci, *Prison Notebooks: Vol. 1* (New York and Oxford, 1975), pp. 136–7.

11 McLellan, *Ideology*, p. 38.

12 Sigmund Freud, *Totem and Taboo: Resemblances between the Psychic Lives of Savages and Neurotics* (London, 1919); Sigmund Freud, *Group Psychology and the Analysis of the Ego* (London and Vienna, 1922).

13 Slavoj Žižek, *The Sublime Object of Ideology* (London and New York, 1989).

14 John Thompson, *Studies in the Theory of Ideology* (Cambridge, 1984); John Thompson, *Ideology and Modern Culture* (Stanford, CA, 1990).

15 David Harvey, *The Condition of Postmodernity: An Enquiry into the Origins of Cultural Change* (Oxford, 1989); Fredric Jameson, *Postmodernism, Or the Cultural Logic of Late Capitalism* (London and New York, 1991); Jean-François Lyotard, *The Postmodern Condition: A Report on Knowledge* (Manchester, 1984).

16 Fredric Jameson, 'Postmodernism, or the Cultural Logic of Late Capitalism', *New Left Review*, Vol. 146 (1984), p. 78.

17 Barbara Ehrenreich, *Nickled and Dimed: Undercover in Low-Wage America* (London, 2002).

18 See Peter Sloterdijk, *Critique of Cynical Reason* (London, 1989).

19 See Žižek, *The Sublime Object of Ideology*.

20 Dick Hebdige, *Subculture: The Meaning of Style* (London: 1979); Ien Ang, *Watching Dallas: Soap Opera and the Melodramatic Imagination* (London, 1985); Angela McRobbie, *Feminism and Youth Culture* (Basingstoke, 1991); Eagleton, *Ideology*.

21 Janet Wolff, *The Social Production of Art* (London, 1981), p. 49.

22 Jon Dovey, 'Reality TV', in Glen Creeber, ed., *The Television Genre Book* (London, 2001), p. 134.

23 Paul Wells, 'The Documentary Form: Personal and Social "Realities"', in Jill Nelmes, ed., *An Introduction to Film Studies* (London and New York, 1996), p. 169.

24 Ibid.

25 Stella Bruzzi, *New Documentary: A Critical Introduction* (London and New York, 2000), p. 76.

12. Visual Practices in the Age of Industry

Matthew Rampley

Introduction

The vast social and economic changes known as the Industrial Revolution that took place in Europe and North America over the past 250 years have had a profound impact on every level of social and cultural practice. At a most basic level it has been argued that human perception and the body itself were altered, and that the experience of space and time have been transformed irrevocably.[1] This process is ongoing globally: China, India, Indonesia and many other Asian states are currently undergoing a massive process of industrialisation with breathtaking rapidity. The focus of this chapter is the impact of the industrial and scientific inventions of modernity on the visual culture of the last 200 or so years in the West. It is a vast topic, and one can explore only a few specific issues. Consequently this chapter focuses in particular on how large-scale technological production impacted on debates about cultural value and meaning, and on how technology presented the practices of visual culture with *political* challenges.

Photography and/as Modernism

> From today painting is dead.[2]

This celebrated statement by French painter Paul Delaroche (1797–1856) remains one of the best-known reactions to the invention of photography. It presents striking

testimony to the impact of the new technology. In common with many of his contemporaries Delaroche held that the invention of the photograph rendered painting's task of depicting the visible world redundant. The photograph's ability to record every visual detail, with a precision beyond the capacities of the most observant painter, was welcomed by many, for it lived up to the positivist ideals of a scientific and mechanical age obsessed with factual objectivity. Others were rather less positive.

In certain respects Delaroche misread the significance of this new invention. Mostly, the photograph was treated as an accessory. As a mechanical process, devoid of manual skill, photography failed to gain the status of painting. Instead, it was put to a variety of other social and scientific uses, from private family portraits to scientific illustrations to police records. When photographers did aspire to the status of artist, their images mimicked the painterly practices of their time. This is evident in the phenomenon of 'pictorialism', for example, a self-consciously aesthetic form of photographic image-making espoused by American photographers such as Edward Steichen, Alfred Stieglitz and Frank Eugene in the period between 1890 and 1920. Not only did 'pictorialism' imitate the visual language and subject-matter of contemporaneous painting, its practitioners also sought access to galleries and museums to display their work in imitation of fine art.

Despite its lower social status, it is alleged that the photograph nevertheless presented painting with specific challenges, questioning in particular the latter's traditional representational role. The modernist renunciation of mimetic realism from the 1870s and 1880s onwards has been seen as perhaps the most visible effect of the invention of photography. According to Arthur Danto, painting struggled, during the following 80–90 years, to redefine itself in order to highlight its difference from photography.[3] The heightened and non-naturalistic use of colour by artists as diverse as Vincent van Gogh, Henri Matisse or August Macke was a response to the challenge of the photograph, exploring painting's chromatic possibilities (in contrast to black-and-white photography) and renouncing its former mimetic role. Other artists saw in painting the depiction of the invisible essence of things, a notion that opened the way up to abstraction. For Wassily Kandinsky or Piet Mondrian, for example, the adoption of abstraction was directly related to the attempt to depict the spiritual, a task felt to lie beyond photography, with its ties to the visible world. Abstraction has been seen as one of the most obvious characteristics of modern painting, and while many continued to explore the possibilities of figurative representation, abstraction was the most powerful sign of what Danto characterised as the determination of modern artists to carve out a domain for art that would not be threatened by photography. In certain respects Danto adapted the more famous writings of Clement Greenberg (1909–94), who equated avant-garde abstraction with a shutting out from art of anything deemed non-artistic.[4] For Greenberg this aimed primarily at maintaining the 'purity' of art in the face of popular culture; while photography

is not specifically targeted for critique by Greenberg, it clearly stands as a crucial medium of popular visual representation.

The accounts of both Greenberg and Danto have been the object of criticism. As Thomas Crow has pointed out, the flat quality of much modernist and abstract painting was often modelled on the flatness of lithographic commercial posters.[5] Moreover, the causal connection drawn between modernism and photography hinges on the assumption that painting was concerned *primarily* with mimetic representation, whereas historically this was only one of many functions ascribed to art, including narration, moral improvement and social commentary.[6] None of these was challenged by the advent of photography; indeed, photography came to play a crucial role in advancing these functions within art. According to Walter Benjamin, for instance, photography captures what lies *beneath* the threshold of perception; it makes visible a subliminal awareness comparable to what numerous abstract painters were attempting to evoke.[7] Benjamin was also intensely interested in contemporary art, and many avant-garde figures, including André Kertesz, Claude Cahun, Man Ray and Tina Modotti relied either exclusively or heavily on photography as a medium. Nevertheless, the response of Delaroche and others suggests that many felt photography confronted art with significant questions. For example, in 1920 the surrealist André Breton argued:

> The invention of photography has dealt a mortal blow to the old modes of expression . . . Since a blind instrument now assured artists of the aim they had set themselves up to that time, they now aspired, not without recklessness, to break with the imitation of appearances.[8]

Here Danto's position is confirmed by a leading figure of the surrealist movement, and a key feature of surrealist art practice was to allude to the presence of *invisible* desire within the visible world. Indeed, surrealist photography has become the object of considerable interest in the past decade or so precisely because of its embodiment of what Rosalind Krauss has termed the 'optical unconscious'.[9]

Clearly, there are arguments both for and against the idea that photography prompted the development of modern art. However this particular debate is resolved, it is generally accepted that photography subsequently played a crucial role in shaping the theory and practice of art. Painting ceased to be a *dominant* artistic medium in the 1960s, at the same time that photography came to be accepted as a legitimate art practice. Photography played a key role in the documentation of performance art, for example, and was a central exploratory medium in the conceptual art of the 1960s and 1970s. Indeed, much of the critical thrust behind the establishment of visual culture as a field of study has been motivated by recognition of the role of photography as a medium that erodes older boundaries between art and other, popular, forms of image production.

Art in the Age of Technical Production

> Man is a technological animal . . . man must as far possible economize his energy and must in any event coordinate all his forces with the level of modern technology.[10]

> With . . . the first technical specialists in the rationalisation of the movements of workers, we see an alignment, as it were, of the human organism with the functioning of the machine.[11]

Questions about photography form part of a much larger debate on the place of art within modern Western industrial and technical society. The continued attachment to traditional notions of art, which valued its expressive qualities and its uniqueness, was already a target of criticism in the early decades of the twentieth century. For many, such an attachment constituted a romantic withdrawal from the realities of modern society and culture. Most famously, perhaps, Walter Benjamin identified the fetishism of artistic authenticity as a conservative reaction to the revolutionary potential of technical reproduction.[12] Benjamin was concerned with developments in European culture of the 1930s, but debates to do with both the impact and the potential of modern technology had been taking place for a century or more, beginning with concern over the effects of large-scale industrial production on the quality of craft and design. Britain was the first state to undergo widescale industrialisation in the first half of the nineteenth century, in which small-scale, traditional, artisan-based small-scale manufacture was replaced by larger-scale, factory-based production. As Juliette MacDonald argues in her discussion of craft, there was widespread opposition to industrial society and its allegedly negative impact on the quality and nature of art and design, leading to the campaigns of Ruskin and Morris, but neither offered genuine solutions to the problems it allegedly created. Morris's return to high-quality, hand-made designs and products failed to recognise contemporary economic conditions; though popular with wealthy middle-class clients, they proved to be inadequate to the demands of a mass society.

Much criticism of technology centred on the loss of the sense of touch. In the opening of the twentieth century the Viennese art historian Alois Riegl outlined the evolution, in Western society, of perception from a tactile orientation towards one of vision, and this theme was repeated in numerous variations.[13] Likewise, Walter Benjamin bemoaned the loss, in the modern era, of touch as the means whereby craftsmen could leave the imprint of experience on their work.[14] Such regret was expressed more forcefully in the art historian Henri Focillon's *The Life of Forms* published in 1934. Focillon celebrates the artist/artisan as a survivor of the 'hand age' in the age of the machine, and castigates the 'cruel inertia' of photogra-

phy as manifesting a 'handless eye'. Hence, Focillon argues, 'Even when the photo-graph represents crowds of people it is the image of solitude, because the hand never intervenes to spread over it the warmth and flow of human life.'[15] A similar criticism was made by Focillon's compatriot Barthes in a short essay on toys. Here Barthes bemoans the replacement of wooden by plastic toys:

> Current toys are made of a graceless material, the product of chemistry, not of nature . . . the plastic material of which they are made has an appearance at once gross and hygienic, it destroys all the pleasure, the sweetness, the humanity of touch.[16]

At the root of such criticisms was the sense that the touch of the craftsman was alien to the mechanical demands of the machine. This is certainly how the design theorist Siegfried Giedion interpreted the relation of the two, arguing that 'In its very way of performing movement the hand is ill fitted to work with mathematical precision and without pause . . . It cannot continue a movement in endless rotation. That is precisely what mechanization entails: endless rotation.'[17] A distinction between the hand-made and the machine-made was crucial, too, for the craft theorist David Pye, whose influential work distinguished between the anonymous, mechanical 'workmanship of certainty' associated with technology, and the 'workmanship of risk' of hand-made manufacture which, lacking machine precision, leaves the object with marks of imprecision and irregularity, the latter, for Pye, offering traces of humanity.[18]

Such criticisms, while often persuasive, were often rather backward-looking. At times, they could indulge in mystification, such as the following assertion by the Mexican poet Octavio Paz in the voiceover for the 1974 film *In Praise of Hands*:

> the craft object preserves the fingerprints – be they real or metaphorical – of the artisan who fashioned it. These imprints are not the signature of the artist; they are not a name . . . Rather, they are a sign: the scarcely visible, faded scar of commemorating the original brotherhood of men and their separation.[19]

Marxism is also an instructive example. While condemning the dehumanisation of modern industrialised capitalist society many Marxist thinkers have maintained a persistent faith in the capacity of technology to emancipate the oppressed of modern society. Marx himself asserted that machine-based factory production had produced a vast expansion in the scope of human exploitation, including young children. More generally, he argued:

> Factory work exhausts the nervous system to the uttermost; at the same time it does away with the many-sided play of the muscles and confiscates every atom of freedom both in bodily and intellectual activity.[20]

Other Marxist thinkers offered similar criticisms. Hence Herbert Marcuse (1898–1979) could claim: 'Not only the application of technology but technology itself is domination (of nature and men) – methodical, scientific, calculated, calculating control.'[21] In *Dialectic of Enlightenment* Max Horkheimer and Theodor Adorno pondered on the paradox that modern technological rationality, while affording emancipation from superstition and fear of nature, had turned into a tool of oppression and domination.[22] Most immediately, they had in mind the industrialised killing of the Holocaust, but their more general point was that modern technology had evolved hand in hand with increasing control of Western populations, from the 'disciplining' of workforces (including set hours and workloads) to the bureaucratic cage of the modern state. In contrast, however, Benjamin, for all his comments on the loss of human touch, maintained an optimistic sense of technology's liberating potential.

As early as 1914 such critiques were themselves being questioned. Thorstein Veblen pointed out that factory-based production was already in place before the rise of large-scale machine technology; the first stages of the industrial revolution consisted of a systematic division of labour *within* handicrafts, and in particular, textiles.[23] Veblen also took issue with romantic notions of pre-modern society, arguing that even in so-called 'primitive' cultures there is a degree of technological rationality: 'all instinctive activity is teleological. It involves holding to a purpose. It achieves some end and involves some degree of intelligent faculty to compass the instinctively given purpose.'[24] In other words, rational calculation is not only a feature of *modern* life, but is rooted in basic human instincts. As Adrian Forty has also argued, the polemic against technology and mass production blamed the symptom rather than the cause; designed goods were mass produced in order to meet a demand for cheap, readily available commodities, and technology was adapted to maximise profitability.[25]

Many avant-garde writers and artists also celebrated modern technology; the Italian Futurists fit into this pattern, engaging in a romantic and often chauvinistic fetishism of the machine and also attacking the backward nature of contemporary Italy. Venice in particular was singled out by the group leader Filippo Marinetti (1876–1944) for its status as a living mausoleum that fetishised the past, and alongside artists such as Umberto Boccioni (1882–1916) or Carlo Severini (1883–1966) Marinetti declared the liberating potential of the machine and modern technology.[26] Technology was also endorsed by the 'constructivist' avant-garde of the early Soviet Union, their fascination with the potential of modern technology combined with a commitment to the politics of revolutionary Marxism. For artists and writers such as Vladimir Tatlin (1885–1953), Alexander Rodchenko (1891–1956) or Naum Gabo (1890–1977) technology held the key to emancipation from the alienating conditions of industrial modernity. Although currently the instrument of large-scale oppression – particular attention was paid to low-paid factory workers

– many argued modern technology held a utopian potential to free workers from the drudgery of the daily grind of repetitive, dehumanising labour. Art was also the object of particular criticism; for the constructivists the issue was not simply which *kind* of art one should produce, but whether art was itself relevant in revolutionary society. It was faulted for a number of reasons. First, it was the relic of a medieval system of training and production, in which the basic technologies of art making had hardly changed in 500 or so years. Second, as a small-scale process of production it was still oriented towards a limited, social elite, rather than to a mass audience. Third, the romantic myth of art as expression gave it a private quality that made its relevance questionable in a culture aiming at large-scale social emancipation. As Aleksandr Bogdanov argued in 1920: 'The technical methods of the old art have developed in isolation from the methods of other spheres of life; the techniques of proletarian art must seek consciously to utilize the materials of all those methods. For example, photography, stereography, cinematography . . . must find their own places as media within the system of artistic techniques.'[27] Hence, traditional art had become disconnected from the realities of contemporary society, and it was an obligation for the producers of revolutionary ('proletarian') art to make good that gap. A similar view was put forward by Alexei Gan:

> The fact that all so-called art is permeated with the most reactionary idealism is the product of extreme individualism . . . Art is indissolubly linked with theology, metaphysics and mysticism. It emerged during the epoch of primeval cultures, when technology existed in the embryonic state of tools and forms of economy floundered in utter primitiveness.[28]

A brief burst of experimentation occurred in the years immediately following the Bolshevik Revolution of 1917, in which the concept of art itself was interrogated. Tatlin and Gabo produced abstract structures the status of which was ambiguous; it was difficult to term them 'sculpture' since they seemed more allied to engineering than to traditional notions of art. Gabo foregrounded a continuing interest in engineering and technology, producing heads that envisaged human beings as engineering achievements in place of humanist notions of consciousness or the soul. Finally, Rodchenko turned to photography, with work that hovered between avant-garde artistic practice and social and political documentary. In the work of these three figures, perhaps the most significant representatives of constructivism, there was a deliberate blurring of boundaries; art, architecture, engineering and social documentation all merged as part of a campaign to further the political aims of the revolution, and in support of the argument that the conditions of modern industrial society compelled a reassessment and eventual relinquishing of practices that were relics of an earlier age. As Rodchenko declared, 'Art has no place in modern life . . . Every modern cultured man must wage war on art as on opium.'[29]

A similar celebration of modern technology occurred in the 1920s and 1930s in the United States. The cultural historian David Nye has explored the 'technological sublime' in America, where the sheer immensity of projects such as the Hoover Dam or Brooklyn Bridge was the cause of a patriotic awe and marvel.[30] In 1934 the Museum of Modern Art (MOMA) in New York staged an exhibition entitled 'Machine Art' (Figure 12.1), which was an exploration of the aesthetic qualities of modern industrially produced artefacts.[31]

On the one hand, the exhibition was the celebration of a new machine aesthetic, which was accompanied by a sense of the redundancy of traditional craft. As the catalogue states, 'the craft spirit does not fit an age geared to machine technique . . . and the real handicrafts have lost their original vigor'.[32] Yet more was at stake, for the exhibition consisted primarily of the display of contemporary industrial and consumer goods, ranging from gasoline pumps to electric toasters and items of furniture. In most cases the name of the company and the price were also listed, while the catalogue looked as if it was for a contemporary design shop (Figure 12.2). This was significant, for it suggested both the displacement of art by machine-made commodities and also the hegemony of modern consumerism.

MOMA subsequently returned to a rather more traditional notion of art practice, and its name became synonymous with the attempt to maintain the autonomy of art *against* the encroachments of industrial modernity, but the espousal of a machine aesthetic became widespread in the 1930s. In a now classic work on machine art published in 1936, Sheldon and Martha Cheney celebrated the rise of industrial design that coupled feats of engineering with a new aesthetic based on precision.[33] Streamlining was of particular significance (Figure 12.3). It was interpreted not simply as a functional design element – the minimisation of air resistance to moving vehicles – but also as a visual symbol of the value of the modern age: speed, dynamism and 'contemporary life flow'.[34] While the Cheneys recognised the substantial interest of modern artists in modern technology, they were ultimately damning of the inability of society to meet the challenges of the industrial world. They critiqued in particular the failures of art and design education in responding to contemporary realities: 'educators still are thinking in terms of the old divided world: of the machine as one thing . . . of art as another, existing (rather ornamentally) in a realm totally removed from that of practical affairs.'[35] Consequently, they conclude, there are 'nineteenth-century colleges of engineering and nineteenth-century art schools and handicraft schools, but there are no twentieth-century art-in-relation-to-technology schools'.[36] What the Cheneys and numerous others argued was that a thorough engagement with technology involved more than surface adoption of a mere 'style'; rather, it implied a recognition of the much larger changes in systems of production that could ultimately lead to the dissolution of traditional practices of 'art', 'craft' or 'design'.

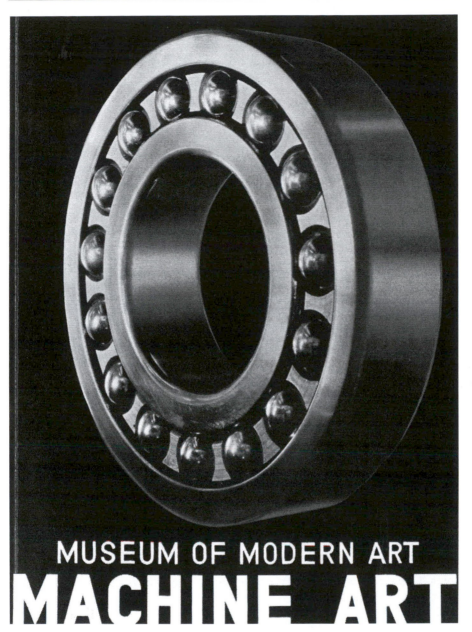

Figure 12.1 – Josef Albers, Cover of the exhibition catalogue *Machine Art*, New York, Museum of Modern Art (1934). Photograph © SCALA, Florence.

75

Health scale, number 711

Hanson Scale Co.

$12.95. Department and hardware stores

73

Silver Streak carpet sweeper

Bissell Carpet Sweeper Co.

$5.00. Department, furniture
ware stores

Figure 12.2 – Illustrations 75 and 73 from *Machine Art* catalogue, New York, Museum of
Modern Art (1934). Photograph © SCALA Florence.

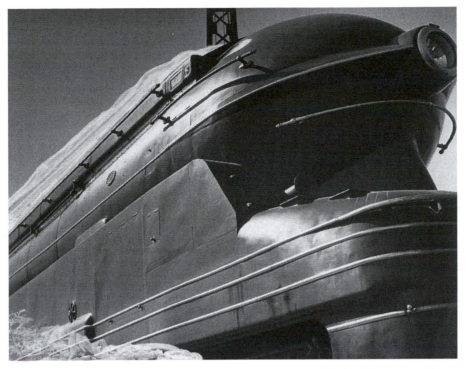

Figure 12.3 – David E. Scherman, *World's Fair Locomotive* (1939). Photograph courtesy of Time & Life Pictures.

After Constructivism

After the second world war, the fascination with machines underwent a number of transformations. Within the Soviet Union the Constructivists were seen as too disruptive and their work was increasingly censored and passed over in favour of officially approved art, Socialist Realism, which, employing traditional narrative forms and techniques, celebrated the achievements of the Communist regime. In the West the utopian celebration of technology took on new forms and in the 1960s, focused increasingly on the potential of the computer and the computer network. The British artist Roy Ascott, for example, explored computer systems and cybernetics – the theory of information control and feedback – to promote an artistic practice that would overcome the elitism of most art by enhancing interaction between the audience and the artwork.[37] This interest in the computer culminated in a number of high profile exhibitions in the late 1960s such as *Cybernetic Serendipity* mounted by Jasia Reichardt in the Institution of Contemporary Arts in London in 1968, and *Software* organised by Jack Burnham in the Jewish Museum in New York in 1970. Burnham also authored an important book, *Beyond Modern Sculpture. The Effects of Science and Technology on the Sculpture of this Century*, which presented the introduction of computerised systems of control and organisations as presenting

an unavoidable challenge to existing notions of art – as a material object rather than as a system of information.[38]

The interest in cybernetics and networks was eventually subsumed in the 1980s and 1990s by debates concerning the internet and global media, which are explored later in this book.[39] Yet while there was a continuing celebration of technology – the most extreme example within art might be the attempts by the contemporary Australian artist Stelarc to transform himself into a cybernetic organism – there was also considerable scepticism regarding its utopian possibilities. Norbert Wiener, the founder of cybernetics, believed that it could be used for the purpose of social progress and improvement, but was dismayed by the postwar militarisation of new technologies.[40] The most extensive recent criticism of this process has been undertaken by the French cultural theorist Paul Virilio.[41]

In the United States, on the other hand, the ideas of the Constructivists, having been banished from Soviet Russia, gained a resurgence of interest from the 1960s onwards. Minimalist artists such as Robert Morris or Donald Judd openly declared their intellectual debt to Constructivism, producing artworks that employed raw industrial materials, or neon lights in the case of Dan Flavin. Significantly, they distanced their work from connotations of 'art', Judd, for example, referring to his works as 'objects' rather than sculptures.[42] Various critics, most famously Michael Fried, took issue with minimalism on account of its failure to pursue the aesthetic goals felt to be the proper concern of art. Indeed, for Fried the work of Morris, Judd and others was a form of artistic degeneracy he preferred to term 'theatre' rather than art.[43] Fried's point was perhaps more insightful than he might have realised, for minimalist work contributed to a much wider erosion, in the 1960s and 1970s, of traditional distinctions between art and non-art. Minimalism existed in an ambiguous space between art and industry, and as if to reinforce this, its pared-down forms have subsequently been appropriated by contemporary commercial designers such as John Pawson.[44]

Constructivist ideology also gained a renewed impetus in the late 1970s with the publication of the journal *October* in the United States. Founded in 1976, the title alone of *October* – with its reference to the Russian Revolution – highlighted this, and it was established in order to break with an unquestioned subscription to romantic notions of art. The writers associated with *October* aimed above all to promote 'critical practice', which meant not only overt political critique, but also an undermining of art as a social institution. A central place was allotted to photography. This was deemed to have an *intrinsically* critical potential not open to more traditional forms such as painting or sculpture. For the American critic Douglas Crimp, photography had 'overturned the judgement seat of art', a fact which modernism, in its anxiety to maintain autonomy, had repressed.[45] Accordingly, the rise of postmodernism was a kind of return of the photographic 'repressed'. Crimp and others also supported artists such as Cindy Sherman, Sherrie Levine, Hans Haacke

or Louise Lawlor, who placed photography at the centre of their practice. As Abigail Solomon-Godeau argued, 'photography has come to mediate, if not wholly represent the empirical world for most of the inhabitants of industrialized societies' and consequently 'it has become a principal agent and conduit of culture and ideology'.[46] As the dominant medium for the dissemination of images, photography had become the central vehicle of visual meaning, and to remain attached to other artistic media was to be focused on an obsolescent and irrelevant form. For, she argued, 'every critical and theoretical issue with which postmodernist art may be said to engage in one sense or another can be located in photography'.[47] One figure who attracted considerable critical attention in this context was the painter Gerhard Richter, whose paintings were held to inhabit a space *between* painting and photography. They resemble and make reference to photographs, but remain unmistakeably paintings. Richter, who has been working since the 1960s, appears to be engaged on an extended meditation on the impossibility of traditional painting in the era of photography. That, at least, is how he has been interpreted. As Benjamin Buchloh suggested in interview with Richter: 'pictures have lost their descriptive and historical function, among other reasons because photography does it so perfectly. Hence this task is no longer given.' Consequently, the 'high artistic quality of old pictures' is also no longer possible.[48]

Much of the critical energy of the early years of *October* was directed against the alleged neutering of photography's critical potential. It castigated museums – and in particular John Szarkowski, MOMA curator of photography – for transforming photography into a merely aesthetic practice.[49] Photography's potential to disrupt the boundaries of art was halted by its incorporation into the art museum. Likewise, in his historical essays Buchloh criticised the process whereby avant-garde photographic experiments in the 1910s and 1920s, including montage, photocollage and oblique-angle images, were later appropriated and robbed of their critical impact and employed as propaganda for Stalinism, or for the war effort of the US government in the 1940s.[50]

Central to these accounts was the notion that photography has an *intrinsically* critical potential. Using photography for other 'non-critical' purposes was attacked as reactionary, a repression of its properly critical function. This echoed wider arguments about the progressive nature of new technologies. Already in the 1920s and 1930s architects held that modern, technologically-driven urban and architectural planning could effect progressive social change. As Le Corbusier argued in 1924, with the introduction of mass-produced standardised architectural elements, 'our towns will lose that appearance of chaos which blights them at the moment . . . That order which the poet seeks by looking back to past eras will reign once again.' Le Corbusier had in mind not only architectural and aesthetic, but also social and cultural order.[51] Technology was not a neutral 'tool', but was enmeshed within wider social and political contexts.

Criticisms

A recurrent criticism levelled at many of these accounts has singled out their *technological essentialism*, in other words, their reliance on the idea that a specific technology has intrinsic properties and that its social impact is generated by the workings of those properties, rather than by the uses to which it is put. For the Soviet writer Osip Brik (1888–1945), even the most progressive painting practice was hampered by the intrinsic inability of painting to articulate the experience of modern society, while for Buchloh the renewed interest in painting in 1970s and 1980s Neo-Expressionism was a politically reactionary turn to the past.[52] Many film theorists in the 1960s and 1970s likewise argued that the technology of the camera is *intrinsically* ideological.[53]

The difficulty with such views is that technological change occurs as part of a complex set of social, historical and cultural forces, and these often *frame* the effects of the technology in question. The steam engine was invented in Hellenistic Egypt in the first century, but because of other social factors – including the prevalence of slavery – it remained a novelty and died with its inventor, Hiero of Alexandria. While gunpowder was invented in China, its use was restricted to fireworks; only when adopted in Europe in the early fourteenth century was it used as a weapon. The computer, as its name suggests, was originally a machine for performing difficult mathematical calculations; there was nothing intrinsic to the technology that would lead it to become a powerful *visual* instrument.

Such accounts also rely on a notion of history as a one-way process; reverting to 'old' media is seen as an historical regression. However, history does not progress in such a linear fashion; the utopian predictions of Benjamin with regard to cinema, for example, have been revealed as naïve. It has featured as both a progressive and a politically regressive medium. While revolutionary films were made by the Soviet director Sergei Eisenstein, some of the most compelling cinematic productions were those of Nazi filmmaker Leni Riefenstahl. Indeed, Adorno came to devote considerable effort to the analysis of the negative and regressive character of cinema. Recent developments also cast doubt on the binary opposition between small-scale, hand-made artisanry and large-scale technologically-based production. Contemporary craft is currently engaging in a sustained dialogue with contemporary technology, including the use of computer-based haptic virtual interfaces which enable a return of the sense of touch.[54] Using such technology, traditional craft skills are married with the latest technology. In addition, many contemporary artists, such as Gary Hill, Andreas Gursky and Susan Hiller, employ current media, ranging from photography to digital video, but their practice often stands at odds with claims made on behalf of the technology in question. Although a work such as *Flex* (2002) by the video artist Chris Cunningham, for example, may have the high-quality technical values commonly associated with expensive film

productions, it remains an exception. The work of many artists using such media, including, for example, Tacita Dean and Bill Viola, cultivates a low-tech aesthetic, resulting in low-resolution, grainy imagery that consciously differentiates between video-based art and commercial film and video. Older romantic models of art as standing apart from the precise, technologically oriented society of modernity persist despite the employment of newer media and, in the case of Viola, this is allied to the resurrection of age-old humanistic artistic themes to do with life, death and rebirth with distinctly unmodern religious overtones.

It is also important, finally, to highlight the many criticisms of the fascination with technology made by feminist commentators and critics. As early as Futurism, the celebration of the machine was allied with a repugnant masculine chauvinism, and it has been argued more generally that in Western societies technology embodies a specifically masculine set of values. While critics and visual practitioners have attempted to reclaim technology for a feminist politics, persistent criticisms remain as to its gendered nature.

Conclusion

The past 150 or so years have seen fundamental shifts in European and North American visual culture, not only formally and aesthetically, but also in terms of the systems of production and dissemination. The German art historian Hans Belting has argued that such a decisive a break with the past has occurred as to make it impossible to speak of a continuous development up to the present.[55] For the present purposes perhaps the most important consequence of these changes has been a radical scepticism regarding the viability of traditional discourses of art, architecture or craft, coupled with a rise of critical interest in the notion of visual culture as a means of analysing new realities. Arguably, the technologies of modernity have both enabled and, for some, compelled the erasure of such differences. Art long ago ceased to be the most significant visual articulation of cultural identity and value; in an era of mass technological production and reproduction of artefacts and images, the continuing attachment to concepts of individual creativity and expression can seem incongruous.

For Adorno artistic practice was an essential weapon of resistance to a society in which personal identity was under threat of annihilation.[56] Yet for others such attachment to the individual can seem like a cultivated mannerism or archaic throwback. Most material objects and visual images encountered are produced on a mass scale, anonymously. One might think of the unknown designers working for agencies, or the nameless producers of the stock photographs disseminated in their millions on a daily basis, or indeed the anonymous technicians responsible for producing much of what currently counts as art. It is this context that forms an essential element in the analysis of both contemporary visual practices and key

debates informing their interpretation. The notion of visual culture suggests that traditional modes of analysis, inherited from individual disciplines, are perhaps no longer adequate as a basis for understanding contemporary practices. What is equally evident, though, it that it has proved difficult to shake them off.

Further Reading

Asendorf, Christoph. *Batteries of Life* (Los Angeles, 1992).

Banham, Reyner. *Theory and Design in the First Machine Age* (London, 1960).

Ihde, Don. *Technology and the Lifeworld* (Indianapolis, 1990).

Giedion, Siegfried. *Mechanization Takes Command* (Oxford, 1948).

Notes

1 See, for example, Wolfgang Schivelbusch, *The Railway Journey. The Industrialization and Perception of Time and Space* (Los Angeles, 1990); Stephen Kern, *The Culture of Time and Space 1880–1914* (Cambridge, MA, 1983).

2 Paul Delaroche, cited in Mary Warner Marien, *Photography and its Critics* (Cambridge, 1997), p. 55.

3 See in particular Arthur Danto, 'Approaching the End of Art', in *State of the Art* (New York, 1987), pp. 202–20.

4 Clement Greenberg, 'Avant-Garde and Kitsch' (1939) and 'Towards a Newer Laocoon' (1940), in Francis Frascina, ed., *Pollock and After. The Critical Debate* (London, 1992), pp. 21–34 and 35–46.

5 See Thomas Crow, 'Modernism and Mass Culture in the Visual Arts', in Frascina, *Pollock and After*, pp. 233–66.

6 See Paul Crowther, 'Postmodernism in the Visual Arts: a Question of Ends', in Thomas Docherty, ed., *Postmodernism: a Reader* (Hemel Hempstead, 1993), pp. 180–93.

7 See Walter Benjamin, 'Little History of Photography,' in W. Benjamin, *Selected Writings. Vol. 2: 1927–34* (Cambridge, MA, 1999), pp. 507–30.

8 André Breton, 'Max Ernst', in F. Rosemount, ed., *What is Surrealism?* (London, 1978), p. 7.

9 Rosalind Krauss, *The Optical Unconscious* (Cambridge, MA, 1993). The term was originally coined by Walter Benjamin, although for Krauss the notion of the 'optical unconscious' has a rather different set of connotations.

10 Nikolai Punin, 'Lectures' [1919], in J. Bowlt, ed., *Russian Art of the Avant-Garde. Theory and Criticism 1902–1934* (London, 1976), p. 175.

11 Georges Canguilhem, *La Connaissance de le Vie* (Paris, 1971), p. 126. First published Paris, 1952.

12 Walter Benjamin, 'The Work of Art in the Age of its Technical Reproducibility', in W. Benjamin, *Selected Writings. Vol. 3: 1935–1938* (Cambridge, MA, 2002), pp. 101–33.

13 See, for example, Alois Riegl, *Spätrömische Kunstindustrie* (Darmstadt, 1992). First published, Vienna, 1901.

14 Walter Benjamin, 'The Storyteller. Observations on the Work of Nikolai Leskov,' in Benjamin, *Selected Writings. Vol. 3*, pp. 143–66.

15 Henri Focillon, *The Life of Forms in Art* (New York, 1989), p. 174.

16 Roland Barthes, *Mythologies* (London, 1973), p. 54.

17 Siegfried Giedion, *Mechanization Takes Command* (Oxford, 1948), pp. 46–7.

18 David Pye, *The Nature and Art of Workmanship* (London, 1968).

19 Octavio Paz, cited in Malcolm McCullough, *Abstracting Craft* (Cambridge, MA, 1998), p. 10.

20 Karl Marx, *Capital. Vol. I* (Harmondsworth, 1976), p. 548.

21 Herbert Marcuse, 'Industrialization and Capitalism in Max Weber' [1964], in H. Marcuse, *Negations. Essays in Critical Theory* (London, 1988), pp. 223–4.

22 Theodor Adorno and Max Horkheimer, *Dialectic of Enlightenment* (London, 1979).

23 Thorstein Veblen, *The Instinct of Workmanship and the State of the Industrial Arts* (New York, 1914), pp. 302ff.

24 Ibid., p. 31.

25 Adrian Forty, 'Design and Mechanisation', in *Objects of Desire* (London, 1995), pp. 42–61.

26 See Pontus Hulten, ed., *Futurism and Futurisms* (London, 1987).

27 Cited in Bowlt, *Russian Art of the Avant-Garde*, p. 181.

28 Cited in ibid., p. 221.

29 Cited in ibid., p. 253.

30 David Nye, *The American Technological Sublime* (Cambridge, MA, 1994).

31 Alfred Barr, ed., *Machine Art* (New York, 1934).

32 Ibid.

33 Sheldon and Martha Cheney, *Art and the Machine* (New York, 1936).

34 Ibid., p. 98.

35 Ibid., p. 265.

36 Ibid.

37 See Roy Ascott, *Telematic Embrace. Visionary Theories of Art, Technology and Consciousness*, ed. Edward Shanken (Los Angeles, 2003). For a useful outline of Ascott's ideas, see Edward Shanken, 'From Cybernetics to Telematics: The Art, Pedagogy and Theory of Roy Ascott', in ibid., pp. 1–96.

38 Jack Burnham, *Beyond Modern Sculpture. The Effects of Science and Technology on the Sculpture of this Century* (New York, 1968). Jasia Reichardt also edited a useful anthology of texts, *Cybernetics, Art and Ideas* (London, 1971) which offers an indication of the kinds of ideas being explored at the time.

39 For a general outline of the role of the computer in recent art see Frank Popper, *Art of the Electronic Age* (New York, 1993).

40 See Norbert Wiener, *The Human Use of Human Beings. Cybernetics and Society* (New York, 1967).

41 See Paul Virilio, *War and Cinema* (London, 1989); and Paul Virilio, *The Aesthetics of Disappearance* (New York, 1991).

42 See Donald Judd, 'Specific Objects', in *Arts Yearbook*, Vol. 8 (1965), pp. 74–82.

43 See Michael Fried, 'Art and Objecthood', in C. Harrison and P. Wood, eds, *Art in Theory 1900–1990* (Oxford, 1992), pp. 822–34.

44 In *Minimum* Pawson promoted his design 'philosophy' of minimal form. Although drawing on an eclectic, and ultimately incoherent, range of sources, the importance of 1960s minimalism is clear. See John Pawson, *Minimum* (London, 1998).

45 Douglas Crimp, 'The Photographic Activity of Postmodernism', in D. Crimp, *On the Museum's Ruins* (Cambridge, MA, 1993), pp. 108–19.

46 Abigail Solomon-Godeau, 'Photography after Art Photography', in B. Wallis, ed., *Art after Modernism: Rethinking Representation* (New York, 1984), p. 76.

47 Ibid., p. 80.

48 Benjamin Buchloh, in Charles Harrison and Paul Wood, eds, *Art in Theory 1900–2000* (Oxford, 2003), p. 1149.

49 Christopher Phillips, 'The Judgement Seat of Photography', in *October*, Vol. 22 (1982), pp. 27–63.

50 Benjamin Buchloh, 'From Faktura to Factography', in *October*, Vol. 30 (1984), pp. 82–119.

51 Le Corbusier, 'Mass Produced Buildings', in T. Benton and C. Benton, eds, *Form and Function. A Source Book for the History of Architecture and Design 1890–1939* (London, 1975), p. 135.

52 See Osip Brik, 'From Pictures to Textile Prints' [1924], in Bowlt, *Russian Art of the Avant-Garde*, pp. 244–9; and Benjamin Buchloh, 'Ciphers of Authority, Figures of Regression', in *October*, Vol. 16 (1981), pp. 39–68.

53 See Jean-Louis Comolli, 'Technique and Ideology: Camera, Perspective and Depth of Field', in Bill Nichols, ed., *Movies and Methods, Vol. II* (Los Angeles, 1985), pp. 40–57; Jean-Louis Baudry, 'Ideological Effects of the Basic Cinematographic Apparatus', in ibid., pp. 531–42.

54 See McCullough, *Abstracting Craft*.

55 Hans Belting, *The End of Art History*, trans. C. Wood (Chicago, 1987).

56 Theodor Adorno, 'The Schema of Mass Culture', in T. Adorno, *The Culture Industry* (London, 1991), pp. 61–97.

13. Technical Reproduction and its Significance

Ruth Pelzer

Introduction

The idea of technical reproduction suggests a number of possibilities. Most immediately, it might be associated with *photography*, but there are numerous other kinds of reproduction, ranging from recordings of musical performances, to computer simulations, to the transformation of design prototypes into mass-produced objects.[1] While the era of technical reproduction is usually seen as particularly modern, the first medium of mass-reproducible images, the woodcut, was invented in the fifteenth century, while the use of metal coinage – arguably the first type of mass reproduced image – can be traced back even further to the eighth century BCE.

This chapter focuses on technically reproduced and reproducible images. Although printed images have been in circulation for more than 500 years, the invention of photography introduced shifts in the function of visual culture which far exceeded the impact of printmaking. It vastly increased the *quantities* of reproduced images and crucially enabled most individuals to produce and reproduce their own visual imagery. Accordingly, the following questions will be addressed: What characterises technical reproduction as the main feature of the mechanical age? What were and are its implications for visual culture? How did these changes affect the meaning and practice of art?

Society of the Image

The contemporary economic, social and political environment of Western culture is not only defined by mass produced *objects*, it is also defined by mass-produced or, strictly speaking, mass-'reproduced' media forms, such as newspapers, cinema, magazines, radio, television, CDs, DVDs, and so on. Alongside other products of mass-produced consumer culture, such as fashion items or designed objects these media, individually and collectively, serve to identify who we are. Certainly this holds true in Western countries, and, to an increasing degree, in the so-called developing world too. Most people in the West could tell their life-story in relation to the TV programmes they watched in the different phases of their lives. Personal biographies appear to resemble fictional characters from TV soap operas and films. Such dramas, comedies and the like were themselves created in response to the social and cultural climate of the time.[2]

Historical events, likewise, are remembered in terms of the images the mass media disseminate and recycle. Of course, the images that come to mind and the particular relationship an individual person may have with them, will be partly dependent on gender, race, sex, age, nationality and location. Yet some images have almost global distribution: the Holocaust, Kennedy's assassination or, more recently, the destruction of the Twin Towers of the World Trade Center in New York on 11 September 2001 by al-Qaeda. None of these images is neutral. One only has to think of the type of image and the context in which it occurs to realise the ideological nature of the media industry.

For practitioners of visual culture the question arises as to what extent they are dependent on access to reproduced images as part of the discourses which map out their discipline. These may be in the form of books, catalogues, specialist periodicals, videos, television programmes, the Internet and CD-Roms and DVDs. The art historian William Ivins made this point in 1953 when writing about the impact of print media on knowledge:

> The printing of pictures . . . made possible, for the first time pictorial statements of a kind that could be exactly repeated during the effective life of the printing surface. This exact repetition of pictorial statements has had incalculable effects upon knowledge and thought, upon science and technology, of every kind.[3]

What is a 'technically reproduced image'? Prints, as indicated in Ivins' statement, were the first technically reproduced images. They were directly created for reproduction or intended as inexpensive multiple copies of existing paintings, drawings or sculptures. In either case, a drawing was transferred to or executed on a base, be it wood in the case of a woodcut, a metal plate for an engraving or etching

and stone in case of the lithograph. The resulting matrix allowed multiple repro-
ductions or copies of the image onto paper by running the plate through a printing
machine. The woodcut from the early 1400s represents the earliest form of the
reproducible image, followed by engravings and etchings in the sixteenth century
and the lithograph at the beginning of the nineteenth. The latter was considered a
major advance since it overcame the limitations of earlier processes whereby the
material nature of the matrix or plate meant a quick deterioration of the print
image's quality. In other words, the economic viability of such prints was curbed.
In contrast, reproduction through lithography allowed almost limitless copies of
good quality. The method also speeded up the drawing process as direct drawing
on the stone was possible. This permitted greater immediacy of execution and
therefore increased the commercial scope of prints.

For cultural historians, the beginning of technical reproduction of the image in
the modern sense is often located in the emergence of photography in the late
1830s. A photograph could be defined as a technically produced image with the
inherent capacity for reproduction. Throughout the 1800s inventions and changes
to the process of printing photographs allowed for mass dissemination. An early
manifestation was the popularity of the picture postcard of well-known personal-
ities, tourist spots, and so on. Thus, photography accompanied and helped to define
the emerging cultural and socio-economic fields which today are known as 'media
publicity' and 'tourism'.[4] A further stage in the dissemination of images was the
inclusion of the photographic image in newspapers from the beginning of the twen-
tieth century and in magazines from the 1920s. Cinema films and television were
the other main forms of technically reproduced image until the widespread emer-
gence of computers during the 1980s and the almost explosive image multiplica-
tion through the world wide web from the early to mid-1990s.

The implications of these technological changes for visual culture have preoccu-
pied many thinkers in the twentieth century, notably Walter Benjamin, the
Canadian communications theorist Marshall McLuhan (1911–80) and the French
media theorist Jean Baudrillard (1929–). Their writings continue to inform think-
ing across the social sciences. New academic disciplines such as media and film
studies in the 1970s and, more recently, visual culture studies have emanated from
recognition of the changes brought about by reproductive image technologies.

Already in the 1930s Benjamin insisted that reproduction is the crucial aspect of
modernity. The importance of the reproductive nature of the camera-based image
does not just lie in the quantitative possibility of the reproduction in huge numbers.
Another, qualitative aspect of the photograph related to reproduction is its assumed
potential to 'reproduce' or 'copy' reality. Debates in film and photography theory
over the last thirty years have questioned this commonly held assumption.
Photographic 'realism' is now seen to constitute a historical form of representa-
tion.[5] Nevertheless, the privileged role that camera-based images still have in

terms of their purchase on reality was made obvious most recently in the extent and type of media coverage during the so-called 'second Gulf War' in spring 2003.

The ability of technically produced and reproduced images to penetrate space and time has resulted, according to Marshall McLuhan, in the creation of a 'global village'. This phrase has now entered public consciousness. It refers to the fact that, thanks to the reproduction of the same images and information on an almost global scale, people receive the same news and media products worldwide. The mass production of newspapers, magazines and films started this process and it has been greatly expanded by, first, television and subsequent modes of transmission such as satellite or cable and the Internet. McLuhan's recognition of the global aspect of this phenomenon has to be qualified, however. The socio-economic structures of dissemination, distribution and reception favour the economically and politically more dominant countries with Europe, Asia and North America in the lead. In his study of the 'network society' Manuel Castells quotes figures supplied by UNESCO: 'in 1992 there were over 1 billion TV sets in the world (35 percent of which were in Europe, 32 percent in Asia, 20 percent in North America, 8 percent in Latin America, 4 per cent in the Middle East and 1 percent in Africa).'[6]

Despite such a qualification, the global reach of the media could be seen as confirmation of McLuhan's best known assertion: 'The medium is the message.' This is often misunderstood as suggesting that the technical means of reproduction are of greater significance than the content: the 'how' of transmission being more important than the 'what'. It is more fruitful, however, to read it as drawing attention to the different possibilities of technical image modes. In the context of McLuhan's writing it relates both to the interrelationship between media and ourselves and also to the changes they instigate. In physical terms a photograph is a relatively permanent and static image that is easily transportable. In its mass-produced form it is also cheap and hence disposable. It further allows repeated and close as well as a casual, distracted viewing. Television images, in contrast, are moving, mostly non-permanent, not so easily transportable (except in the form of video and DVDs) but permit viewing over a duration of time. The immediacy of TV tends to compensate for its impermanence. A particular medium can assume different meanings. A useful example can be seen in the consumption of TV and newspaper media – both visual and textual – at the time of the events of 11 September 2001. One might think that television was the preferred medium due to its directness and immediacy. Yet, a rise in the sales of newspapers (Figure 13.1) immediately after the event indicates that each medium offers a specific and distinct benefit valued by audiences. Different media complement rather than replace one another. In the case of current events, television gives the viewer a sense of participation almost as events unfold, whereas the written word and printed photographic image provide relative permanence and hence carry more authority.

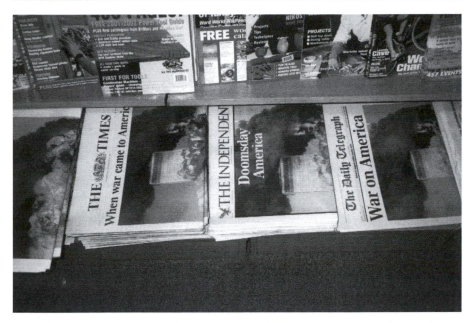

Figure 13.1 – Newspapers reporting 11 September 2001 on a newspaper stand in London. Author's photograph.

Baudrillard has expanded many of McLuhan's ideas. His particular focus is the technically reproduced image and its relationship to our notion of reality. Like McLuhan, several of Baudrillard's often inflated pronouncements have turned into popular catch-phrases, most famously, perhaps, his suggestion that we now live in a state of 'hyperreality'. For Baudrillard, the real has been replaced by 'simulation'. Many aspects of culture and society are now based on a fake reality achieved by the reproduction of what once was real. The American *Disneyland* theme parks serve as Baudrillard's example: 'Disneyland exists in order to hide that it is the "real" country, all of "real" America that *is* Disneyland.'[7]

This substitution of the real through representations had already been identified by the French writer and political activist Guy Debord.[8] For Debord every aspect of life in contemporary Western society is infiltrated by commercialisation or the 'commodity system', based on spectacular reproduction. It is often the case that we have seen a representation of a particular event or an everyday situation in a soap opera or a commercial on television before we actually experience it ourselves. Moreover, the visual imaginary space we inhabit – furnished by media images – vastly exceeds anything we could ever possibly experience ourselves 'for real'.

It could be argued that simulation and the hyperreal have always been an aspect of the products of the imagination through myth, fairy tales, literature and other art forms. However, mediatisation in its commodified form has been unprecedented. Unlike its meaning in everyday language, the 'hyperreal' for Baudrillard

does not suggest that something is 'surreal' or 'unreal', but that that it is 'more than reality itself'.[9] The immensely popular reality TV series *Big Brother* in the UK and other countries is a telling example. A group of people come together and live their life under the constant surveillance of TV cameras. They act out a simulated version of life. This state is neither completely 'real' nor 'not real'; it is a heightened version of how people behave in real life, hence it can be considered 'hyperreal'. *Big Brother* is an especially apt instance of another much cited assertion by Baudrillard regarding 'the dissolution of TV into life, the dissolution of life into TV'.[10] In this respect television is part of the increasing erosion of the boundaries between the public and private sphere, which had been one of the constituents of modernity.

One further aspect of hyperreality concerns not only the effect and functioning of the media, but also the visual appearance of media products themselves. Andrew Darley makes the following point: 'just as images are becoming more and more "convincing", so also are they becoming increasingly detached from traditional representation and more and more caught up in modes of serial equivalence, modulation and self-referentiality.'[11] Media images feed off each other and function by recycling or reproducing other images, image modes or genres. The two sequels and assorted DVD and computer game spin-offs of *The Matrix* demonstrate the phenomenon of 'serial equivalence'. The 'modulation' referred to by Darley takes the form of variations on the theme and format of the initial film. The latter itself constitutes an example of the self-referentiality of media products as one reviewer noted: 'Just stopping short of being totally derivative, the Wachowskis [the directors of the films] instead manage to take everything we've already seen just one exhilarating step further . . .'[12]

But why do we like media images so much; why should watching television or going to the cinema be so compelling? Reproductive image technologies have extended the possibilities of 'scopophilia', a term from Freud which refers to the basic erotic pleasure in looking.[13] Benjamin spoke also of the 'shock' that watching films induces; for McLuhan the extension of the body which the media constitute turns the body 'ecstatic', even 'electric'. This heightened quality of our lives in and through the media is also apparent in the 'plugged-in' character of many of our daily activities: listening to music or speaking and watching images on the mobile telephone while shopping. Referring to both Benjamin and McLuhan, Hal Foster has elaborated on the physiological and psychological effect of the media on the viewer: 'technology is both an excessive stimulus, a shock to the body *and* a protective shield against such stimulus-shock with the stimulus converted into the shield (which then invites more stimulus and so on).'[14] The 'reality factor' of camera-based images can generate stronger physiological and psychological reactions than a painting might do. At the same time they provide a safety-net against the shock they themselves induce. A photograph representing an extremely

violent scene may cause us to be shocked, even to feel nauseated, but watching it 'safely' at a remove from the actual scene simultaneously 'shields' us from the shock. Being exposed to increasing numbers of images showing extreme situations such as starvation or violence leads to so-called 'compassion fatigue'. One effect is that images have to become ever more violent and/or spectacular to elicit a reaction as Susan Sontag has argued in her book *On Photography* (1971): 'Photographs shock insofar as they show something novel. Unfortunately, the ante keeps getting raised – partly through the very proliferation of such images [of horror].'[15] The public debates surrounding pornographic images or violence on screen are a further indication of some of the problems raised by the multiplication and widespread availability of images.

McLuhan, Debord and Baudrillard have mapped the trajectories of a mediated culture and society which we can recognise at the beginning of the present century. However, their vision does not allow for the incongruencies, the sheer diversity of possibilities presented by the continuation of older or other modes of cultural production, often in hybrid form, with new ones. They run the danger of instilling political apathy as they give insufficient recognition to the reception of media products on part of audiences. Their theories run close to older conceptions of the effect of technical media as implied by the term 'mass media'. The term 'mass media' denotes systems of communication which reach large numbers of people. To the 'primary' mass media such as radio, television, cinema, newspaper and magazines we now have to add the Internet and world wide web. Despite its continuing usage, this term has been critically evaluated by media and cultural theorists. The word 'mass' connotes an undifferentiated multitude of mute and passive receivers and does not take account of the much more differentiated make-up of both the products and the recipients of the media. The former is evident in the 'narrow-casting' that television now allows ('narrow-casting' refers to channels or programmes that address very specialised and 'niche' audiences such as ethnic or other minorities, or people with specialised interests). There is also greater awareness of the complexities of consumption in general and of the active participation that the consumption of media products in particular involves. Stuart Hall's classification of different 'reading' positions as 'dominant-hegemonic', 'negotiated' and 'oppositional' accounts for different viewers' reaction to a given television programme or other media products.[16] The audience for *The West Wing* may accept its politics or reject it while still enjoying the series.

Art in the Age of Technical Reproduction

The work most referred to in the context of the effect of technical reproduction is Walter Benjamin's essay 'The Work of Art in the Age of its Technical Reproducibility', published in 1936. Its translation into English in 1968 coincided

with the beginnings of academic film and media studies.[17] Benjamin considers the impact of technical reproduction on art in a twofold manner. The effect of photography and film on art in its dominant traditional form is outlined. At the same time Benjamin is concerned with the cultural and material aspects of these two media and their artistic potential in terms of a Marxist-inspired revolutionary politics. The 'artwork' essay can be seen as a response to the political challenges of the 1930s for the Left in Europe. The potential of the new mass media had first been recognised by the Communist government of the USSR in the 1920s. Russian revolutionary artists such as Sergei Eisenstein, Dziga Vertov, El Lissitzky and Gustav Klucis had formulated a revolutionary aesthetics, the former two in the medium of film, the latter two in photography (Figure 13.2).

By the 1930s, when Benjamin wrote his essay, the systematic deployment of film and photography in the service of politics had also become a major propaganda tool of Fascist politics in Germany and Italy. A now notorious case of 'the aesthetisation of politics', as Benjamin called the spectacular orchestration of Nazi power in its public rallies and party gatherings, are the films of Leni Riefenstahl, such as *Triumph of the Will* (1935).

This positive casting of technology differentiates Benjamin from certain cultural critics then and now. Theodor Adorno and, in the United States, Clement Greenberg held that art has its strongest political function by remaining 'difficult' and separate from popular cultural forms. This position tended to imply a preference for abstract art and a rejection of the new media of film and photography. The integration of new forms of media into what Adorno termed the capitalist 'culture industry', especially in form of popular entertainment, destroyed their critical potential in view of these writers.[18]

From a contemporary perspective, the division between high and popular culture is questionable. Contemporary cultural theorists emphasise the fluidity and cross-overs between these categories rather than their separateness. Benjamin's more open stance may explain why his essay has enjoyed continuing popularity. It is this aspect of his writing which has been credited with predicting 'the movement from a modernist . . . to a postmodernist epoch' as 'mechanical reproduction offers the prospect of an art which may be brought back into relationship with the world in which it is produced and received'.[19] In other words, technological media in the arts are considered to be in the privileged position of being able to reflect on their own impact on society at large as well as on art itself. The adoption by Andy Warhol and Robert Rauschenberg of the silk screen process at the beginning of the 1960s is a notable example; the employment of the medium of print represented not only the oldest mode of reproduction, the silk screen process was also its most recent commercial form. With its potential for unlimited reproduction it served to establish a productive rhetorical tension between the unique art object in its traditional sense and art as commodity and media object (Figure 13.3).

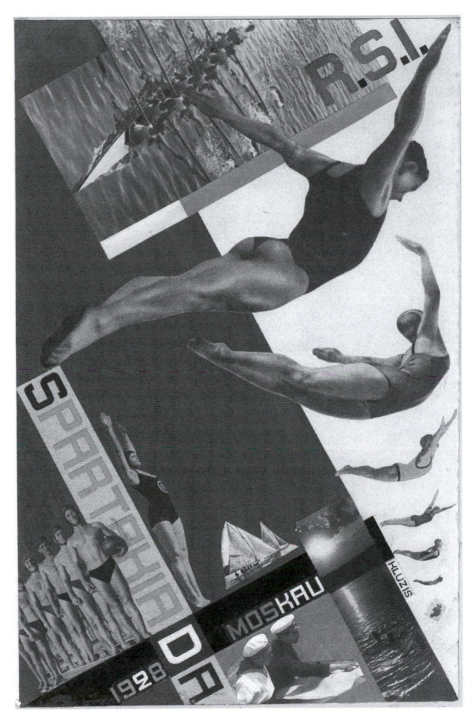

Figure 13.2 – Gustav Klucis, design for a postcard for the All-Union Olympiad in Moscow (Spartakiada) (1928). Photograph © State Museum of Art, Riga, Latvia.

Figure 13.3 – Robert Rauschenberg, *Press* (1960). © Robert Rauschenberg/VAGA, New York/DACS, London 2004.

But what are the implications of technical reproducibility for works of art? As already indicated, artworks have, in principle, been reproducible since antiquity. To the reproduction by print, one must add the different means of reproducing three-dimensional works of art, such as the casting of a sculpture in bronze. So

where does the novelty of the situation lie? Benjamin's theses centre on the fact that 'technical reproduction can place the copy of the original into situations which the original itself cannot attain'[20] (Figure 13.4). Crucial to this is his term 'aura'.

A useful illustration can be seen in Michelangelo's decoration of the Sistine Chapel in Rome (painted 1508–12). Practically all readers of this book will immediately have a mental image of some if not all of this work's central scenes. This is equally true for those who have not visited Rome. Through the availability of multiple copies of images of the Sistine Chapel in circulation (or, rather, parts thereof – this is a point to which we will return), the work can be seen by many more people than those who visit the Vatican. By the same token, the reproduction of works of art contributes in no small measure to the increase in tourism that sites such as Rome attract. It has greatly contributed if not wholly generated its own genre of travel: 'cultural tourism'.

The way in which most of us will have encountered Michelangelo's work is also telling: be it as an advertisement in a newspaper or magazine; on a humorous birthday card; an image in an art book; a fashion shoot in a women's magazine; a TV programme about the top ten tourist spots in Italy; a picture on a T-shirt or a postcard or a mug, or even as part of another work of art (Figure 13.5).

What these examples indicate is the fact that the technically reproduced work is not only taken out of context but also taken apart. What are the consequences of this de- and re-contextualisation? In the Sistine Chapel the particular meaning of the frescoes as a whole and the specific significance of its individual parts as an instrument of religious and political power of the Catholic Church are transposed through reproduction into mere 'signs'. They can be used to signify any number of meanings according to the context in which they are deployed, none of which may relate to their original meaning. They have become exchangeable and can be recombined in any manner.

Benjamin did not foresee this development. He considered the 'universal equality of things' as an indication that the process of emancipation of the working classes was imminent. The other aspect of the change in an artwork's condition from 'original' to copy was similarly considered a step in this direction. Hence Benjamin stated: 'what withers in the age of the technological reproducibility of the work of art the latter's aura.'[21] He likens the aura of a work of art to that of 'natural objects':

> We define the aura of [natural objects] as the unique apparition of a distance, however near it may be. To follow with the eye – while resting on a summer afternoon – a mountain range on the horizon or a branch that casts its shadow on the beholder, is to breathe the aura of those mountains, of that branch.[22]

The distance as a quality of the aura can be understood as a function of the work of art's original religious power. Benjamin refers to this as the artwork's 'cult

Figure 13.4 – Postcards from a kiosk stand, Paris. Author's photograph.

value', but as art became more secular its function was increasingly that of visual display, it took on 'exhibition value'. The Sistine Chapel demonstrates this shift rather well; what had been a visible demonstration of both the power of the Catholic Church and its doctrines is today, for the majority of people who visit it,

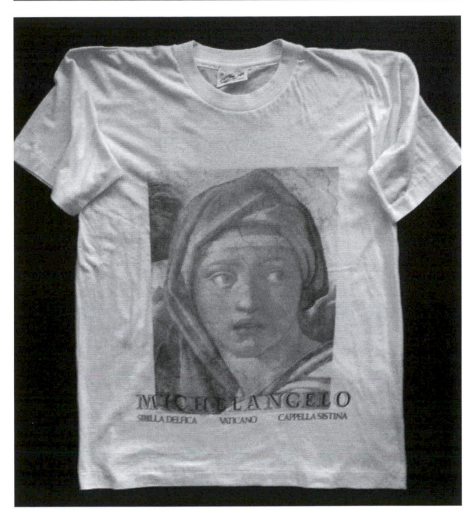

Figure 13.5 – T-shirt with detail from Michelangelo's ceiling to the Sistine Chapel, Vatican, Rome. Photograph: the author.

a cultural experience, a landmark of 'great art', if not simply another site on the tourist trail.

In addition to the socio-political and historical factors mentioned above, the loss of aura can be attributed to the physical change the work of art undergoes through reproduction: we respond differently to an image the size of a postcard or a design on a T-shirt than to a large painting, such as the Sistine Chapel, which dwarfs the viewer by its sheer size. Benjamin assumed that through reproduction the special status of artworks would gradually vanish. Loss of the distance that had been a function of its power made the work of art open to an analysis based on politics. According to John Storey, this view has had a 'profound (if often unacknowledged)

influence on cultural theory and popular culture'. He goes on to say: 'Whereas Adorno locates meaning in the mode of production (how a cultural text is produced determines its consumption and significance), Benjamin suggests that meaning is produced at the moment of consumption'.[23] This emphasis may explain why Benjamin's essay has long been considered a precursor to more recent theories of media consumers making 'their own meanings in their acts of consumption'.

Works of art are now accessible to large numbers of people – more so than in Benjamin's time – and in many respects have become part of popular culture. Yet Benjamin's hopes for a more politicised cultural politics have not materialised. One might even ask whether reproducibility has not increased a certain type of aura, as John Berger did in his influential book and TV series *Ways of Seeing* of 1972. Berger popularised Benjamin's ideas, speaking, for example, of the 'bogus religiosity' now attached to works of art.[24] In addition, the media often cast art in Romantic terms of 'genius', 'originality' and 'uniqueness'. As Benjamin himself stated, it is no coincidence that emphasis on these concepts arose at a time when photography threatened the 'original' work through reproduction. Coupled with the explosive expansion of the art market since the 1960s and the stellar sums paid for artworks, these notions appear to have resulted not in a 'withering' but rather in an intensification of aura. Aura has become the side-effect of what Berger termed the work's 'market value' or, more precisely, commodity-fetishism.

Benjamin also appears to have overestimated the political potential of particular media forms. Processes he saw as progressive *per se* can be equally deployed by opponents of the political Left. For Benjamin, montage in film and photography in the avant-garde practices of the 1920s in the USSR and Germany was endowed with critical potential. Until recently, this view has persisted. Yet already in the 1920s and 1930s photomontage had become a favoured aesthetic form for advertising – hardly a critical mode. Claims as to the critical potential of a particular aesthetic medium cannot be sustained. It performs a critical function only under certain circumstances and particular conditions and may be quickly incorporated into the capitalist media system. This resilience of the system, its capacity to appropriate rebellion and subversion, and the difficulty of developing oppositional media strategies have been commented on by Fredric Jameson. Any challenges 'are somehow secretly disarmed and reabsorbed by a system of which they (i.e. oppositional forces) themselves might be considered a part, since they can achieve no distance from it'.[25]

The other categories affiliated with aura in Benjamin's account – 'originality', 'uniqueness' and 'authenticity' – are similarly subject to change through reproduction. However, reproducibility does not necessarily extinguish the value placed on these notions even in works of art which endeavour to subvert them by employing the same means of reproduction. A case in point is the so-called appropriation art of Sherrie Levine, who in the 1980s re-photographed work by well-known photog-

raphers such as Edward Weston, Walker Evans and Karl Blossfeldt. By foregrounding the reproducibility of the medium of photography, she purportedly queried high art's persistent claim to uniqueness, originality and authenticity. But as David Hopkins has wryly observed in reference to the critical stance of this kind of work: 'Deconstruction of authorial presence did not lead to artists deconstructing their own authority . . . backed up by a highly professionalised critical and academic discourse and a publishing industry quick to cash in . . . "oppositional postmodernism" often smacked of mannerism.'[26]

During the last twenty years an explosive acceleration from mechanical reproduction to digital reproduction has taken place due to the widespread incorporation of digital technologies in all aspects of economic production, administration, research and the media. One result is that the reproduction or dissemination of information in various media forms has been expanded and speeded up to an almost unimaginable degree. The transformation of particular media forms into signs, commented on earlier, continues in a more extreme form. This translation into digital signs occurs in media with which we are already familiar as in the digitisation of photographs or films. At the same time new media forms such as the Internet have been created.

Conclusion

The challenge for the study of visual culture is the development of a terminology and method for analysing new media forms and their aesthetic potential and practice in parallel with the formation of the new media themselves. Often it seems that the speed of new developments makes yesterday's techniques and related attempts to put these into a theoretical framework obsolete. Yet it is equally important to avoid the danger of over-emphasising the novelty of emerging forms and also of overlooking their embeddedness in older social practices and cultural forms. Often, discussion has been marked by an uncritical and utopian technophilia or its opposite, an extreme pessimism about the impact of such media.[27] While both positions have identified key effects of the technically reproduced image, the media of reproduction are neither wholly positive or negative. Nor have they replaced older models of cultural practice, despite the more pessimistic pronouncements of Baudrillard.

Further Reading

Baudrillard, Jean. *Simulacra and Simulation* (Ann Arbor, MI, 1994).

Benjamin, Walter. 'The Work of Art in the Age of its Technological Reproducibility', in W. Benjamin, *Selected Writings. Vol. 4: 1935–1938* (Cambridge, MA, 2003), pp. 251–83.

Debord, Guy. *The Society of the Spectacle* (Detroit, 1977).

McLuhan, Marshall. *Understanding Media, The Extensions of Man* (London, 1964).

Notes

1 For a wide ranging discussion of reproduction and copying, see Hillel Schwarz, *The Culture of the Copy* (New York, 1996).

2 The British artist Georgina Starr is one of many whose works reflect this cross-over between personal and media life. The Australian artist Tracey Moffat takes a similar approach, but from the particular perspective of an ethnically divided society. Georgina Starr, *Visit to a Small Planet* (1995), in *The British Art Show 4* (London, 1995); Lynne Cooke, *Tracey Moffat: Free Falling* (New York, 1997–98).

3 William Ivins, *Prints and Visual Communication* (London, 1953), pp. 2–3.

4 Jean-Claude Lemagny, *A History of Photography* (Cambridge, 1987), p. 38; see also John Tagg, 'A Democracy of the Image: Photographic Portraiture and Commodity Production', in J. Tagg, *The Burden of Representation* (London, 1988), pp. 34–60; also John Taylor, *A Dream of England, Landscape, Photography and the Tourist's Imagination* (Manchester, 1994).

5 Marita Sturken and Lisa Cartwright, *Practices of Looking, An Introduction to Visual Culture* (Oxford and New York, 2002), chapter 4. See also Allan Sekula, 'On the Invention of Photographic Meaning', in Victor Burgin, *Thinking Photography* (London, 1982), pp. 84–109.

6 Manuel Castells, *The Rise of the Network Society: The Information Age. Economy, Society and Culture* (Oxford, 2000).

7 Jean Baudrillard, 'The Precession of Simulacra', in J. Baudrillard, *Simulacra and Simulation* (Ann Arbor, MI, 1994), p. 12.

8 Guy Debord, *The Society of Spectacle* (Detroit, 1977).

9 Steven Connor, *Postmodernist Culture* (Oxford, 1989), p. 56.

10 Jean Baudrillard, quoted in Andrew Darley, *Visual Digital Culture. Surface Play and Spectacle in New Media Genres* (London and New York, 2000), p. 65.

11 Ibid., p. 63.

12 Clayton Campbell, review of *The Matrix* in *Flash Art* (October 1999), p. 111.

13 Laura Mulvey, 'Visual Pleasure and Narrative Cinema' and 'Afterthoughts on Visual Pleasure and Narrative Cinema', in L. Mulvey, *Visual and Other Pleasures* (Bloomington, 1989), pp. 14–27 and 29–38. See also Sturken and Cartwright, *Practices of Looking*, Chapter 3 'Spectatorship, Power and Knowledge', pp. 72–108.

14 Hal Foster, *The Return of the Real* (Cambridge, MA), p. 220.

15 Susan Sontag, *On Photography* (Harmondsworth, 1973), p. 19.

16 Stuart Hall, 'Encoding, Decoding', in Simon During, ed., *The Cultural Studies Reader* (London, 1993), pp. 90–103. See also Sturken and Cartwright, *Practices of Looking*, Chapter 2 'Viewers Make Meaning', pp. 45–71.

17 A more up-to-date translation is now available: 'The Work of Art in the Age of its Technological Reproducibility: Third Version', in Walter Benjamin, *Selected Writings Vol. 4: 1938–1940* (Cambridge, MA, 2003), pp. 251–83. Benjamin wrote two earlier versions of this essay, but it is the third that is most often cited. For an in-depth analysis of his writing and the politics of technology, see Esther Leslie, *Walter Benjamin, Overpowering Conformism* (London, 2000).

18 Clement Greenberg, 'Avant Garde and Kitsch', in Francis Frascina, ed., *Pollock and After* (London, 1985), pp. 21–34; Theodor Adorno, *The Culture Industry. Selected Essays on Mass Culture* (London, 1991).

19 Connor, *Postmodernist Culture*, p. 196.

20 Benjamin, *Selected Writings, Vol. 4*, p. 254.

21 Ibid., p. 254.

22 Ibid., p. 255.

23 John Storey, *An Introductory Guide to Cultural Theory and Popular Culture* (Hemel Hempstead, 1993), p. 109.

24 John Berger, *Ways of Seeing* (Harmondsworth, 1972), p. 21.

25 Fredric Jameson, quoted in Connor, *Postmodernist Culture*, p. 57.

26 David Hopkins, *After Modern Art 1945–2000* (Oxford and New York, 2000), p. 212.

27 One of the leading technophiles is Pierre Lévy; see Pierre Lévy, *Becoming Virtual: Reality in the Digital Age* (New York, 1998). See also the cyber-feminism of Sadie Plant, *Zeros and Ones: Digital Women and the New Technocultures* (New York, 1997).

14. From Mass Media to Cyberculture

Glyn Davis

Introduction

The 1995 science fiction film *Strange Days*, directed by Kathryn Bigelow, envisages a proximate future – the movie is set in 1999, on the cusp of the new millennium – in which individuals pay to access the memories of other people. Electronic chips containing brief stored extracts of the thoughts, experiences and interactions of others exchange hands for money. These chips are then attached to a febrile wire structure known as a SQUID device: the SQUID is placed over the consumer's skull like a cap, delivering the purchased memories at the press of a button. Notably, there is a booming black market for violent and pornographic chips.

 Although SQUID machinery has yet to become a reality, *Strange Days* recognises (and fictionally riffs on) a pervasive aspect of contemporary existence: an increased dependency on technology, including the use of specific devices to store crucial components of our lives. DV handycams are employed to record digital documents for posterity in the form of ones and zeros; ATMs and online bank accounts eliminate the need for face-to-face encounters with staff, with money itself increasingly consisting of 'virtual' figures on a screen; and so on. Certainly, on a global scale, there are marked differences both between and within countries regarding the individual uptake of new technologies. Yet for most denizens of the world's wealthiest states, cyberculture – that is, culture that melds people and machines, the organic and the inorganic – is difficult to avoid.

Cyberculture

For decades the spread of technological innovations has been occurring swiftly and regularly, at an unprecedented pace and pitch, specific items and behaviours rapidly becoming obsolescent, outmoded or even simply unfashionable. Our social and cultural existence adapts to the new machines, with older methods, systems and patterns erased almost painlessly. To take just one example, handwritten personal letters are becoming less prevalent, replaced by e-mails; these electronic missives may be saved on hard drives, as digital memories or records, perhaps within files devoted to specific individuals. The ability to write by hand is now a less significant skill than typing speed. And the language of e-mails – as with mobile phone text messages – is markedly different from that of handwritten interaction, being more conversational, abbreviated, grammatically clumsy and peppered with unimportant spelling errors.

However, the proliferation and dispersion of technologies that characterises – indeed, constitutes – cyberculture spreads far beyond the use of electronic mail. Specific forms of culture and communication are finding themselves fundamentally reshaped. At present, for instance, the music industry is facing problems with the sale and distribution of CDs, difficulties most notable with popular music. Online sharing and trading of digital music files, the popularity of the iPod (a personal stereo that can hold hundreds of songs as digitised data) and the low cost of burning copies of CDs have all contributed to plummeting sales and a crisis in the singles market. Individual artists and groups, including Muse and Air, are presently experimenting with selling their singles as cheap, downloadable files only, bypassing the direct CD sales market entirely. The future shape of the music industry in this regard is uncertain and unpredictable.

Not only popular music, but specific channels and forms of mass media communication and entertainment are undergoing constant transmogrification. Computer-generated imagery (CGI) is now a regular element of many Hollywood feature films, one that is continually being refined and improved. This transforms the kinds of movies that can be made – witness, for instance, the plethora of superhero and comic book films made by the major studios in recent years, from Ang Lee's *Hulk* (2003) (Figure 14.1) to *Hellboy* (2004).

It also arguably affects the experience of cinematic spectatorship; in turn, this impacts upon our experience of the everyday. As Michelle Pierson writes:

> the popularization and pervasiveness of electronic technology has profoundly altered our spatial and temporal sense of the world . . . the hyperreal space of electronic simulation – whether it be the space of computer-generated special effects, video games, or virtual reality – is characterized by a new depthlessness: one which is at the same time expansive and inclusive.[1]

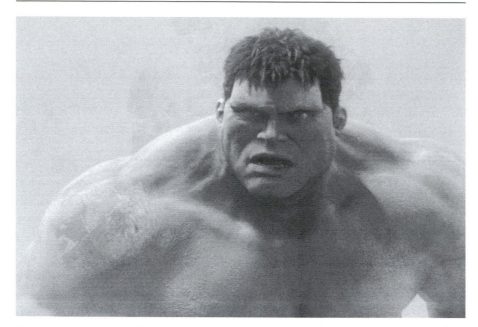

Figure 14.1 – In Ang Lee's *Hulk* (2003), the monstrous alter-ego of Dr Banner (Eric Bana) – released every time he becomes angry – was computer-generated. Image © Universal Television and Networks Group.

Films containing significant quantities of CGI begin to look like computer games. Indeed, movies are sometimes based on games – including *Lara Croft: Tomb Raider* (2001) and *Resident Evil* (2002) – and films spawn successful video games, as with the *Lord of the Rings* trilogy, *Spiderman* and the *Star Wars* franchise. As Pierson argues:

> Every effects-laden science-fiction film is a sign that cinematographic space is in the process of being reformulated according to the new electronic coordinates and experiential values of a postmodern, video-game culture.[2]

As a second example of a medium in transition, digital television – which boasts interactivity, although so far this remains underemployed – is now a fixture within more than 50 per cent of British homes. This new form of television fundamentally disrupts established notions of TV's form and purpose, as well as the shape of the television industry. To cite one recent commentator,

> The technological promise of digital television, in the form of higher-definition images, greater bandwidth and interactive services, has thrown into crisis, or at least historiographic relief, long-established industry practices, business relationships and textual forms. The uneven adoption of digital technologies across the fields of consumer electronics, programme production and delivery systems

has exposed new fissures among sectors of the television industry and brought new economic players into the business . . . The current uncertainty has also put into question traditional industry and popular accounts of the medium's role as signifier of national identity (and public service broadcasting's political rationale in the UK and elsewhere), its ontology of liveness and photographic realism and its place as a consumer product within the gendered household.[3]

Noteworthy transitions are underway. Most significantly for UK citizens, perhaps, multi-channel access to a variety of commercial stations, such as those digital TV provides, complicates the public service broadcasting (PSB) ideals of Britain's terrestrial television channels to inform, educate and entertain. Indeed, the Blair government has decreed that the first task of the recently inaugurated TV industry watchdog, Ofcom, will be to assess the significance (and shelf-life) of PSB in relation to Britain's present and future television landscape.

Individual mass media forms – radio, television, cinema, newspapers – are thus being constantly reconfigured by developments in technology characteristic of the era of cyberculture. Yet one of the most significant innovations associated with 'the digital age' is the arrival of a *new* mass medium: the Internet. The genesis and rapid dispersal of the Internet were accompanied by bold pronouncements from critics and commentators, declaring either its utopian potential or its debilitating and dangerous impact. Statements such as these have accompanied the invention and proliferation of *all* mass media, from comic books to video. However, the unique characteristics of the Internet, taken in tandem with the rapid acceptance of Internet access in countries across the globe, have led to a phenomenal level of cultural discussion and argument. This chapter will provide an introduction to some of these debates. However, before focusing on these topics in detail, it is vital to contextualise the Internet as a mass medium by considering two dominant models for conceptualising the role and impact of the media: 'the global village' and 'the realm of simulation'.

The Global Village

As chapter 13 indicates, the term 'the global village' was coined by, and is associated with, Marshall McLuhan. McLuhan (1911–80) remains best known for three books: *The Mechanical Bride* (1951), *The Gutenberg Galaxy* (1962) and *Understanding Media* (1964). For fans of Woody Allen, McLuhan is recognisable from his brief appearance as himself in *Annie Hall* (1977). McLuhan never espoused a fixed viewpoint in his writings; there is no complex argument or thesis that unfolds across the pages of his work. McLuhan himself advocated dipping into his books as one would 'step into' a newspaper, sampling small portions in a random order, rather than attempting a linear journey through the texts in their entirety. McLuhan's

writings are crucial to consider in any broad discussion of the mass media, for two
reasons: first, because he attempted to expand critical understanding of what the
media *are* and what they *can be*, as well as how they operate; second, because he
conceived of the media in almost wholly positive terms.

For McLuhan, a medium was not simply a channel for communication. Rather, as
W. Terrence Gordon puts it, 'a medium – while it may often be a new technology –
is *any* extension of our bodies, minds, or beings'.[4] The examples McLuhan used in
his redefinition of the term included clothing, housing, bicycles, horse stirrups and
computers. McLuhan also believed that conceiving of messages as parcels of infor-
mation transmitted by or through media neglected the fact that the significance of
messages is their impact. Moreover, as Gordon notes, simply defining 'message' as
content or information to be transmitted misses what McLuhan believed to be one
of the most important features of media: their power to change the course and func-
tioning of human relations and activities. Consequently, McLuhan redefines the idea
of the 'message' of a medium as 'any change in scale, pace, or pattern that a medium
causes in societies or cultures'.[5] Through these reconstituted definitions of the
terms 'medium' and 'message', McLuhan was able to postulate his snappy dictum,
'the medium is the message'. As McLuhan himself explained, this is merely to say
that the personal and social consequences of the medium – that is, of any extension
of ourselves – result from the new scale that is introduced into our affairs by each
extension of ourselves, or by any new technology.[6]

McLuhan's bold pronouncements served as a provocation to readers to recon-
sider their own preconceived ideas of what 'the media' are, what they do, what they
can do. McLuhan invites us to explode 'the media' out into our everyday existence,
to recognise our lives as heavily mediated in the broadest sense, and to identify the
significant personal, interpersonal and political alterations brought about by that
mediation. Equally provocative is McLuhan's notion of the 'global village', the idea
that through intense interaction with electronic media 'the human tribe can
become more truly one family and man's consciousness can be freed from the
shackles of mechanical culture and enabled to roam the cosmos'.[7] To a contempo-
rary reader, such an opinion may seem both optimistic and naïve. The suggestion
that the spread of electronic media forms could produce a global scenario, in which
the planet's inhabitants are all 'truly one family', echoes the early twentieth-
century modernist faith in machinery as well as embodying the hippie rhetoric of
the late 1960s. McLuhan's 'global village' sounds like an unattainable dream. Yet,
as Ruth Pelzer has argued, the notion of global extension has become a key concept
for discussing the contemporary media landscape. The presence of the same mass
media channels in different countries across the globe enables traffic of media
content between those countries, and thus the partial erosion of national boundar-
ies. The level of erosion differs from country to country, however; the production
of media content and its distribution across and between continents requires sig-

nificant financial clout. For this reason the term 'globalisation' is often used as a substitute for 'Americanisation'. The latter denotes the global process of homogenisation effected by conglomerates operating out of the United States, the product of which has been scathingly termed 'McWorld'.[8] As Gill Branston and Roy Stafford have pointed out, given that the development of global communications systems has been undertaken largely by American corporations in collaboration with the government, 'it is not a giant leap, then, to argue that US media power is a form of cultural or media imperialism. Traditional, local cultures are argued to be destroyed in this process, and new forms of cultural dependency are shaped which mirror older imperialist relations of power.'[9]

Despite the significant size of the US conglomerates, the global media landscape is not, however, so simply dominated by America. Of the major international media conglomerates in operation at the time of writing, several non-American companies own holdings in North America, but are not based there. Bertelsmann is German, Vivendi is French, while Sony is Japanese. Further, the international trade in media culture may be dominated by American products and might, but this domination is far from total. For instance, television programmes are exported around the world from their country of origin, often via unpredictable paths, in order to satisfy consumer demand. Thus, South American soap operas (or 'telenovellas') reach an international audience of millions; Asian audiences in Britain can subscribe to channels such as Deepam and Zee TV, designed to serve the interests of specific ethnic identities. As a second example, British cinemas and video/DVD rental stores are largely dominated by Hollywood movies, and yet alternative modes of distribution and spaces of exhibition continue to flourish, providing access to films from a plethora of countries.

McLuhan's vision of a 'global village' may not have been realised in the utopian manner he envisaged, but the concept of globalisation remains key to any contemporary understanding of the mass media. The value of McLuhan's perspective on the 'global village' is his sense of hope. Considering the size and economic force of several of the planet-straddling multi-media conglomerates, a knee-jerk pessimism regarding globalisation is understandable. And yet, as with his opinions regarding what the media *can be* – which, arguably, is up to us – McLuhan invites his readers to see the positive potential in the erosion of national limits produced by the spread of the media.

The Simulated Realm

In stark contrast to McLuhan, the writings of Jean Baudrillard have undertaken a sustained, pessimistic, coruscating attack on the mass media – particularly advertising, television and cinema – and their construction of a simulated world that, he claims, bears almost no resemblance or relation to lived experience. For

Baudrillard, recent decades have witnessed the proliferation of specific media forms and methods of communication, systems that breed what he terms 'simulations'. These simulations are images with very little reference to reality: television adverts for 'summer meadow' washing-up liquids, for instance, sell products in which synthetic combinations of chemicals stand in for some hallucinated lost referent. So widespread are these simulations, so all-pervasive, that the distance between reality and the realm of simulations and simulacra implodes, and the experience of the real world disappears; or as Mark Poster puts it: 'simulation . . . undermines any contrast to the real, absorbing the real within itself. Instead of a "real" economy of commodities that is somehow bypassed by an "unreal" myriad of advertising images, Baudrillard now discerns only a hyperreality, a world of self-referential signs.'[10] The hyperreal has become a culturally dominant experience: tourists go on holiday to Disneyland, a fake city populated by cartoon characters, or to Centreparcs, an idealised, and almost entirely synthetic, version of the countryside.

Baudrillard is especially critical of Hollywood cinema. In one well-known essay, he admonishes *The Last Picture Show* (1971) – a film about teenagers growing up in a small town in Texas, set in the 1950s – for its nostalgic self-indulgence and its formal skill in successfully, and disconcertingly, recreating the 'look' of 1950s cinema. So exact is the film's simulation of the style of 1950s cinema that, to the lay spectator, *when* the film was made may be difficult to discern. More generally, Baudrillard has argued that 'Cinema plagiarises and copies itself, remakes its classics, retroactivates its original myths, remakes silent films more perfect than the originals, etc'.[11] Hollywood studios recycle their own films via sequels and imitations; the summer of 2003, for instance, witnessed the release into cinemas of fourteen sequels, including *Charlie's Angels: Full Throttle* and the Wachowski brothers' *The Matrix Reloaded*. Further, 'classics' are remade for new audiences, including *Planet of the Apes* (2001) and *The Italian Job* (2003). The end result, Baudrillard claims, is that 'cinema itself becomes more cinema than cinema, in a kind of vertigo in which . . . it does no more than resemble itself and escape in its own logic, in the very perfection of its own model'.[12]

Hollywood cinema, then, is a seductive empire of the visual. The movies produced by the major studios construct an imaginary, simulated world based on other movies, a world familiar from other movies, yet far removed from the 'ordinary' or 'everyday'. This simulated realm of experience may consume 'the real', overrun it, directly affect our experiences of actual events. Fictional films based on real historical occurrences – from *Titanic* (1997) to *U-571* (2000) – may substitute in the minds of spectators for actual, authentic fact. Further, the ubiquitous nature of Hollywood cinema might cause us to interpret real events as cinematic: why, for instance, did the television footage of the destruction of the World Trade Center look like a scene from a blockbuster film?

Television, and its impact on audiences, serve as a useful illustration of Baudrillard's ideas. Television actors – in particular, those appearing in soap operas – regularly report being confronted in the street by spectators who confuse them with, and treat them as though they *are*, the characters that they play. Actors from the US medical series *ER* were hired by a pharmaceutical company to advertise their products in television commercials; sales boomed, with audiences seemingly prepared to believe the advice of 'fake', fictional doctors over that of 'real', qualified experts. The popularity of the science fiction programme *The X-Files*, a long-running paranoid conspiracy thriller which implied that a cabal of governmental agents was working to cover up evidence of human–alien contact, allegedly led to a dramatic increase in the American population's belief in extraterrestrials. These three examples – none of which is discussed by Baudrillard in his writings – highlight the extent to which simulations consume the real world, and indeed become 'more real than real'.

Baudrillard has written about television *news* at length, however. Most famously, perhaps, he argued, in a book of the same title, that the Gulf War of 1991 did not take place. By this he did not mean that actual fighting, death and destruction did not occur. Rather, for the viewers at home watching the conflict unfold on television screens, all that they witnessed were flashy computer graphics, sanitised combat reports, vacuous commentaries and desperate attempts to narrativise the messy situation in the field. This 'simulated' version of the war became the dominant one, even for those taking part in combat, or those reporting on events from the location itself. As Richard Lane writes, there was

> an absurd moment in the reporting of the war in which the news channel CNN switched to a group of reporters 'live' in the Gulf to ask them what was happening, only to discover that they were watching CNN to find out themselves . . . This absurd moment reveals the detachment from the real, and the production of 'reality' with third-order simulation . . . news isn't being generated by some singular event. Rather, news is producing the 'reality' of the war, not only for viewers, but also for those involved.[13]

This was arguably even more apparent with the invasion of Iraq that began in 2003. Empty buzz-phrases – 'Operation Enduring Freedom', 'Weapons of Mass Destruction', 'embedded journalists' – became common parlance. The United States had a 'press stage' constructed by Hollywood set designers which cost thousands of dollars. Spectacular 'set-piece' events, such as the toppling of the statue of Saddam Hussein (Figure 14.2) wrapped in the US flag – allegedly, and rather conveniently for jingoistic purposes, the same flag that was flying at the Pentagon when it was attacked on 11 September 2001 – were heavily stage-managed.

However, Baudrillard's pessimistic, sweeping model of the 'evil demon of images' – and he has claimed in his writings that the only potential escape from the

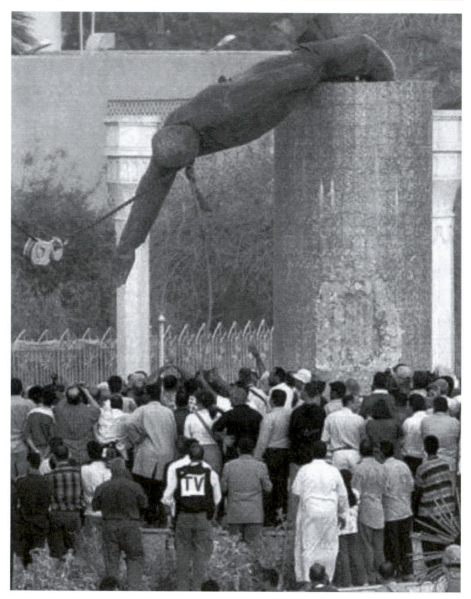

Figure 14.2 – 9 April 2003. A statue of Saddam Hussein was symbolically pulled down in Baghdad's Firdus Square. But was the event staged for the media? Photograph courtesy of AP Photo/Koji Harada, Kyoto.

hyperreal realm of simulation is through death – cannot successfully accommodate, or account for, the range of varied messages available to the diligent consumer during the recent conflict in Iraq. Certainly, 'rolling news' stations such as CNN and Sky News provided only a simulated version of events in the Middle East. But other channels of communication made available alternative perspectives: many

with cable and satellite could access Al-Jazeera television, for an Arabic view of events; the Internet proved to be a resource for dissent and discussion; publications from *Private Eye* to *New Internationalist* critiqued the actions and policies of the Blair and Bush administrations from the outset. Indeed, since the 'end' of the simulated version of the conflict, the synthetic veneer has publicly cracked: news reports now reveal that more US soldiers have died in Iraq since the 'end' of the war than were killed during the months of fighting. In Britain, the suicide of Dr David Kelly (a former government weapons inspector) served to expose the degree of political 'spin' effected by the Blair cabinet; former senior government figures in Britain and North America have resigned and now openly criticise the actions of the dominant parties. More recently, both the British and US governments have been forced to hold inquiries into why the intelligence claims about the presence of 'weapons of mass destruction' were so wrong.

Baudrillard's opinions, like those of McLuhan, are thus open to critique and correction. Baudrillard often seems to assume that the power of mass media imagery overwhelms every Western citizen (and, evidently, there are problems with applying his arguments to those living elsewhere in the world). He thereby ignores the sceptical nature of many individuals living in environments heavily saturated by mass media forms. He also fails to acknowledge the significant differences between the key characteristics and methods of public usage of specific media. The Internet, for instance, shares some characteristics with other mass media, but crucially it also has unique features.

Life Online: Fear and Loathing

The Internet, in its present form, emerged out of the American ARPAnet university network, which was established for military purposes by the Advanced Research Projects Agency in 1957. The Internet has a web-like form: it is made up of an interlinked system of a variety of computers in a diverse range of geographical locations. No one of these computers is individually essential. This was the intention of the military when the network was built: they wanted a decentralised computer system, so that any damage caused to part of the infrastructure by strategic attacks would be minimal. This means that the Internet's hardware is located both everywhere and nowhere. As a whole, it is a resource with no real base; it relies on the existence of a range of hosts.

After its creation by the military, the Internet was taken up by the American university system. It was not until the 1980s that it began to seriously infiltrate domestic spaces, connecting individual homes to each other through computer monitors. It was this move of Internet technology into the home that led to the creation and expression of fears and worries about the role of the new mass medium. Some of these concerns were old ones, such as accompanied the appearance of other media:

the Internet could cause eye strain (similar opinions were stressed in the late 1800s with the appearance of comic books, and in the 1950s and 1960s when television became widely integrated into Western homes). Using the Internet was sometimes also seen as dangerously 'immersive', in the same way that computer games have been conceptualised. For some critics, spending too much time in front of a VDU could reduce the user's social skills. Michele Willson, for instance, has argued that excessive Internet usage could produce serious repercussions, claiming that 'the dissolution or fragmentation of the subject and the instantaneous, transient nature of all communication disconnect or abstract the individual from physical action and a sense of social and personal responsibility to others'.[14] Again, arguments connecting a specific mass medium with antisocial behaviour are far from original; cinema, for instance, was often accused of 'causing' juvenile delinquency in the 1950s.

Worries about the Internet have often circulated around the difficulties of policing the new medium. Whilst monitoring and censoring the content of television and cinema, for example, is handled relatively smoothly, if not entirely effectively, by specific organisations, controlling the Internet – a topographically vast arena, encompassing millions of sites, many of which lie outwith the reach of the dominant search engines – is an altogether trickier business. A major concern, of course, is pornography. Annual search engine records always reveal that pornography features highly in the 'top ten' search items of each and every year. The sheer volume of online pornography is astonishing (some estimates place it at around 80 per cent of all available material), with websites catering for every fetish and special interest. In recent years, paedophilia – and the use of the Internet to find and disseminate sexual images featuring children – has become a significant concern of politicians and the public. Indeed, at present, 'the paedophile' arguably occupies a cultural position in Western countries as the most vilified and demonised public figure. Fears of adults 'pretending' to be children online, in order to meet children for their own devices, are expressed in public forums – perhaps most obviously, in newspapers and on radio and television talk shows. A recent advertisement screened in Britain on television and in cinemas featured a man talking in the dubbed voice of a young boy about his hobbies and pastimes: the warning card at the end of the ad raised awareness of how it is possible to lie about our identities online. With this topic, an old mass media worry about the difficulties of overseeing the private use of particular media that solicit personal, solitary interaction, such as computer games and VCR/DVD consumption resurfaces. The concern is complicated, however, by the genuine impossibility, beyond relatively simple 'nanny' protection devices, of policing the content of the Internet.

Aside from pornographic imagery, the other troubling form of content available online is that which is politically or ideologically subversive or dissident. Whereas some individual countries have laws against incitement to racial hatred, for instance, numerous racist and xenophobic websites exist and flourish. Similarly, it

is easy to access a plethora of virulently homophobic sites, such as www.godhates-fags.com, the mouthpiece of the Reverend Fred Phelps. In addition to these specific instances of ideological violence, the banned publication *The Anarchist's Cookbook*, which contains information on building bombs, mixing petrochemical cocktails, and so on, is easily accessible online. For liberal critics, the availability of a broad range of uncensored views via the Internet should be maintained for reasons associated with 'freedom of speech'. However, this ideal raises problems at a global level: if the Internet really does span the planet, then how can countries whose religious, moral and ethical beliefs differ from those of, most especially, the United States, control what citizens of individual nations can access?

Utopianism and the Internet

Of course, not all commentaries about the Internet are negative in tone. Indeed, a number of proselytisers have proclaimed the arrival of the world wide web as a significant political moment, affording social and cultural opportunities presently unavailable in the real world, and new malleable 'spaces' in which individuals can forge a utopian future. Many of these aspirations revolve around people meeting online, using the Internet as a dispersed 'venue' containing neutral 'places' in which to interact. For instance, those who find social interaction in the real world difficult – and reasons for this could vary from shyness to speech impediments to mobility problems – may be able to forge bonds online. With social communication in cyberspace, physical appearance is arguably considerably less significant than in the real world; a person is more likely to be judged by their verbal dexterity and typing speed.

For a number of feminist cultural commentators, the Internet also holds great potential as a 'female' space and tool for women's emancipation. Whereas computer technology has usually been conceptualised as a male domain – the number of computer games designed for, and played by, girls and women is very small, and most hardware and software continues to be constructed by men – the very *shape* of the Internet is rather feminine. Macho phrases like 'the information superhighway' may conceive of the Internet as a linear location, one that users would drive vehicles down at high speeds, but the diffuse, web-like form of the Internet is anything but straight and unidirectional. It has been argued, for instance, that women may feel a gender-specific affinity with the Internet, traversing through its links and connections with more ease than men.[15]

Aside from these politicised implications and uses of the Internet, it can also serve as a viable 'place' in which isolated, like-minded individuals can share their passions for specific interests. Media fandom, for instance, has proliferated online. Fanzines and conventions, although still in existence, have been supplemented by an explosion of fan-sites devoted to musicians, actors and actresses, television programmes, and so on. Rare items of information and merchandise are exchanged.

Fandom, due to the Internet, has arguably become more social – and considerably more extensive. In an echo of McLuhan's 'global village', the geographical location of individuals chatting online about their interests becomes almost irrelevant, distances between computers eradicated by high-speed phone lines.

All of these perspectives on the Internet conceive of computer terminals as routes into new forms of community, in which interaction with other people has a different shape and uses an alternative language. Perhaps this interpretation of the world wide web should come as no surprise, as a range of commentators have claimed in recent years that, in the real world, stable senses of community are breaking down, producing a search for new communities. Anthony Giddens, for instance, wrote in 1994 that 'On each side of the political spectrum today we see a fear of social disintegration and a call for the revival of community'.[16] In urban centres in wealthy nations, connections between individuals are fracturing. Although we may press up against other people on public transport, and may (inadvertently) witness the people in the building opposite in states of undress, we may not even know our own neighbours. Of course, communities have not disappeared entirely; outside of metropolitan centres, smaller towns and villages may maintain a feeling of public community. And a sense of one's connection to a community, even within large cities, will depend on one's race, ethnicity, class, gender and sexual orientation. Most metropolitan hubs, for instance, from Manchester to New York, have 'gay villages', sections of the city predominantly inhabited and used by lesbians and gay men. However, the fragmentation of older communities would seem to be a constituent component of the contemporary existence of many Western individuals. As Michele Willson writes:

> In an age when people have more capacity – through technologically aided communication – to be interconnected across space and time than at any other point in history, the postmodern individual in contemporary Western society is paradoxically feeling increasingly isolated and is searching for new ways to understand and experience meaningful togetherness.[17]

And it is the Internet that could be used to overcome that isolation, to forge new links between individuals. Indeed, a number of authors have claimed that outmoded forms of community in the real world are being replaced by those mediated by computer technology and online connections, producing a new form of community appropriate to our era. The links made between people online are qualitatively different from those created in real life. As Willson argues further, virtual communities:

> are presented by growing numbers of writers as exciting new forms of community which *liberate* the individual from the social constraints of embodied

identity and from the restrictions of geographically embodied space; which *equalize* through the removal of embodied hierarchical structures; and which promote a sense of connectedness (or *fraternity*) among interactive partici-pants. They are thereby posited as the epitome of a form of postmodern com-munity within which multiplicity of self is enhanced and difference proliferates uninhibited by external, social structures.[18]

This utopian model of online interaction and community needs to be tempered. Many individuals *never* use the Internet for meeting other people, chatting and social-ising – indeed, it may simply be used as another outlet for consumerist impulses (as the popularity of websites such as Amazon and Ebay would seem to attest). Further, the idealisation of online communities is undercut by the limited access that some countries, classes and racial groups have to the necessary technological resources. Finally, it is crucial to enquire whether the online 'person' or the Internet 'commu-nity' is simply a Baudrillard-style simulation. To cite Willson once more:

> It is necessary to ask if 'community' can be sufficiently defined by the mach-inations of thin/emptied-out selves interacting via text through cyberspace; or whether, by removing the difficulties and limitations of more traditional communities, we are also stripping away many of the factors that 'make' com-munity meaningful for its participants.[19]

As online communities are only a recent development, their shape still malleable and open to exploration, final statements regarding this debate are not yet possible.

Conclusion

Recent decades have witnessed a widespread proliferation of new technologies (most notable in wealthier countries), and a rapid turnover in the forms and appli-cations of these machines and systems. Our lives have rapidly adapted to accommo-date these technological innovations. Alongside significant alterations to old media (cinema, television, and so on), one of the key developments of the digital age has been the appearance of a new mass medium – the Internet – and the swift accep-tance of this channel as a store of information and method of interpersonal commu-nication. In relation to dominant models of the mass media – such as McLuhan's global village and Baudrillard's empire of simulacra – the Internet can be seen to share key characteristics with other media forms, as well as posing medium-specific quandaries to consumers and cultural commentators due to its unique characteris-tics (such as its imperviousness to control and legislation, and the new modes of interaction it demands). The Internet itself will continue to alter its form with further technological innovations – the possibility of connecting ourselves to our

consoles by SQUID-type devices is not so far away. With such developments, conceptual understandings of the role and function of the mass media in general will, without a doubt, require reformulation.

Further Reading

Darley, Andrew. *Visual Digital Culture. Surface Play and Spectacle in New Media Genres* (London and New York, 2000).
Gray, Chris, ed. *The Cyborg Handbook* (London, 1995).
Jordan, Tim. *Cyberpower: the Culture and Politics of Cyberspace and the Internet* (London, 1999).
Levinson, Paul. *Digital McLuhan: a Guide to the Information Millennium* (London, 2001).
Mitchell, William. *City of Bits: Space, Place and the Infobahn* (Cambridge, MA, 1995).

Notes

1 Michelle Pierson, 'CGI Effects in Hollywood Science-Fiction Cinema 1989–1995', *Screen*, Vol. 40, No. 2 (Summer 1999), p. 167.
2 Ibid.
3 William Boddy, 'New Media as Old Media: Television', in Dan Harries, ed., *The New Media Book* (London, 2002), p. 242.
4 W. Terrence Gordon, *McLuhan for Beginners* (London and New York, 1997), p. 43.
5 Ibid., p. 44.
6 Marshall McLuhan, *Understanding Media: The Extensions of Man* (London and New York, 2001), p. 7.
7 McLuhan cited in Gordon, *McLuhan for Beginners*, p. 103.
8 Herman and Robert McChesney, eds., *The Global Media: The New Visionaries of Corporate Capitalism* (London, 1997).
9 Gill Branston and Roy Stafford, *The Media Student's Book* (London and New York, 2003, 3rd edition), p. 408.
10 Mark Poster, ed., *Jean Baudrillard: Selected Writings* (London, 1988), p. 6.
11 Jean Baudrillard, 'The Evil Demon of Images and the Precession of Simulacra', in Thomas Docherty, ed., *Postmodernism: a Reader* (New York and Oxford, 1993), p. 196.
12 Ibid., p. 195.
13 Richard J. Lane, *Jean Baudrillard* (London and New York, 2000), p. 95.
14 Michele Willson, 'Community in the Abstract: A Political and Ethical Dilemma?', in David Bell and Barbara M. Kennedy, eds, *The Cybercultures Reader* (London and New York, 2000), p. 650.
15 Sadie Plant, *Zeros + Ones: Digital Women and the New Technoculture* (London, 1997).
16 Anthony Giddens, *Beyond Left and Right: The Future of Radical Politics* (Cambridge, 1994), p. 124.
17 Willson, 'Community in the Abstract', p. 644.
18 Ibid., p. 647.
19 Ibid., p. 651.

15. Visual Culture and its Institutions

Fiona Anderson

Introduction

In the mid-1940s Theodor Adorno and Max Horkheimer argued that 'the whole world is made to pass through the culture industry'.[1] The concept of the culture industry, which they developed in relation to the new media and entertainment industries such as film, radio and television, highlights the role of institutions in shaping understanding and experience of visual culture. This chapter devotes specific attention to institutions in order to elucidate further the relationships between them, the ideas and actions of their individual staff and wider public consciousness about visual culture.

The institutions of visual culture help to shape fundamentally its constantly shifting nature by acting as its funders, promoters and facilitators. This can be seen if one considers the careers of some of the so-called young British artists of the 1990s, such as Damien Hirst or Tracey Emin, whose work is regularly debated in the popular press as indicative of the state of contemporary art. In the process of acquiring this level of fame, Hirst and Emin both attended prominent London art schools and attracted the attention of influential collectors, gallery curators and critics. Their successful negotiation of a series of institutions and the communication and power networks linked to them have been imperative to the development of their stellar careers as artists.[2] This remains true of almost all past or currently practising artists, designers, craftspeople and film- and videomakers.

The chapter begins by looking at various definitions of what constitutes an institution. It then takes a more specific focus by considering how institutions work in

relation to education, the production and dissemination of knowledge and under-
standing and also funding and sponsorship. Owing to the breadth and complexity
of these issues, the chapter will look in more depth at museums and, in particular,
at debates raised by the *Streetstyle* exhibition held at the Victoria and Albert
Museum in London in 1994–5.

What is an Institution?

Institutions of visual culture have the potential to stimulate, educate and entertain
the public by giving them access to the objects and images of visual culture and to
new ideas that contest existing conceptions of society and culture. However, many
argue that institutions use their power and control of funding, information and
communication to exclude those who challenge accepted social norms, and thus
help to maintain existing inequalities of power.[3] As Janet Wolff has argued:

> In the production of art, social institutions affect, amongst other things, *who*
> becomes an artist, *how* they become an artist, how they are then able to *prac-
> tice* their art, and how they can ensure that their work is produced, performed
> and *made available* to a public. Furthermore, judgements and evaluations of
> works and schools of art . . . are not simply individual and 'purely aesthetic'
> decisions, but socially enabled and socially constructed events.[4]

Before looking in more depth at these debates, it is useful to consider some basic
definitions.

Anthony Giddens states that 'Institutions are by definition the more enduring
features of social life', whereas Raymond Williams concludes that in the twentieth
century '"institution" has become the normal term for any organised element of a
society'.[5] A more specific definition is offered by John Walker and Sarah Chaplin,
who state that it is 'an organisation or establishment for the promotion of a partic-
ular object, usually one for some public, educational, charitable or similar purpose
. . . a building used for such work'.[6] Amongst the institutions of visual culture one
would count public bodies such as museums and galleries, universities and colleges
of art and design, or organisations such as the Crafts Council, the Arts Council or
the British Film Institute. These have equivalents in most Western countries; in the
United States, for example, the National Endowment for the Arts has an impor-
tant role in supporting much contemporary art practice. One should also include
private institutions, which increasingly have displaced older public bodies in impor-
tance. These include, for example, independent and commercial galleries, inde-
pendent arts organisations and media companies.

This chapter focuses on the role of social institutions such as those listed above,
but it is important to stress that the term institution can also cover 'the variable

relations in which "cultural producers" have been organized or have organized themselves'.[7] In this sense, being an artist, a designer or an architect, or even being a member of the gallery-going public, is to be part of a social and cultural institution.[8] This involves adhering to certain social norms and expectations, following implicit rules, and so forth.

The large range of different types of institution illustrates the huge diversity of possible roles, concerns and relationships connected with specific institutions and in particular the different degrees of freedom and power they possess. For example, if curators working for a large, publicly funded museum wish to mount an exhibition, the idea will be considered by a committee in competition with many other competing priorities, giving them little control over whether the project goes ahead. If supported, however, they will potentially have access to large-scale funding and high-profile contacts, and their exhibition will attract worldwide publicity. On the other hand, an individual working for a small independent gallery may have considerably more power over decision-making and the creative process. However, they will need to produce the exhibition with less funding, fewer specialised resources, and the project will be unlikely to garner international media and public attention.

What these different institutions have in common is that they operate within a narrow context, such as the art world, or the film world, whilst concurrently sitting within the wider context of society and culture. The capacity of institutions to influence public understanding and opinions is dependent on the effective promotion and communication of that institution's views. In addition to pragmatic issues such as the effectiveness of marketing strategies, this also concerns their legitimacy. The question of how institutions themselves achieve the legitimacy that gives them the power to endorse the work of others is an interesting and complex area of debate. In general, institutional legitimacy is centred simultaneously within the narrow, specialised context of its area of operation (e.g. art, architecture, film and media production) and within the wider social and cultural context. The concept of the art world, for example, implies a group of people with specialised knowledge who interact primarily through a large international network of institutions, including galleries, auction houses, publishers and artists agencies. As John Randal states:

> Literature, art and their respective producers do not exist independently of a complex institutional framework which authorises, enables, empowers and legitimises them. This framework must be incorporated into any analysis that pretends to provide a thorough understanding of cultural goods and practices.[9]

The key phrase here is 'authorises, enables, empowers and legitimises them'. For example, how does the public (which is itself a special kind of institution) come

to an understanding of who or what constitutes a significant film director, artist or designer? Moreover, if one wishes to become a cultural agent of some kind, whether making, displaying or promoting some practice, what power structures and individuals will 'authorise, enable and empower' one to do so?

In order to consider these questions, it is important to explore what institutions actually do. In practice, the activities and ideas associated with most institutions are multilayered and interwoven with those of other social institutions. This chapter turns first to education, before considering other kinds of institutional operation.

Education

Although in many cultures learning the skills associated with craft, design, art and other visual practices still occurs on an apprenticeship basis, most states have formal institutions for teaching the theories and practices of visual culture. Exploring different historical and contemporary examples indicates that many of these have taken highly specific approaches to the nature and content of their teaching. Within Britain and North America, a major shift has occurred in art and design education since the 1960s, in which attention to traditional 'craft' skills, including the teaching of drawing, largely gave way to an emphasis on encouraging students to develop and articulate aesthetic, social and political ideas through their practice. This was also linked to the rise of interdisciplinary teaching and practice, in which students combined practices and techniques from a variety of different fields, rather than honing specialised skills in a narrower subject area. This shift has had notable consequences. For example, the contemporary American architectural glass artist James Carpenter is reputed for his abilities to integrate his glass installations effectively into buildings through successful collaborative partnerships with architects. This is undoubtedly linked to the fact that he studied architecture prior to becoming a glass artist.[10]

It is interesting to explore the relationships between certain educational institutions and the development of different movements in art and design. For example, the Bauhaus School of Art and Design, founded in Weimar, Germany in 1919, provided an important meeting point for those who wished to challenge accepted ways of thinking about the theory, practice and teaching of art, design and architecture. In the early twentieth century the social, aesthetic and pedagogic ideas of Bauhaus staff and students coalesced, with a range of activities and debates taking place throughout Europe and the Soviet Union.[11] Teachers at the Bauhaus, such as the architect Walter Gropius and the designers Marcel Breuer and Marianne Brandt, also produced highly significant buildings and objects that have been extremely influential internationally (Figure 15.1).

The Bauhaus methods of teaching have also had a major impact on art and design teaching worldwide. This was undoubtedly linked to its closure by the National

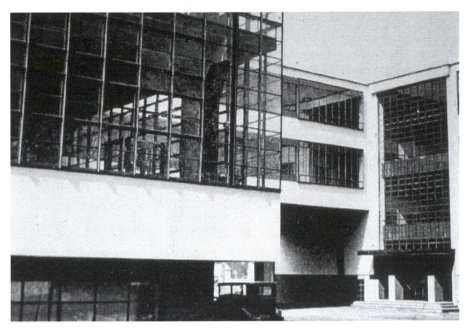

Figure 15.1 – Walter Gropius, The Bauhaus, Dessau (1919). Photograph courtesy of RIBA Library Photographs Collection.

Socialists in 1933, after which many of the school's teachers and students emigrated and took up commissions and teaching work in the United States, Britain and elsewhere.[12]

In addition to providing students with knowledge about and experience of the technical, artistic and intellectual aspects of their chosen area of visual culture, educational establishments provide status, professional credibility and important networks of contacts to individuals who wish to be involved with cultural production and promotion. They also interweave with the activities and concerns of other institutions important to the future professional practitioner, such as galleries, museums, retail outlets, agencies and promotional media. These aspects of educational institutions do not merely concern the practical facilitating of career progress; embedded within this complex intermingling of individuals is the wider issue of education as a means of generating cultural capital. A particular role is played by taste. In his influential study *Distinction* Pierre Bourdieu deals with taste as an indication of 'how individuals struggle to improve their social position by manipulating the cultural representation of their situation in the social field'.[13] In other words, all aspects of taste and lifestyle, whether manifested in clothing, house furnishings, choice of car or appreciation of certain films or works of art, operate as part of individual and group strategies to increase or maintain people's class or status level in society. Bourdieu's study, based on French society of the 1960s,

argued that knowledge about and appreciation of, for example, abstract art was valued as a sign of belonging to the educated bourgeoisie. Cultural knowledge and the ability to make certain value judgements about objects and images are therefore crucially important to how people are positioned within society. Bourdieu further indicates the social importance of cultural capital, by arguing that it is one of the prime means by which people gain access to economic capital. Bourdieu's work is an extremely useful way of thinking about how the educational institutions of visual culture interact with their students and the wider society and culture. The acquisition of knowledge and the mere fact of attending a college or university – in which important social networks are also formed – may be seen as a highly productive means of acquiring cultural capital. Yet translation of this into economic capital is not as straightforward as Bourdieu seems to imply. Studying art practice or filmmaking is not a guarantee of a financially viable career as an artist or filmmaker. Angela McRobbie describes how these contradictions are often resolved within contemporary society:

> In an aestheticised culture, art becomes another transferable skill. Train as an artist to become a DJ. Work nights in a club or bar and get a commission from the promoters to do an installation. Make a video, take photographs, etc.[14]

In other words, education, and the cultural capital that comes from it, may lead to the acquisition of economic capital, but this relationship often works itself out through a highly complex and unpredictable set of social scenarios. However, it should also be borne in mind that certain academic paths of study such as architecture or graphic design are more closely linked to specific career structures than areas such as art or video production.

Production and Dissemination of Knowledge and Understanding

Educational institutions are a key means of disseminating specific, formal approaches to knowledge, but everyday life offers constant exposure to objects, images, displays and writing about visual culture, all of which propose a particular view of the world. All types of institutions, from museums to independent arts organisations, are involved with the production and dissemination of knowledge and understanding. However, some institutions are more influential than others. The most familiar types of institution that we consciously observe as being involved in this everyday shaping of knowledge are those linked to the media and advertising industries. As Sturken and Cartwright state:

> The capacity of the mass media to reach so many viewers both nationally and globally gives it a significant amount of power. . . . The historical argument

states that TV and radio provided a centralized means for mobilizing the new mass culture or mass society around a unified set of issues and ideas. The idea was that mass broadcasting, with its ability to reach large numbers of people with the same messages, fostered conformity to dominant ideas about politics and culture.[15]

The domineering and controlling role played by both government-funded and private media institutions is most clearly illustrated by their powers to shape and censor the practices of visual culture. Many countries such as Britain, France Italy or the United States have large, public television companies, explicitly linked to governments or large corporations, and which have played a key role in shaping social values. Regarding American consumer culture, for example, an NBC executive stated on radio in 1948 that 'advertising on television will be a potent educational force, and consequently will be of almost as much value to our American way of life as the entertainment itself'.[16] Most of the activities of an organisation like the BBC do not clearly indicate to viewers that it is an element of the British state apparatus. However, when certain programmes are banned owing to their political or sexual content, this relationship of control over the public's knowledge and viewpoints becomes more overt. Although the BBC is nominally independent, it has been under constant pressure to present news that supports the government's case, from the Falklands War of 1982 through to the 2003 invasion of Iraq. Indeed, this difficult relation culminated in the so-called Hutton affair – in which the BBC became locked in conflict with the Blair government over allegations about the government's honesty in presenting the case for the invasion of Iraq – resulting in the capitulation of the BBC.[17]

In television or newspaper reporting, the fact that political viewpoints shape the images shown seems glaringly apparent. However, media institutions also shape the public understanding of society and culture through more subtle means and in unexpected contexts. For example, when a leading arts programme chooses to focus on a single, formerly controversial artist, designer or filmmaker, it instantly signals their artistic credibility and fosters acceptance of their work by the wider public. Despite the powerful influence of media forms, the concept of the mass media as a singular, cohesive entity that feeds information of dubious truth to a gullible public has been criticised by many, who argue that the composition of the media and its interaction with its audiences are more complex than this viewpoint would imply.[18] Certainly, thinking of the public as a 'mass' audience with similar, unified characteristics is not relevant to the complex and variegated nature of many contemporary societies, which are composed of different cultures and communities. Thus while the media often confirm the powerful influence of dominant ideologies, there is ambivalence from audiences about certain political ideas and a contestation of mainstream ideas about society and culture.

Despite their overall diversity, all types of institutions of visual culture involve the production and dissemination of knowledge and understanding about visual culture and society. Indeed, in the 1960s art theorists such as Arthur Danto and George Dickie defined art by reference to how it was interpreted and valorised by leading art institutions and critics, rather than the qualities of individual art-works.[19] Although these ideas may be criticised from a variety of perspectives including whether something as complex as the art world produces consensual values, consideration of the powerful legitimising role of major institutions such as the Pompidou Centre in Paris or MOMA in New York certainly lends some credibility to Michael Phillipson's view that 'Above all, art is something to be managed, to be accommodated to the needs of the institutional machinery that must continually reprocess and transform its objects of knowledge to provide for and secure the future of its own practices.'[20]

Institutions such as the Crafts Council, the Arts Council of England and Wales and, in the United States, the National Endowment for the Arts carry out a whole range of activities that help shape professional practice and the public understanding of it. They provide opportunities for the exchange of intellectual, artistic, commercial and technical knowledge, which is vital to those working within visual culture. These institutions are publicly funded and interface with both the professional and public spheres. This often leads to conflict and controversy since professional and public views of what are valid visual and intellectual ideas are sometimes radically divergent. These key institutions are therefore very revealing as to the political and power networks and struggles informing the practices of visual culture. They illustrate the practical working out of different ideological views, which are continually tested against others in the pursuit of dominance or hegemony. Jonathan Harris reveals how these struggles are to a significant extent played out in the everyday subjective decisions and actions of individuals. He states:

> Subject to sharp criticism in recent years over its organisation, location and policy decisions, from both the left and right in Britain, each with their own agendas for reform or transformation *and* from artists who see themselves as the clients of the organisation, the Arts Council has faced and continues to face a *crisis of legitimacy* regarding its role and value in contemporary society.[21]

The issue of cultural capital is relevant here again, for institutions such as the Arts Council are run by people with a significant degree of expertise about the visual arts. These individuals and the institutions are, by implication, seen to be in possession of a large degree of cultural capital, which is of course a sign of professional competence in their field. This often leads to accusations of blinkered and elitist approaches that do not relate to wider public tastes. Over the last fifteen years many international, publicly funded institutions of visual culture, in particu-

lar museums and galleries, have come under pressure to form more equitable relationships with their audiences, but the complex ideological relationships involved in these contexts means that, despite significant change, unequal power relationships still persist.

Funding and Sponsorship

One vital way in which institutions stimulate and control visual culture is by funding or sponsoring its production. Due to the desire to reveal the political and social structures implicit in the practices, objects and images of visual culture, most analyses of institutions tend to focus on the negative aspects of power-infused funding relationships. Whilst these relationships may indeed be limiting or even coercive, a significant proportion of the images and artefacts that have been produced would never have existed without some form of patronage or sponsorship. Exploring funding relationships can be a most revealing means of tracing the development of significant social and aesthetic changes.

Different areas of visual culture such as film, art, television, photography, design and fashion all have distinctive histories in terms of key funding sources and structures. These histories vary from one country to another; the history of filmmaking in Australia, for example, is distinctive from that of the United States, and a large part is played by the different institutional structures underpinning filmmaking in the two countries.[22] It is not possible therefore to give a full, or even a partial, historical account of the development of funding structures within visual culture within this chapter. Therefore, I will focus on historical shifts within the patronage of craft and design.

From the medieval period to the late seventeenth century designed goods other than immediate necessities were largely available only internationally to a small elite. The aristocracy and wealthy merchants were therefore the major patrons of craftspeople like jewellers, furniture-makers, ceramicists, glass-makers, dressmakers and milliners. The Church was also an important patron within Europe; it commissioned a whole range of objects, from fine textiles and stained glass to entire buildings. From the mid-eighteenth century in Britain, due to the development of industrialisation and relative increases in incomes, luxury goods began to be more accessible to the middle classes. The patronage of design therefore began to be representative of a set of class interests beyond those of the most privileged elite.[23] By the early nineteenth century the steady expansion of mass manufacturing led to government efforts to promote British design actively amongst the populace and improve aesthetic standards within industry. Between 1835 and 1836 a government select committee met to 'inquire into the best means of extending a knowledge of the ARTS and of the PRINCIPLES OF DESIGN among the people (especially the Manufacturing Population) of the Country'.[24]

Figure 15.2 – Pavilion de L'Intransigent, architect Henri Favier, from the Paris Exposition des Arts Decoratifs et Industriels of 1925. Photograph courtesy of F. R. Yerbury/Architectural Association.

Acknowledgement of the important role of public patronage of design and the perceived need by government to shape public taste and standards of workmanship led to the immediate setting up of the government Schools of Design – one of which eventually became the Royal College of Art. It also led to the founding of the South Kensington (later, the Victoria and Albert) Museum in London. These developments signalled the emergence of a new and powerful player in the patronage of design: the public museum of design and the decorative arts. Increased government intervention in the promotion and patronage of design also occurred internationally in that period, including the Great Exhibition in London of 1851 and later expositions in Europe and America, such as the Paris *Exposition des Arts Décoratifs et Industriels* of 1925 (Figure 15.2).

From the 1920s onwards goods, from furniture to fashion, became almost exclusively mass produced, and this expansion in the availability of designed goods raises interesting issues about the funding of design and the power and control linked to it. For example, the conventional ideology of Western consumer capitalism posits that the rise of mass consumption was essentially a democratising process whereby everyone could, in theory, express their individuality and personal choices through acts of consumption. Yet many critics have illustrated the power and control exerted by global corporations and their associated advertising and marketing networks on consumers and even governments.[25] Moreover designers or craft 'makers' who produce objects in small batches, or as one-off artefacts,

have had to rely increasingly on private or gallery commissions, or on grant support from government-funded bodies such as the National Endowment for the Arts or the Crafts Council. The funding schemes and contact networks of these institutions have been instrumental in enabling many practitioners to survive and develop their creative work, but the fact that they are public bodies, accountable to the government and the public for the allocation of resources, means that their role is often constrained by the need to avoid controversy.

The Museum and Popular Culture: the Example of 'Streetstyle'

The Victoria and Albert Museum (V&A) is the national museum of art and design in Britain and has the largest fashion collection in the world. Since its founding in 1852 it has enjoyed many innovations, yet retains the legacy of its origins as a nineteenth-century decorative arts museum.[26] In addition to a permanent display of dress, the V&A organises major temporary exhibitions and smaller displays of fashion.

A principal emphasis on historical dress was retained until 1971 when the exhibition *Fashion: an Anthology*, organised by Sir Cecil Beaton, 'firmly established the role of the Museum as a collector and exhibitor of contemporary fashion'.[27] Since then, the collection of dress has grown according to the Textile and Dress Department's policy to 'collect design which leads'. This has led to an emphasis on designer-level fashion, though execution of this policy also acknowledged that style is not universally led by the catwalk.[28] The *Streetstyle: From Sidewalk to Catwalk* exhibition (Figure 15.3) was held between November 1994 and February 1995 and was curated jointly by Amy de la Haye and Cathie Dingwall of the V&A and the sociologist Ted Polhemus. This exhibition was held some time ago, but it remains a fascinating example for discussion due to the issues linked to institutions of visual culture that it raised and confronted.

The motivation of the exhibition was to document an important part of British fashion identity and also to explore an area of popular culture that is a significant influence on designer level fashion. The curators adopted Stuart Hall's definition of youth subcultures, as follows:

> Subcultures must exhibit a distinctive enough shape and structure to make them different from their parent culture. They must be focused around certain activities, values, certain uses of material artifacts, territorial spaces.[29]

The exhibition centred on 'a unique collection of subcultural clothes worn from the 1940s to the 1990s', now embraced within the V&A's permanent collection of textiles and fashion.[30] This clothing was collected from the original owners and wearers wherever possible, along with oral testimonies and sometimes photographs of the donor, thus following the aim of the curators to document people's lived experience.

Figure 15.3 – Skinhead outfit photographed for the *Surfers, Soulies, Skaters and Skinheads* publication that was linked to the Streetstyle exhibition. A similar style of presentation to the exhibition is featured in the photograph. Image courtesy of the V&A Picture Library.

A persistent tension was generated between the perceived image of the V&A as a major national institution, a part of the British 'establishment', and the inclusion of clothes linked to youthful 'street' identities. Many reviewers debated whether the V&A should have mounted the display at all.[31] Despite the fact that the curators had not attempted to represent each subculture in its entirety and intended that the

clothes displayed should merely represent the people who wore them, critics inter-
preted the exhibition as presenting 'generic types, even stereotypes'.[32] The exhibi-
tion attracted a positive response from the public in that visitor figures were high,
but it also elicited debate and negative comments that deserve further scrutiny.

The most common criticism was that the clothes did not represent visitors' rec-
ollections of what they wore as a member of a certain subculture. Caroline Evans
comments on this as follows:

> It was not so much that the representations were wrong; rather, the inter-
> viewees felt transfixed, immobilized, like a butterfly impaled on a pin in
> somebody else's butterfly collection – furthermore, a collection that did not
> take into account the fact that in subcultures, more than anywhere else, iden-
> tities are fluid, mobile and on the move.[33]

This statement pinpoints the disparities between the cultural practices and power
relationships involved with a national museum owning and displaying 'streetstyle'
and the social contexts within which the outfits were originally assembled and
worn. It is interesting to consider these different modes of collecting sartorial iden-
tity in the light of the following passage from Walter Benjamin. He states:

> Every passion borders on the chaotic, but the collector's passion borders on the
> chaos of memories. More than that: the chance, the fate, that suffuse the past
> before my eyes are conspicuously present in the accustomed confusion of these
> books. For what else is this collection but a disorder to which habit has accom-
> modated itself to such an extent that it can appear as order ? . . . These are the
> very areas in which any order is a balancing act of extreme precariousness.[34]

Benjamin's words, although written specifically about books, encapsulate elo-
quently the precarious and fragile nature of the identity we knit together, in part
through the accumulation of material things. Memory is an important instrument
by means of which we gain an understanding of who we are as individuals and how
we relate to the society we live in and through. The *Streetstyle* collection intervened
in these processes in a number of different ways. Through a large powerful museum
taking over ownership of the clothing of specific individuals it simultaneously pre-
served these individual memories and also made them accessible to a wider public.
Despite the fact that this was done with the willing participation of those con-
cerned, this process still disturbed the precarious relationship between the individ-
ual collector, memory and material objects outlined by Benjamin. This might
account in part for the frequent criticisms from visitors that 'it wasn't like that'.
However, these comments cannot merely be attributed to the fact that subcultural
identities are fluid and mobile, as fashionable identities in general are shifting and

unstable. What is more relevant is the fact that subcultural identities are group identities and therefore, for example, punks felt a strong sense of community with their immediate social grouping and also, particularly through media representations of their subculture, with other punks nationally and internationally. Yet, due to the localised and shifting nature of everyday subcultural practices, this wider identification with others often belies significant stylistic and taste differences between individuals. Each individual's memory of their 'own' subculture therefore amounts to a 'chaos of memories', both imagined and real, that cannot be represented in a satisfactory or apposite way for each potential visitor to an exhibition.

Despite these inherent difficulties and contradictions, it is still worth considering whether the V&A might have approached the exhibition differently, in a manner more appropriate to the subject matter. The perspectives employed in creating the display are outlined by the curators as follows:

> Social history collections often demand a different viewpoint from that of art and design institutions. Re-creating the total environment . . . involves a different policy from that of a decorative arts museum, such as the V&A, which tends to focus upon the object per se and then on its dynamic relationship to similar objects, augmented with contextual written information.[35]

The *Streetstyle* exhibition was groundbreaking within the context of the international curatorship of dress, and the project entailed building a unique and important historical record of British subcultures. Yet there is an intrinsic contradiction between presenting subcultures primarily as a source of stylistic influence on fashion and the way those engaged with subcultures use style as a manifestation of social relationships. Furthermore, the design of the exhibition followed the approaches outlined in the comment above, rather than further contextualising the objects displayed. This reveals that the V&A's approach to *Streetstyle* was strongly shaped by its overall perspectives as an institution. The minimal social and cultural context provided in the exhibition may also have been due to a desire to avoid controversy on the grounds of racial, gender and sexual politics. Nevertheless, *Streetstyle* was an ambitious and daring project, which took the V&A into new and unexplored territory, far away from its established constituency of the middle classes with a taste for high culture. This was entirely in line with contemporary ideas that museums should engage more with popular culture and treat visitors as active participants rather than passive onlookers. Reactions to the exhibition, however, clearly demonstrated that for a major national institution to move from being a 'site of authority' to operating as a responsive 'site of mutuality' is a highly complex matter, not without its problems.[36] The large attendance figures and public criticisms reveal the contradictions generated by addressing a topic such as youth subcultures. Comments about whether the exhibition adequately represented the

subcultures indicate that the museum achieved a questioning of its authority by a public who, for once, felt they knew more than the curators. These fascinating contradictions are very revealing as to how large institutions relate to wider society and culture. As Marcia Pointon states:

> Every museum . . . involves a dialogue between inside and outside: the interior of the building versus its exterior; the curators versus the visitors; the objects contained within in relation to identical, comparable or different objects not inside the museum but elsewhere; the body of knowledge claimed and guarded by those designated museum professionals and contested by others outside claiming comparable but different knowledges.[37]

Conclusion

In the early twenty-first century the broad scope of media, educational and other types of institutions means that they are central to the formulation and expression of our values, ideas and beliefs. Public engagement with visual culture in order to communicate, provide enjoyment and learn, generally only occurs through the mediating power of some kind of institution. Indeed, institutions of the kind discussed in this chapter play a key role in shaping the discourses of visual culture, from which emerges a wider understanding of concepts like the 'past', the 'contemporary', 'tradition' and 'the new'. The example of the *Streetstyle* exhibition reveals the specific complexities of the social relationships involved in the engagement with institutions. Whilst ideology clearly shapes the relationships between institutions and their audiences, the diversity and complexity both of institutions and of how they relate to their audiences reveals scope for great ambivalence on the part of the public, leading to an active contestation of their role and purpose within society.

Further Reading

Alexander, Victoria. *Sociology of the Arts: Exploring Fine and Popular Forms* (Oxford, 2003).

Bourdieu, Pierre. *The Field of Cultural Production* (Cambridge, 1993).

Lacey, Nicholas. *Media Institutions and Audiences* (Basingstoke, 2002).

Pointon, Marcia, ed. *Art Apart: Art Institutions and Ideology across England and North America* (Manchester, 1994).

Notes

1 Theodor Adorno and Max Horkheimer, 'The Culture Industry: Enlightenment as Mass Deception', in Simon During, ed., *The Cultural Studies Reader* (London, 1993), p. 33.

2 On the phenomenon of the young British artists, see Julian Stallabrass, *High Art Lite*

(London, 1999). See also Neil Mulholland, *The Cultural Devolution. Art in Britain in the Late Twentieth Century* (Aldershot, 2003).

3 Marcia Pointon, 'Introduction' to *Art Apart: Art Institutions and Ideology Across England and North America* (Manchester, 1994), pp. 1–5.

4 Janet Wolff, *The Social Production of Art* (London, 1993), p. 40.

5 Anthony Giddens, *The Constitution of Society* (Cambridge, 1984), p. 24; Raymond Williams, *Keywords* (London, 1976), p. 169.

6 John Walker and Sarah Chaplin, 'Institutions', in *Visual Culture: an Introduction* (Manchester, 1997), pp. 81–95.

7 Raymond Williams, *Culture* (London, 1981), p. 35.

8 On the rise of the public, see Jürgen Habermas, *Structural Transformation of the Social Sphere: an Inquiry into a Category of Bourgeois Society* (Cambridge, 1989). On the rise of the art public, see Thomas Crow, *Painters and Public Life in Eighteenth-Century Paris* (London and New Haven, CT, 1985).

9 Johnson Randal, 'Introduction' to Pierre Bourdieu, *The Field of Cultural Production: Essays on Art and Literature* (Cambridge, 1993), p. 10.

10 Information about James Carpenter's collaborations with architects can be gleaned from the James Carpenter Design Associates Inc website at www.jcdainc.com.

11 On the theory and practice of teaching at the Bauhaus, see Rainer Wick, *Teaching at the Bauhaus* (Stuttgart, 2000).

12 Paul Greenhalgh, 'Introduction' to *Modernism in Design* (London, 1990), pp. 1–24; Jonathan Woodham, 'Design and Modernism', in *Twentieth-Century Design* (Oxford, 1997), pp. 29–63.

13 Celia Lury, *Consumer Culture* (Cambridge, 1996), p. 83. Pierre Bourdieu, *Distinction: a Social Critique of the Judgement of Taste* (London, 1984).

14 Angela McRobbie, *In the Culture Society: Art, Fashion and Popular Music* (London, 1999), p. 8.

15 Marita Sturken and Lisa Cartwright, *Practices of Looking: an Introduction to Visual Culture* (Oxford, 2001), p. 8.

16 Cited in William Boddy, 'The Beginnings of Television', in Anthony Smith, ed., *Television: an International History* (Oxford, 1998), p. 33.

17 The allegation was that the government had exaggerated the threat posed by Iraqi 'weapons of mass destruction'. The source of the report was a government arms adviser who, when exposed as the source of information, committed suicide.

18 See, for example, David Morley, 'Changing Paradigms in Audience Studies', in E. Seiter, H. Borchers, G. Krentzner and E. Warth, eds, *Remote Control Television: Audiences and Cultural Power* (London, 1991); C. Geraghty and D. Lusted, eds, *The Television Studies Book* (London, 1998); Pertti Alasuutari, ed., *Rethinking the Media Audience* (London, 1999).

19 Arthur Danto, 'The Art World', in *Journal of Philosophy*, Vol. 6 (1964), pp. 571–84; George Dickie, *Art and the Aesthetic: an Institutional Analysis* (Ithaca, NY, 1974).

20 Michael Phillipson, 'Managing Tradition', in Chris Jenks, ed., *Visual Culture* (London, 1995), p. 207.

21 Jonathan Harris, 'Cultured into Crisis: the Arts Council of Great Britain', in Pointon, *Art Apart,* p. 179.

22 The classic institutional analysis of Hollywood cinema remains David Bordwell, Janet Staiger and Kristin Thompson, *The Classical Hollywood Cinema* (London, 1985).

23 See John Brewer and Roy Porter, eds, *Consumption and the World of Goods* (London, 1993); Maxine Berg and Helen Clifford, *Consumers and Luxury: Consumer Culture in Europe 1650–1850* (Manchester, 1999).

24 British Parliamentary Papers, *Report of the Select Committee on Arts and Manufactures*, 1836, quoted in Louise Purbrick, 'The South Kensington Museum: the Building of the House of

Henry Cole', in Pointon, *Art Apart,* p. 70. On this debate, see too Quentin Bell, *The Schools of Design* (London, 1963).

25 See, for example, Stuart Ewen, *All Consuming Images: the Politics of Style in Contemporary Culture* (New York, 1988); Lury, *Consumer Culture*; Naomi Klein, *No Logo* (London, 2001).

26 On the history of the museum, see Anthony Burton, *Vision and Accident: The Story of the Victoria and Albert Museum* (London, 1999).

27 Interview with Valerie Mendes, then chief curator of the V&A's Textiles and Dress Department, 1 March 2000.

28 See Valerie Mendes, Avril Hart and Amy de la Haye, 'Introduction' to N. Rothstein, ed., *Four Hundred Years of Fashion* (London, 1992).

29 Stuart Hall, cited in Amy de la Haye and Catherine Dingwall, eds, 'Conclusion' to *Surfers, Soulies, Skinheads & Skaters* (London, 1996), np. The original source is Stuart Hall's *Resistance Through Rituals* (London, 1975).

30 de la Haye and Dingwall, eds, 'Introduction' to *Surfers, Soulies, Skinheads & Skaters.*

31 Caroline Evans, 'Dreams That Only Money Can Buy . . . Or, the Shy Tribe in Flight from Discourse', in *Fashion Theory*, Vol. 1, No. 2 (1997), pp. 169–88.

32 de la Haye and Dingwall, eds, 'Conclusion' to *Surfers, Soulies, Skinheads & Skaters.*

33 Evans, 'Dreams', p. 180.

34 Walter Benjamin, 'Unpacking my Library', in Walter Benjamin, *Selected Writings. Vol. 2: 1927–1934* (Cambridge, MA, 1999), p. 486. First published in 1927.

35 de la Haye and Dingwall, eds, 'Conclusion' to *Surfers, Soulies, Skinheads & Skaters.*

36 Eilean Hooper Greenhill, *Museum, Media, Message* (London, 1995), p. xi.

37 Pointon, *Art Apart*, p. 2.

Index